PRESIDENT'S AWARD GOLD AWARD SILVER AWARD SILVER NOMINATION

The 40th Annual of the Best in British and International Design and Advertising 2002

D&AD is a professional association and charity that represents the thriving design and advertising communities. Its purpose is to set creative standards, educate and inspire the next creative generation and promote the importance of good design and advertising in the business arena.

To find out more visit:

www.dandad.org

Or write to:

D&AD
9 Graphite Square
Vauxhall Walk
London
SE11 5EE

CREDITS

Cover and Section Design:
Mother

Annual Design:
Esterson Lackersteen

Project Management:
Louise Fowler
Lloyd Kirton

Editorial Assistance:
Pauline Shakespeare
Jeremy Downing
Sophie Lloyd

Editorial Content:
Meg Carter
Hugh Aldersey-Williams

Image Manipulation:
Supported by Admagic
www.admagic.co.uk

Archive Images:
Supported by Getty Images
www.gettyimages.co.uk

Jury Portraits:
Paul Tozer

Film and Processing:
Film: AGFA APX 100
Paper: AGFA Multicontrast Premium
RC and AGFA Multicontrast Classic FB
Film Developer: AGFA Studional
Paper Developer: AGFA Neutol WA
Fix: AGFA Agefix

Print Production:
Martin Lee Associates

Origination, Printing and Binding:
Mondadori Printing, Verona, Italy

The captions and artwork in this book
have been supplied by the entrants.
Whilst every effort has been made to
ensure accuracy, D&AD does not under
any circumstances accept responsibility
for errors or omissions.

The D&AD logo and pencil are the
registered trademarks of British Design
& Art Direction.

Distributed in the UK by:
Airlift Book Company
8 The Arena
Mollinson Avenue
Enfield
Middlesex EN3 7NL

T. +44 (0)20 8804 0400

Distributed throughout the rest of the
world by:
Harper Collins International
10 East 53rd Street
New York
NY 10022
USA

T. +001 212 207 7218
F. +001 212 207 7654

All direct mail enquiries to:
D&AD
9 Graphite Square
Vauxhall Walk
London SE11 5EE

T. +44 (0)20 7840 1128

Published 2002 by:
D&AD (British Design & Art Direction)
9 Graphite Square
Vauxhall Walk
London SE11 5EE

T. +44 (0)20 7840 1111

Copyright © 2002 D&AD
(British Design & Art Direction)

ISBN Number 0-9542784-0-2

THE CONTENTS

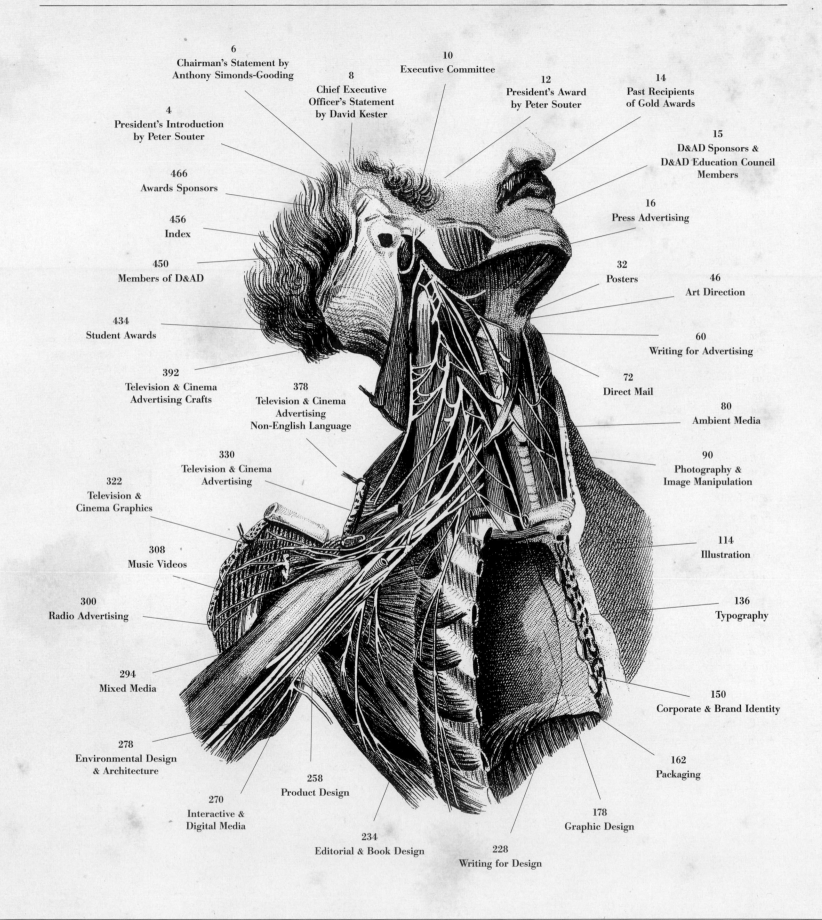

THE PRESIDENT
THE MOST EMINENT DR. PETER SOUTER

This is a story about an extremely famous and outrageously talented copywriter. Because a crime of sorts occurs in the middle of the story, as a friend, I feel I must conceal his true identity. Let's call him 'Tim'. Back in the late 80's when Tim was already outrageously talented, but before he was very famous, he found himself working in a dinosaur advertising agency. One night, soon after he had joined but long before he got paid, he and his partner were working late (for the sake of argument let's call his partner 'Walden'). They decided to go for a stroll around the creative department and soon wandered into the palatial office of a respected stegosaurus. There on a high shelf sat a complete set of D&ADs. Tim climbed on a chair (he's not that tall) and ran his finger along the top of the Annuals. His face lit up. He showed his finger to Walden. "Dust!" he cried and promptly stole them all.

Now stealing a well-thumbed D&AD is a heinous crime. But rescuing an abandoned Annual from a cruel and neglectful owner was, in Tim's mind practically a public duty. D&ADs are like reverse Tamagotchis, you must take them off the shelf often so they can feed you. The dust meant that they would not be missed. The Royal Society for the Prevention of Cruelty to Books, were they to be hurriedly formed to suit this story, would undoubtedly approve of the rescue. Tim and his partner Walden went on to win twenty-one yellow pencils and four blacks (I hope I haven't given too much away). The Annual you are holding in your hands is the most important book in our industry. Please, for your own sake, don't let it gather too much dust.

SPECIMENS FROM DR. SOUTER'S RESEARCH OF THE CRIMINALLY INSANE.

PAST PRESIDENTS

Year	President
2002	PETER SOUTER
2001	DAVID STUART
2000	LARRY BARKER
1999	RICHARD SEYMOUR
1998	TIM MELLORS
1997	MIKE DEMPSEY
1996	GRAHAM FINK
1995	MARY LEWIS
1994	ADRIAN HOLMES
1993	AZIZ CAMI
1992	TIM DELANEY
1991	MARTIN LAMBIE-NAIRN
1990	RON BROWN
1989	JOHN HEGARTY
1988	GERT DUMBAR
1987	JEREMY SINCLAIR
1986	JOHN McCONNELL
1985	ALLEN THOMAS
1984	RODNEY FITCH CBE
1983	TONY BRIGNULL
1982	MARCELLO MINALE
1981	MARTIN BOASE
1980	LORD SNOWDON
1979	ARTHUR PARSONS
1978	MICHAEL RAND
1977	JOHN SALMON
1976	ALAN PARKER
1975	DAVID ABBOTT
1974	ALAN FLETCHER
1973	PETER MAYLE
1972	MICHAEL WOLFF
1971	EDWARD BOOTH-CLIBBORN
1970	EDWARD BOOTH-CLIBBORN
1969	EDWARD BOOTH-CLIBBORN
1968	DENNIS HACKETT
1967	EDWARD BOOTH-CLIBBORN
1966	EDWARD BOOTH-CLIBBORN
1965	EDWARD BOOTH-CLIBBORN
1964	EDWARD BOOTH-CLIBBORN
1963	EDWARD BOOTH-CLIBBORN
1962	JOHN COMMANDER

Anthony Simonds-Gooding

THE CHAIRMAN

'WEATHERING THE STORM'

Sketches From The Chairman's
'Study of the Mind of the Lower Classes'

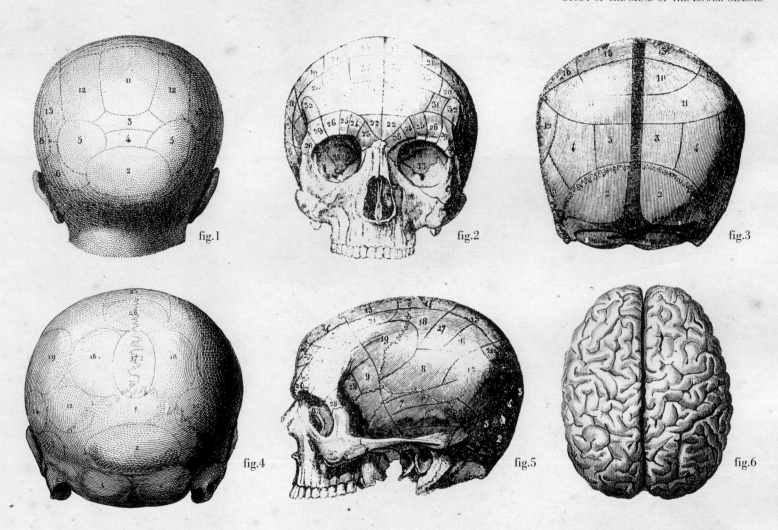

fig.1 fig.2 fig.3 fig.4 fig.5 fig.6

Too many brands survive, simply because they have been about long enough to become an unchallenged habit. Then along comes recession. Overnight it's goodbye to inertia and hello to new usefulness and value.

This is the tenth year that I have written this Chairman's piece. For nine of those years the market has been benign. In this tenth year, recession hit all markets fiercely, and I admit to wondering how the D&AD brand would stand up to the undoubtedly tough challenges that lay ahead. The past year has been a difficult one for all brand owners. As it has turned out, this has been my most satisfying year thus far – simply because, when recession came, the D&AD brand was not found wanting.

The number of awards entries exceeded 18,000 items. The work in the book is as impressive as ever. Our new foreign language television category on its first outing enjoyed an astonishing success. We increased rather than reduced our educational programmes. Our donors and sponsors continued to invest in us. We did not make a single redundancy. We ended the year with our financial reserves untouched and intact.

I conclude from this happy result, that the D&AD brand is useful, is relevant, is good value, even when economic trends move against us. The enterprise will do all it can to keep it that way. Meanwhile, thank you for all the support, which has come to us from all quarters. I know that it has been a difficult year for everyone.

DAVID KESTER

THE CHIEF EXECUTIVE OFFICER

THE RIGHT HONOURABLE MR. DAVID KESTER SHARES HIS NOBLE THOUGHTS

What do a pregnant man, a candle burning at both ends, the identity for Reuters, and Andy Warhol's Chelsea Girl have in common? The answer is that they will all feature in 'Rewind', a major retrospective exhibition of 40 years of the D&AD Awards this autumn at London's V&A museum.

If there's one clear message from Rewind, it is that in design and advertising, cutting-edge creativity endures, and helps redefine its medium. So what if we push the 'pause' button and look at this year's creative output. A rifle through the pages of this year's mock precious Annual (courtesy of post-modern-ironic and Gold-winning agency, Mother) provides us with proof, if needed, that creativity also thrives in adversity. From the poignant September 11th 'Broadway Tribute' film by BBDO New York, to the achingly funny Fox Sports spots by TBWA\Chiat Day. From the witty use of copy in packaging by Leo Burnett Chicago for Heinz, to the sculptural use of product design in Tŷ Nânt's bottled water range by Ross Lovegrove. Across all the disciplines those in the business of communicating demonstrated that creativity is both a defining element of our common humanity, as well as a vital component of business survival and success.

The ceremony in May proved a fitting celebration for the 40th D&AD Awards. What started out in 1962, as a common cause for a pioneering band of London designers and art directors, has grown and transformed over four decades into a truly international affair. This year over half the entries came from outside the UK, and there was overwhelming support from all around the world for the new non-English language TV category. Television ads, such as the humorously simple spot for Sealy mattresses by Leo Burnett Mexico, drew enthusiastic rounds of applause, as did the presence of Apple supremo Steve Jobs who arrived with designer Jon Ive, to pick up the company's fourth Gold in a row.

D&AD's education and training programmes held up admirably in the face of the economic storm-clouds (thanks hugely to industry generosity) and also echoed the international theme. The Student Awards scheme grew by 12% to an impressive 2,300 entries. A fifth came from non-UK colleges and talented young winners flew in from the States, Singapore, and Australia to pick up their 'baby pencils'. D&AD's on-line talent service, the Getty Images Bloodbank also grew internationally – it now boasts 16,000 registered users. One other highlight was the successful launch of D&AD Workout, a new creative development programme for professionals. The first pilot modules received

a thumbs-up from delegates, and work is already in hand to expand the programme from its current advertising base into design, and include a summer school version for international delegates.

Peter Souter's President's Lecture series kept literally thousands enthralled over the year. Two of the biggest crowd-pullers proved to be Emma Freud interviewing her partner Richard Curtis, and a Dutch design night which launched the D&AD Graphics Book.

In what was unquestionably a hard year, it has also been hugely reassuring that D&AD's membership has remained stable at around the 2,300 mark. Thanks to the help and involvement of many members, including those on the Executive, as well as the constant efforts of the team in Vauxhall, we have managed to maintain investment in the industries' future, and keep all the fires burning despite minimum fuel. As we push the 'fast forward' button and look to the future it is as hard as ever to know which oracle to believe. However, at D&AD we are planning our year ahead with energy and enthusiasm. We will continue to expand our international remit, both within education and the awards, whilst rolling out new membership initiatives to support and strengthen our creative community.

THE REVOLUTIONARY DAVID KESTER TECHNIQUE – 'YOU'LL NEVER SNORE AGAIN'

fig.1

fig.2
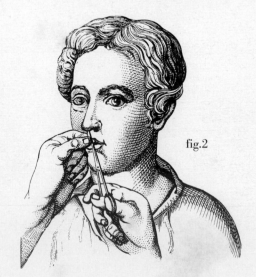

fig.3

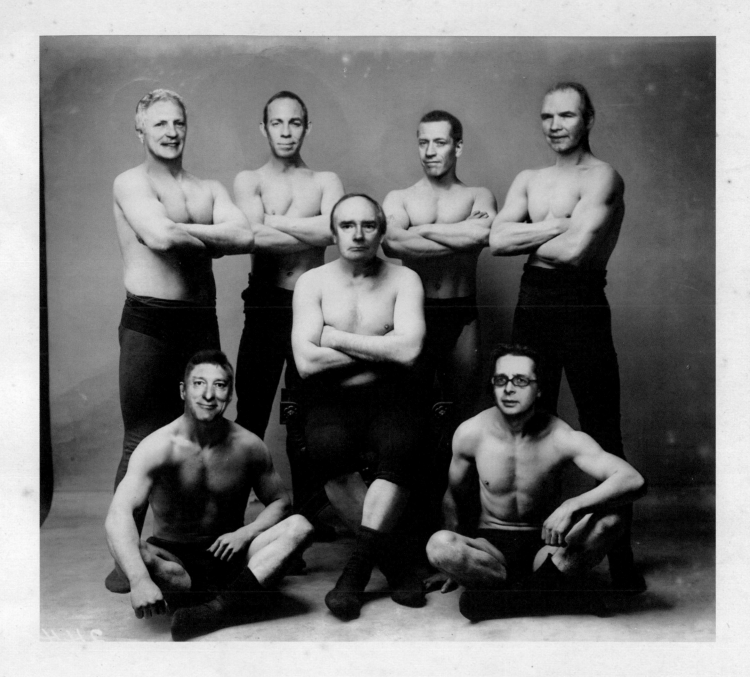

Top Row; *Left to Right:*

HOWARD FLETCHER, Writer • **ROBERT CAMPBELL**, Rainey Kelly Campbell Roalfe Y&R • **JOHN PALLANT**, Saatchi & Saatchi • **DICK POWELL**, Seymour Powell

Bottom Row; *Left to Right:*

KEN HOGGINS, Banks Hoggins O'Shea • **PATRICK COLLISTER**, EHS Brann • **MICHAEL JOHNSON**, Johnson Banks

THE EXECUTIVE COMMITEE

Athletic Male Bonding Club

Left to Right:
KEREN HOUSE, SIEBERT HEAD • LYNN TRICKETT, TRICKETT & WEBB

THE EXECUTIVE COMMITEE

Ladies Society for Good Book Keeping & The Conservation of Asparagus

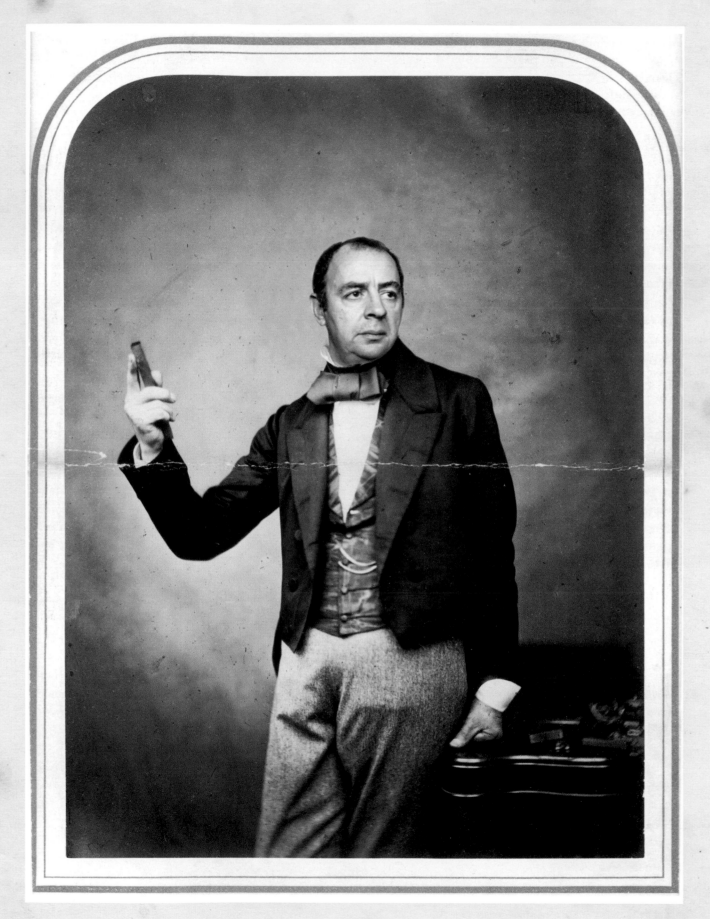

PAUL WEILAND

THE PRESIDENT'S AWARD

PRESENTED TO PAUL WEILAND BY PETER SOUTER

It is said, rather cruelly I've always thought, that if you want to look like Paul Weiland, peer closely into the hub cap of an old Volkswagen beetle.

I open with this for two reasons. Firstly, Paul is the nation's premier exponent of the cruel joke and therefore really ought to be on the receiving end every now and then. And, secondly, because everything else I have to say about him is an embarrassing mix of undiluted admiration and love. It's important to get a little balance.

God made Paul slightly less than beautiful so he didn't get too carried away with being one of the most brilliant men in the country. Under that layer of sharp and quite possibly poisonous spikes you have all over your body Paul, you're

an amazing man. You have an enormous heart, a terrifyingly brilliant mind and, of course, a tiny wallet. But we'll let that pass. In an odd way you are responsible for literally dozens of people not winning a D&AD Gold pencil.

Not, I hasten to add, because you mucked up the shooting of their scripts. The lost Golds are simply down to the fact that your unequalled Guardian 'Points of View' commercial didn't get one. Despite being one of the best ads ever made, it merely won a Silver. So for years juries rang with the phrase "we can't give that a Gold if 'Points of View' didn't get one." I bring this up because, truth be told, Paul you're a bit pissed off with us aren't you? You feel that, despite having a black pencil, nine yellows, eighteen

nominations and a staggering 68 entries into the book, you have never got the recognition you deserve. You have written and directed commercials that have made us laugh, made us cry and relentlessly made us buy stuff. There's even a wild rumour that you got a press ad in once. Your ads have been included in the Annual every year since 1974, apart from the two years you took off to shoot movies.

If you were a different kind of man you might shrug and let the enormous body of your work speak for itself. But you're not. You're pissed. You feel you deserve more.

Well, here we go Paul. It's the best I could do. I more or less tried to get myself elected President just so I could give you the D&AD President's Award. I hope it helps a little.

'THE WEILAND METHOD'
FOR PAYING CLOSE ATTENTION
WITH THE LEFT EYE

 PAST PRESIDENT'S AWARD RECIPIENTS

Year	Recipient
2002	PAUL WEILAND
2001	MARY LEWIS
2000	TIM DELANEY
1999	BOB GILL
1998	DAVID BAILEY
1997	MARTIN LAMBIE-NAIRN
1996	PAUL ARDEN
1995	RICHARD SEYMOUR & DICK POWELL
1994	JOHN HEGARTY
1993	JOHN GORHAM
1992	NEIL GODFREY
1991	ABRAM GAMES
1990	RIDLEY SCOTT
1989	SIR TERENCE CONCRAN
1988	FRANK LOWE
1987	MARCELLO MINALE & BRIAN TATTERSFIELD
1986	DAVID ABBOTT
1985	JOHN McCONNELL
1984	BOB BROOKS
1983	BILL BERNBACH
1982	JOHN WEBSTER
1981	HAROLD EVANS
1980	ALAN PARKER
1979	JOHN SALMON
1978	JEREMY BULLMORE
1977	ALAN FLETCHER & COLIN FORBES
1976	COLIN MILWARD

GOLD AWARD RECIPIENTS

2002

Michel Gondry
Frank Budgen
Mark Hunter
Tony McTear
Bart Andre
Danny Coster
Daniele De Iuliis
Richard Howarth
Jonathan Ive
Steve Jobs
Duncan Kerr
Matthew Rohrbach
Doug Satzger
Cal Seid
Christopher Stringer
Eugene Whang

2001

Markus Bjurman
Joe De Souza
Cecilia Dufils
Kim Gehrig
Durrell Bishop
Roger Mann
Julia Barfield
David Marks
Bart Andre
Danny Coster
Daniele De Iuliis
Richard Howarth
Jonathan Ive
Steve Jobs
Duncan Kerr
Matthew Rohrbach
Doug Satzger
Cal Seid
Christopher Stringer

Eugene Whang

2000

Chris Cunningham
Walter Campbell
Tom Carty
Jonathan Glazer
Bart Andre
Danny Coster
Daniele De Iuliis
Richard Howarth
Jonathan Ive
Steve Jobs
Matthew Rohrbach
Doug Satzger
Christopher Stringer

1999

Bart Andre
Danny Coster
Daniele De Iuliis
Richard Howarth
Jonathan Ive
Steve Jobs
Cal Seid
Christopher Stringer

1998

Thomas Heatherwick
Jonathan Thomas
Michael Riley
Andrew Niccol

1997

Richard Flintham
Andy McLeod

1996

Tony Kaye

1995

No Gold Awards
presented

1994

Steve Burrell
Mark Chaudoir
Penny Delmon
Iain Greenway
Jason Harrington
Maylin Lee
Tim Platt
Jane Wyatt

1993

Larry Frey
Tony Meeuwissen
Anthony Michael
Stephanie Nash
Alex Proyas
Teresa Roviras
Larry Shiu
Dean Turney
Stacy Wall
Francis Wee

1992

No Gold Awards
Presented

1991

Paul Elliman
Peter Miles

1990

Roger Woodburn

1989

No Gold Awards
Presented

1988

Leslie Dektor
Mary Lewis
Kathy Miller
Veronica Nash
Mark Shap

Alan Stanton
Paul Williams

1987

Gert Dumbar
Michel de Boer
Ruhi Hamid

1986

David Bailey
Alan Page
Jeremy Pemberton
Nick Thirkell

1985

Ken Carroll
Mike Dempsey
Peter Gatley
Paul Leeves
John Pallant
Alan Tilby

1984

Andy Arghyrou
Axel Chaldecott
John Hegarty
Steve Henry
Barbara Nokes
Chris O'Shea
Richard Sloggett

1983

Tim Delaney
Rob Kitchen
Martin Lambie-Nairn
Bernard Lodge
Ian Potter
Griff Rhys-Jones
Mel Smith

1982

Gert Dumbar
David Pelham

John Webster

1981

Mike Cozens
John Horton
Simon Langton
John McConnell
David Myerscough-
Jones
Ken Turner
Graham Watson

1980

David Horry
Paul Weiland
Peter Windett

1979

Mike Cozens
Pat Gavin
Alan Waldie

1978

Guy Gladwell
Tony Hertz

1977

Neil Godfrey
Bob Isherwood
Ralph Steadman

1976

David Driver
Terry Lovelock

1975

Colin Craig
Dane Keith Wilson
John Krish

1974

George Dunning
Alan Fletcher
Neil Godfrey
Alan Parker

1973

Nancy Fouts
David Hillman
Hugh Hudson

1972

Don McCullin
Tony Meeuwissen
Sarah Moon
Alan Parker

1971

John Hegarty
Peter Philips
Charles Saatchi
Peter Webb

1970

Michael Rand

1969

Michael Rand

1968

No Gold Awards
Presented

1967

Harry Peccinotti

1966

No Gold Awards
Presented

1965

Robert Brownjohn

1964

No Gold Awards
Presented

D&AD SPONSORS

ABBOTT MEAD VICKERS.BBDO, ADOBE, AGFA, MONOTYPE, APPLE, AQUENT, ADVERTISING STANDARDS AUTHORITY, AVID, BMG MUSIC PUBLISHING, BMP DDB, BOOMERANG MEDIA, BT, CAMPAIGN, CONSUMERS' ASSOCIATION, CORUS, DESIGN COUNCIL, DIMENSION DATA, EARDRUM, THE ECONOMIST, FRAMESTORE CFC, GETTY IMAGES, GLENFIDDICH, THE GUARDIAN, HÄAGEN-DAZS, HANDSPRING, HARPER MACKAY, THE HEAD TRUST, IDEO, THE INDEPENDENT, ITC, KEEN, KIRIN BEER, KISS FM, LYCOS, MAIDEN OUTDOOR, THE MILL, THE NATIONAL MAGAZINE COMPANY, NESTA, OLYMPUS, OUTDOOR ADVERTISING ASSOCIATION, PEARL & DEAN, PHAIDON PRESS, PREMIER PAPER GROUP, PRÊT À MANGER, PRINTOUT, RAB, ROTRING, ROYAL MAIL, SAATCHI & SAATCHI, SEYMOUR POWELL, SHELL LIKE, SVC, TBWA\GGT DIRECT, TISCALI, TRANSPORT FOR LONDON, VENTURA, WEBOPTIMISER, WPP.

D&AD EDUCATION COUNCIL MEMBERS

Abbott Mead Vickers.BBDO, Peter Souter
Banks Hoggins O'Shea, Ken Hoggins
Bartle Bogle Hegarty, John Hegarty
BMP DDB, Chris Powell
Burkitt DDB, Jon Canning
The Chase, Ben Casey
Citigate Lloyd Northover, Jim Northover
Coley Porter Bell, Stephen Bell
Corporate Edge, Peter Shaw
D'Arcy, Nick Hastings
DFGW, Dave Waters
EHS Brann, Phil Jones
Elmwood Design, Jonathan Sands
FutureBrand, Robert Soar
Grey Worldwide, Tim Mellors
The Identica Partnership, Michael Peters OBE
J Walter Thompson, Jaspar Shelbourne
Landor Associates, Charles Wrench
Leo Burnett, Nick Bell
Lewis Moberly, Mary Lewis
Lowe, Adrian Holmes
M&C Saatchi, James Lowther
Marketplace Design, Bryan Brown
Miles Calcraft Briginshaw Duffy,
Paul Briginshaw
Ogilvy, Steve Dunn
The Partners, David Stuart
Partners BDDH, Will Awdry
Publicis, Gerry Moira
Rainey Kelly Campbell Roalfe/Y&R,
Robert Campbell
Siebert Head, Keren House
St Luke's, Andy Law
Silk Pearce, Jack Pearce
TBWA\London, Trevor Beattie

PRESS ADVERTISING

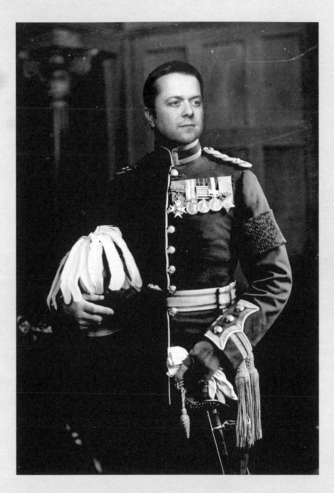 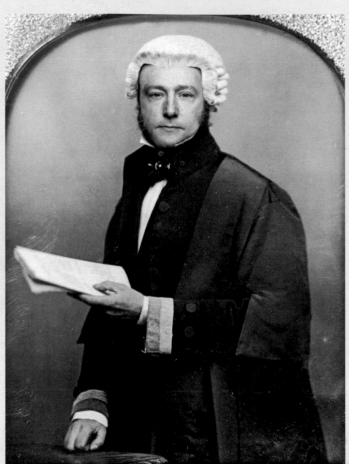

Left to Right:
MICK MAHONEY, MUSTOE MERRIMAN LEVY • **STEVE DUNN,** OGILVY

PRESS ADVERTISING

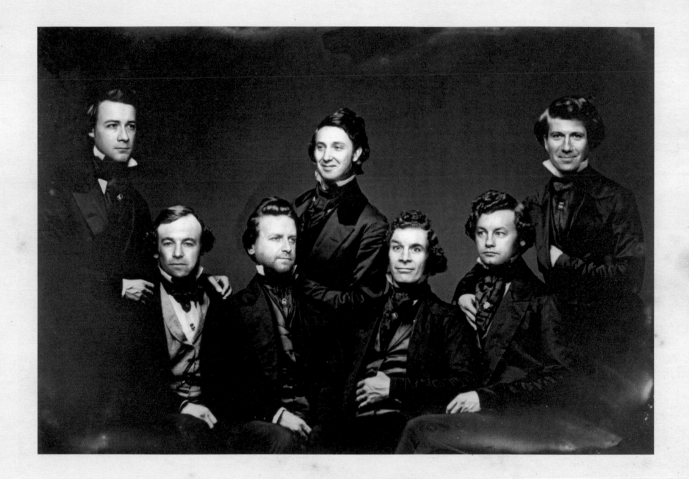

TOP ROW; *Left to Right:*
JORGE CARRENO, TBWA\PARIS • **NIK STUDZINSKI**, SAATCHI & SAATCHI • **DAVE DYE**, CAMPBELL DOYLE DYE
BOTTOM ROW; *Left to Right:*
RICHARD FLINTHAM, FALLON LONDON • **NICK GILL**, BARTLE BOGLE HEGARTY • **MALCOLM DUFFY**, MILES CALCRAFT BRIGINSHAW DUFFY • **EWAN PATTERSON**, BMP DDB

Comment by Richard Flintham

Out, out, in. 2,206 rejected. 22 accepted. This looks like the work of a particularly ruthless bunch, but it was actually a very open-minded and positive jury. I think everyone would have liked more work featured, and consequently lots of ads were called back for discussion. Ultimately, though, there were 22 pieces that not only fulfilled D&AD's criteria, but also passed every jury member's 'I wish I'd done that' test. And you can't say fairer than that.

PRESS ADVERTISING SPONSORED BY ADMAGIC • PUBLIC SERVICE & CHARITIES SPONSORED BY BMP DDB FOR GREAT ORMOND STREET HOSPITAL

Silver Nomination
for the most
outstanding
Colour Newspaper
Advertisement
sponsored by
Admagic

Art Directors
Nick Burrage
Luca Bertoluzzi

Copywriters
Nick Burrage
Luca Bertoluzzi

Typographer
Kevin Clarke

Creative Director
Andrew Fraser

Advertising Agency
BMP DDB

Account Handler
Simon Lendrum

Marketing Executive
Marc Sands

Client
The Guardian

OF LOVE AND WAR: LOST IN LILLE.

By Gustave Clemenceau (1919-1944)

Ah Stella! My Love and Sorrow!

Down in the Rimington's garden

We kissed goodbye my former pain

I stroke your head, your gentle hair

Was made of gold – and then I left:

Milan, for 5 long weeks,

I can reveal so much

Then back to France, all in love for you

And you were gone.

You were gone, the guardian of your house

Said so.

But I'm going to battle this Saturday.

Will I see you again? *Je ne sais pas.*

Translation by Nick Lucas

Stella
Rimington
former
head
of
Mi 5
reveal s
all in

the guardian

this Saturday.

INSTRUCTIONS:
Go to page 3 in main newspaper. Place over poem.

Silver Nomination
for the most
outstanding
Consumer Magazines
Campaign
sponsored by
Admagic

Art Director
Antony Nelson

Copywriter
Mike Sutherland

Photographer
Trevor Ray Hart

Typographer
Scott Silvey

Creative Director
David Droga

Advertising Agency
Saatchi & Saatchi

Account Handler
James Griffiths

Marketing Executives
Clare Burns
Andy Tidy

Client
Club 18-30

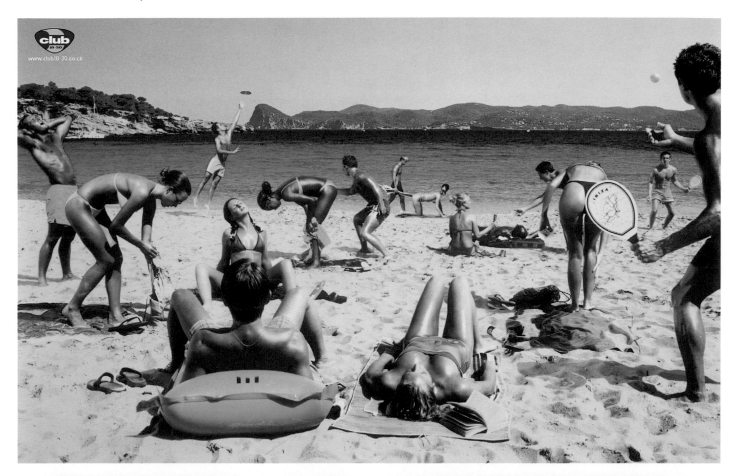

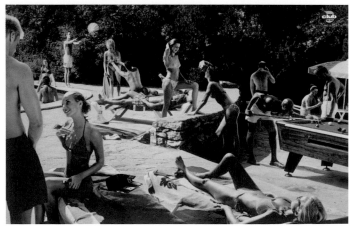

Consumer Magazines, Colour

Art Director
Antony Nelson

Copywriter
Mike Sutherland

Photographer
Trevor Ray Hart

Typographer
Scott Silvey

Creative Director
David Droga

Advertising Agency
Saatchi & Saatchi

Account Handler
James Griffiths

Marketing Executives
Clare Burns
Andy Tidy

Client
Club 18-30

Consumer Magazines, Colour

Art Director
Antony Nelson

Copywriter
Mike Sutherland

Photographer
Trevor Ray Hart

Typographer
Scott Silvey

Creative Director
David Droga

Advertising Agency
Saatchi & Saatchi

Account Handler
James Griffiths

Marketing Executives
Clare Burns
Andy Tidy

Client
Club 18-30

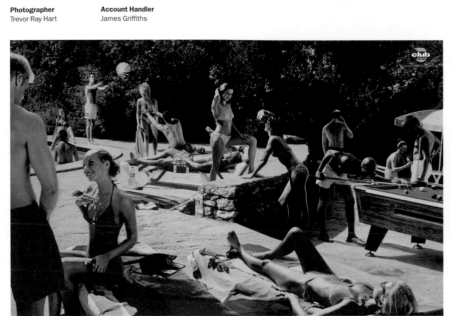

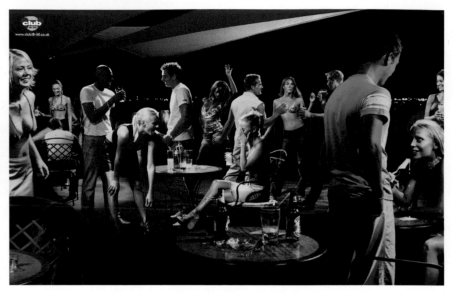

Consumer Magazines, Colour

Art Director
Antony Nelson

Copywriter
Mike Sutherland

Photographer
Trevor Ray Hart

Typographer
Scott Silvey

Creative Director
David Droga

Advertising Agency
Saatchi & Saatchi

Account Handler
James Griffiths

Marketing Executives
Clare Burns
Andy Tidy

Client
Club 18-30

Consumer Magazines, Colour

Art Directors
Bradley Wood
Christopher Toland

Copywriter
Steve Morris

Photographer
Ken Anderson

Illustrator
Christopher Toland

Creative Directors
Harry Cocciolo
Sean Ehringer

Advertising Agency
Leagas Delaney San
Francisco

Account Handler
Katie Meyers

Marketing Executive
Beth Portello

Client
Adidas North America

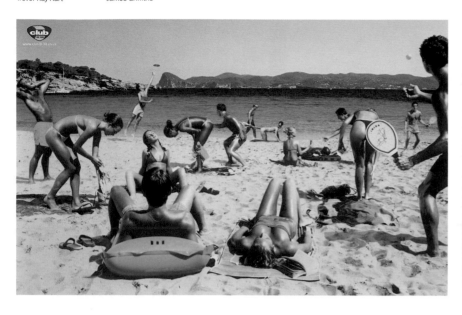

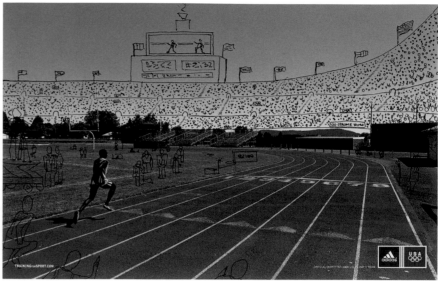

Consumer Magazines, Colour

Art Directors
Ewan Paterson
Rob Jack

Copywriters
Rob Jack
Ewan Paterson

Photographer
Ashton Keiditsch

Typographer
Kevin Clarke

Creative Directors
Mike Hannett
Dave Buchanan

Advertising Agency
BMP DDB

Account Handler
Frances Page

Marketing Executive
David George

Client
Volkswagen UK

Consumer Magazines, Colour

Art Directors
John Foster
Steve Back

Copywriter
Sion Scott-Wilson

Photographer
Ian Butterworth

Illustration
Electric Art

Typographers
John Foster
Steve Back

Creative Director
Sion Scott-Wilson

Advertising Agency
Saatchi & Saatchi
(Singapore)

Account Handler
Tan Jwee Peng

Marketing Executive
Diane Lee

Clients
Reebok
Royal Sporting House

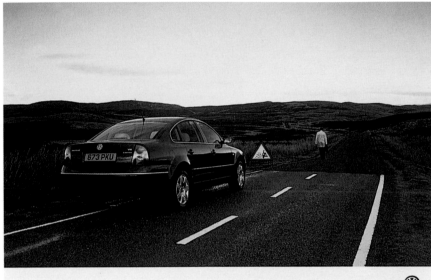

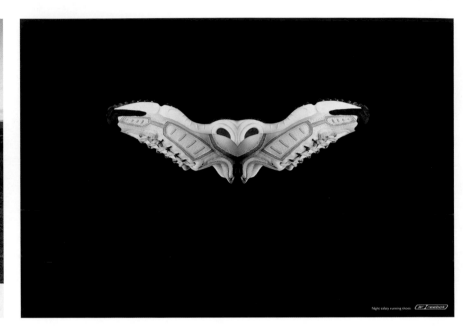

Newspapers, Colour

Art Director
Richard Dennison

Copywriter
Derek Payne

Photographer
Ashton Keiditsch

Typographer
John Tisdall

Creative Directors
Robert Campbell
Mark Roalfe

Advertising Agency
Rainey Kelly Campbell
Roalfe/Y&R

Account Handler
Douglas Thursby-
Pelham

Marketing Executive
Anthony Bradbury

Client
Land Rover

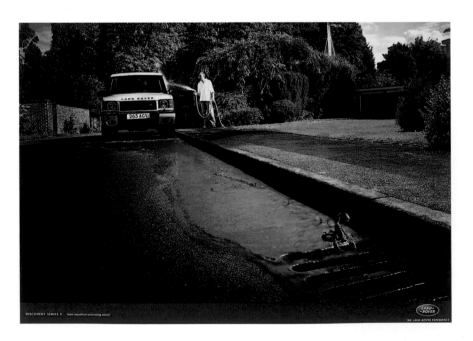

Consumer Magazines, Colour

Art Director
Jerry Hollens

Copywriter
Mike Boles

Photographer
Nick Georghiou

Typographer
Ryan Shellard

Creative Directors
Robert Campbell
Mark Roalfe

Advertising Agency
Rainey Kelly Campbell
Roalfe/Y&R

Account Handler
Douglas Thursby-
Pelham

Marketing Executive
Anthony Bradbury

Client
Land Rover

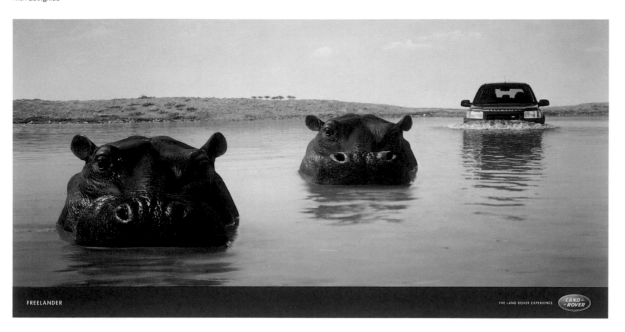

FREELANDER

THE LAND ROVER EXPERIENCE

LAND-ROVER

**Consumer Magazines,
Colour**

Art Directors
Chris Groom
Tony Davidson

Copywriters
Chris Groom
Tony Davidson

Photographer
Paul Zak

Typographer
Chris Groom

Creative Directors
Tony Davidson
Kim Papworth

Advertising Agency
Wieden + Kennedy UK

Account Handler
Scott Morrison

Marketing Executive
Jack Gold

Client
Nike

**Consumer Magazines,
Colour**

Art Director
Tom Cullinan

Copywriters
Tom Cullinan
Mike Ellman-Brown

Photographer
Tom Cullinan

Typographer
Tom Cullinan

Creative Director
Mike Schalit

Account Handlers
Boniswa Pezisa
Delia Ferreira

Client
Hollard Insurance

Vehicle theft tops South Africa's extremely high crime statistics.

This full-page ad was placed in a weekly used car magazine called 'Auto Trader'. It faithfully replicates the publication's layout and design style to attract the reader's attention.

Newspapers, Colour

Art Director
Jerry Hollens

Copywriter
Mike Boles

Photographer
Nick Georghiou

Typographer
Ryan Shellard

Creative Directors
Robert Campbell
Mark Roalfe

Advertising Agency
Rainey Kelly Campbell
Roalfe/Y&R

Account Handler
Douglas Thursby-
Pelham

Marketing Executive
Anthony Bradbury

Client
Land Rover

Newspapers, Colour

Art Director
Richard Dennison

Copywriter
Derek Payne

Photographer
Ashton Keiditsch

Typographer
John Tisdall

Creative Directors
Robert Campbell
Mark Roalfe

Advertising Agency
Rainey Kelly Campbell
Roalfe/Y&R

Account Handler
Douglas Thursby-
Pelham

Marketing Executive
Anthony Bradbury

Client
Land Rover

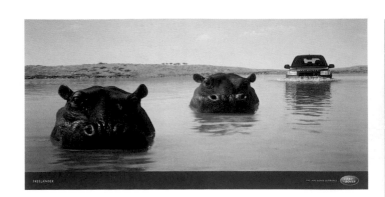

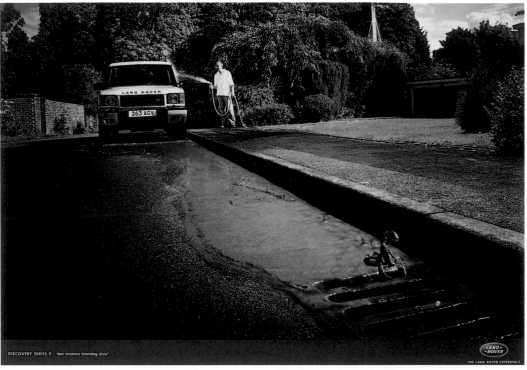

Newspapers, Colour

Art Directors
Chris Groom
Andy Smart

Copywriters
Matt Follows
Roger Beckett

Illustrator
Andy Smith

Typographer
Richard Hooker

Creative Directors
Tony Davidson
Kim Papworth

Advertising Agency
Wieden + Kennedy UK

Account Handler
Edward Donald

Marketing Executive
Jack Gold

Client
Nike

APRIL IS A CYNIC.
APRIL SAYS RUNNING IS FOR FREAKS.
APRIL SAYS YOUR CAR IS YOUR BEST FRIEND.
APRIL SAYS WHY RUN WHEN YOU CAN EAT CHIPS?
APRIL STANDS ON THE RIGHT. SITS IN THE PUB. LIES ON THE SOFA.
APRIL SAYS RUN. YOU? WITH THOSE LEGS? STAY IN BED AND EAT PASTE.
APRIL IS A NON BELIEVER.
APRIL IS LAZY.
IGNORE APRIL.

TRAIN FOR JULY 22. NIKE 10K
RUNLONDON
TEL: 00 0000 10,000

MAY IS KEEN BUT CRAP.
MAY SAYS RACE THAT MILK FLOAT. RACE THAT PRAM. RACE THAT PENSIONER.
MAY HATES HILLS. LOVE BENCHES.
MAY GETS STICHES. GETS SHIN SPLINTS. GETS BACK INTO BED.
MAY RUNS IN THE DARK. DRIBBLES SNOT. STEPS IN DOG POO.
MAY SAYS ON YOUR MARKS. GET SET. STOP.
MAY SAYS IT'S TOO COLD. TOO HOT. TOO DARK. TOO.......WEDNESDAY.
MAY SAYS RUN TOMORROW.
BEAT MAY.

TRAIN FOR JULY 22. NIKE 10K
RUNLONDON
TEL: 00 0000 10,000

JUNE IS A PSYCHO.
JUNE WAKES YOU UP AT 6AM.
JUNE SAYS RUN TO WORK. RUN UP THE STAIRS. RUN TO HELL AND BACK.
JUNE BUYS SIX PAIRS OF IDENTICAL SHORTS.
JUNE SAYS DON'T EAT CHIPS LARDY.
JUNE RACES BUSES. SWEARS AT CARS. CHASES DOGS. EATS BANANAS.
JUNE SAYS FAT DOBBER MOTORISTS.
JUNE SAYS YOU CAN FLY.
ENJOY JUNE.

TRAIN FOR JULY 22. NIKE 10K
RUNLONDON
TEL: 00 0000 10,000

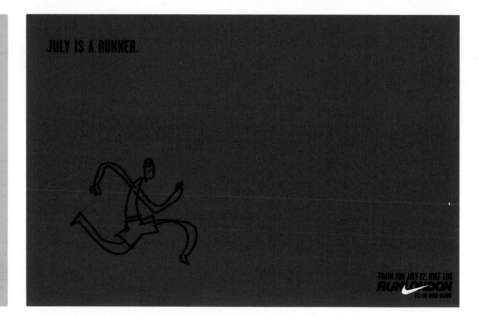

JULY IS A RUNNER.

TRAIN FOR JULY 22. NIKE 10K
RUNLONDON
TEL: 00 0000 10,000

Newspapers, Colour

Art Director
Justin Tindall

Copywriter
Adam Tucker

Photographer
Ben Stockley

Typographer
Kevin Clarke

Creative Director
Mark Reddy

Advertising Agency
BMP DDB

Account Handler
Philip Heimann

Marketing Executive
Julia Bowe

Client
Harvey Nichols

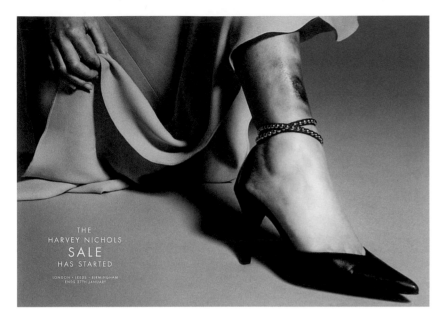

Newspapers, Colour

Art Director
Justin Tindall

Copywriter
Adam Tucker

Photographer
Ben Stockley

Typographer
Kevin Clarke

Creative Director
Mark Reddy

Advertising Agency
BMP DDB

Account Handler
Philip Heimann

Marketing Executive
Julia Bowe

Client
Harvey Nichols

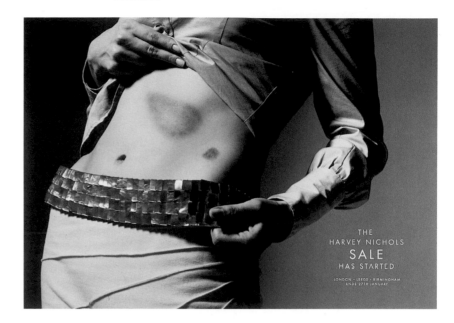

Newspapers, Colour

Art Director
Justin Tindall

Copywriter
Adam Tucker

Photographer
Allun Crockford

Typographer
Pete Mould

Creative Director
Andrew Fraser

Advertising Agency
BMP DDB

Account Handler
Simon Lendrum

Marketing Executive
Marc Sands

Client
The Guardian

Public Service and Charities, Individual

Art Director
David Sullivan

Copywriter
Tom Ewart

Photographer
Rankin

Typographer
Dave Wakefield

Creative Director
Dave Dye

Advertising Agency
Abbott Mead
Vickers.BBDO

Account Handler
Caroline Colwell

Client
COI/DTLR

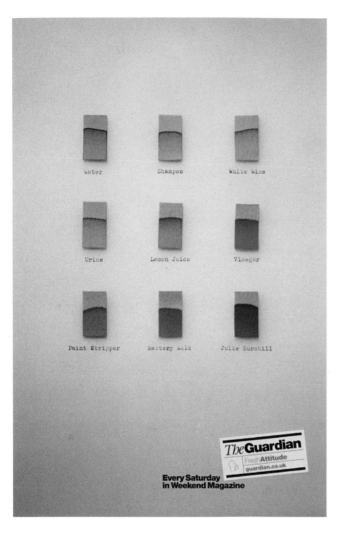

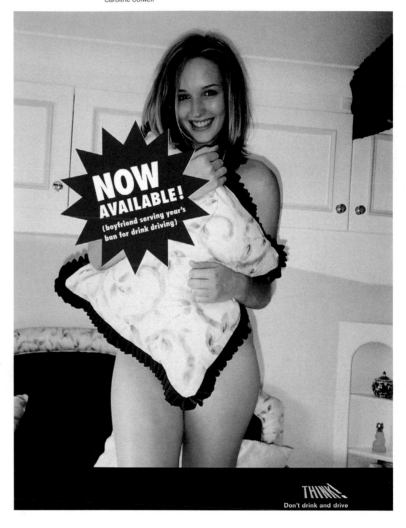

Campaigns, Newspapers

Art Director
Justin Tindall

Copywriter
Adam Tucker

Photographer
Ben Stockley

Typographer
Kevin Clarke

Creative Director
Mark Reddy

Advertising Agency
BMP DDB

Account Handler
Philip Heimann

Marketing Executive
Julia Bowe

Client
Harvey Nichols

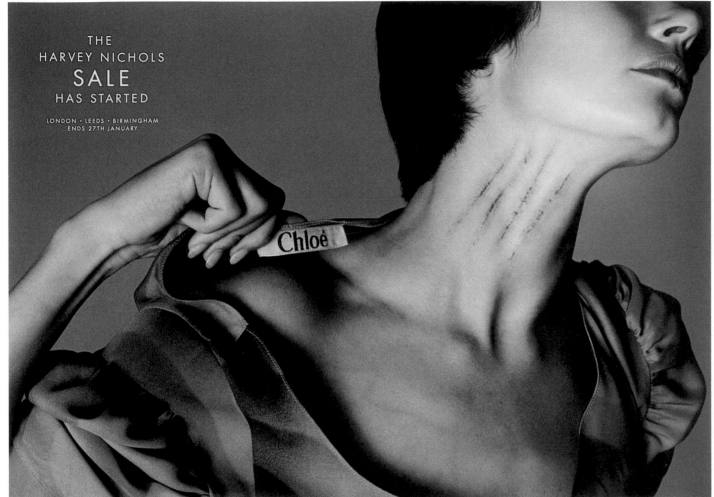

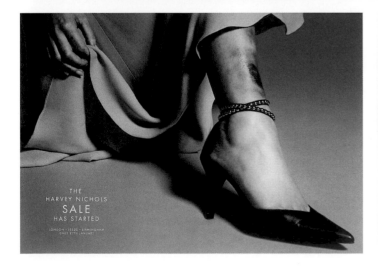

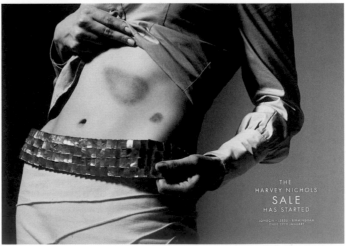

Campaigns, Consumer Magazines

Art Directors
Richard Flintham
Dave Masterman

Copywriters
Andy McLeod
Ed Edwards

Photographer
Mark Polyblank

Typographer
James Townsend

Creative Directors
Richard Flintham
Andy McLeod

Advertising Agency
Fallon London

Account Handler
Karina Wilsher

Marketing Executive
Martin Prothero

Client
Umbro

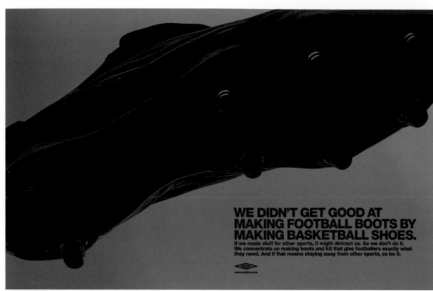

WE DIDN'T GET GOOD AT MAKING FOOTBALL BOOTS BY MAKING BASKETBALL SHOES.
If we made stuff for other sports, it might distract us. So we don't do it. We concentrate on making boots and kit that give footballers exactly what they need. And if that means staying away from other sports, so be it.
www.umbro.com

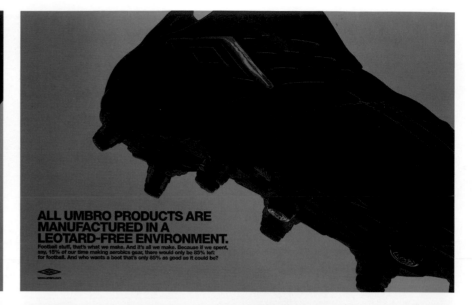

ALL UMBRO PRODUCTS ARE MANUFACTURED IN A LEOTARD-FREE ENVIRONMENT.
Football stuff, that's what we make. And it's all we make. Because if we spent, say, 15% of our time making aerobics gear, there would only be 85% left for football. And who wants a boot that's only 85% as good as it could be?
www.umbro.com

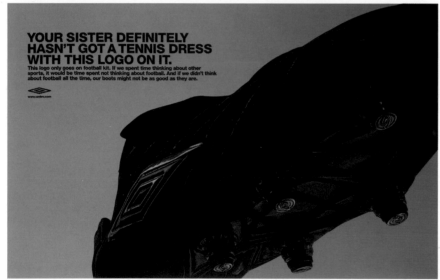

YOUR SISTER DEFINITELY HASN'T GOT A TENNIS DRESS WITH THIS LOGO ON IT.
This logo only goes on football kit. If we spent time thinking about other sports, it would be time spent not thinking about football. And if we didn't think about football all the time, our boots might not be as good as they are.
www.umbro.com

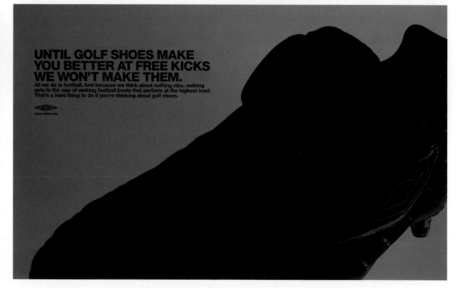

UNTIL GOLF SHOES MAKE YOU BETTER AT FREE KICKS WE WON'T MAKE THEM.
All we do is football. And because we think about nothing else, nothing gets in the way of making football boots that perform at the highest level. That's a hard thing to do if you're thinking about golf shoes.
www.umbro.com

Campaigns, Consumer Magazines

Art Directors
Andy Johns
Sean Thompson
Dave Masterman

Copywriters
John Cross
Ros Sinclair
Ed Edwards

Photographer
Blinkk

Typographer
James Townsend

Creative Directors
Richard Flintham
Andy McLeod

Advertising Agency
Fallon London

Account Handler
Karina Wilsher

Marketing Executive
Chris Hawken

Client
Skoda

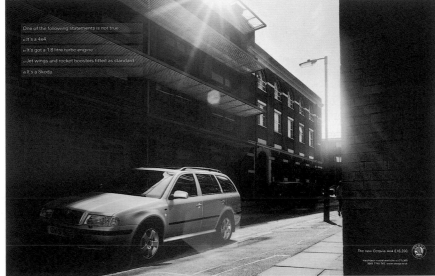

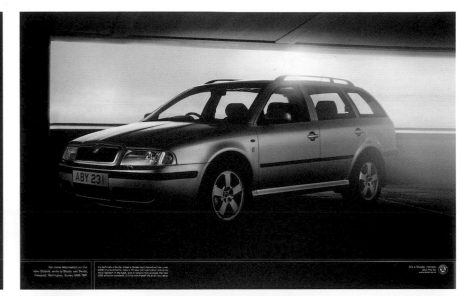

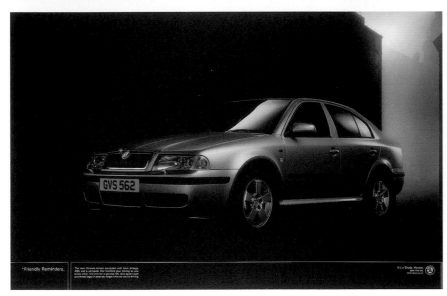

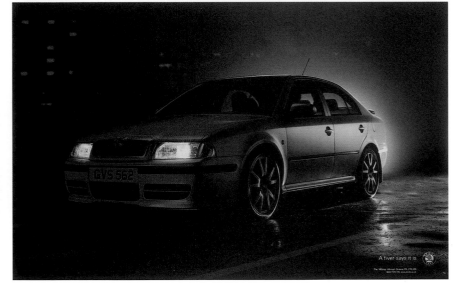

POSTERS

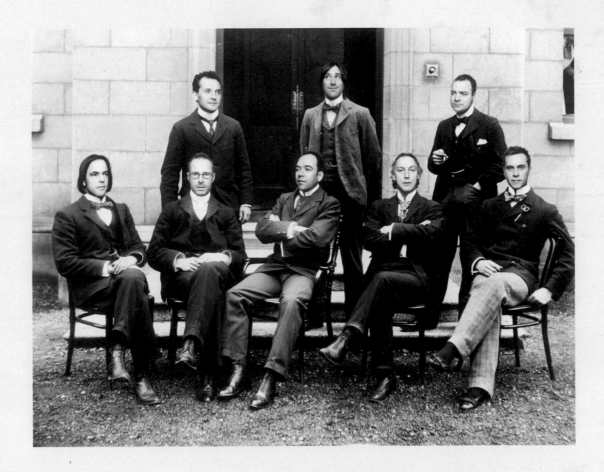

Top Row; *Left to Right:*
WILL AWDRY, PARTNERS BDDH • **FRED RAILLARD**, BARTLE BOGLE HEGARTY • **NICK BELL**, LEO BURNETT
Bottom Row; *Left to Right:*
ED EDWARDS, FALLON LONDON • **NICK HINE**, TBWA\LONDON • **JEREMY CRAIGEN**, BMP DDB • **RICHARD FOSTER**, ABBOTT MEAD VICKERS.BBDO • **PETER GATLEY**

Comment By Nick Bell

Little did I imagine as I pogo-ed to The Stranglers in 1980 that I'd be judging adverts at the same venue 22 years later. We viewed 1,300 posters and I can't honestly say I got as worked up about any of them as I did about Hugh Cornwell and Jean-Jacques Burnel all those years ago. (On the plus side, I didn't spit at any of them either.) The bad news for the aspirants behind this year's entries is that the standard was set before we even entered The Brighton Centre. Rudely posted on the sea sprayed doors was a work more surprising in its execution than anything we viewed subsequently. A4 landscape in format, crudely art directed and typeset, though surely a contender in any writing category. 'SORRY! CLIFF RICHARD SOLD OUT', the headline informed us and Peter Gatley swore he'd never believed he would see those five words arranged in that order. On the following pages, you will find eighteen pieces in the book and three Nominations. I'd like to see The Economist's 'Missing Piece' receive a pencil. I've heard a lot of snipes recently that the industry shouldn't still be awarding a 13 year old campaign. My own view is that the campaign's writers deserve praise for ensuring that it is constantly reinvigorated and that it's for the rest of us to create something dramatically better.

POSTERS SPONSORED BY OUTDOOR ADVERTISING ASSOCIATION • PUBLIC SERVICE & CHARITIES SPONSORED BY BMP DDB FOR GREAT ORMOND STREET HOSPITAL

Silver Award
for the most
outstanding
Consumer Poster,
48 or 96 Sheet
sponsored by
Outdoor Advertising
Association

Art Director
Martin Casson

Copywriter
Matthew Abbott

Creative Director
Peter Souter

Advertising Agency
Abbott Mead
Vickers.BBDO

Account Handlers
Oliver Forder
Mark Petersen

Marketing Executive
Jacqui Kean

Client
The Economist

Silver Nomination for the most outstanding Consumer Poster, 48 or 96 Sheet sponsored by Outdoor Advertising Association

Art Director
Jerry Hollens

Copywriter
Mike Boles

Photographer
Nick Georghiou

Typographer
Ryan Shellard

Creative Directors
Robert Campbell
Mark Roalfe

Advertising Agency
Rainey Kelly Campbell
Roalfe/Y&R

Account Handler
Douglas Thursby-Pelham

Marketing Executive
Anthony Bradbury

Client
Land Rover

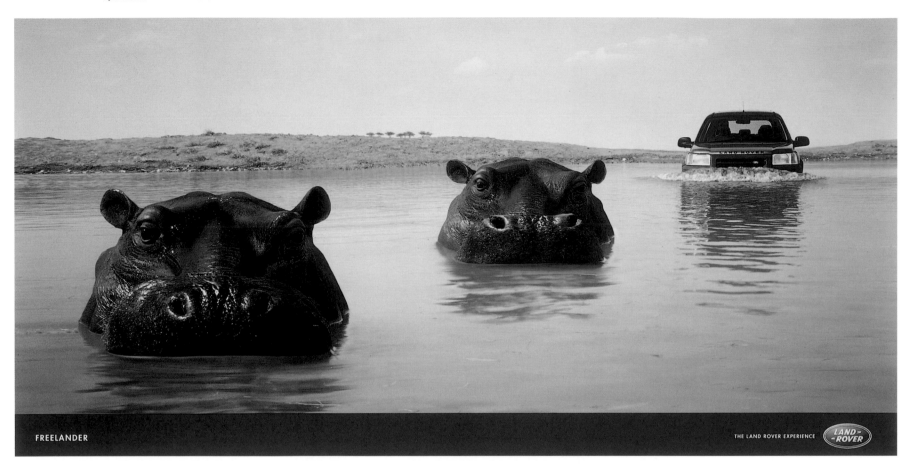

Silver Nomination
for the most outstanding Consumer Posters Campaign sponsored by Outdoor Advertising Association

Art Director
Antony Nelson

Copywriter
Mike Sutherland

Photographer
Trevor Ray Hart

Typographer
Scott Silvey

Creative Director
David Droga

Advertising Agency
Saatchi & Saatchi

Account Handler
James Griffiths

Marketing Executives
Clare Burns
Andy Tidy

Client
Club 18-30

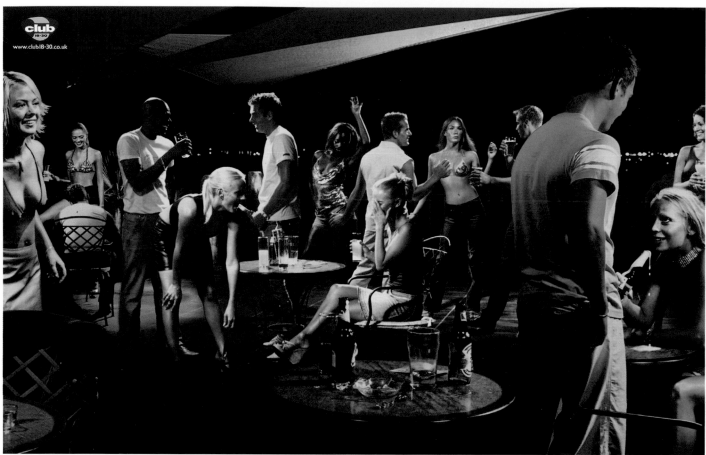

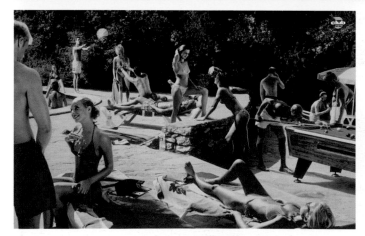

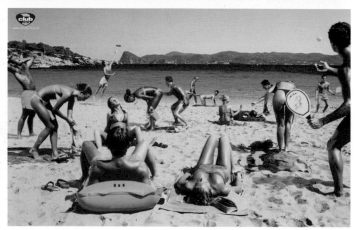

**Consumer Posters,
6 Sheet**

Art Director
Mark Tutssel

Copywriter
Nick Bell

Photographer
Andy Roberts

Typographer
Aaron Moss

Creative Directors
Nick Bell
Mark Tutssel

Advertising Agency
Leo Burnett London

Account Handler
Charlotte Cottrell

Marketing Executive
John Hawkes

Client
McDonald's

**Consumer Posters,
4 or 16 Sheet**

Art Directors
Toh Han Ming
Patrick Low

Copywriter
Mark Fong

Photographer
Hon Boon Heng

Illustrator
Shinta Sutono

Creative Directors
Mark Fong
Patrick Low

Advertising Agency
Dentsu, Young &
Rubicam Singapore

Account Handler
Arthur Sung

Marketing Executive
Angela Tong

Client
Class 95 FM

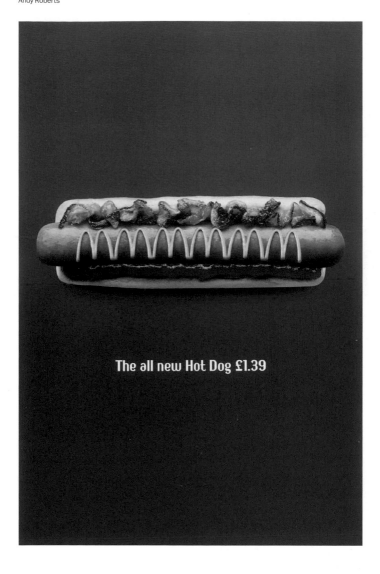

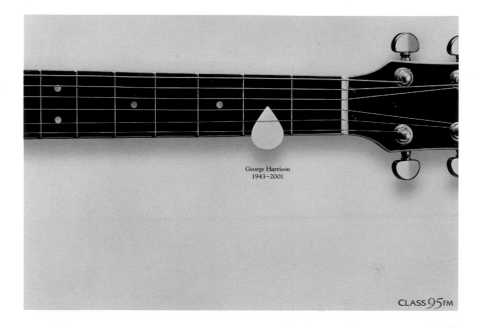

**Consumer Posters,
4 or 16 Sheet**

Art Director
Gareth Lessing

Copywriter
Benjamin Abramowitz

Photographer
Clive Stewart

Illustrator
Gareth Lessing

Creative Directors
Frances Luckin
Sandra De Witt

Advertising Agency
TBWA\Hunt\Lascaris

Account Handler
Bridget Booms

Marketing Executive
Sue Cockroft

Client
Sony

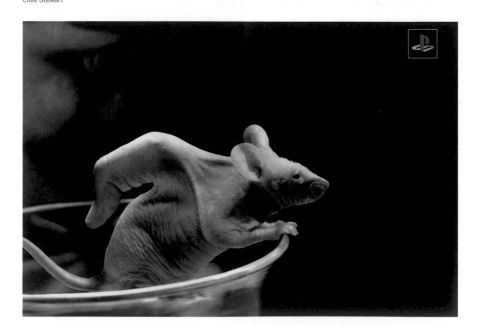

**Consumer Posters,
4 or 16 Sheet**

Art Director
Mark Tutssel

Copywriter
Nick Bell

Photographer
Andy Roberts

Typographer
Aaron Moss

Creative Directors
Nick Bell
Mark Tutssel

Advertising Agency
Leo Burnett London

Account Handler
Charlotte Cottrell

Marketing Executive
John Hawkes

Client
McDonald's

**Consumer Posters,
48 or 96 Sheet**

Art Director
Richard Flintham

Copywriter
Andy McLeod

Typographer
James Townsend

Creative Directors
Richard Flintham
Andy McLeod

Advertising Agency
Fallon London

Account Handler
Charlotte Hurrell

Marketing Executive
Richard Reed

Client
innocent

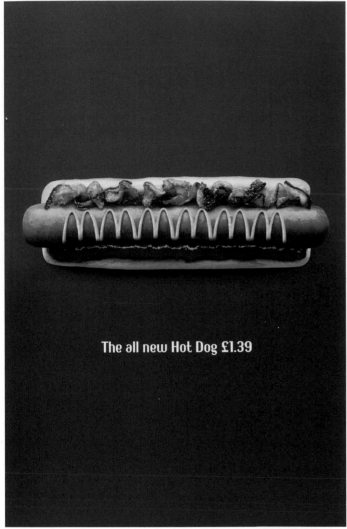

The all new Hot Dog £1.39

If you've enjoyed your smoothie, why not try our other products like sand, rainbows, or perhaps plankton.

Made by nature™

Consumer Posters, 48 or 96 Sheet

Art Director
Antony Nelson

Copywriter
Mike Sutherland

Photographer
Trevor Ray Hart

Typographer
Scott Silvey

Creative Director
David Droga

Advertising Agency
Saatchi & Saatchi

Account Handler
James Griffiths

Marketing Executives
Clare Burns
Andy Tidy

Client
Club 18-30

Consumer Posters, 48 or 96 Sheet

Art Director
Antony Nelson

Copywriter
Mike Sutherland

Photographer
Trevor Ray Hart

Typographer
Scott Silvey

Creative Director
David Droga

Advertising Agency
Saatchi & Saatchi

Account Handler
James Griffiths

Marketing Executives
Clare Burns
Andy Tidy

Client
Club 18-30

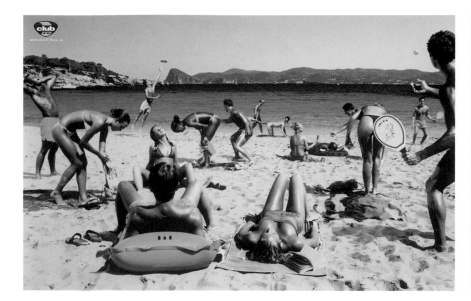
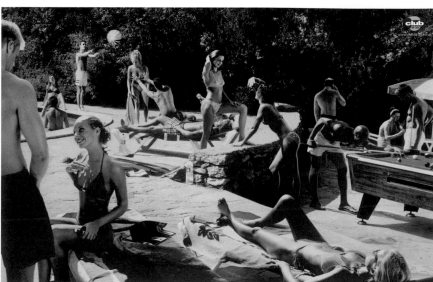

Consumer Posters, 48 or 96 Sheet

Art Director
Antony Nelson

Copywriter
Mike Sutherland

Photographer
Trevor Ray Hart

Typographer
Scott Silvey

Creative Director
David Droga

Advertising Agency
Saatchi & Saatchi

Account Handler
James Griffiths

Marketing Executives
Clare Burns
Andy Tidy

Client
Club 18-30

Consumer Posters, 48 or 96 Sheet

Art Directors
Thirasak
Thanapatanakul
Anurux Jansanjai

Photographer
Anuchai
Sricharunputong

Copywriters
Kitti Chaiyaporn
Suthisak
Sucharittanonta
David Guerrero

Illustrator
Anuchai
Sricharunputong

Creative Directors
Suthisak
Sucharittanonta
Anurux Jansanjai

Advertising Agency
BBDO Bangkok

Account Handlers
Peter Wilken
Arto Hampartsoumian

Marketing Executives
Rajesh Subramaniam
Malcolm T Sullivan

Client
Federal Express

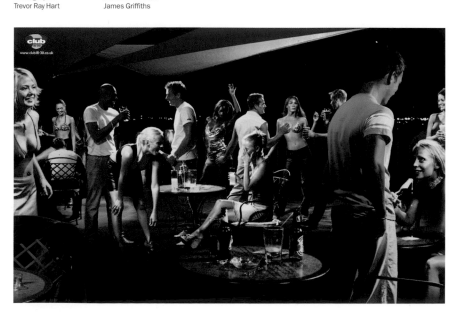
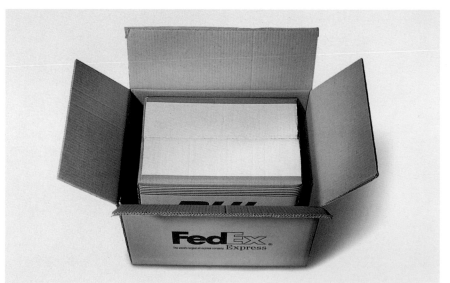

Consumer Posters, Transport

Art Director
Jerry Hollens

Copywriter
Mike Boles

Photographer
Nick Georghiou

Typographer
Ryan Shellard

Creative Directors
Robert Campbell
Mark Roalfe

Advertising Agency
Rainey Kelly Campbell
Roalfe/Y&R

Account Handler
Douglas Thursby-Pelham

Marketing Executive
Anthony Bradbury

Client
Land Rover

Consumer Posters, Transport

Art Director
Richard Flintham

Copywriter
Andy McLeod

Typographer
James Townsend

Creative Directors
Richard Flintham
Andy McLeod

Advertising Agency
Fallon London

Account Handler
Charlotte Hurrell

Marketing Executive
Richard Reed

Client
innocent

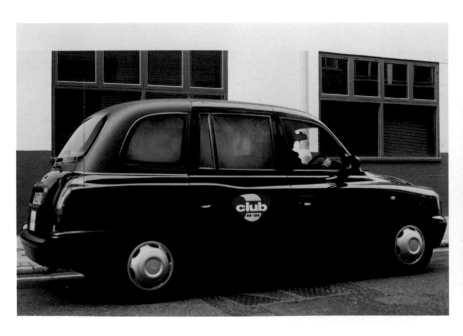

If you've enjoyed your smoothie, why not try our other products like sand, rainbows, or perhaps plankton.

Made by nature™

Consumer Posters, Transport

Art Directors
Dave Askwith
Andrew Fisher

Copywriters
Dave Askwith
Andrew Fisher

Creative Director
David Droga

Advertising Agency
Saatchi & Saatchi

Account Handlers
James Griffiths
Jamie Maker

Marketing Executives
Clare Burns
Andy Tidy

Client
Club 18-30

Consumer Posters, Specials

Art Director
Dave Hobbs

Copywriter
Richard Stoney

Typographer
Kerry Roper

Creative Directors
Paul Briginshaw
Malcolm Duffy

Advertising Agency
Miles Calcraft
Briginshaw Duffy

Account Handler
Melissa Horn

Marketing Executive
Simon Clarkson

Client
Radio Times

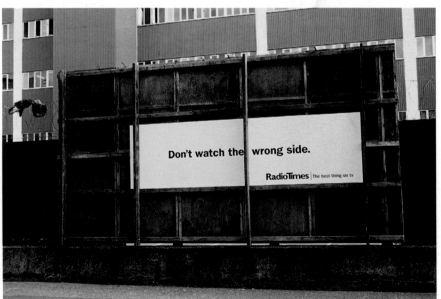

Don't watch the wrong side.

RadioTimes | The best thing on tv

Consumer Posters, Campaigns

Retouching
Edward Loh

Account Handler
Laurie Kwong

Art Director
Maurice Wee

Creative Director
Craig Davis

Marketing Executive
Kim Shaw

Copywriter
Renee Lim

Advertising Agency
Saatchi & Saatchi
(Hong Kong)

Client
Campaign Brief Asia

Photographer
Stanley Wong

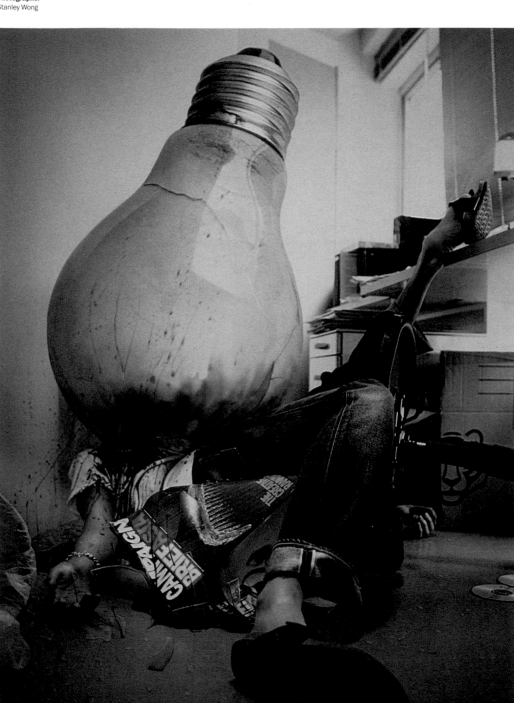

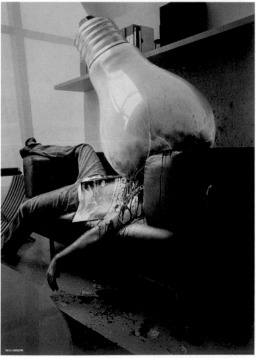

Consumer Posters, Campaigns

Art Directors
Michael Long
Adam Scholes

Copywriters
Hugh Todd
Anna Toosey

Photographer
Frank Budgen

Typographer
Roger Kennedy

Creative Director
David Droga

Advertising Agency
Saatchi & Saatchi

Account Handler
Louise Bohmann

Marketing Executives
Samantha Roddick
Adae-Elena Amats

Client
Coco de Mer

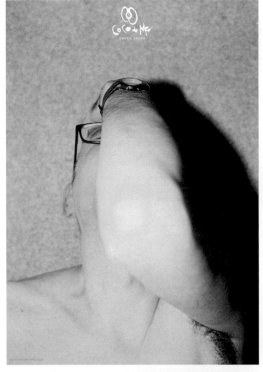

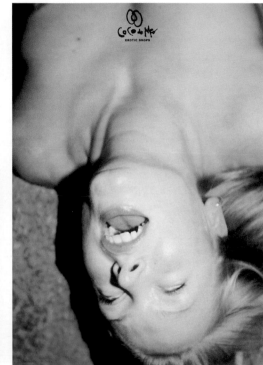

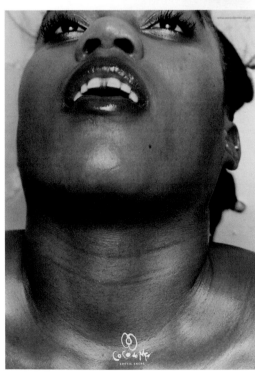

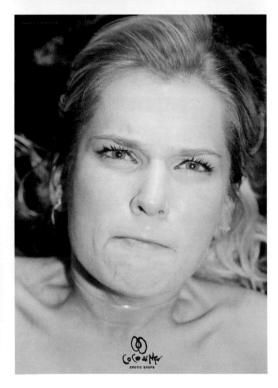

**Public Service and
Charities, Individual**

Art Director
Tom Carty

Copywriters
Tom Carty
David Lindo

Typographer
Russell de Rozario

Producer
Carol Powell

Sound Design
Apollo 99

Sound Mixer
Tony Rapaccioli

Creative Director
Peter Souter

Advertising Agency
Abbott Mead
Vickers.BBDO

Account Handlers
Kathy Reeves
Verity Williams

Marketing Executive
Charlotte Morrissey

Client
RSPCA

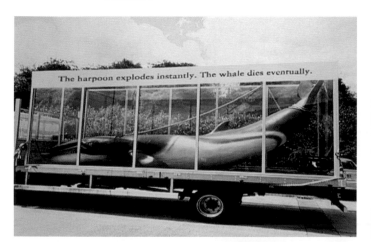

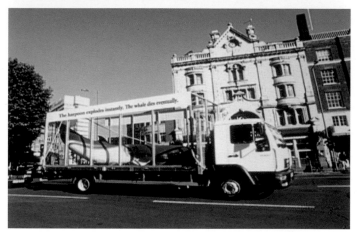

In July 2001 the International Whaling Commission held a conference in London to discuss the possibility of a return to commercial whaling.
 The RSPCA wanted to influence the delegates and remind them of the brutality involved in whaling.
 So, we drove a perspex lorry containing a harpooned and bloody carcass of a whale around London and parked outside the conference hotel.

Public Service and
Charities, Individual

Art Directors
Regan Grafton
Haydn Morris

Copywriter
Dan Moth

Photographer
Robert Jackson-Mee

Retoucher
Duncan Munro

Production
Greg Owen

Creative Director
Gordon Clarke

Advertising Agency
young&rubicam.
thinking

Account Handler
Stewart Carruthers

Marketing Executive
Kitch Cuthbert

Client
Waitakere City Council

Public Service and Charities, Specials

Art Director
Vince Lagana

Copywriter
Luke Chess

Photographers
Giacomo Pirozzi
Franck Charton
Edinger
M Kawanaka

Typographer
Vince Lagana

Production
Jenny McMahon

Creative Directors
Luke Dunkerley
Malcolm Poynton

Advertising Agency
Saatchi & Saatchi
(Sydney)

Account Handler
Vicky Drake

Marketing Executive
Richard Green

Client
UNICEF Australia

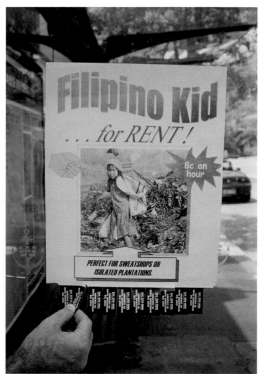
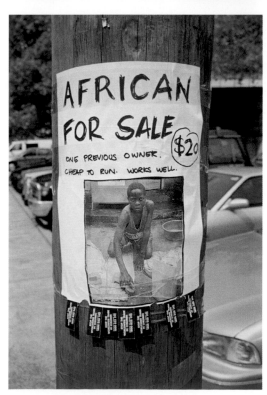
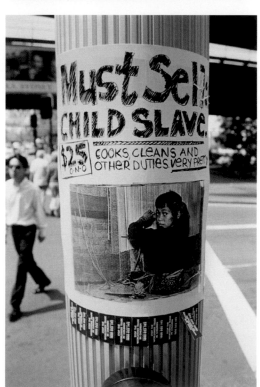

ART DIRECTION

 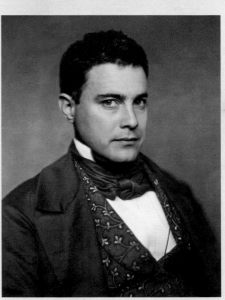

Top Row; *Left to Right:*
PAUL SHEARER, WIEDEN+KENNEDY AMSTERDAM • ROB FLETCHER, BANKS HOGGINS O'SHEA FCB • BRIAN CAMPBELL, TBWA\London

Bottom Row; *Left to Right:*
AJAB SAMRAI SINGH, SAATCHI & SAATCHI • NIGEL ROSE, EURO RSCG WNEK GOSPER • DAMON COLLINS, LOWE

ART DIRECTION

Left to Right:
MARK ROALFE, RAINEY KELLY CAMPBELL ROALFE/Y&R • **DEBORAH BEE**

Comment by Mark Roalfe

Overall the standard of art direction was very high. On the first round of voting we voted in over 35 pieces of work. This then got whittled down leaving a category some may feel looks thinner than in previous years. The reason's simple. Art Direction is always quite a strange category to consider as there are so many differing views on what makes 'good' art direction. This year we tried to pick stuff that had a strong branded look and where the art direction enhanced the idea, rather than ads that were just over designed. We hope you agree.

ART DIRECTION SPONSORED BY AQUENT

Silver Award
for the most
outstanding
Art Direction
sponsored by
AQUENT

Art Director
Antony Nelson

Copywriter
Mike Sutherland

Photographer
Trevor Ray Hart

Typographer
Scott Silvey

Creative Director
David Droga

Advertising Agency
Saatchi & Saatchi

Account Handler
James Griffiths

Marketing Executives
Clare Burns
Andy Tidy

Client
Club 18-30

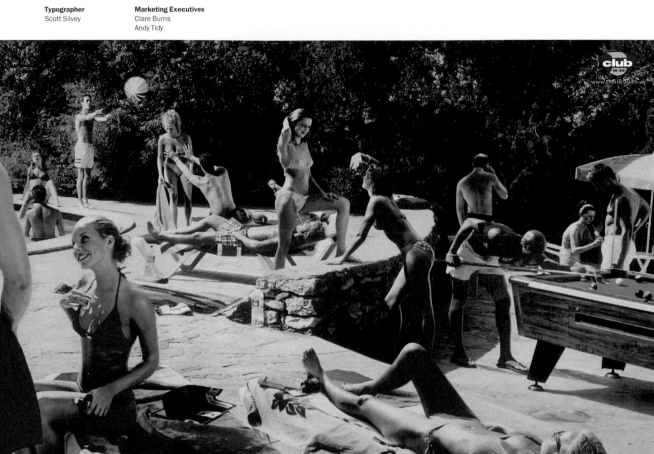

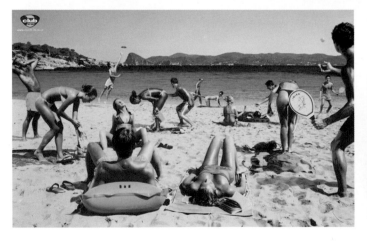

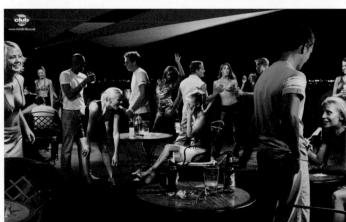

Individual

Art Directors
John Foster
Steve Back

Copywriter
Sion Scott-Wilson

Photographer
Ian Butterworth

Illustration
Electric Art

Typographers
John Foster
Steve Back

Creative Director
Sion Scott-Wilson

Advertising Agency
Saatchi & Saatchi
(Singapore)

Account Handler
Tan Jwee Peng

Marketing Executive
Diane Lee

Clients
Reebok
Royal Sporting House

Individual

Art Director
Antony Nelson

Copywriter
Mike Sutherland

Photographer
Trevor Ray Hart

Typographer
Scott Silvey

Creative Director
David Droga

Advertising Agency
Saatchi & Saatchi

Account Handler
James Griffiths

Marketing Executives
Clare Burns
Andy Tidy

Client
Club 18-30

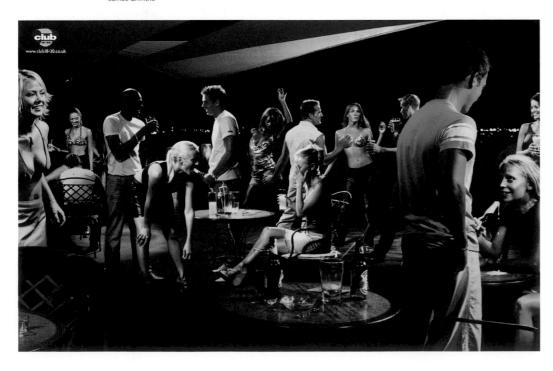

Individual

Art Director
Vicki Maguire

Copywriter
Vicki Maguire

Illustrator
Paul Slater

Typographer
David Wakefield

Creative Director
Steve Dunn

Advertising Agency
Ogilvy & Mather

Account Handler
Sophie Harwood Smith

Marketing Executive
Gerald Noone

Client
Severn Trent Water

Individual

Art Directors
John Foster
Steve Back

Copywriter
Sion Scott-Wilson

Photographer
Ian Butterworth

Illustration
Electric Art

Typographers
John Foster
Steve Back

Creative Director
Sion Scott-Wilson

Advertising Agency
Saatchi & Saatchi
(Singapore)

Account Handler
Tan Jwee Peng

Marketing Executive
Diane Lee

Clients
Reebok
Royal Sporting House

"Severn Trent's clean rivers have attracted hundreds of Kingfishers to the area," says Sally. "That'll please Dad," says Sam, "Mum says he likes common birds."

Severn Trent Water is jolly good for us all.

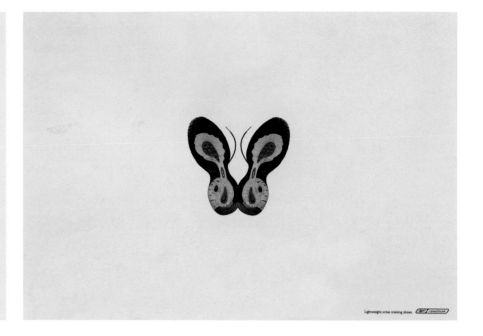

Lightweight cross training shoes. Reebok

Individual

Art Director
Antony Nelson

Copywriter
Mike Sutherland

Photographer
Trevor Ray Hart

Typographer
Scott Silvey

Creative Director
David Droga

Advertising Agency
Saatchi & Saatchi

Account Handler
James Griffiths

Marketing Executives
Clare Burns
Andy Tidy

Client
Club 18-30

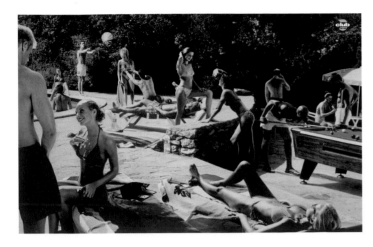

Individual

Art Director
Antony Nelson

Copywriter
Mike Sutherland

Photographer
Trevor Ray Hart

Typographer
Scott Silvey

Creative Director
David Droga

Advertising Agency
Saatchi & Saatchi

Account Handler
James Griffiths

Marketing Executives
Clare Burns
Andy Tidy

Client
Club 18-30

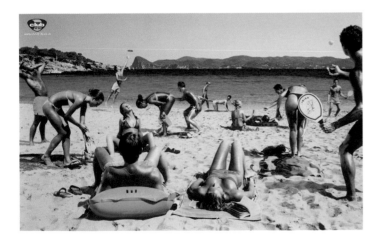

Individual

Art Director
Justin Tindall

Copywriter
Adam Tucker

Typographer
Pete Mould

Creative Director
Andrew Fraser

Advertising Agency
BMP DDB

Account Handler
Simon Lendrum

Marketing Executive
Marc Sands

Client
The Guardian

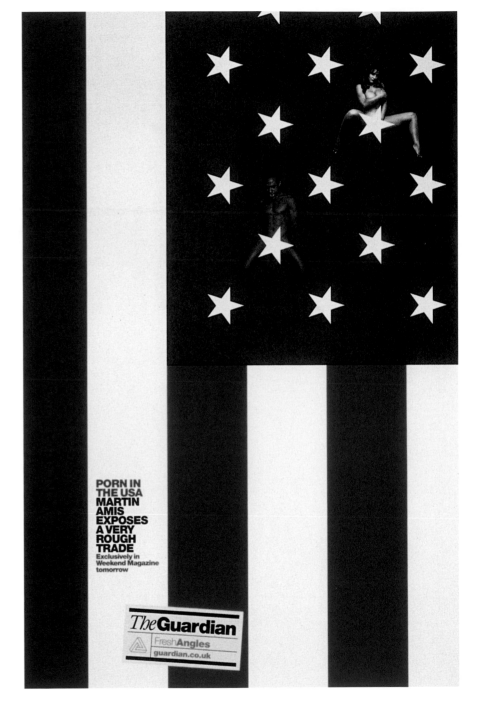

Individual

Art Directors
Chris Groom
Tony Davidson

Copywriters
Chris Groom
Tony Davidson

Photographer
Paul Zak

Typographer
Chris Groom

Creative Directors
Tony Davidson
Kim Papworth

Advertising Agency
Wieden + Kennedy UK

Account Handler
Scott Morrison

Marketing Executive
Jack Gold

Client
Nike

Individual

Art Director
Feargal Ballance

Copywriter
Dylan Harrison

Typographer
Kevin Clarke

Creative Directors
Jeremy Craigen
Joanna Wenley

Advertising Agency
BMP DDB

Account Handler
Simon Lendrum

Marketing Executives
Marc Sands
Karen Byrne

Client
The Guardian

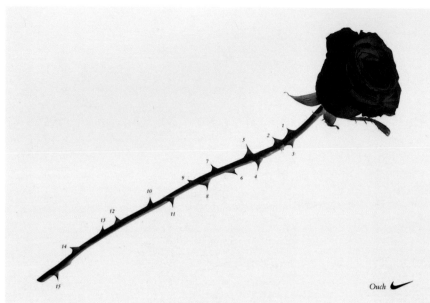

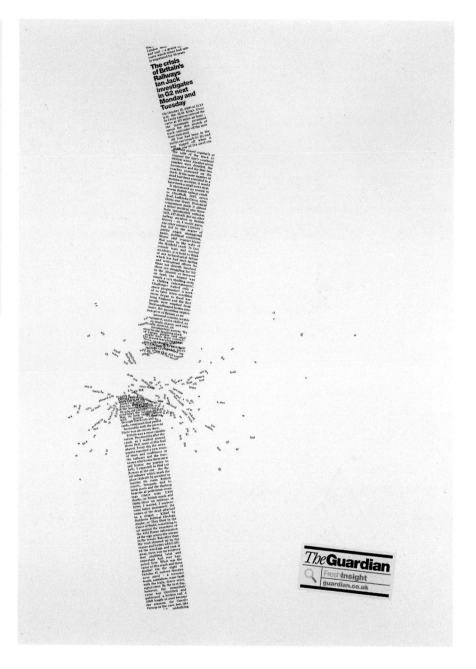

Campaigns

Art Directors
Gregory Yeo
Steve Hough

Copywriters
Steve Hough
Gregory Yeo

Images
Changi Museum

Illustrators
Alice Lee
Gary Choo
Lay Ling

Typographers
Gregory Yeo
Steve Hough

Creative Directors
Andy Greenaway
Craig Smith

Advertising Agency
Ogilvy & Mather
Singapore

Client
Changi Museum

Account Handler
David Mayo

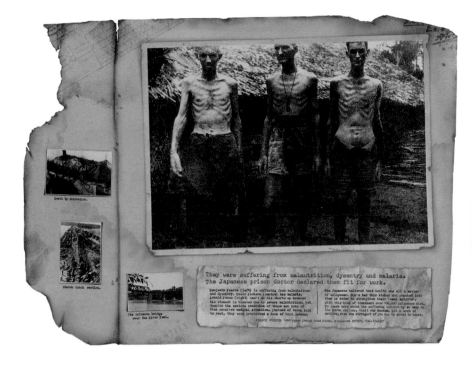

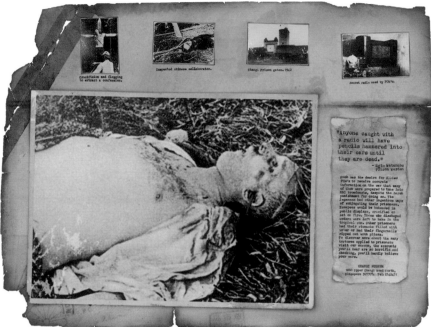

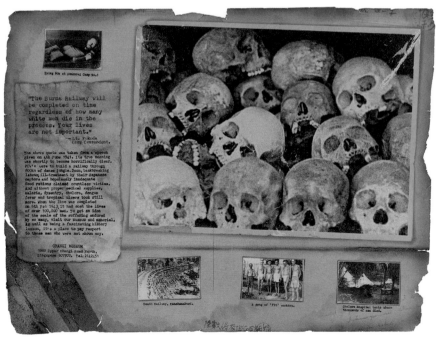

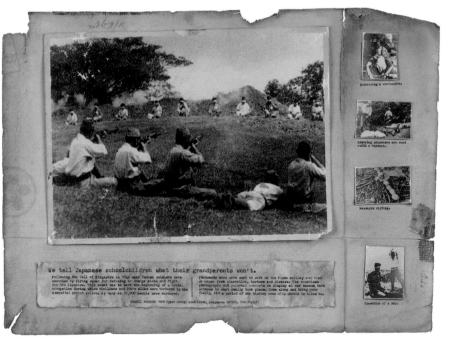

Campaigns

Art Directors
Dave Masterman
Richard Flintham

Copywriters
Ed Edwards
Andy McLeod

Photographer
Mark Polyblank

Typographer
James Townsend

Creative Directors
Richard Flintham
Andy McLeod

Advertising Agency
Fallon London

Account Handler
Karina Wilsher

Marketing Executive
Martin Prothero

Client
Umbro

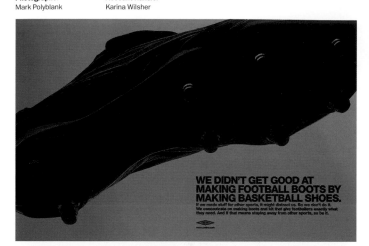

WE DIDN'T GET GOOD AT
MAKING FOOTBALL BOOTS BY
MAKING BASKETBALL SHOES.
If we made stuff for other sports, it might distract us. So we don't do it.
We concentrate on making boots and kit that give footballers exactly what
they need. And if that means staying away from other sports, so be it.

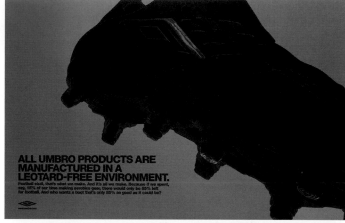

ALL UMBRO PRODUCTS ARE
MANUFACTURED IN A
LEOTARD-FREE ENVIRONMENT.
Football stuff, that's what we make. And it's all we make. Because if we spent,
say, 15% of our time making aerobics gear, there would only be 85% left
for football. And who wants a boot that's only 85% as good as it could be?

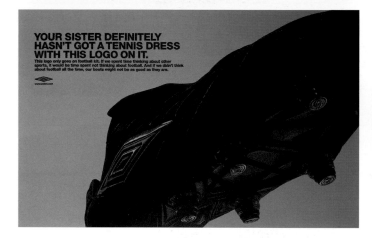

YOUR SISTER DEFINITELY
HASN'T GOT A TENNIS DRESS
WITH THIS LOGO ON IT.
This logo only goes on football kit. If we spent time thinking about other
sports, it would be time spent not thinking about football. And if we didn't think
about football all the time, our boots might not be as good as they are.

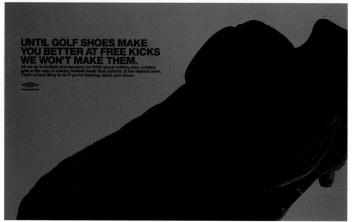

UNTIL GOLF SHOES MAKE
YOU BETTER AT FREE KICKS
WE WON'T MAKE THEM.
All we do is football. And because we think about nothing else, nothing
gets in the way of making football boots that perform at the highest level.
That's a hard thing to do if you're thinking about golf shoes.

Campaigns

Art Director
Sam Walker

Copywriter
Joe De Souza

Illustrator
John Lucas

Creative Directors
Robert Saville
Mark Waites
Jim Thornton

Advertising Agency
Mother

Account Handler
Paul Adams

Marketing Executive
Stuart Williams

Client
Q Magazine

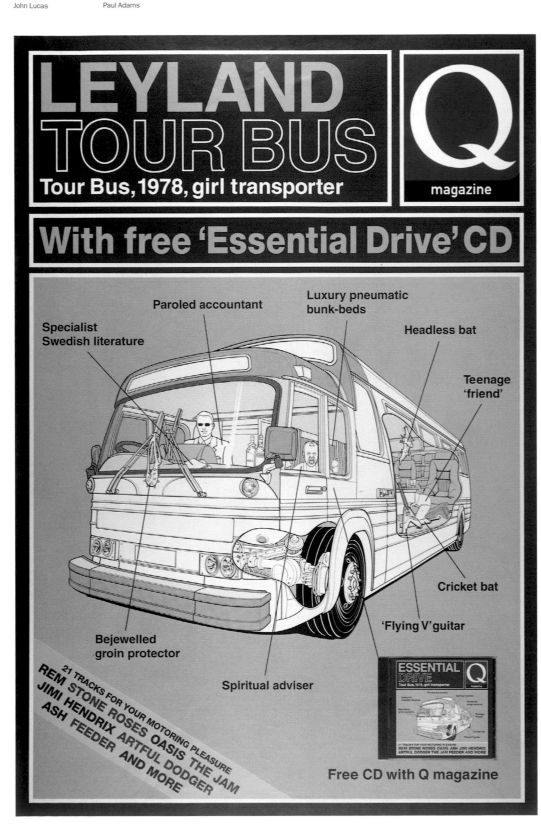

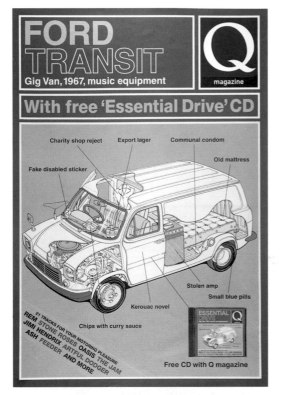

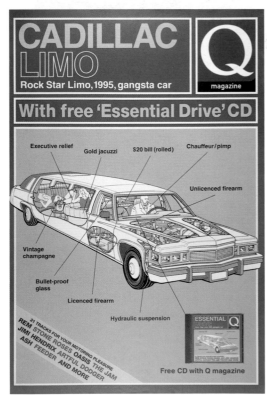

Campaigns

Art Director
Maurice Wee

Copywriter
Renee Lim

Photographer
Stanley Wong

Retouching
Edward Loh

Creative Director
Craig Davis

Advertising Agency
Saatchi & Saatchi
(Hong Kong)

Account Handler
Laurie Kwong

Marketing Executive
Kim Shaw

Client
Campaign Brief Asia

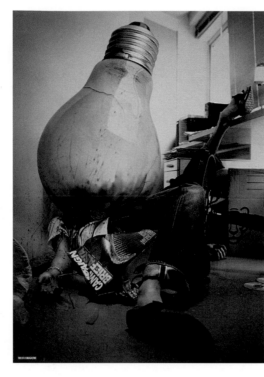
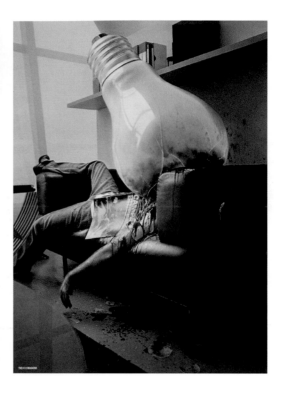

Campaigns

Art Director
Jeremy Carr

Copywriter
Jeremy Carr

Illustrator
Faiyaz Jafri

Typographers
Brian McHale
Robin Warrington

Creative Director
Peter Souter

Advertising Agency
Abbott Mead
Vickers.BBDO

Account Handler
Caspar Thykier

Marketing Executive
Mark Sandys

Client
Guinness GB

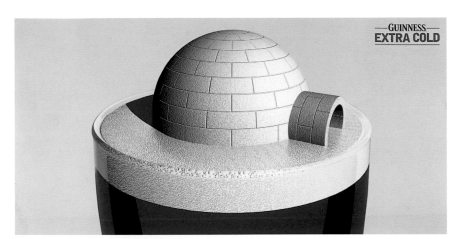

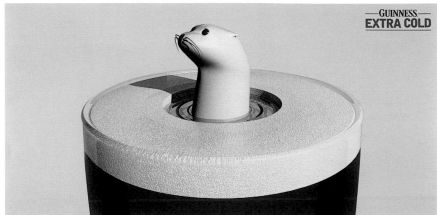

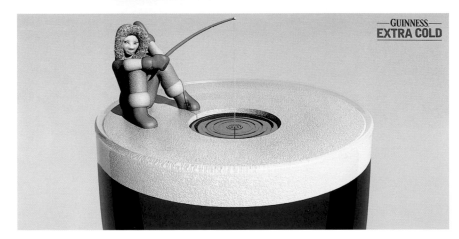

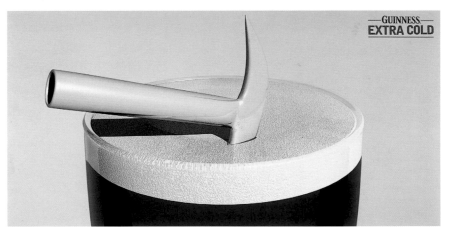

Campaigns

Art Directors
Judith Francisco
Mario Guay

Copywriter
Jessica Lehrer

Photographers
Anette Aurell
Marc de Groot
Elaine Constantine
Lee Jenkins
Robert Wyatt

Illustrators
Paul Davis
Jasper Goodall
Jason Brooks
Ian Bilbey
Fiona Hewitt

Typographers
Judith Francisco
Frederique Daubal
Mario Guay

Creative Directors
Glenn Cole
Paul Shearer

Advertising Agency
Wieden + Kennedy
Amsterdam

Account Handlers
Julia Porter
Becky Barwick

Heads of Advertising
Phil McAveety
Stefan Olander

Brand Managers
Thierry de Ridder
Paolo Tubito

Client
Nike

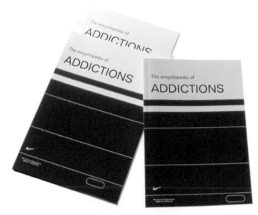

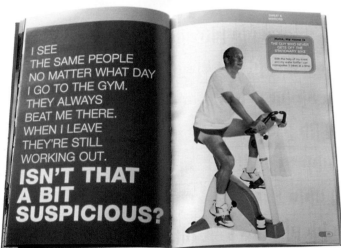

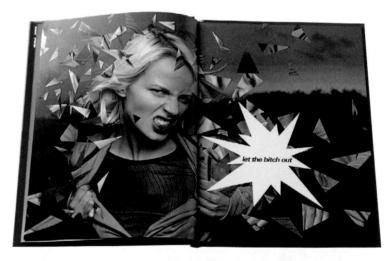

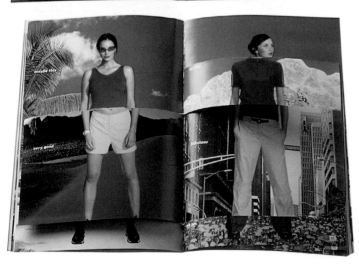

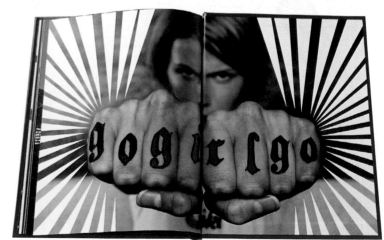

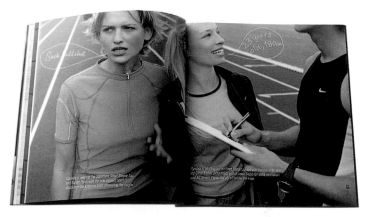

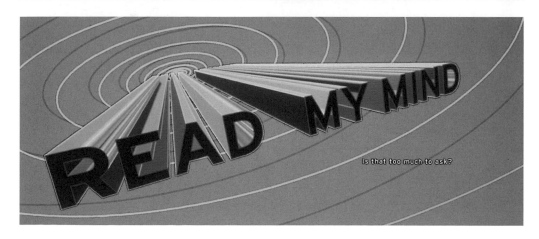

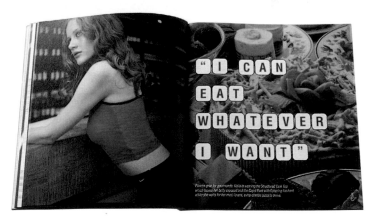

WRITING FOR ADVERTISING

Top Row; *Left to Right:*
MIKE McKENNA, Leo Burnett • **CLIVE PICKERING**, Bartle Bogle Hegarty • **CHRIS HODGKISS**, Rainey Kelly Campbell Roalfe/Y&R
Bottom Row; *Left to Right:*
GEOFF SMITH, Lowe • **JASPAR SHELBOURNE**, J Walter Thompson • **PATRICK COLLISTER**, EHS Brann

WRITING FOR ADVERTISING

Left to Right:
CHRIS O'SHEA, BANKS HOGGINS O'SHEA FCB • MATT BEAUMONT • NIGEL ROBERTS, ABBOTT MEAD VICKERS.BBDO

Comment by Chris O'Shea

Maybe, just maybe, copy isn't dead. (Whoops I mean 'Writing for Advertising'.) Indeed, we detected quite a few signs of life with 157 separate entries. What also became clear is that if copy is coming back, it is in a number of different guises. Long, short and none were all acceptable just as long as they were all well written. There was, of course, the obligatory discussion on whether a three word poster headline is or isn't copy. On this, everyone had their say, the votes were cast and democracy prevailed. We found the standard of entries high, there was lots of discussion and some altered decisions, but no real argy-bargy. It was, as one would expect from a group of nine writers, a thoroughly civilized affair.

WRITING FOR ADVERTISING SPONSORED BY THE GUARDIAN

Silver Nomination
for the most
outstanding
Writing for Advertising
sponsored by
The Guardian

Art Directors
Nick Burrage
Luca Bertoluzzi

Copywriters
Nick Burrage
Luca Bertoluzzi

Typographer
Kevin Clarke

Creative Director
Andrew Fraser

Advertising Agency
BMP DDB

Account Handler
Simon Lendrum

Marketing Executive
Marc Sands

Client
The Guardian

OF LOVE AND WAR: LOST IN LILLE.

By Gustave Clemenceau (1919-1944)

Ah Stella! My Love and Sorrow!
Down in the Rimington's garden
We kissed goodbye my former pain
I stroke your head, your gentle hair
Was made of gold – and then I left:
Milan, for 5 long weeks,
I can reveal so much
Then back to France, all in love for you
And you were gone.
You were gone, the guardian of your house
Said so.
But I'm going to battle this Saturday.
Will I see you again? *Je ne sais pas.*

Translation by Nick Lucas

Stella
Rimington
former
head
of
Mi 5
reveal s
all in

the guardian

this Saturday.

INSTRUCTIONS:
Go to page 3 in main newspaper. Place over poem.

Silver Nomination
for the most
outstanding
Writing for Advertising
sponsored by
The Guardian

Copywriter
Richard Bullock

Art Director
Taras Wayner

Creative Director
Eric Silver

Advertising Agency
Cliff Freeman &
Partners

Account Handler
Shana Brooks

Marketing Executives
Anthony von Mandl
Glenn Wong

Client
Mike's Hard Lemonade

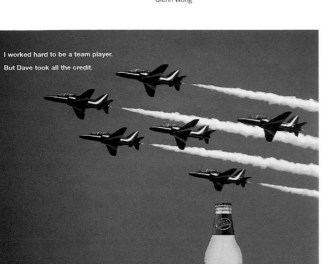

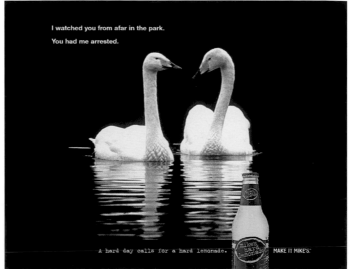

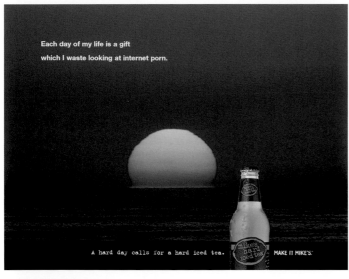

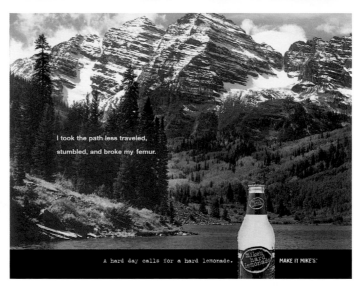

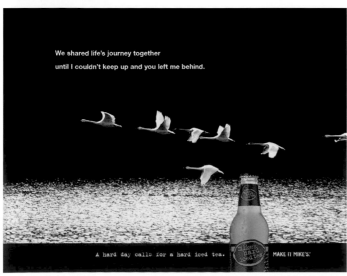

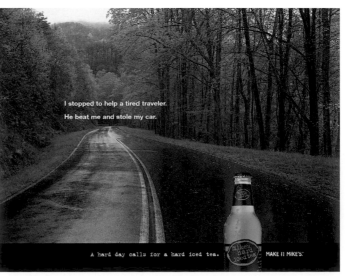

Silver Nomination
for the most
outstanding
Writing for Advertising
sponsored by
The Guardian

Copywriters
Roger Beckett
Matt Follows

Art Directors
Andy Smart
Chris Groom

Illustrator
Andy Smith

Typographer
Richard Hooker

Creative Directors
Tony Davidson
Kim Papworth

Advertising Agency
Wieden + Kennedy UK

Account Handler
Edward Donald

Marketing Executive
Jack Gold

Client
Nike

APRIL IS A CYNIC.
APRIL SAYS RUNNING IS FOR FREAKS.
APRIL SAYS YOUR CAR IS YOUR BEST FRIEND.
APRIL SAYS WHY RUN WHEN YOU CAN EAT CHIPS?
APRIL STANDS ON THE RIGHT. SITS IN THE PUB. LIES ON THE SOFA.
APRIL SAYS RUN. YOU? WITH THOSE LEGS? STAY IN BED AND EAT PASTE.
APRIL IS A NON BELIEVER.
APRIL IS LAZY.
IGNORE APRIL.

TRAIN FOR JULY 22. NIKE 10K
RUNLONDON
TEL: 08 0800 10,000

MAY IS KEEN BUT CRAP.
MAY SAYS RACE THAT MILK FLOAT. RACE THAT PRAM. RACE THAT PENSIONER.
MAY HATES HILLS. LOVE BENCHES.
MAY GETS STICHES. GETS SHIN SPLINTS. GETS BACK INTO BED.
MAY RUNS IN THE DARK. DRIBBLES SNOT. STEPS IN DOG POO.
MAY SAYS ON YOUR MARKS. GET SET. STOP.
MAY SAYS IT'S TOO COLD. TOO HOT. TOO DARK. TOO.......WEDNESDAY.
MAY SAYS RUN TOMORROW.
BEAT MAY.

TRAIN FOR JULY 22. NIKE 10K
RUNLONDON
TEL: 08 0800 10,000

JUNE IS A PSYCHO.
JUNE WAKES YOU UP AT 6AM.
JUNE SAYS RUN TO WORK. RUN UP THE STAIRS. RUN TO HELL AND BACK.
JUNE BUYS SIX PAIRS OF IDENTICAL SHORTS.
JUNE SAYS DON'T EAT CHIPS LARDY.
JUNE RACES BUSES. SWEARS AT CARS. CHASES DOGS. EATS BANANAS.
JUNE SAYS FAT DOBBER MOTORISTS.
JUNE SAYS YOU CAN FLY.
ENJOY JUNE.

TRAIN FOR JULY 22. NIKE 10K
RUNLONDON
TEL: 08 0800 10,000

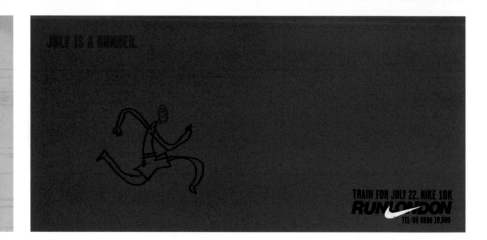

JULY IS A RUNNER.

TRAIN FOR JULY 22. NIKE 10K
RUNLONDON
TEL: 08 0800 10,000

APRIL SAYS
THE TELLY LOOKS
GOOD TONIGHT.

JUNE SAYS IT'S ALL MEANINGLESS, REGURGITATED DRIVEL, SPEWED OUT OVER THE TV ZOMBIE MASSES PERPETUATING THE MYTH THAT SOMEBODY SOMEWHERE IS ACTUALLY WATCHING. NOW PUT YOUR SHORTS ON AND RUN.

TRAIN FOR JULY 22. NIKE 10K
RUNLONDON
TEL: 08 0800 10,000

APRIL SAYS
DO THE LAMBETH WALK.

JUNE SAYS
KNEES UP MOTHER BROWN.

TRAIN FOR JULY 22. NIKE 10K
RUNLONDON
TEL: 08 0800 10,000

MAY SAYS
IT'S WARM AND COSY
IN YOUR CAR.

JUNE SAYS
COSY IS FOR
TEAPOTS.

TRAIN FOR JULY 22. NIKE 10K
RUNLONDON
TEL: 08 0800 10,000

APRIL SAYS
BEWARE OF PICKPOCKETS.

JUNE SAYS
GIVE THEM A HEAD START.

TRAIN FOR JULY 22. NIKE 10K
RUNLONDON
TEL: 08 0800 10,000

Individual

Copywriter
Richard Russell

Art Director
Chris Groom

Typographer
A N Olivetti

Creative Directors
Tony Davidson
Kim Papworth

Advertising Agency
Wieden + Kennedy UK

Marketing Executive
Chris Thompson

Client
D&AD

Individual

Copywriter
Alex Grieve

Art Director
Adrian Rossi

Photographer
Nadav Kander

Typographer
Matt Kemsley

Creative Director
John O'Keeffe

Advertising Agency
Bartle Bogle Hegarty

Account Handler
Julian Douglas

Marketing Executive
Andrew Nebel

Client
Barnardo's

Is it me, or is it just taking the piss to ask the oldest Creative in the department to write the CALL FOR ENTRIES ad for THE CANNES YOUNG CREATIVES COMPETITION? To ask someone who never goes anywhere exotic or mysterious (apart from the Ladies toilet when no one's around) to tell people that THE WINNERS GO TO THE CANNES ADVERTISING FESTIVAL FOR FREE, WITH £500 SPENDING MONEY. To expect someone lurching towards 40 (and voted at the Christmas Party, 'Most Likely To Be Keeping Quiet About Haemorrhoids') to happily flag up that TEAMS MUST BE AGED 28 OR YOUNGER TO ENTER. Well, it's a damn cheek in my book. I've never once been to Cannes - not even when I won a sodding Gold - and here's D&AD and Pearl & Dean giving the chance to some pimply, snot-nosed virgin who, get this CANNOT BE WORKING FULL TIME IN THE ADVERTISING INDUSTRY. It's not as if these young pretenders even have to do anything terribly taxing to win the trip. Just tear themselves away from their video games long enough to SEND 5 PIECES / CAMPAIGNS FROM A PORTFOLIO AND ANSWER A BRIEF, BY FRIDAY 20 APRIL 2001. Oh, and they MUST HAVE WORKED ON PLACEMENT OR ATTENDED A D&AD ADVERTISING WORKSHOP IN THE LAST YEAR. But don't worry, there's no official requirement to know your arse from your elbow so that's alright then. It also says here that THE WINNERS WILL REPRESENT THE U.K. IN THE INTERNATIONAL YOUNG CREATIVES COMPETITION - whatever that may be. A search for the best joined-up writing in Europe, perhaps. No, I'm sorry, but someone is having a pop at me here and, frankly, I've half a mind not to do the ad at all. Better still, I'll make it all-copy - then no one will read it anyway. FOR APPLICATIONS RING CHRIS THOMPSON AT D&AD ON 020 7840 1118, OR E-MAIL chris@dandad.co.uk. (Young Creatives should always remember to ask permission from the person who pays the 'phone bill.)

PEARL & DEAN

D&AD Cannes Young Creatives Competition
sponsored by Pearl & Dean

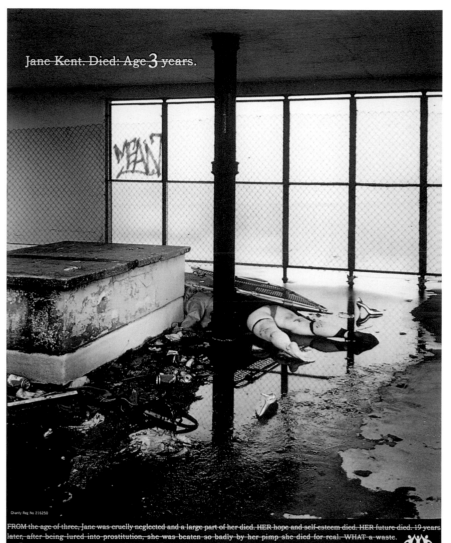

Jane Kent. Died: Age 3 years.

FROM the age of three, Jane was cruelly neglected and a large part of her died. HER hope and self-esteem died. HER future died. 19 years later, after being lured into prostitution, she was beaten so badly by her pimp she died for real. WHAT a waste. AT Barnardo's we want to save children like Jane from a living death. WE work with families, offering advice and counselling to give children back their future and life. ALL this takes time. THAT'S why Barnardo's works over the long term, helping 50,000 children a year who have nowhere else to turn. NEXT time you read a story like Jane's in this newspaper (and you will) you'll say, "this must never happen again". PLEASE, help us ensure it doesn't. MAKE a donation. CALL 0845 844 0180 or visit www.barnardos.org.uk

Barnardo's
GIVING CHILDREN
BACK THEIR FUTURE

Individual

Copywriter
Mike McKenna

Art Director
Greg Martin

Photographer
Henrik Knudsen

Typographer
Aaron Moss

Creative Directors
Nick Bell
Mark Tuttsel

Advertising Agency
Leo Burnett London

Account Handler
Annabel Hewitt

Marketing Executive
Juliet Foster

Client
H J Heinz Company

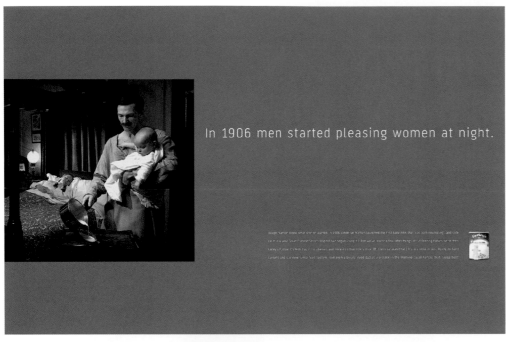

Individual

Copywriter
Mike McKenna

Art Director
Greg Martin

Photographer
Henrik Knudsen

Typographer
Aaron Moss

Creative Directors
Nick Bell
Mark Tuttsel

Advertising Agency
Leo Burnett London

Account Handler
Annabel Hewitt

Marketing Executive
Juliet Foster

Client
H J Heinz Company

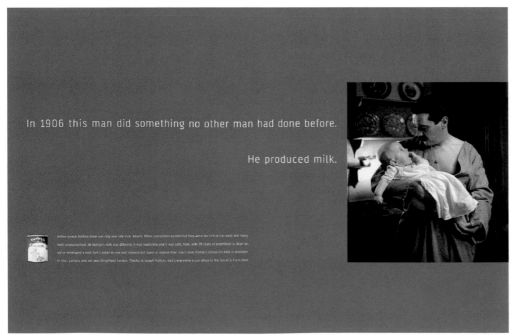

Individual

Copywriter
Mike Nicholson

Art Director
Daryl Corps

Typographer
Joe Hoza

Creative Directors
Peter Souter
Dave Dye

Advertising Agency
Abbott Mead
Vickers.BBDO

Account Handler
Mark Petersen

Marketing Executive
Jacqui Kean

Client
The Economist

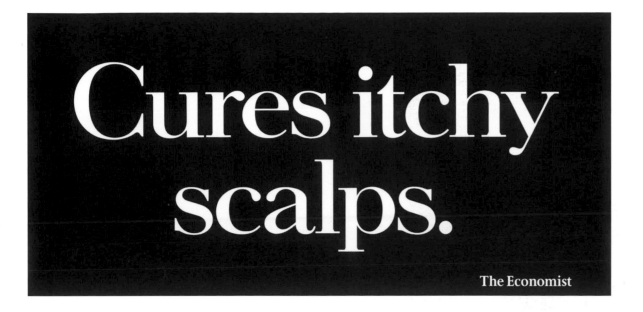

Individual

Copywriter
Greg Hahn

Art Director
Steve Driggs

Photography
Lou Capozzola

Creative Director
David Lubars

Advertising Agency
Fallon Minneapolis

Account Handler
Nicole Nye

Marketing Executive
John Rodenburg

Client
Sports Illustrated

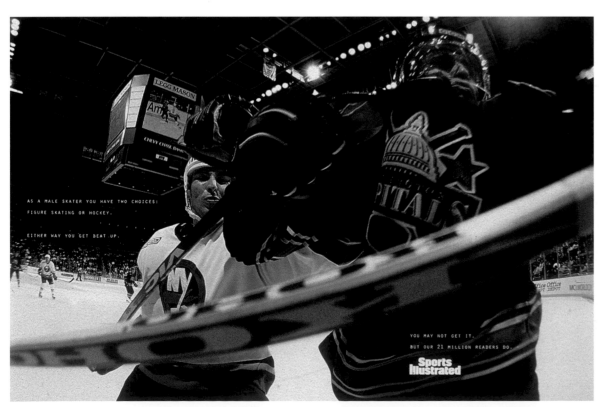

Individual

Copywriter
Patrick McClelland

Art Director
Grant Parker

Director
Jamie Cato

Agency Producer
Richard Chambers

Creative Director
Larry Barker

Advertising Agency
BMP DDB

Account Handlers
Philippa Roberts
Glen Lomas

Marketing Executives
Marc Sands
Chris Moisan

Client
Guardian Unlimited

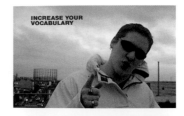
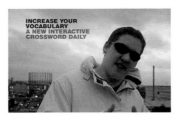

Rapper
We open on a street-wise youth rapping to camera. From the vocabulary he uses, we soon realise he is almost impossibly articulate.
SFX: Bass beat throughout.
Rapper: I'm the inception of a counter cultural revolution. I expectorate axioms like they're a pollution. Don't endeavour to vituperate me or I'll perambulate on your physiognomy. Get individuals of my rapacious capacity for coitus. If your skills aren't commensurate, go propagate with a rhesus. I'm cryptic, I'm elliptic. In my vestibule I got a Rothco triptych. Is it any wonder the post-pubescent glacial maidens come to me for their inculcation? I'm a pedagogue here for their libation. YO! DJ abrade those polymers. Let's get assiduous.
Fade to black.
SUPER: Increase your vocabulary.
SUPER: A new interactive crossword daily.
LOGO: Guardian Unlimited. Fresh Dimension.

Individual

Copywriter
Eliot Powell

Art Directors
Paul Shelly
Lance Vining

Photographer
Michael Meyersfeld

Typographer
Paul Shelly

Creative Director
Hein Botha

Advertising Agency
Young & Rubicam
Gitam Johannesburg

Account Handler
Laura Pozniak

Marketing Executive
Paul Melhuish

Client
Land Rover South
Africa

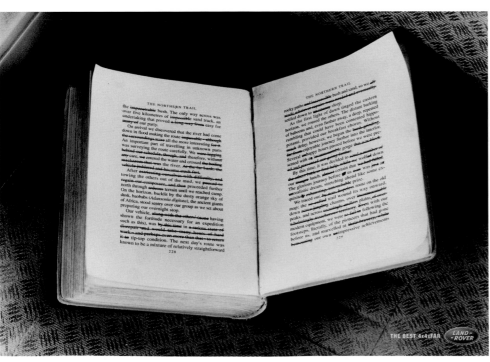

Campaigns

Copywriter
Tony Barry

Art Director
Damon Collins

Typographer
Marc Donaldson

Creative Director
Charles Inge

Advertising Agency
Lowe

Account Handler
Harriet Bell

Marketing Executive
Greg Hill

Client
Merrill Lynch HSBC

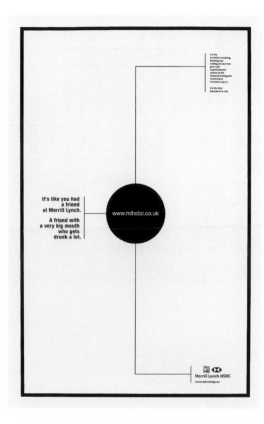

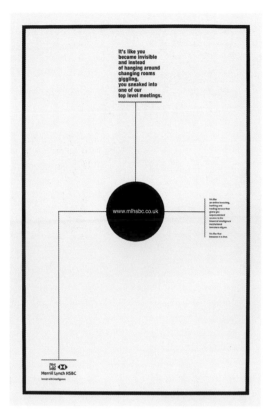

Campaigns

Copywriter
Justin Hooper

Art Director
Christian Cotterill

Photographer
Dave McKean

Illustrator
Dave McKean

Typographers
Christian Cotterill
Steve Darson

Creative Director
Nick Hastings

Advertising Agency
D'Arcy

Account Handler
Anthea Willey

Marketing Executive
Fiona Samson

Client
COI/Department
of Health

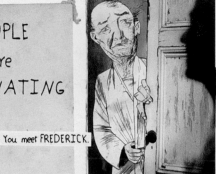
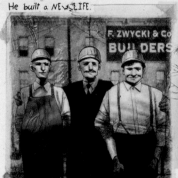
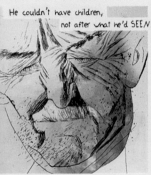
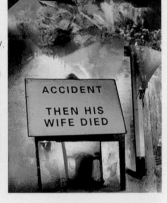
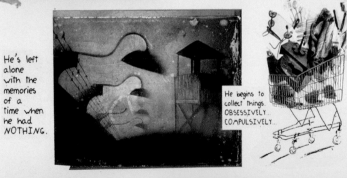
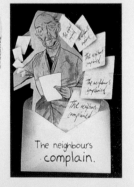

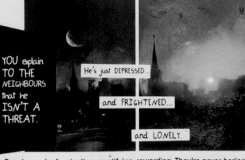

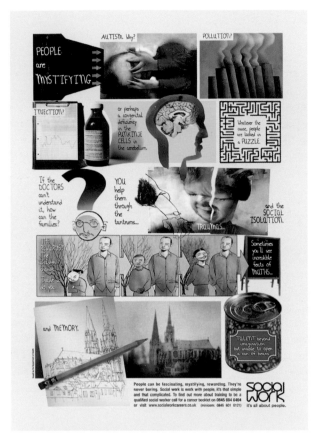
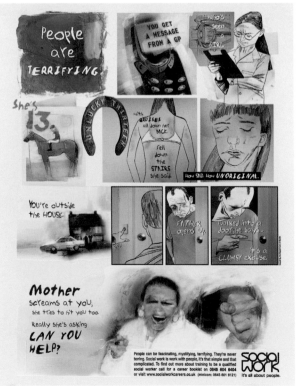

Campaigns

Copywriter
Neil French

Art Director
Neil French

Photographer
David Wong

Typographer
Brian Charles Capel

Creative Director
Sonal Dabral

Advertising Agency
Ogilvy & Mather
Malaysia

Account Handlers
Norlina Yunus
Sheena Lim

Marketing Executive
Vittavat Tantivess

Client
Unilever Malaysia

Skin Fact Nº21

The smoke from burning giraffe skin is used to treat nosebleeds among some tribes in Africa. These tribes always travel with a spare giraffe and a box of matches, in case they bump into a tree.

(Not really: I made that last bit up.)

(Dove is all you need to know about skincare.)

Skin Fact Nº28

The skin of the Crested Newt tastes horrid. This is said to be a defense against predators. On the other hand, since this wouldn't work until you were actually being eaten, it seems a somewhat questionable means of defense.

Revenge maybe.

(Dove is all you need to know about skincare.)

Skin Fact Nº37

Some toads have rather knobbly skin that exudes hallucinogenic slime.

Devotees avail themselves of this 'high' by scraping the slime from the back of the animal, or, in more urgent cases, licking the toad. Our question has always been what sort of a person would think it a great idea to lick a toad in the first place, before the dubious properties of its sweat were discovered.

(Dove is all you need to know about skincare.)

DIRECT MAIL

Top Row; *Left to Right:*
IAN HAWORTH, WWAV RAPP COLLINS • PETER YORK • ANDY BLACKFORD, GREY WORLDWIDE
Bottom Row; *Left to Right:*
JACK NOLAN • SHAUN MCILRATH, HERESY • WILL COLLIN, NAKED

DIRECT MAIL

Left to Right:
ADAM TUCKER, BMP DDB • GARY SHARPEN, LEONARDO • MARC NOHR, KITCATT NOHR ALEXANDER SHAW

Comment by Gary Sharpen

While overall standards in this category are rising, there was a disappointingly small amount of work that genuinely excited the jury, let alone stood apart as extraordinary. One feature evident in all the best work this year was pure creative ideas produced on a budget. Not so encouraging was the volume of work apparently engineered to enter awards, and entries where money appeared to have been thrown at a problem with no strong creative idea. The Barnardo's mailer, however, stood out for a number of reasons. It links well with the other media in the campaign while representing a fresh interpretation of the overall campaign theme. It also appeared to have been produced on a modest budget, yet stood apart thanks to a top quality idea and good crafting. Meanwhile, The Guardian insert was intelligent and rewarded the consumer's interaction – a simple, witty idea with elegant copy. Both entries show this category will improve as creatives keep reinterpreting the definition of that old-fashioned and often misleading term: 'direct mail'. However, everyone producing work must have a long, hard look at what they do and raise creativity to the next level for 'direct mail' to truly come of age.

DIRECT MAIL SPONSORED BY ROYAL MAIL • PUBLIC SERVICE & CHARITIES SPONSORED BY BMP DDB FOR GREAT ORMOND STREET HOSPITAL

Silver Nomination
for the most
outstanding Insert
sponsored by
Royal Mail

Art Directors
Nick Burrage
Luca Bertoluzzi

Copywriters
Nick Burrage
Luca Bertoluzzi

Typographer
Kevin Clarke

Creative Director
Andrew Fraser

Advertising Agency
BMP DDB

Account Handler
Simon Lendrum

Marketing Executive
Marc Sands

Client
The Guardian

Direct Mail

OF LOVE AND WAR: LOST IN LILLE.

By Gustave Clemenceau (1919-1944)

Ah Stella! My Love and Sorrow!
Down in the Rimington's garden
We kissed goodbye my former pain
I stroke your head, your gentle hair
Was made of gold – and then I left:
Milan, for 5 long weeks,
I can reveal so much
Then back to France, all in love for you
And you were gone.
You were gone, the guardian of your house
Said so.
But I'm going to battle this Saturday.
Will I see you again? *Je ne sais pas.*

Translation by Nick Lucas

Stella

Rimington

former

head

of

Mi 5

reveal s

all in

the guardian

this Saturday.

INSTRUCTIONS:
Go to page 3 in main newspaper. Place over poem.

Silver Nomination
for the most
outstanding Insert
sponsored by
Royal Mail

Art Director
Richard Robinson

Copywriter
Graham Lakeland

Typographer
Chris Chapman

Creative Director
John O'Keeffe

Advertising Agency
Bartle Bogle Hegarty

Account Handler
Julian Douglas

Marketing Executive
Andrew Nebel

Client
Barnardo's

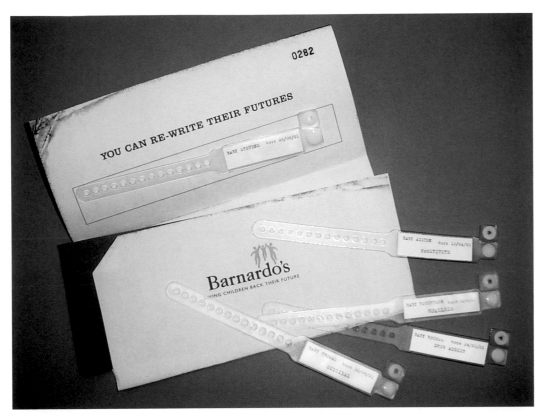

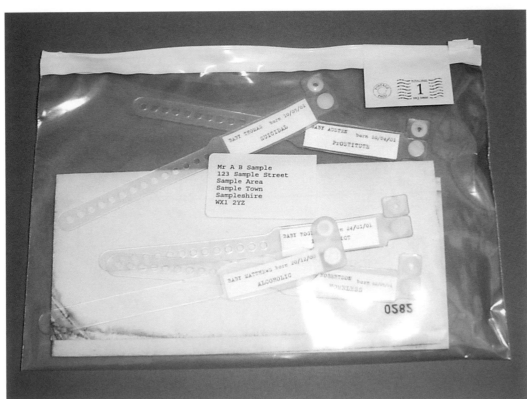

Low volume mailings (niche market, up to 10,000)

Design Director
Christine Jones

Designer
Christine Jones

Art Director
Christine Jones

Copywriter
Meg Rosoff

Illustrator
Meg Rosoff

Typographer
Christine Jones

Creative Director
Jaspar Shelbourne

Advertising Agency
J Walter Thompson

Account Handler
Clare Calow

Marketing Executive
Jane Brewin

Client
Tommy's, the baby charity

Low volume mailings (niche market, up to 10,000)

Art Director
Tom Richards

Copywriter
Pete Armstrong

Creative Director
Billy Mawhinney

Advertising Agency
Faulds Advertising

Account Handler
Alicia Columbine

Marketing Executive
Moira Carter

Client
Scottish National Blood Transfusion Service

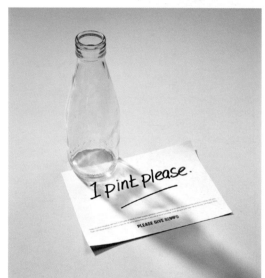

Low volume mailings (niche market, up to 10,000)

Art Director
Richard Irving

Copywriter
Simon Sinclair

Typographer
Richard Irving

Creative Director
Simon Sinclair

Advertising Agency
Prada

Account Handler
Cath Warrington

Marketing Executive
Marcus Pagnam

Client
Poynton Dry Cleaners

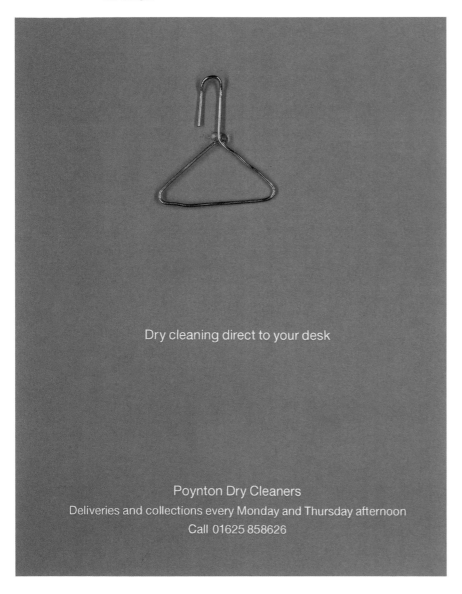

Dry cleaning direct to your desk

Poynton Dry Cleaners
Deliveries and collections every Monday and Thursday afternoon
Call 01625 858626

Low volume mailings (niche market, up to 10,000)

Designer
Kamalan Naidoo

Art Director
Theo Ferreira

Copywriter
John Davenport

Typographer
Kamalan Naidoo

Creative Director
Mike Schalit

Advertising Agency
Net#work BBDO

Account Handlers
Bronwen Diviani
Renee Schonborn

Marketing Executives
Clifford Joffe
Evita Levendis

Client
Virgin Atlantic Airlines

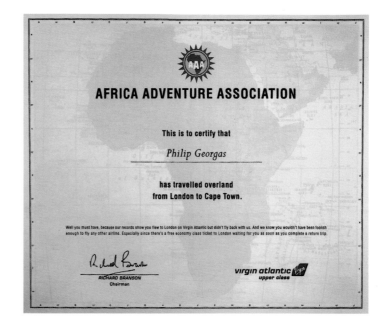

High volume mailings (mass market, over 10,000)

Art Director
Phil McVicar

Copywriter
Jamie Putnam

Creative Director
Rob McDonald

Advertising Agency
KLP Euro RSCG

Account Handler
Brett McKibbin

Marketing Executive
Chris Moisan

Client
Guardian Unlimited

High volume mailings (mass market, over 10,000)

Art Director
Anthony Cliff

Copywriter
Stephen Timms

Creative Directors
Jack Nolan
Graham Mills

Advertising Agency
Harrison Troughton
Wunderman

Account Handler
Guy Steele-Perkins

Marketing Executive
David Tyres

Client
Automobile
Association

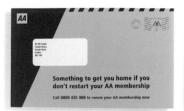

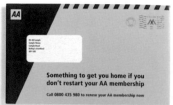

High volume mailings (mass market, over 10,000)

Art Director
Stephen Stretton

Copywriter
Matt Morley-Brown

Photographer
Lorentz Gullachsen

Typographer
Jacqui Ferns

Creative Directors
Stephen Stretton
Matt Morley-Brown

Advertising Agency
archibald ingall stretton...

Account Handler
Matthew North

Marketing Executive
Chris Hawken

Client
Skoda

Public Services and Charities

Art Director
Tony Clewett

Copywriter
Mandy Duffy

Creative Director
Nick Moore

Advertising Agency
TBWA\GGT Direct

Account Handler
Andy Male

Marketing Executive
Caromy Shannon

Client
UNICEF

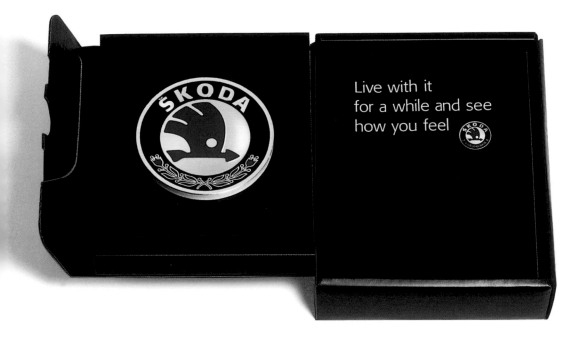

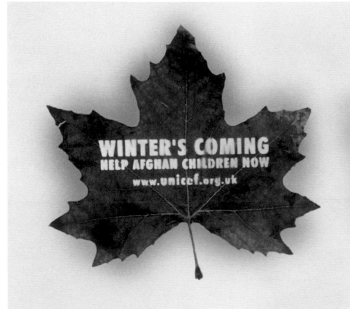

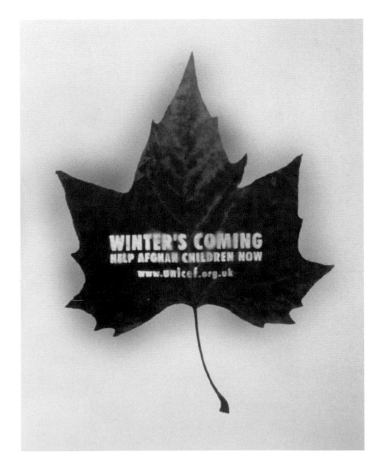

AMBIENT MEDIA

Top Row; *Left to Right:*
CHAS BAYFIELD, ARKWRIGHT • ALISON JACKSON, ALISON JACKSON PHOTOGRAPHY • DAVID HOBBS, MILES CALCRAFT BRIGINSHAW DUFFY
Bottom Row; *Left to Right:*
MICHAEL CROWE, OGILVY • WALTER AMERIKA, FHV\BBDO • ED PRICHARD, MRM PARTNERS WORLDWIDE • STEVE TURNER, MILK

AMBIENT MEDIA

Left to Right:
MARK WAITES, MOTHER • KIM PAPWORTH, WIEDEN+KENNEDY UK • JAY POND-JONES, HHCL AND PARTNERS

Comment by Mark Waites

Not a classic year for ambient media, but a good year if you're in toilet media. There were stickers in toilets, around toilets, on toilet walls, on the backs of doors. We had pencils with no lead in them for a fertility clinic, and we had pencils with too much lead in them for... a fertility clinic. It's considered a new medium and maybe that's why there is so much duplication. Everyone thinks they are the first person to do a particular idea and maybe they all are. But it takes something very special to win in this category and this year it just wasn't there. The two Silver Nominations are for a bonsai tree specialist, which might be a large slow moving target of a brief but a funny solution, and a lung-shaped ashtray for the Singapore Cancer Society. How many ads we've seen for anti-smoking over the years I can't even think, but this stands out as one of the best.

AMBIENT MEDIA SPONSORED BY BOOMERANG MEDIA

Silver Nomination
for the most
outstanding
Ambient Media
sponsored by
Boomerang Media

Art Director
Stuart Richings

Copywriter
Stuart Richings

Typographer
Chris Wigmore

Creative Director
David Woolway

Advertising Agency
McCann - Erickson
Bristol

Account Handler
Harriet Stone

Marketing Executive
Geoff Matthews

Client
Glenbrook Bonsai
Nursery

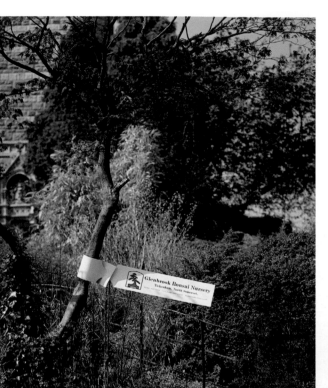
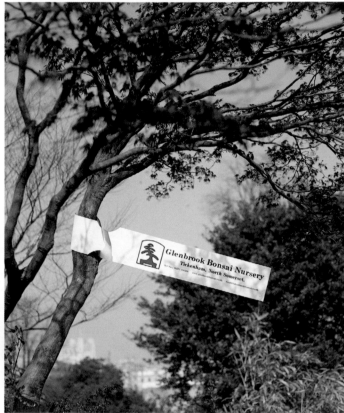

Glenbrook Bonsai Nursery may be big in the Bonsai world, but its advertising budget is as small as the trees that it sells. So, instead of using expensive outdoor poster sites, we wrapped oversized plant tags around highly visible and beautifully shaped full-sized trees around the local area. The tags were carefully produced to match real garden centre tags in everything but size, screen-printed onto tough PVC and even fastening round the tree in exactly the same manner.

Silver Nomination
for the most
outstanding
Ambient Media
sponsored by
Boomerang Media

Art Director
Toh Han Ming

Copywriter
Toh Han Ming

Designers
Toh Han Ming
Dawn Lee

Creative Directors
Mark Fong
Patrick Low

Advertising Agency
Dentsu, Young &
Rubicam Singapore

Account Handler
Thomas Ong

Marketing Executive
Gladys Chick

Client
Singapore Cancer
Society

These special ashtrays were placed in participating
pubs. They remind smokers of the damage they're
doing to their lungs.

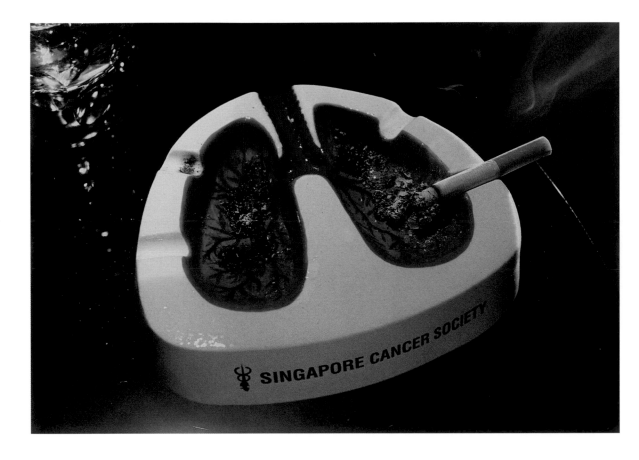

Ambient Media

Art Director
Dave Hobbs

Copywriter
Richard Stoney

Typographer
Kerry Roper

Creative Directors
Paul Briginshaw
Malcolm Duffy

Advertising Agency
Miles Calcraft
Briginshaw Duffy

Account Handler
Melissa Horn

Marketing Executive
Simon Clarkson

Client
Radio Times

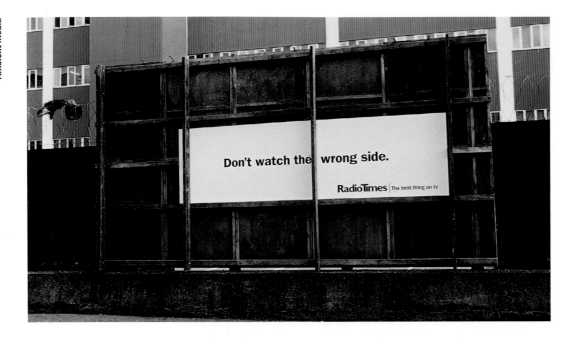

Ambient Media

Animator
Johnny Hardstaff

Director
Johnny Hardstaff

Producer
John Payne

Production Company
RSA Films

Telecine
Alistair Thompson

Editing/Sound Design
Dayn Williams

Client
Sony Computer
Entertainment Europe

Ambient Media

Art Director
Phil Clarke

Copywriter
Joel Bradley

Photographer
Paul Reas

Typographer
Chris Poole

Creative Director
David Droga

Advertising Agency
Saatchi & Saatchi

Account Handler
Ila De Mello Kamath

Marketing Executive
Pushpa Dougall

Client
Child Accident
Prevention Trust

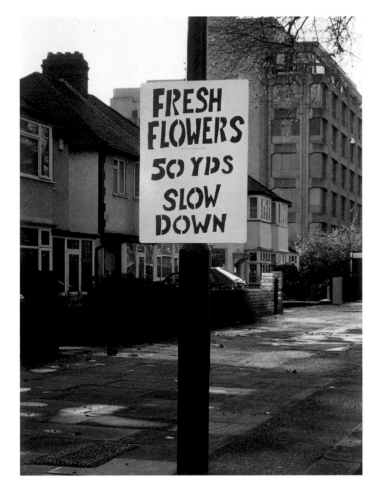
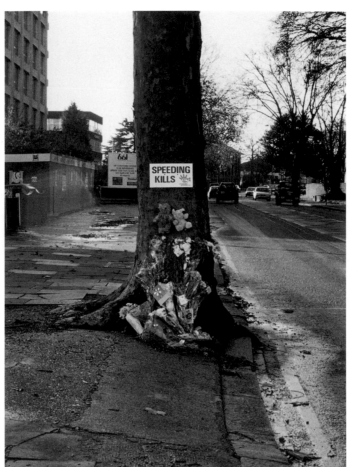

Ambient Media

Art Director
Billy McQueen

Copywriters
Chris Schofield
Seymour Pope

Photographer
Billy McQueen

Producer
Cheryl Millar

Typographer
Billy McQueen

Creative Director
Oliver Maisey

Advertising Agency
GeneratorBates

Account Handler
Fleur Campbell

Marketing Executive
Geoff Penrose

Client
Auckland Art Gallery

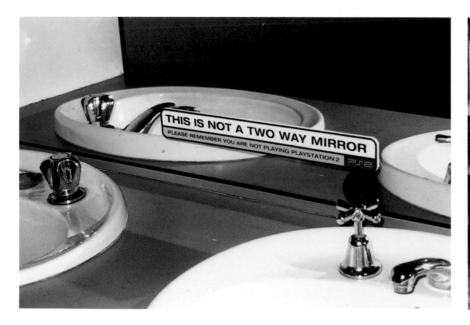

This campaign used inner city manhole covers to advertise an exhibition, which featured the history of New Zealand's most prolific independent record label, Flying Nun. We placed a variety of different stickers, based on classic Flying Nun designs on manholes in areas of high student traffic, like universities and other tertiary institutions.

Ambient Media

Art Directors
Matty Burton
Christian Finucane

Copywriters
David Bowman
John Skinner

Typographer
Duncan White

Creative Director
Ian Sizer

Production Company
Jungle Boys

Advertising Agency
Whybin\Lawrence\
TBWA

Account Handler
Geoff Coyle

Marketing Executive
Irena Tolje

Client
Sony Computer
Entertainment

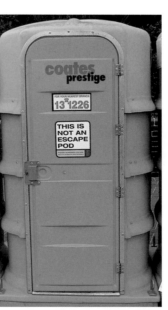

This ambient media campaign for Playstation 2 formed part of a series of sponsorships of nightclubs and concerts. One of the prime sponsorships was of 'Mobile Home', an annual event held on New Year's Eve at Bondi Beach, Sydney. The event drew crowds in excess of 10,000 people, many of whom were on drugs.

This campaign was developed and executed on virtually all of the fixtures of this event. A large number of PlayStation 2 consoles were also set up for partygoers to have a crack at. Each sticker or signpost sought to continually blur the line between reality and gaming.

Ambient Media

Art Directors
Dov Zmood
Simon Greed

Copywriters
Dov Zmood
John Mescall

Advertising Agency
J Walter Thompson
Melbourne

Account Handler
Susan Foley

Marketing Executives
Felicity Craig
Kylie Chavers

Client
Square Clothing

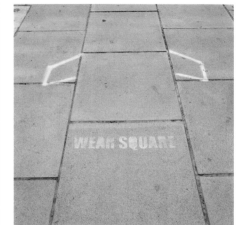

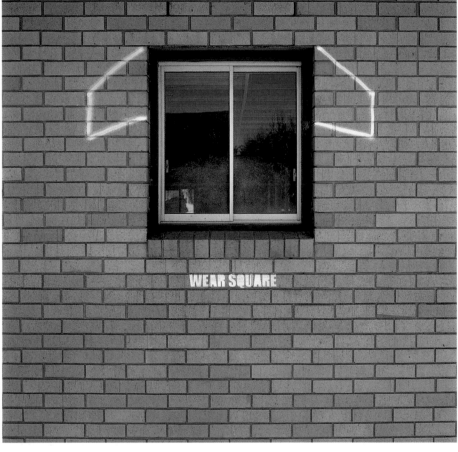
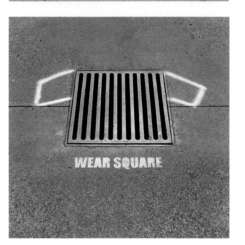

In this campaign for Square Clothing, by adding sleeves, we transformed squares all over the city (paving stones, windows, sewer grates) into shirts. The timing of the campaign was designed to coincide with Melbourne Fashion Week, and the campaign itself was rolled-out over a ten day period.

Ambient Media

Art Director
Lee Ford

Copywriter
Damian Simor

Clients
Damian Simor
Lee Ford

The target audience for this ad were the judges for the ambient media category. In order to reach them the ad was entered into the ambient media category.

CREATIVE TEAM
FOR HIRE
CALL DAN OR LUKE ON
0781 367 4860

Ambient Media

Art Director
Pei Pei Ng

Copywriter
Eugene Cheong

Photographer
Roy Zhang

Typographer
Pei Pei Ng

Creative Directors
Andy Greenaway
Neil French

Advertising Agency
Ogilvy & Mather
Singapore

Marketing Executive
Gerald Png

Client
Churches of the Love
Singapore Movement

The ad was stuck onto apples and sold by greengrocers who were sympathetic to the cause. Like the rest of the campaign, the ad sought to give God a voice that's less Billy Graham and more George Burns.

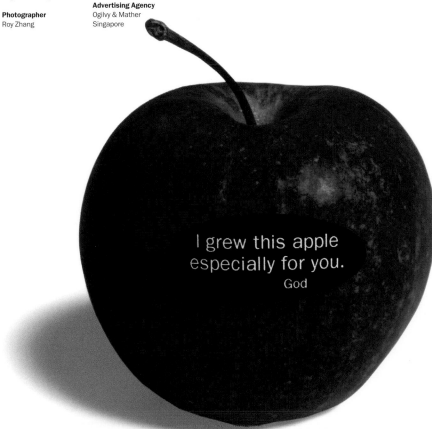

I grew this apple
especially for you.
God

Ambient Media

Art Director
Dave Masterman

Copywriter
Ed Edwards

Typographer
James Townsend

Creative Directors
Richard Flintham
Andy McLeod

Advertising Agency
Fallon London

Account Handler
Charlotte Hurrell

Marketing Executive
Gail Nuttney

Client
BBC Radio 1

In recent years, an increasing number of the visitors to Ibiza have been more interested in causing trouble than enjoying the music. Complaints from locals and proposed action from the authorities cast doubt over future music events.

The Friends of Ibiza is an initiative from BBC Radio One. Their aim is to encourage more responsible behaviour among the dance community.

These immigration cards were distributed on planes and at the airport on arrival in Ibiza.

IMMIGRATION LANDING CARD
To be completed on arrival.

WHAT IS THE PURPOSE OF YOUR VISIT?
(Tick where applicable)

☐ Business ☐ Pleasure

☐ To be an arse ☐ Other

THE AIM OF THE FRIENDS OF IBIZA ASSOCIATION IS TO ENSURE THAT IBIZA REMAINS A SPECIAL PLACE WHERE ISLANDERS AND DANCE MUSIC ENTHUSIASTS LIVE SIDE BY SIDE IN AN ATMOSPHERE OF MUTUAL RESPECT.

THE FRIENDS OF Ibiza

IMMIGRATION LANDING CARD
To be completed on arrival.

ARE YOU *(please tick)*

i) A national? ☐

ii) A visitor? ☐

iii) A tosser? ☐

THE AIM OF THE FRIENDS OF IBIZA ASSOCIATION IS TO ENSURE THAT IBIZA REMAINS A SPECIAL PLACE WHERE ISLANDERS AND DANCE MUSIC ENTHUSIASTS LIVE SIDE BY SIDE IN AN ATMOSPHERE OF MUTUAL RESPECT.

THE FRIENDS OF Ibiza

IMMIGRATION LANDING CARD
To be completed on arrival.

WHILST ON THE ISLAND I WILL
BE STAYING IN A *(please tick)*

Hotel ☐

Villa ☐

Campsite ☐

Cell ☐

THE AIM OF THE FRIENDS OF IBIZA ASSOCIATION IS TO ENSURE THAT IBIZA REMAINS A SPECIAL PLACE WHERE ISLANDERS AND DANCE MUSIC ENTHUSIASTS LIVE SIDE BY SIDE IN AN ATMOSPHERE OF MUTUAL RESPECT.

THE FRIENDS OF Ibiza

IMMIGRATION LANDING CARD
To be completed on arrival.

ARE YOU, OR HAVE YOU EVER
BEEN A DICKHEAD?
☐ yes ☐ no

If yes please give details.

THE AIM OF THE FRIENDS OF IBIZA ASSOCIATION IS TO ENSURE THAT IBIZA REMAINS A SPECIAL PLACE WHERE ISLANDERS AND DANCE MUSIC ENTHUSIASTS LIVE SIDE BY SIDE IN AN ATMOSPHERE OF MUTUAL RESPECT.

THE FRIENDS OF Ibiza

PHOTOGRAPHY & IMAGE MANIPULATION

Top Row; *Left to Right:*
RILEY JOHN-DONNELL, SURFACE MAGAZINE • CLAUDIA SOUTHGATE, BARTLE BOGLE HEGARTY
Bottom Row; *Left to Right:*
NICK TURPIN • SANDERS NICOLSON

PHOTOGRAPHY & IMAGE MANIPULATION

Left to Right:
MARCUS LYON, THE GLASSWORKS • BRIAN STEWART, BRIAN STEWART PHOTOGRAPHY AND CREATIVE DIRECTION

Comment by Brian Stewart

The camera has replaced the keyboard – it's official. The year's large number of entries in the photographic category supports this view. Yes, creative teams have embraced the power of a picture. Communication has become visual not verbal – a true universal advertising language, understood globally. The standard of entries was high, but the diamonds shone through. Club 18-30 is excellent – the picture is the idea. It drags you in thinking one thing, then delivers its sucker punch. Schweppes's artful recreation of paparazzi shots was equally powerful. The Barnardo's campaign explored the darker side with reportage images that chilled the spirit. Editorial entries were glossier. I would like to have seen more photojournalism entries, but that's a small gripe. Again the standards were high, but fashion brands recognised and invested in the power of a great photograph decades ago, so the bar was high. In most cases the jury viewed the photographs in their commercial context. Our criteria were: Did the picture add to the idea? Were the images powerful? Did the photographer fulfil the brief over and above the commercial obligation? If they did, the evidence is in the pages that follow. Congratulations to every one of you. You've earned them.

PHOTOGRAPHY & IMAGE MANIPULATION SPONSORED BY GETTY IMAGES

Silver Award
for the most
outstanding
Photography and
Image Manipulation
for Advertising
sponsored by
Getty Images

Photographer
Trevor Ray Hart

Art Director
Antony Nelson

Copywriter
Mike Sutherland

Typographer
Scott Silvey

Creative Director
David Droga

Advertising Agency
Saatchi & Saatchi

Account Handler
James Griffiths

Marketing Executives
Clare Burns
Andy Tidy

Client
Club 18-30

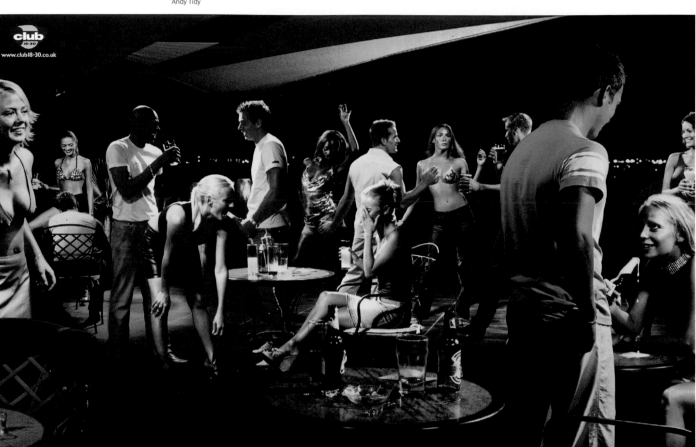

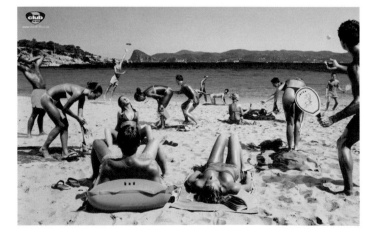

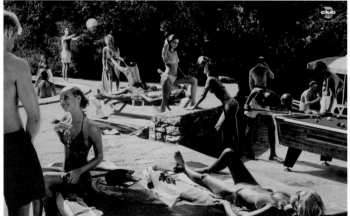

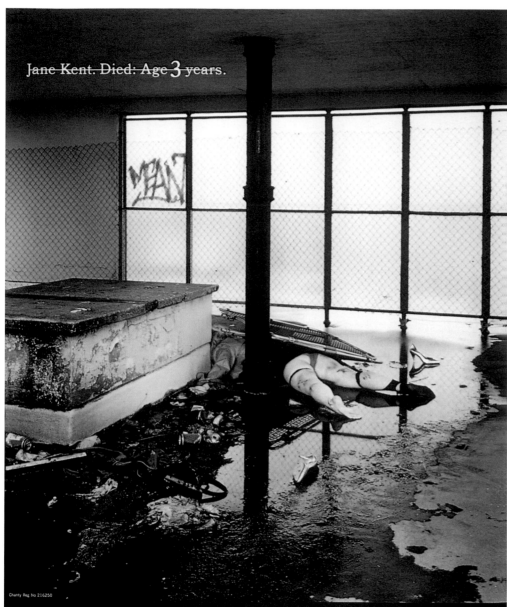

Silver Nomination
for the most
outstanding
Photography and
Image Manipulation
for Advertising
sponsored by
Getty Images

Photographer
Nadav Kander

Art Director
Adrian Rossi

Copywriter
Alex Grieve

Typographer
Matt Kemsley

Creative Director
John O'Keeffe

Advertising Agency
Bartle Bogle Hegarty

Account Handler
Julian Douglas

Marketing Executive
Andrew Nebel

Client
Barnardo's

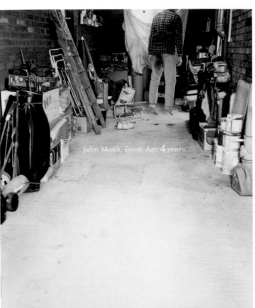

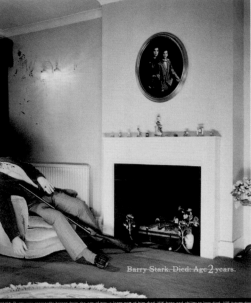

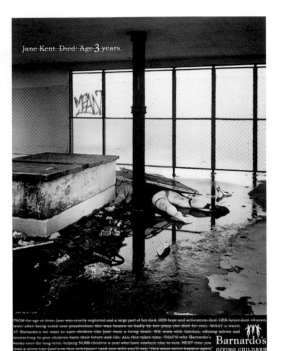

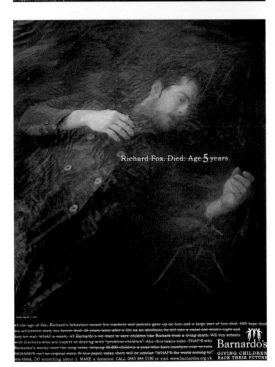

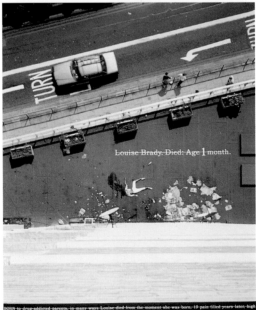

Silver Nomination
for the most outstanding Photography and Image Manipulation for Advertising sponsored by Getty Images

Photographer
Alison Jackson

Art Director
Kim Gehrig

Copywriter
Caroline Pay

Typographer
Ian Hutchings

Creative Directors
Robert Saville
Mark Waites

Advertising Agency
Mother

Account Handler
Kerry Millett

Marketing Executive
Leslie Davey

Client
Coca Cola GB

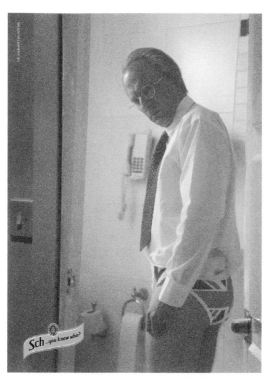

Silver Nomination
for the most
outstanding
Photography and
Image Manipulation
for Advertising
sponsored by
Getty Images

Photographer
Ben Stockley

Art Director
Justin Tindall

Copywriter
Adam Tucker

Typographer
Kevin Clarke

Creative Director
Mark Reddy

Advertising Agency
BMP DDB

Account Handler
Philip Heimann

Marketing Executive
Julia Bowe

Client
Harvey Nichols

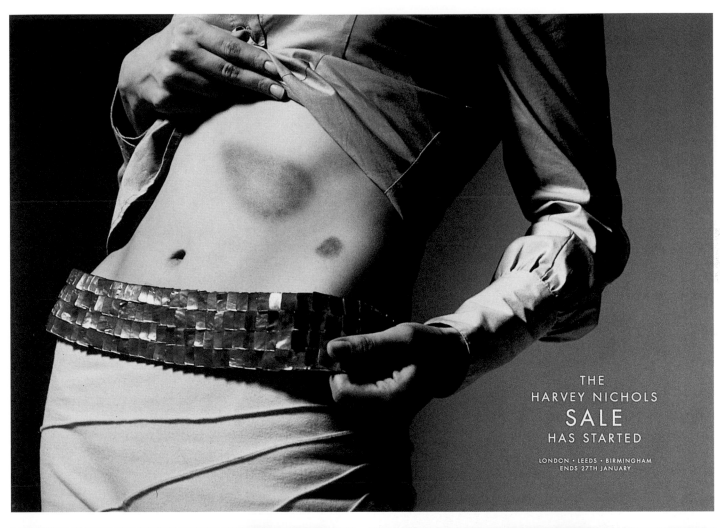

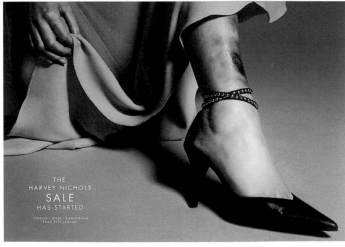

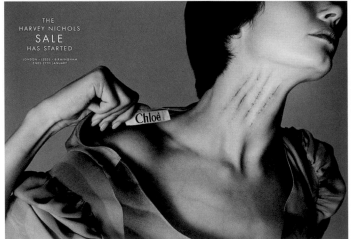

Silver Nomination
for the most
outstanding
Photography and
Image Manipulation
for Advertising
sponsored by
Getty Images

Photographer
Stefan Ruiz

Art Directors
Pablo Martin
Shubhankar Ray

Typographer
Pablo Martin

Creative Director
Shubhankar Ray

Advertising Agency
Grafica

Client
Camper

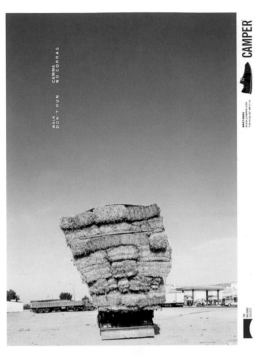

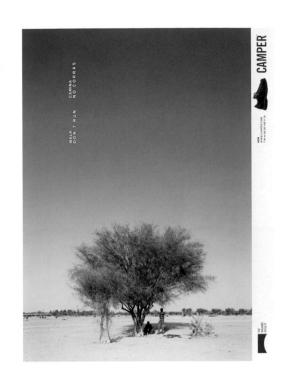

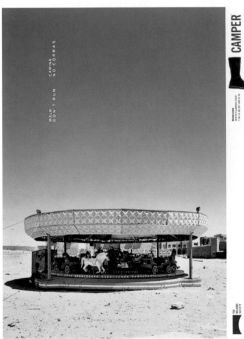

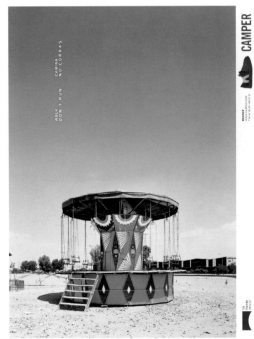

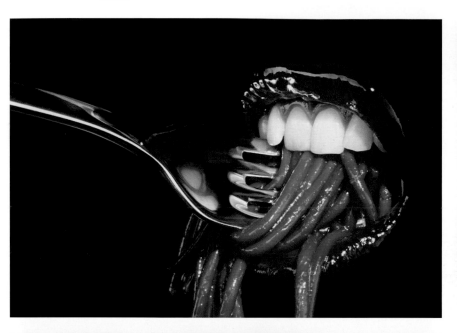
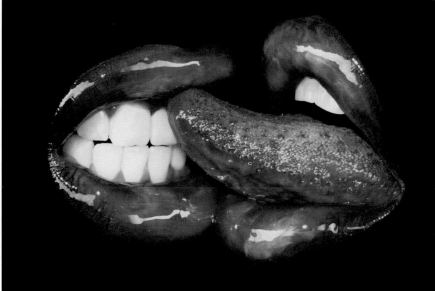
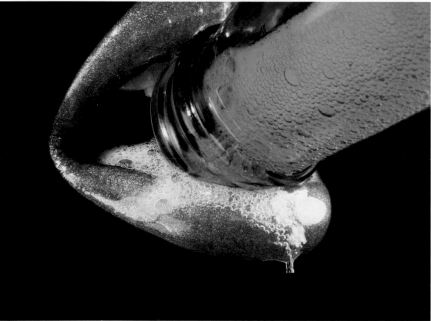

Silver Nomination
for the most
outstanding
Photography and
Image Manipulation
for Design
sponsored by
Getty Images

Photographer
Miles Aldridge

Image Manipulation
Metro Imaging

Marketing Executive
Katie Grand

Client
The Face

Photography and Image Manipulation for Advertising, Individual

Photographer
Frank Budgen

Art Directors
Adam Scholes
Michael Long

Copywriters
Hugh Todd
Anna Toosey

Typographer
Roger Kennedy

Creative Director
David Droga

Advertising Agency
Saatchi & Saatchi

Account Handler
Louise Bohmann

Marketing Executives
Samantha Roddick
Adae-Elena Amats

Client
Coco de Mer

Photography and Image Manipulation for Advertising, Individual

Photographer
Ken Griffiths

Art Director
John Horton

Copywriter
Richard Foster

Typographer
John Horton

Creative Director
Peter Souter

Advertising Agency
Abbott Mead
Vickers.BBDO

Account Handler
Ben Slater

Marketing Executive
Katie Jamieson

Client
BT Genie

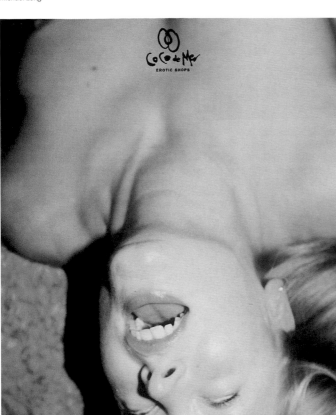

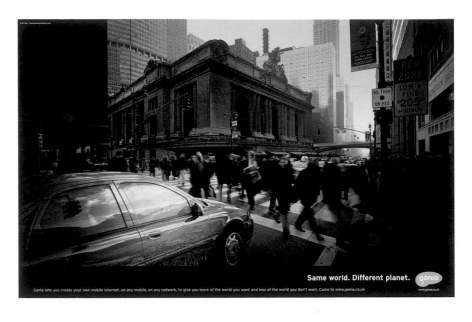

**Photography and
Image Manipulation
for Advertising,
Individual**

Photographer
Nick Georghiou

Art Director
Jerry Hollens

Copywriter
Mike Boles

Typographer
Ryan Shellard

Creative Directors
Robert Campbell
Mark Roalfe

Advertising Agency
Rainey Kelly Campbell
Roalfe/Y&R

Account Handler
Douglas Thursby-
Pelham

Marketing Executive
Anthony Bradbury

Client
Land Rover

**Photography and
Image Manipulation
for Advertising,
Individual**

Photographer
Nadav Kander

Art Director
Adrian Rossi

Copywriter
Alex Grieve

Typographer
Matt Kemsley

Creative Director
John O'Keeffe

Advertising Agency
Bartle Bogle Hegarty

Account Handler
Julian Douglas

Marketing Executive
Andrew Nebel

Client
Barnardo's

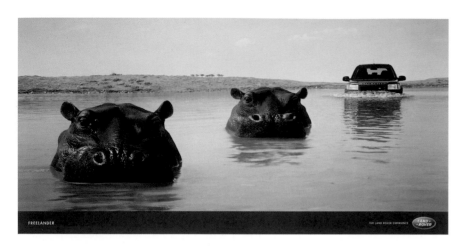

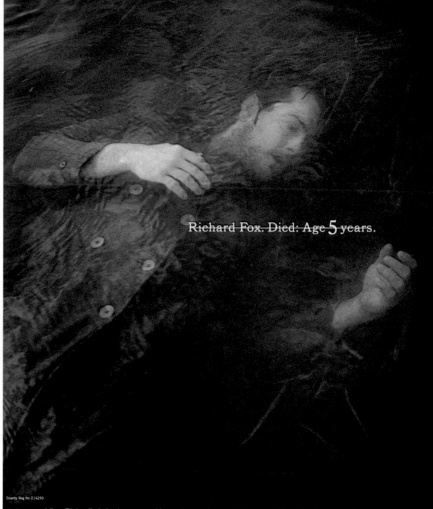

**Photography and
Image Manipulation
for Advertising,
Individual**

Photographer
Nadav Kander

Art Director
Adrian Rossi

Copywriter
Alex Grieve

Typographer
Chris Chapman

Creative Director
John O'Keeffe

Advertising Agency
Bartle Bogle Hegarty

Account Manager
Paul Bradbury

Marketing Executive
Tracy Follows

Client
One 2 One

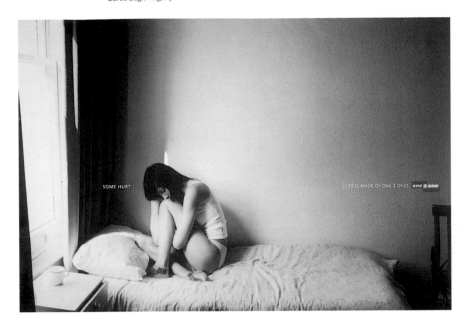

**Photography and
Image Manipulation
for Advertising,
Individual**

Photographer
Nadav Kander

Art Director
Adrian Rossi

Copywriter
Alex Grieve

Typographer
Chris Chapman

Creative Director
John O'Keeffe

Advertising Agency
Bartle Bogle Hegarty

Account Manager
Paul Bradbury

Marketing Executive
Tracy Follows

Client
One 2 One

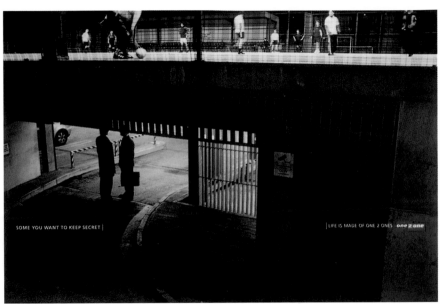

**Photography and
Image Manipulation
for Advertising,
Individual**

Photographer
Ian Butterworth

Art Directors
John Foster
Steve Back

Copywriter
Sion Scott-Wilson

Illustration
Electric Art

Typographers
John Foster
Steve Back

Creative Director
Sion Scott-Wilson

Advertising Agency
Saatchi & Saatchi
(Singapore)

Account Handler
Tan Jwee Peng

Marketing Executive
Diane Lee

Clients
Reebok
Royal Sporting House

**Photography and
Image Manipulation
for Advertising,
Individual**

Photographer
Ian Butterworth

Art Directors
John Foster
Steve Back

Copywriter
Sion Scott-Wilson

Illustration
Electric Art

Typographers
John Foster
Steve Back

Creative Director
Sion Scott-Wilson

Advertising Agency
Saatchi & Saatchi
(Singapore)

Account Handler
Tan Jwee Peng

Marketing Executive
Diane Lee

Clients
Reebok
Royal Sporting House

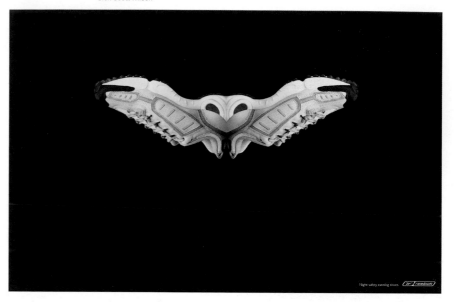

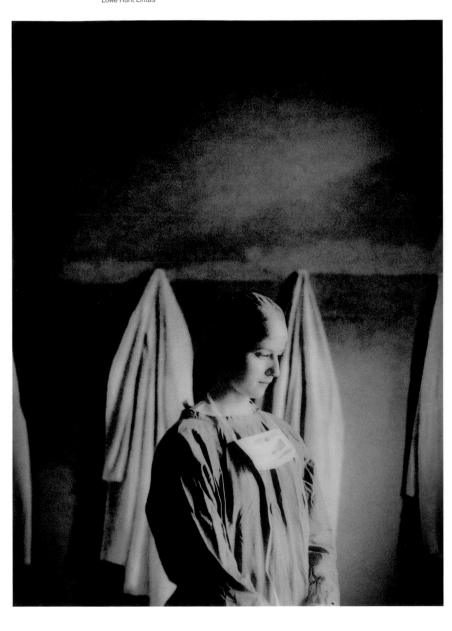

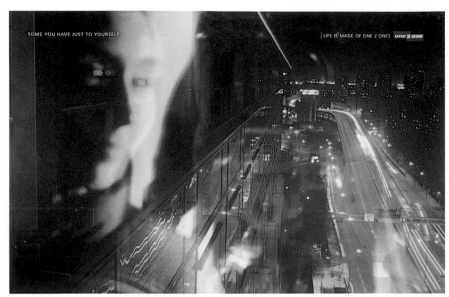

Photography and Image Manipulation for Advertising, Individual

Photographer
David Harriman

Art Director
Dave Beverley

Copywriter
Rob Burleigh

Typographer
Dave Beverley

Creative Directors
Dave Beverley
Rob Burleigh

Advertising Agency
Leagas Delaney

Account Handler
Tim Martin

Marketing Executive
Arthur Hoeld

Client
Adidas

Photography and Image Manipulation for Advertising, Individual

Photographer
David Harriman

Art Director
Dave Beverley

Copywriter
Rob Burleigh

Typographer
Dave Beverley

Creative Directors
Dave Beverley
Rob Burleigh

Advertising Agency
Leagas Delaney

Account Handler
Tim Martin

Marketing Executive
Arthur Hoeld

Client
Adidas

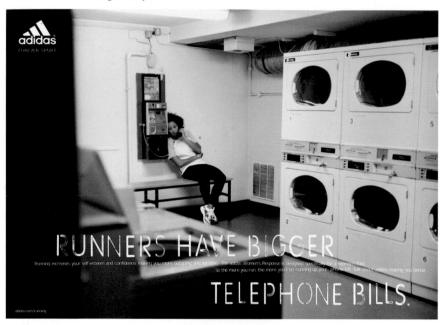

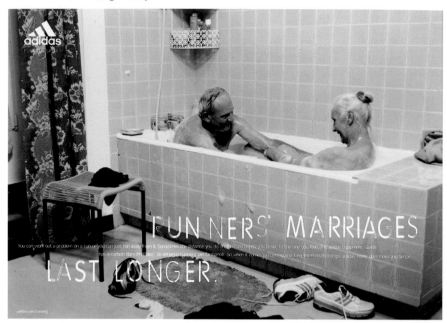

Photography and Image Manipulation for Advertising, Individual

Photographer
Trevor Ray Hart

Art Director
Antony Nelson

Copywriter
Mike Sutherland

Typographer
Scott Silvey

Creative Director
David Droga

Advertising Agency
Saatchi & Saatchi

Account Handler
James Griffiths

Marketing Executives
Clare Burns
Andy Tidy

Client
Club 18-30

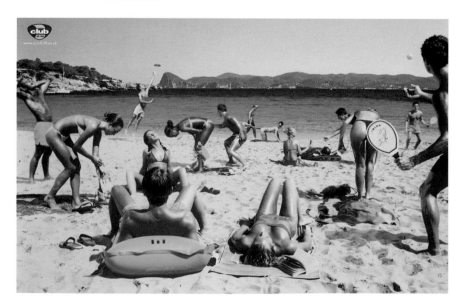

Photography and Image Manipulation for Advertising, Individual

Photographer
Alison Jackson

Art Director
Kim Gehrig

Copywriter
Caroline Pay

Typographer
Ian Hutchings

Creative Directors
Robert Saville
Mark Waites

Advertising Agency
Mother

Account Handler
Kerry Millett

Marketing Executive
Leslie Davey

Client
Coca Cola GB

Photography and Image Manipulation for Advertising, Individual

Photographer
Alison Jackson

Art Director
Kim Gehrig

Copywriter
Caroline Pay

Typographer
Ian Hutchings

Creative Directors
Robert Saville
Mark Waites

Advertising Agency
Mother

Account Handler
Kerry Millett

Marketing Executive
Leslie Davey

Client
Coca Cola GB

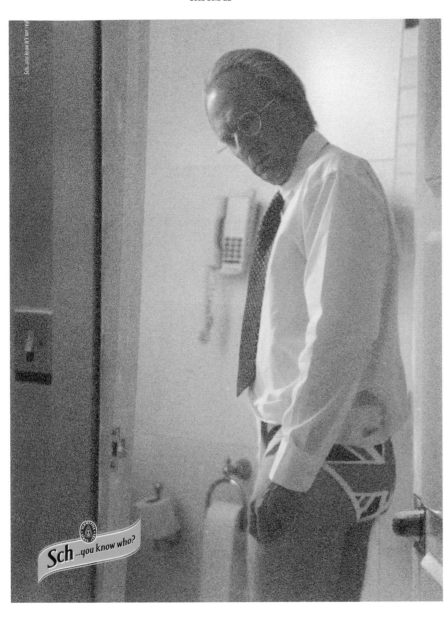

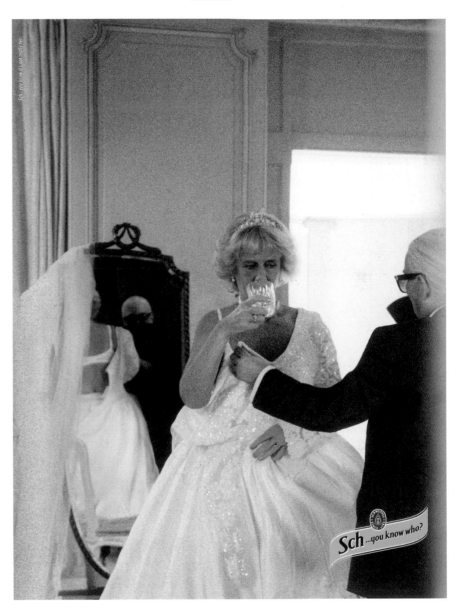

Photography and Image Manipulation for Advertising, Campaigns

Photographer
Frank Budgen

Art Directors
Adam Scholes
Michael Long

Copywriters
Hugh Todd
Anna Toosey

Typographer
Roger Kennedy

Creative Director
David Droga

Advertising Agency
Saatchi & Saatchi

Account Handler
Louise Bohmann

Marketing Executives
Samantha Roddick
Adae-Elena Amats

Client
Coco de Mer

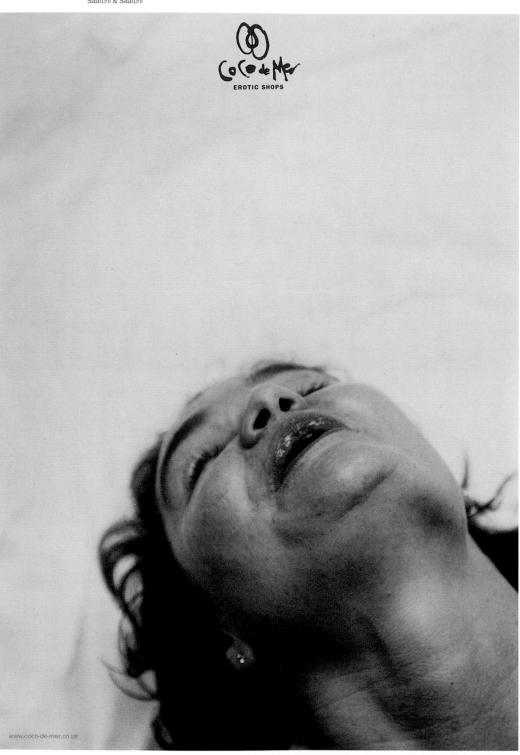

Photography and Image Manipulation for Advertising, Campaigns

Photography
Giblin & James

Image Manipulation
First Base

Art Director
Michael Long

Copywriter
Anna Toosey

Typographer
Roger Kennedy

Modelmaker
Nancy Fouts

Creative Director
David Droga

Advertising Agency
Saatchi & Saatchi

Account Handler
Louise Bohmann

Marketing Executives
Samantha Roddick
Adae-Elena Amats

Client
Coco de Mer

Photography and Image Manipulation for Advertising, Campaigns

Photographer
Nick Knight

Image Manipulation
Metro Imaging
Alan Finnamore

Art Director
Tom Hingston

Client
Christian Dior Couture

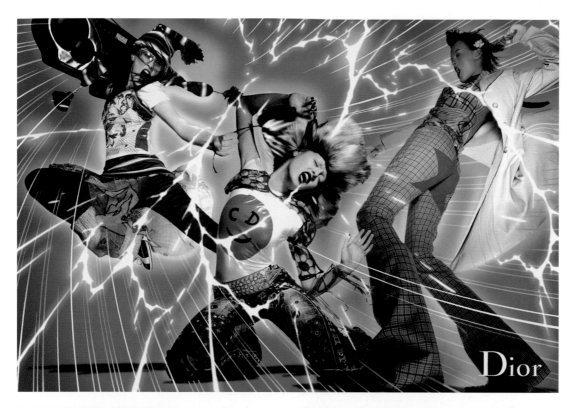

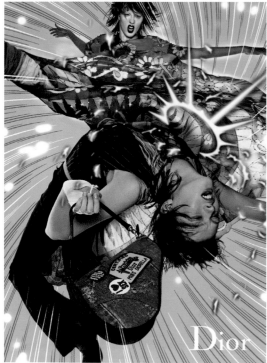

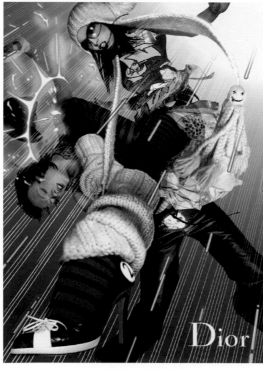

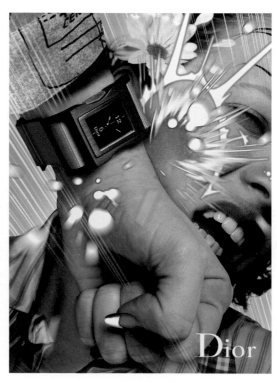

Photography and Image Manipulation for Design

Photographer
Nadav Kander

Stylist
Adam Howe

Image Manipulation
Anthony Crossfield

Client
Black Book Magazine

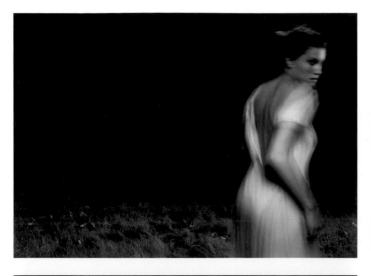
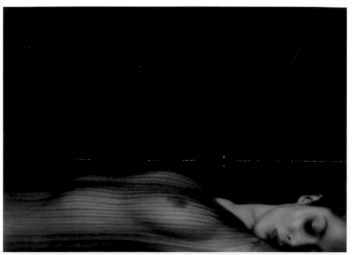

Photography and Image Manipulation for Advertising, Campaigns

Photographer
Richard Burbridge

Art Director
Tiger Savage

Copywriter
Mark Goodwin

Typographers
Simon Warden
Dan Smith

Creative Directors
Tiger Savage
Mark Goodwin

Advertising Agency
M&C Saatchi

Account Handler
Richard Alford

Marketing Executive
Andrew Wiles

Client
Thomas Pink

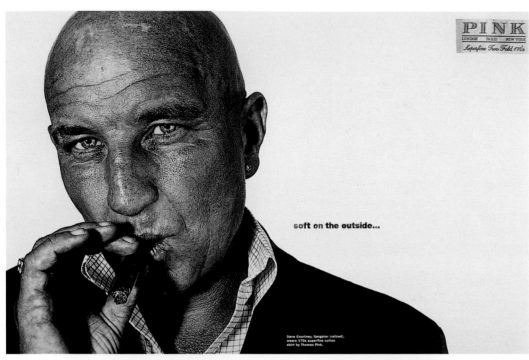

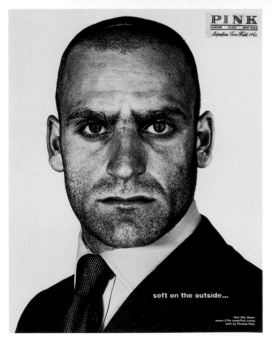

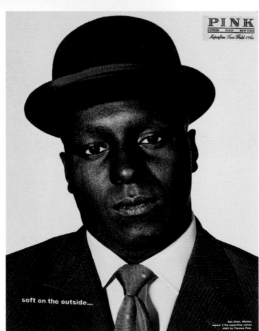

Photography and Image Manipulation for Design

Photographer
Nick Knight

Design Group
Rose Design

Print Manager
Paul Burnett

Design Director
Jane Ryan

Client
Royal Mail

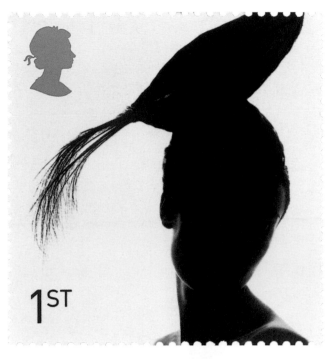
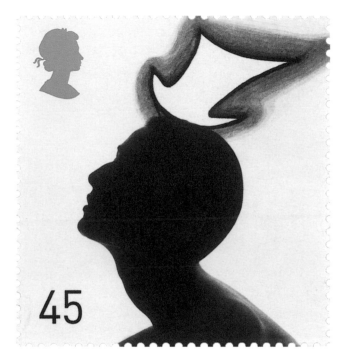

Photography and Image Manipulation for Design

Photographer
Nadav Kander

Design Director
Michael Mack

Designers
Nadav Kander
Michael Mack
Jean-Michel Dentand

Copywriter
Michael Mack

Typographer
Jean-Michel Dentand

Design Consultant
Angus Hyland

Editor
Michael Mack

Editorial Assistant
Catherine Lutman

Marketing Executive
James Crump

Client
Arena Editions

Photography and Image Manipulation for Design

Photographer
David Stewart

Art Directors
Wesley West
Tony Veazey

Design Director
Mike Turner

Typographer
Scott Miller

Design Group
Browns

Account Handler
Carrie Jewitt

Marketing Executive
Helen Edwards

Client
David Stewart

**Photography and
Image Manipulation
for Design**

Photographer
Jocelyn Bain Hogg

Design Director
Gerard Saint

Designers
Gerard Saint
Mark Watkins

Typographer
Gerard Saint

Design Group
Big Active

Clients
Westzone Publishing
Jocelyn Bain Hogg

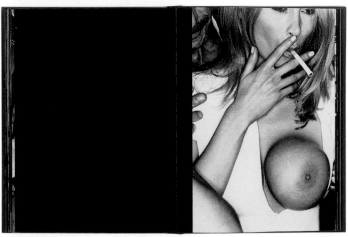

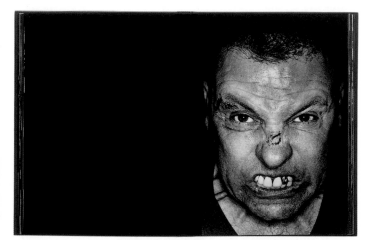

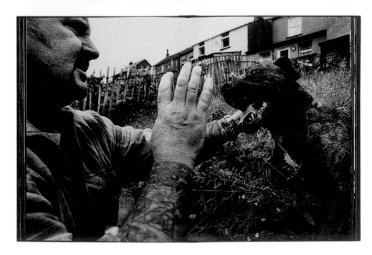

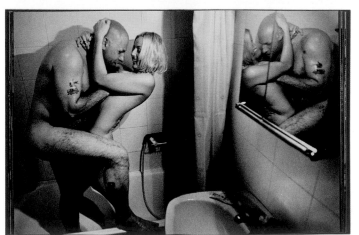

ILLUSTRATION

TOP ROW; *Left to Right:*
MARKUS BJURMAN, MOTHER • JASON FORD, HEART
BOTTOM ROW; *Left to Right:*
JEFF FISHER • LEANNE SHAPTON • ANDY AMADEO, MUSTOE MERRIMAN LEVY

ILLUSTRATION

Left to Right:
BEN STOTT, NB: STUDIO • MARION DEUCHARS

Comment by Marion Deuchars

We found it easy to weed out the strong work from the weak, but then found ourselves unable to get really excited by much of what remained before us. Much of the work entered, especially within advertising, tended to use illustration in a quirky/retro manner. Despite a veneer of PhotoShop, it looked old fashioned and predictable at times. The principal trend in novelty was in the use of new technology, meanwhile a whole generation of young illustrators went unrepresented in the category. We'd like to see better art direction, more contemporary illustration and more risk-taking in future. We were fairly unanimous selecting work to go into the book, which had to be skilled, original and innovative – a good idea communicated well and a good solution to the brief. We found ourselves arguing over Silver Nominations, but we agreed on Trickett and Webb's calendar because of the exceptional skill and craft of its illustrations and the overall impact of the product. Illustration often fails when the original concept, the design and the application don't fit well together. But in the nominated designs, the marriage between all three worked.

ILLUSTRATION SPONSORED BY ADOBE

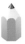

Silver Award
for the most
outstanding
Illustration for
Advertising
sponsored by
Adobe

Illustrator
Faiyaz Jafri

Art Director
Jeremy Carr

Copywriter
Jeremy Carr

Typographers
Brian McHale
Robin Warrington

Creative Director
Peter Souter

Advertising Agency
Abbott Mead
Vickers.BBDO

Account Handler
Caspar Thykier

Marketing Executive
Mark Sandys

Client
Guinness GB

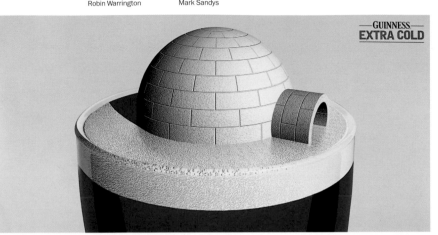

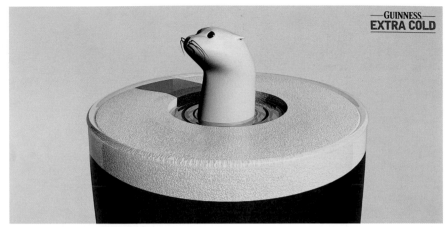

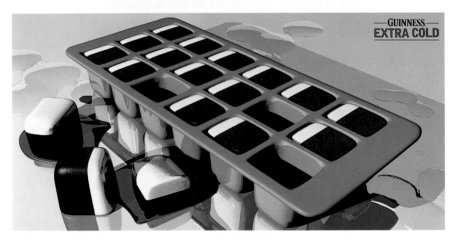

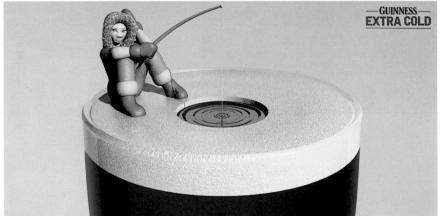

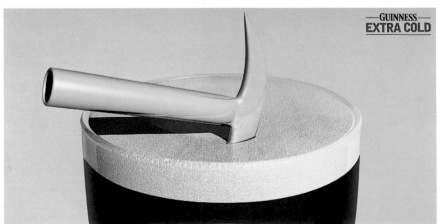

Silver Nomination for the most outstanding Illustration for Advertising sponsored by Adobe

Illustrator
Andrzej Klimowski

Art Director
Michael Durban

Copywriter
Tony Strong

Typographer
Dave Wakefield

Creative Director
Peter Souter

Advertising Agency
Abbott Mead
Vickers.BBDO

Account Handler
Kathy Reeves

Marketing Executive
Charlotte Morrissey

Client
RSPCA

Four bored teenagers played piggy in the middle. With a pig.

They let the piglet out of its pen and chased it round the field, assaulting it with a metal bar, wooden stake and rocks. Eventually one of them killed it by dropping a rock on its head.

We investigate 126,000 cases like this every year. These teenagers were prosecuted, but we've also commissioned research to help understand the wider causes of cruelty and prevent it. ˙

To report suspected cruelty, call 0870 555 5999.

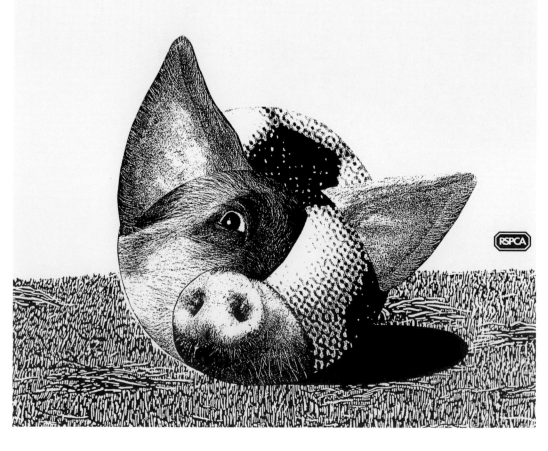

Instead of taking Misty to a vet, her owner took her to a dump.

For seventeen years Misty was her owner's companion. But when she developed skin ulcers he did nothing.

The ulcers became open wounds. The open wounds became infested with maggots.

At last he acted. Convinced she would die anyway, he took her to a dump and abandoned her.

The RSPCA investigate 126,000 cases like this every year. In Misty's case, her owner was convicted. But we've also commissioned research to help understand and prevent the wider causes of cruelty. ˙

To report suspected cruelty, call 0870 555 5999.

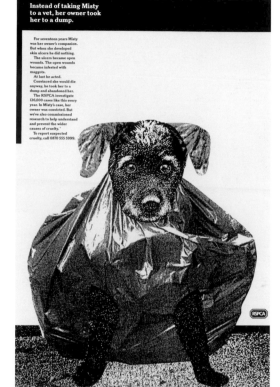

Most dog owners throw sticks. This man threw the dog.

Obi was thrown off a 70ft bridge. Amazingly, he landed in mud and survived. So the young man who'd done it was able to do it all over again.

Obi was eventually rescued. He had a fractured skull and neurological damage, but he made a good recovery. The young man was prosecuted.

As well as investigating 126,000 cases of cruelty every year, the RSPCA has commissioned research to help understand and prevent it. ˙

To report suspected cruelty, call 0870 555 5999.

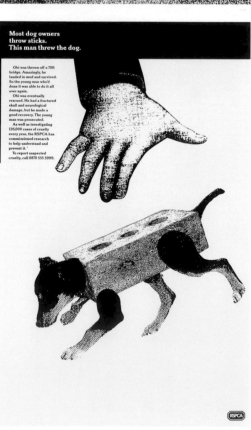

Silver Nomination
for the most
outstanding
Illustration for Design
sponsored by
Adobe

Illustrator
Hannah Bryan

Design Directors
Paul Neale
David McKendrick

Photographer
Hannah Bryan

Design Group
Graphic Thought
Facility

Client
Scarlet Projects

Silver Nomination
for the most
outstanding
Illustration for Design
sponsored by
Adobe

Illustrators
Peter Blake
Marion Deuchars
Andrazej Klimowski
Sara Fanelli
Aude van Ryn
Dan Fern
Ian Beck
Jeff Fisher
Paul Davis
George Hardie

Lawrence Zeegan
Toby Morison
Yvonne Kuschel
Lynn Trickett
Brian Webb

Designers
Lynn Trickett
Brian Webb
Katja Thielen

Copywriter
Michael Benson

Typographers
Lynn Trickett
Brian Webb
Katja Thielen

Design Group
Trickett & Webb

Clients
Augustus Martin
Trickett & Webb

Silver Nomination
for the most
outstanding
Illustration for Design
sponsored by
Adobe

Illustrator
Brian Cronin

Design Director
Tom Brown

Designer
Tom Brown

Prepress
Supreme Graphics

Printer
Benwell Atkins

Design Group
Tom Brown
Art & Design

Client
Brian Cronin

Illustration for Advertising, Individual

Illustrator
Kim Hiorthoy

Art Director
Emer Stamp

Copywriter
Ben Tollett

Typographer
Kim Hiorthoy

Creative Directors
Rob Burleigh
Dave Beverley

Advertising Agency
Leagas Delaney

Board Account Director
Adam Collins

Advertising Manager
Arthur Hoeld

Client
Adidas

Illustration for Advertising, Individual

Illustrator
David Russell

Art Director
Marc Bennett

Copywriter
Simon Bere

Typographer
Nils Leonard

Creative Directors
Phil Cockrell
Graham Storey

Advertising Agency
Rainey Kelly Campbell
Roalfe/Y&R

Account Handler
Tony Harris

Marketing Executive
Henry Bojdys

Client
COI/Directorate of
Naval Recruiting

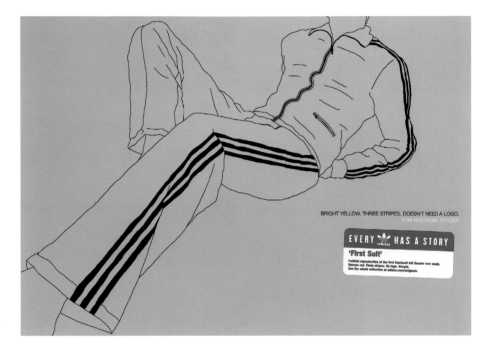

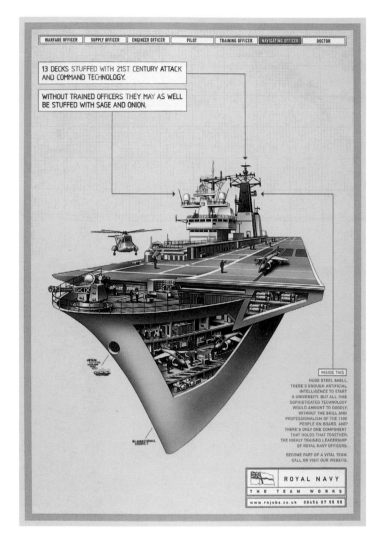

**Illustration for
Advertising, Individual**

Illustrators
Christina Yu
Christian Borstlap

Art Director
Christina Yu

Copywriter
Christina Yu

Typographer
Brad Kumaraswamy

Creative Directors
Zak Mroueh
Paul Lavoie

Advertising Agency
Taxi

Account Handler
Amanda Gaspard

Marketing Executive
Nicole Jolly

Client
Milestone

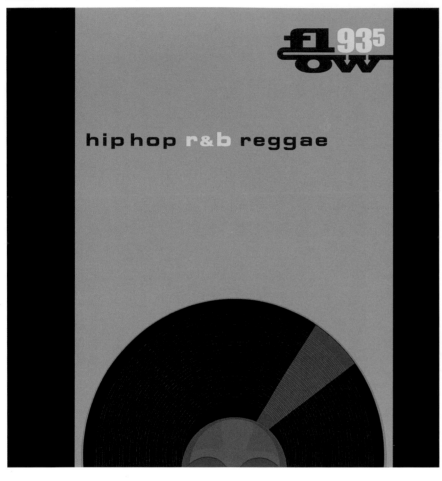

**Illustration for
Advertising, Individual**

Illustrator
Dave McKean

Art Director
Yu Kung

Copywriter
Andy Brittain

Typographer
Doug Foreman

Creative Director
Leon Jaume

Advertising Agency
WCRS

Account Handler
Giles Davis

Marketing Executive
Emma Scammell

Client
BMW (GB)

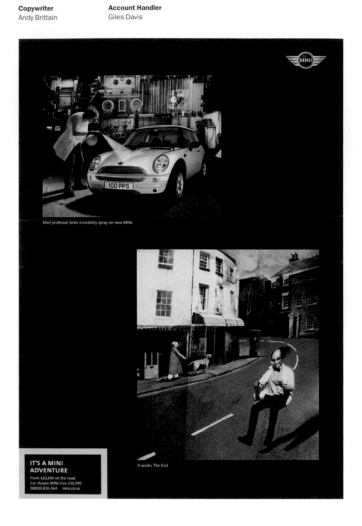

Illustration for Advertising, Individual

Illustrator
eboy

Art Director
Emer Stamp

Copywriter
Ben Tollett

Typographer
eboy

Creative Directors
Rob Burleigh
Dave Beverley

Advertising Agency
Leagas Delaney

Board Account Director
Adam Collins

Advertising Manager
Arthur Hoeld

Client
Adidas

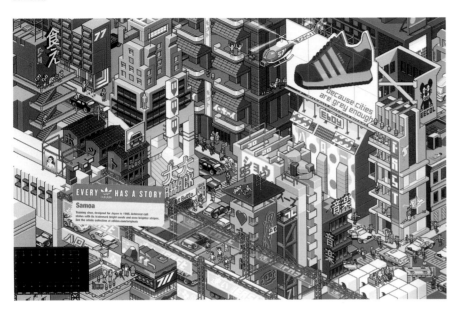

Illustration for Advertising, Individual

Illustrator
U Z Daniel

Art Director
U Z Daniel

Copywriter
Suchitra Gahlot

Creative Director
Syeda Imam

Advertising Agency
Contract Advertising (India)

Account Handler
Anil Kumar

Marketing Executive
Juhi Sahai

Client
The Modicare RBGM Foundation

**Illustration for
Advertising, Individual**

Illustrator
Andy Smith

Art Director
Chris Groom

Copywriter
Matt Follows

Typographer
Richard Hooker

Creative Directors
Tony Davidson
Kim Papworth

Advertising Agency
Wieden + Kennedy UK

Account Handler
Edward Donald

Marketing Executive
Jack Gold

Client
Nike

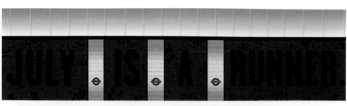

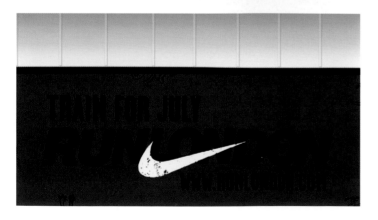

**Illustration for
Advertising,
Campaigns**

Illustrator
Steven Appleby

Art Director
Molly Godet

Copywriter
Jim Saunders

Typographer
Paul Beer

Creative Director
Gerry Moira

Advertising Agency
Publicis

Account Handler
Fiona Hughes

Marketing Executive
Ken Wood

Client
Müller Dairy (UK)

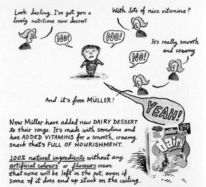

Illustration for Advertising, Campaigns

Illustrator
Mark Thomas

Art Director
Johnny Leathers

Copywriter
George Prest

Creative Director
Rosie Arnold

Advertising Agency
Bartle Bogle Hegarty

Account Handler
Catherine Dickinson

Marketing Executive
Patrick Cairns

Client
Lever Fabergé

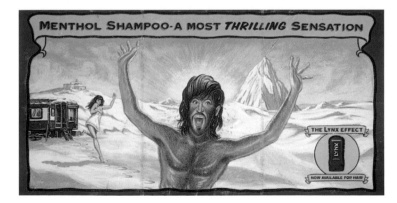

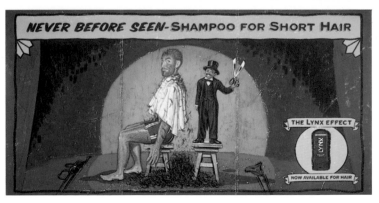

Illustration for Advertising, Campaigns

Illustrator
Dave McKean

Art Director
Christian Cotterill

Copywriter
Justin Hooper

Photographer
Dave McKean

Typographers
Christian Cotterill
Steve Darson

Creative Director
Nick Hastings

Advertising Agency
D'Arcy

Account Handler
Anthea Willey

Marketing Executive
Fiona Samson

Client
COI/Department of Health

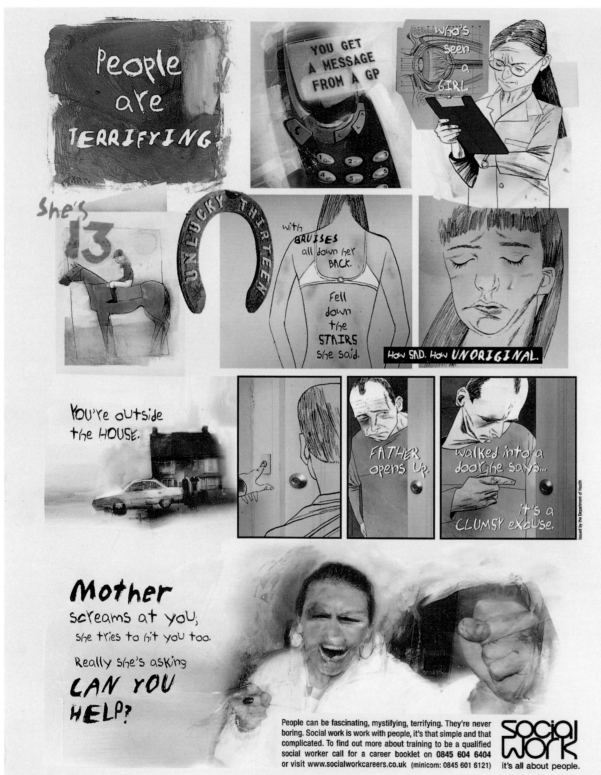

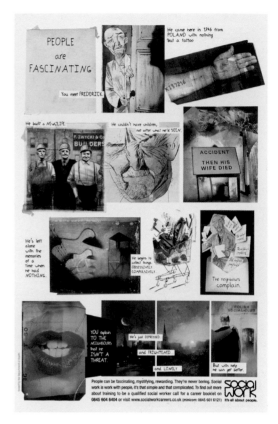

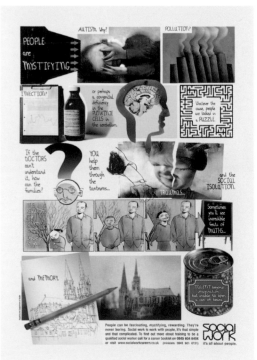

Illustration for Advertising, Campaigns

Illustrator
Peter Grundy

Art Director
CAm Blackley

Copywriter
Ben Kay

Typographer
Dave Wakefield

Producer
Amanda Goonetilleke

Creative Directors
Dave Dye
Peter Souter

Advertising Agency
Abbott Mead
Vickers.BBDO

Design Group
Grundy & Northedge

Account Handler
Ben Slater

Account Handler
Richard Larcombe

Marketing Executive
Lidia Mackow-McGuire

Client
BT Internet Anytime

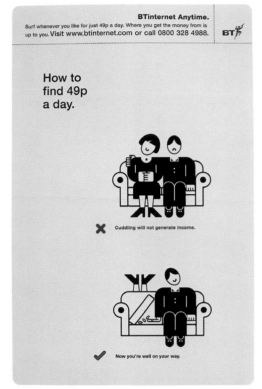

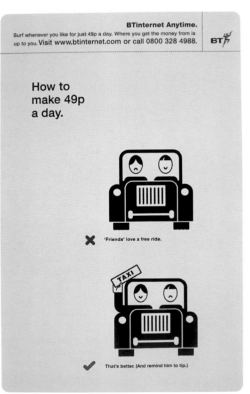

**Illustration for
Advertising,
Campaigns**

Illustrator
Andy Smith

Art Director
Matt Allen

Copywriter
Liam Butler

Typographers
Andy Smith
Jonny Voss
Matt Allen

Creative Director
Vince Squibb

Advertising Agency
Lowe

Account Handler
Sarah Gold

Marketing Executive
Ken Pritchard

Client
Orange

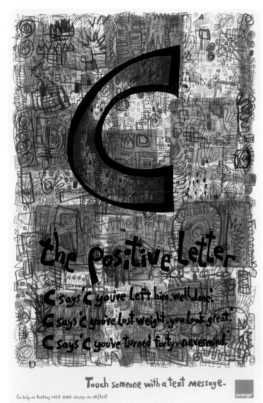

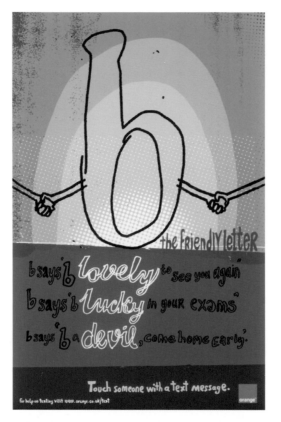

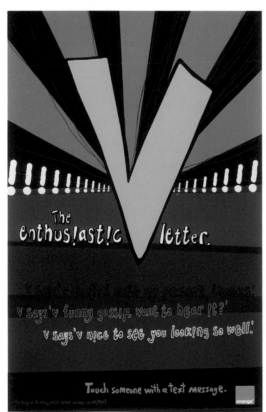

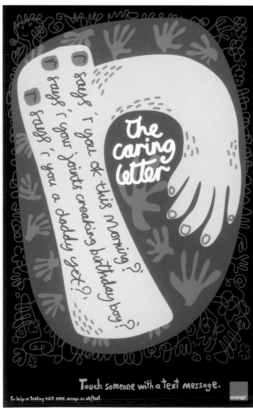

Illustration for Design, Individual

Illustrator
Benoît Jacques

Design Partner
David Stuart

Designer
Rob Howsam

Typographer
Benoît Jacques

Design Group
The Partners

Client
NABS

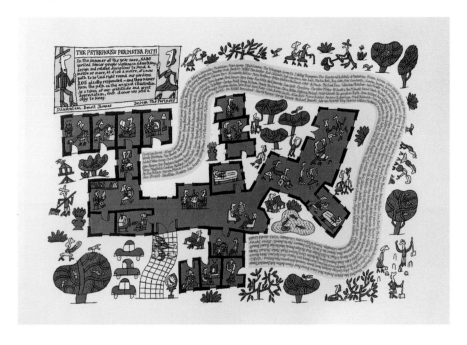

Illustration for Design, Individual

Illustrator
Aude van Ryn

Design Director
Leanne Shapton

Client
Canadian Post
(Toronto)

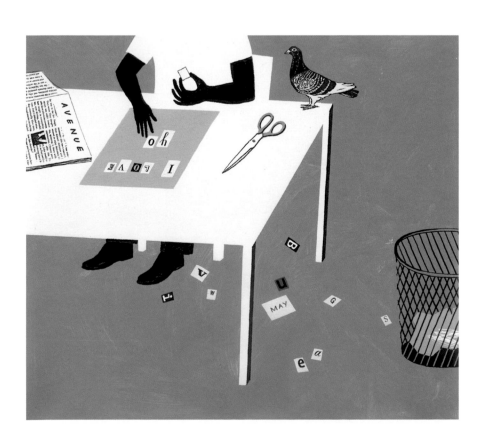

**Illustration for Design,
Series or Sequence**

Design Director
Barry Robinson

Designer
Michael English

**Design Manager /
Research**
Sarah Jones

Print Manager
Paul Burnett

Client
Royal Mail

**Illustration for Design,
Series or Sequence**

Illustrator
Tony Meeuwissen

Design Director
Jane Ryan

Designer
Howard Brown

Print Manager
Paul Burnett

Client
Royal Mail

**Illustration for Design,
Series or Sequence**

Illustrator
Andrzej Klimowski

Typographer
Peter B Willberg

Client
Everyman Library

P.G. WODEHOUSE

JEEVES AND THE FEUDAL SPIRIT

P.G. WODEHOUSE

HEAVY WEATHER

P.G. WODEHOUSE

SUMMER LIGHTNING

P.G. WODEHOUSE

THE MATING SEASON

P.G. WODEHOUSE

LAUGHING GAS

Illustration for Design, Series or Sequence

Client
Financial Times

Illustrator
Annabel Wright

Design Director
Gary Cook

Designer
Gary Cook

Illustration for Design, Series or Sequence

Illustrators
Anthony Burrill
Paul Davis
Marion Deuchars
Miles Donovan
Kate Gibb
Michael Gillette
Jasper Goodall
Nick Higgins
Chris Kasch
Tim O'Riley
Tommy Penton
Shonagh Rae
Graham Rounthwaite
Shiv
Kam Tang
Lucy Vigrass
Spencer Wilson

Design Director
Angus Hyland

Designer
Charlie Smith

Design Group
Pentagram Design

Client
The British Council

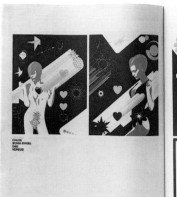
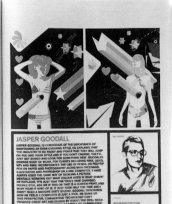

**Illustration for Design,
Series or Sequence**

Illustrators
Paul McNeil
Anthony Burrill
Kjeks
John Maeda
Jeff Fisher
Ian Wright
Alex Williamson

Tommy Penton
Shonagh Rae
Miles Donovan
Chris Kasch
Graham Rounthwaite
QuickHoney
Spencer Wilson
Green Lady
Lucy Vigrass
Paul Davis
Joe Magee

Dave Kinsey
Marion Deuchars
Ceri Amphlett
Roderick Mills
Eikes Grafischer Hort
Faiyaz Jafri
Akio Morishima
Warren Du Preez
Nick Thornton Jones
Reggie Pedro
Kate Gibb

Alan Baker
Nick Higgins
Shiv
René Habermacher
Jasper Goodall
Tim O'Reilley
Kristian Russell
Kim Hiorthøy
Timmy Kucynda
Kam Tang
Steff Plaetz

Evan Hecox
Ian Bilbey
Michael Gillette
Mike Mills

Design Group
Pentagram Design

Client
Laurence King
Publishing

Design Director
Angus Hyland

Designer
Charlie Smith

Design Group
Pentagram Design

Client
Laurence King
Publishing

**Illustration for Design,
Series or Sequence**

Designer
Agathe Jacquillat

Designer
Tomi Vollauschek

Design Group
FL@33

Client
FL@33

**Illustration for Design,
Series or Sequence**

Illustrator
Peter Grundy

Design Group
Grundy & Northedge

Marketing Executive
Paul Atkinson

Client
Atkinson Design
commissioning for
Healey Chemicals

city too

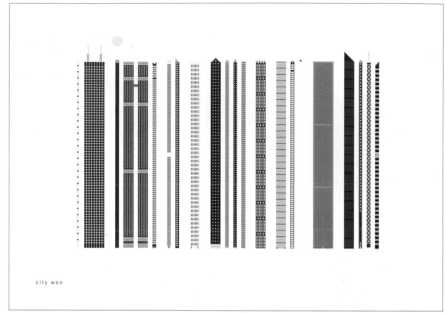

city won

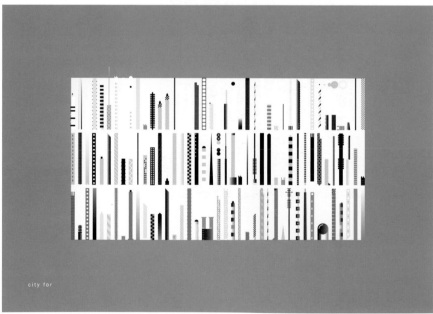

city for

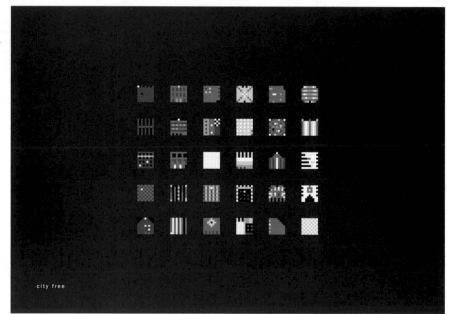

city free

Illustration for Design, Series or Sequence

Illustrator
Danijel Zezelj

Designer
Bertrand Fleuret

Copywriter
Luca Grelli

Creative Directors
Paul Shearer
Glenn Cole

Advertising Agency
Wieden + Kennedy
Amsterdam

Account Handlers
Alessandra Lovinella
Daphne Seror

Marketing Executive
Paolo Tubito

Client
Nike Italy

TYPOGRAPHY

Left to Right:
DAN BECKETT, ABACUS@TBWA • **ALAN DYE,** NB:STUDIO

TYPOGRAPHY

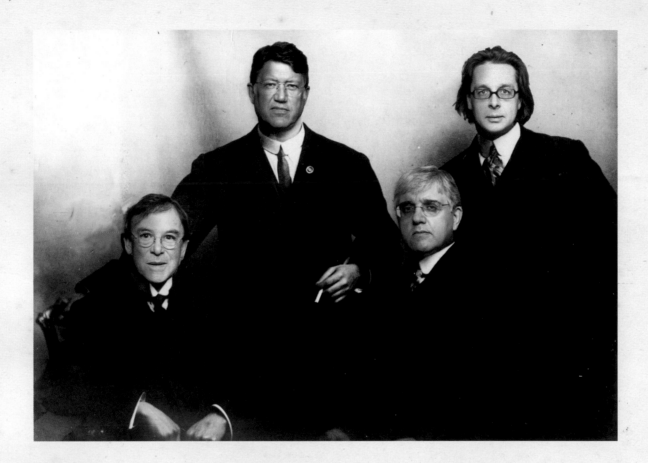

TOP ROW; *Left to Right:*
ROGER KENNEDY, SAATCHI & SAATCHI • MICHAEL JOHNSON, JOHNSON BANKS
BOTTOM ROW; *Left to Right:*
BRIAN WEBB, TRICKETT & WEBB • JOE HOZA, ABBOTT MEAD VICKERS.BBDO

Comment by Michael Johnson

Another year where the work that stood out continued to embrace vernacular, often quite brutal typeforms. Maybe we're all bored with perfect type now. It certainly seemed that way with the jury. We saw type integrated into light switches, type apparently placed massively out of register, type made out of gravy globules. There was a long discussion about some perfect type for an ad campaign which would have won easily years ago, but now seemed, well, just too perfect, too considered. One of our Nominations revealed how we all secretly want to paint type onto garage doors or carve huge letters out of polystyrene. The other was a powerful example of the typographic language of switches being adapted to communicate the plight of the MS sufferer. Both weird, but both great. If I had to isolate one trend I think it would be that almost all the work we responded to showed a complete disregard for the slick qualities of the computer. It seems that the craft of making type appear integrated, and legitimate, and often downright ugly is well and truly back in fashion.

TYPOGRAPHY SPONSORED BY ROTRING

Silver Award
for the most
outstanding
Typography for
Advertising
sponsored by
rotring

Typographer
Roger Kennedy

Art Director
Colin Jones

Copywriter
Michael Campbell

Photographer
Andrew Douglas

Retouching
Actis

Creative Director
David Droga

Advertising Agency
Saatchi & Saatchi

Account Handler
Olivia Blanc

Marketing Executive
Ken Walker

Client
Multiple Sclerosis
Society

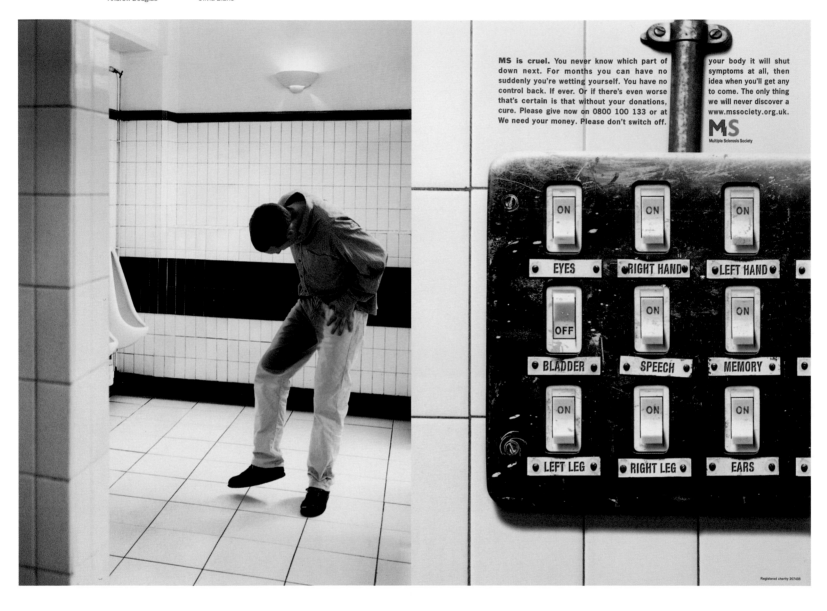

MS is cruel. You never know which part of down next. For months you can have no suddenly you're wetting yourself. You have no control back. If ever. Or if there's even worse that's certain is that without your donations, cure. Please give now on 0800 100 133 or at We need your money. Please don't switch off. your body it will shut symptoms at all, then idea when you'll get any to come. The only thing we will never discover a www.mssociety.org.uk.

MS
Multiple Sclerosis Society

Registered charity 207495

Silver Award
for the most
outstanding
Typography
for Design
sponsored by
rotring

Typographers
Julian Melhuish
Kevin Finn

Design Directors
Kevin Finn
Julian Melhuish

Designers
Kevin Finn
Julian Melhuish

Copywriters
Julian Melhuish
Kevin Finn

Creative Director
Malcolm Poynton

Photographer
Ingvar Kenne

Design Assistant
Jristian Cruz Limsico

Design Assistant
Kelly Boulton

Print Production
Joe Churchward
Kate Brookes

Account Handler
Joe Churchward

Retoucher
Kerry McElroy

Art Buyer
Darina Heckendorf

Design Group
Saatchi Design, Sydney

Marketing Executive
Brian Longmore

Client
Spicers Paper

the brief

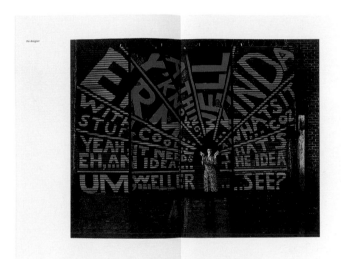

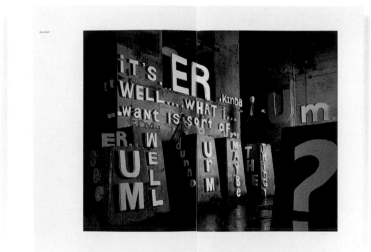

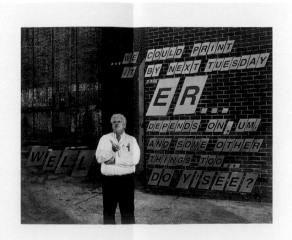

Typography for Advertising, Individual

Typographer
Mathew Cullen

Art Director
Mathew Cullen

Designer
Irene Park

Designer
Brad Watanbe

Designer
Shihlin Wu

Design Group
Motion Theory

Client
Sony

Typography for Advertising, Individual

Typographer
Dave Brady

Art Director
Stuart Button

Copywriter
Wesley Hawes

Creative Director
Gary Sharpen

Advertising Agency
Leonardo

Account Handlers
Sue Hendrikz
Lindsay Egmore-Frost

Marketing Executive
Glyn Williams

Client
VSO

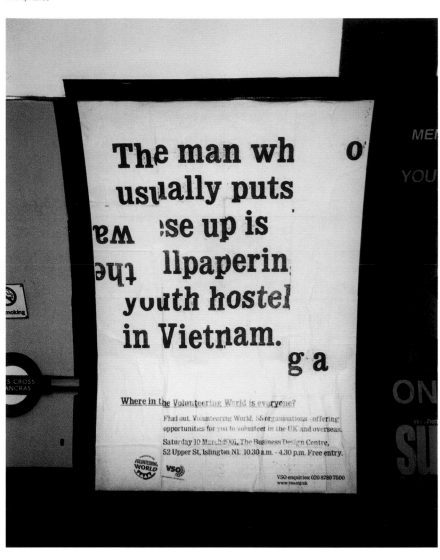

Typography for Advertising, Individual

Typographer
Kevin Clarke

Art Director
Feargal Ballance

Copywriter
Dylan Harrison

Creative Directors
Jeremy Craigen
Joanna Wenley

Advertising Agency
BMP DDB

Account Handler
Simon Lendrum

Marketing Executives
Marc Sands
Karen Byrne

Client
The Guardian

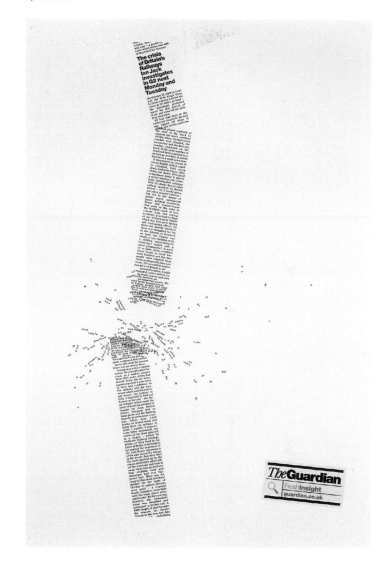

Typography for Advertising, Individual

Typographer
Dave Wakefield

Art Director
Vicki Maguire

Copywriter
Vicki Maguire

Illustrator
Paul Slater

Creative Director
Steve Dunn

Advertising Agency
Ogilvy & Mather

Account Handler
Sophie Harwood Smith

Marketing Executive
Gerald Noone

Client
Severn Trent Water

Typography for Advertising, Individual

Typographer
Roger Kennedy

Art Director
Colin Jones

Copywriter
Michael Campbell

Photographer
Andrew Douglas

Retouching
Actis

Creative Director
David Droga

Account Handler
Olivia Blanc

Marketing Executive
Ken Walker

Client
Multiple Sclerosis
Society

"Severn Trent's clean rivers have attracted hundreds of Kingfishers to the area," says Sally. "That'll please Dad," says Sam, "Mum says he likes common birds."

Severn Trent Water is jolly good for us all.

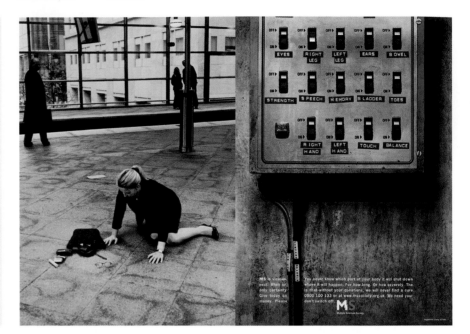

Typography for Advertising, Individual

Typographer
Scott Silvey

Art Director
Brian Connolly

Copywriter
Paul Domenet

Creative Director
David Droga

Advertising Agency
Saatchi & Saatchi

Account Handler
James Griffiths

Marketing Executives
Clare Burns
Andy Tidy

Client
Club 18-30

Typography for
Advertising,
Campaigns

Typographer
Roger Kennedy

Art Director
Colin Jones

Copywriter
Michael Campbell

Photographer
Andrew Douglas

Retouching
Actis

Creative Director
David Droga

Advertising Agency
Saatchi & Saatchi

Account Handler
Olivia Blanc

Marketing Executive
Ken Walker

Client
Multiple Sclerosis
Society

EYES EARS PENIS

ARMS LEGS MOUTH

MS tears you apart. You never know which part of your body it will shut down next. One moment you're fine, the next you're impotent. Or paralysed. Or blind. Or even all three. You don't know how long it will last for. Or how much worse it might get. The only certainty is that without your donations, we will never find a cure. Give now on 0800 100 133 or at www.mssociety.org.uk. We need your money. Please don't switch off.

MS
Multiple Sclerosis Society

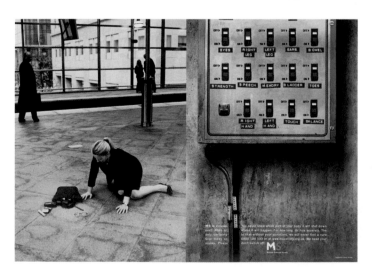

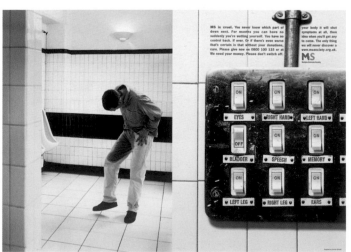

Typography for Advertising, Campaigns

Typographer
Alison Carmichael

Art Director
Steve Williams

Copywriter
Adrian Lim

Photographer
Jan Chlebik

Creative Director
Paul Weinberger

Advertising Agency
Lowe

Account Handler
Sarah Gold

Marketing Executive
Sara Cubitt

Client
Olympus Optical Co

Typography for Advertising, Campaigns

Typographers
Peter Cole
Alex Normanton

Art Director
Andrew Clarke

Copywriter
Ross Ludwig

Photographer
Dan Burn-Forti

Creative Director
David Droga

Advertising Agency
Saatchi & Saatchi

Account Handler
Jamie Copas

Marketing Executive
Gary Coombe

Client
Procter & Gamble

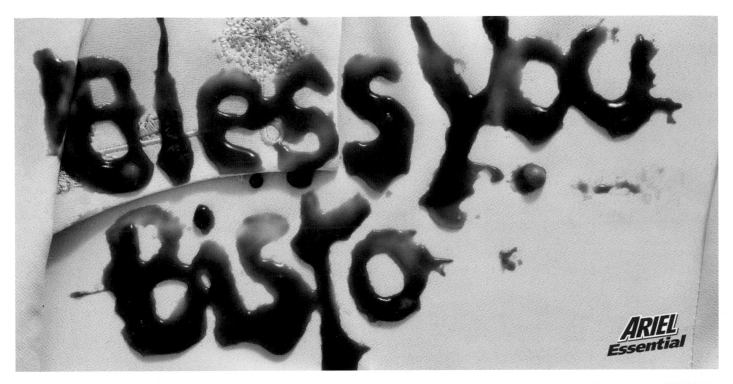

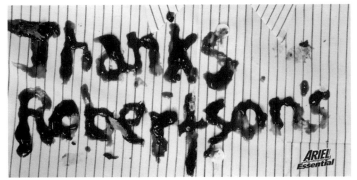

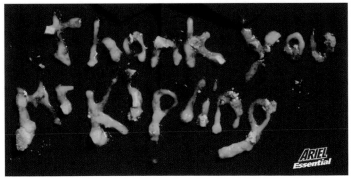

Typography for Advertising, Campaigns

Typographers
Clare Lim
Jess Wong
Chan King Soon

Art Director
Clare Lim

Copywriter
Raymond Ng

Creative Director
Edwin Leong

Advertising Agency
Grey Worldwide
(Malaysia)

Account Handlers
Izmee Ismail
Jennifer Kok
Loke Ai Ney

Marketing Executives
Hoo You Li
Sharon Ong
Alice Wee
Penny Chan

Client
Nike (Malaysia)

Typography for Design

Typographers
Scott Williams
Henrik Kubel

Design Directors
Scott Williams
Henrik Kubel

Designers
Scott Williams
Henrik Kubel

Copywriters
Scott Williams
Henrik Kubel

Illustrators
Scott Williams
Henrik Kubel

Design Group
A2-GRAPHICS/SW/HK

Marketing Executive
Nigel Robinson

Client
Buckinghamshire
Chilterns University
College

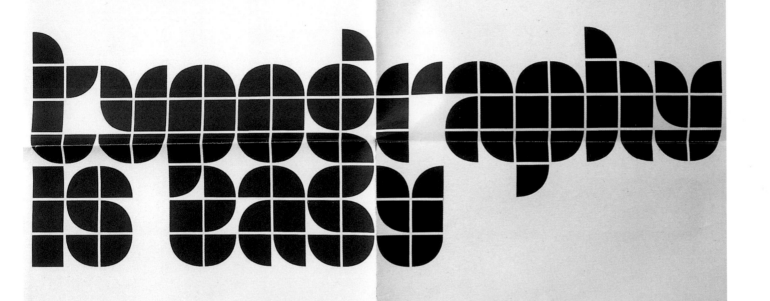

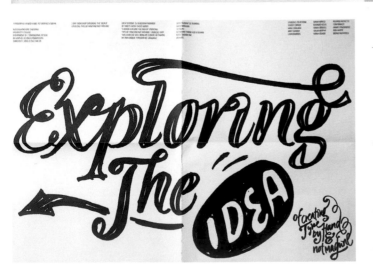

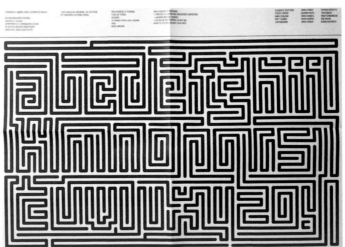

Typography for Design

Typographer
Domenic Lippa

Design Director
Domenic Lippa

Designer
Domenic Lippa

Copywriter
Domenic Lippa

Design Group
Lippa Pearce Design

Client
The Typographic Circle

Typography for Design

Typographers
Mark Bottomley
Adam Lee

Design Director
Mark Bottomley

Designers
Mark Bottomley
Adam Lee

Design Group
Origin

Client
National Centre for
Business and
Sustainability

Typography for Design

Typographer
Michael Johnson

Designer
Michael Johnson

Copywriter
Michael Johnson

Design Group
johnson banks

Client
johnson banks

CORPORATE & BRAND
IDENTITY

Left to Right:
Hazel MacMillan, Wolff Olins • John Bielenberg, C2

CORPORATE & BRAND
IDENTITY

Left to Right:
MICHAEL DENNY, ROUNDEL • **PETER KNAPP,** LANDOR ASSOCIATES • **JON TURNER,** ENTERPRISE IG • **PHILIP CARTER,** CARTER WONG TOMLIN

Comment by Michael Denny

This was not a vintage year. Original ideas were largely vested in the smaller projects. It seems that designers continue to get more freedom working on a more modest scale. Maybe the circumstances of 2001, with its uncertain economic climate following September 11th, dictated an unusually cautious approach. Whatever the explanation, the judges felt that the larger projects relied too much on graphic clichés. Because of the general lack of personality or soul within the work, the rare moments of genuine humour or character stood out.

CORPORATE & BRAND IDENTITY SPONSORED BY VENTURA

Silver Award
for the most
outstanding
Logotype
sponsored by
Ventura

Design Directors
John Messum
Paul Silburn
Simon Spilsbury

Typographer
Roger Kennedy

Design Group
Leith London

Account Handler
Jeremy Pyne

Client
Leith London

Launched just over a year ago, Leith London is the London office of the Edinburgh based Scottish agency, Leith. Our brief was to create an identity that would distinguish us from our sister company whilst retaining a similar tone of voice.

The solution was the integration of English and Scottish icons; Tartan from North of the border and the St. George's Cross from the South.

The combination creates a simple, visual expression of Leith London.

Silver Nomination
for the most
outstanding Logotype
sponsored by
Ventura

Design Director
Phil Carter

Designers
Phil Carter
Nicky Skinner
Marcus Taylor

Typographer
Marcus Taylor

Illustrator
James Judge

Design Group
Carter Wong Tomlin

Account Handler
Ruth Somerfield

Marketing Executive
Sunita Gloster

Client
Lowe & Partners
Worldwide

We were briefed to design an identity that would unite all 160 agencies in 80 countries under one mark, yet allow each to communicate individuality. The new identity has been designed to better communicate and thereby unite the agency around its core belief that 'creativity pays'. The solution was to create a master symbol for the central worldwide agency offices (London and New York), together with a supporting palette for the remaining agencies. This allows partner offices within the group the option to select their own logo colour, reflecting the richness of the group's diversity and the long-held belief that 'local strength leads to collective growth'. The logo itself takes the word 'Lowe', the new name for the agency formerly known as Lowe Lintas.

Silver Nomination
for the most
outstanding
Small Identity Scheme
sponsored by
Ventura

Design Directors
Jonas Hecsher
Jens Kajus
Ole Lund
Jan Nielsen
Nikolaj Knop

Design Groups
2GD/2GRAPHIC
DESIGN AS
Etypes

Client
Danish Designers

Design for designers may sound like an easy task. Or a great honour. Or a place where you can get in deep trouble.

Based on the slogan 'Design can change everything', Danish Designers want to emphasise their identity as a field that stimulates debate. 'A network that does not carve in stone the definition of design, but rather encourages questions about where the boundaries of design are drawn'.

To 2 GD, it was a matter of not getting in the way of the assignment. Every attempt at form would compromise the intention. Colour would drown out character. Instead of moving full force into the task and putting up barriers, we pulled away and created a shared space where the individual fills in the frameworks.

The point of departure is a place void of design: An opportunity waiting to be realised. But also an open question, asking how far can you go before you reach the point of banality.

The two rectangles are a timeless reminder that there is no single definition of (good) design. They are fields to be filled and the task of Danish Designers is the debate about what should go in them.

Like twins, they represent design and politics, designers and users, form and content. As inseparable and constant as comments on what part design plays in society and contemporary life, yet unpretentious and humorous in the admission that design is never an event in itself.

It seems anonymous, but used consistently (and preferably so that it replaces the letter 'd' in running text) it changes character with content and subject. The spark doesn't fly until you put your own values on display in the frame: A colour, a photograph, a black spot.

2GD has handed over the baton. It is up to the user to take it to the finish.

Silver Nomination
for the most
outstanding
Small Identity Scheme
sponsored by
Ventura

Design Directors
Scott Williams
Henrik Kubel

Designers
Scott Williams
Henrik Kubel

Typographers
Scott Williams
Henrik Kubel

Illustrators
Scott Williams
Henrik Kubel

Design Group
A2-GRAPHICS/SW/HK

Marketing Executive
Line Rix

Client
1508. DK A/S

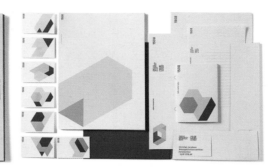

A2-GRAPHICS/SW/HK was commissioned to create the name and a dynamic visual language for a company whose service is to advise and implement strategic communication and design, predominately over the Internet.

The 1508 visual language is inspired by Buckminster Fuller's projection of the earth, a map created to achieve the most accurate visualisation of earth in two-dimensions.

Fuller's projection has been used as a template to create a new representation of the five continents, which allows them to be arranged in numerous ways, enabling one location to connect and unite with another – a reference to 1508's global practice. The aim was to produce a flexible identity that can be easily shifted and changed across all applications.

A principal typeface consisting of 3 weights, specially designed by A2-GRAPHICS/SW/HK, has been employed throughout the project.

The identity and colour scheme were developed in close collaboration with the client.

**Small Identity
Schemes**

Design Directors
Brian Eagle
Grenville Main
Scott Kennedy

Designer
Brian Eagle

Typographer
Brian Eagle

Illustrators
Scott Kennedy
Donna Cross
Brian Eagle

Design Groups
Unreal London
DNA Design

Account Handler
Brian Eagle

Client
Three Eyes Illustration

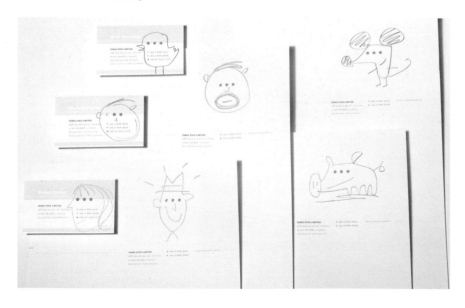

An identity for two illustrators, Scott and Donna, with three eyes between them (Donna has vision in one eye only.) Our challenge was to find a way for them to use one identity to clearly express their individual styles, lively personalities, humour and honesty.

The concept was to create an identity with three holes punched in it – a bare canvas onto which either illustrator could draw whatever they liked. A simple idea, but it makes each application different, spontaneous and surprising. Every time a card is handed out, the receiver gets much more than contact details. They are given nothing less than an original and individual gift of illustration, which can be tailored to the receivers business, creating a more personal connection.

Small Identity Schemes

Design Director
Louis Gagnon

Designers
Louis Gagnon
François Leclercr
Louise Marois
Isabelle D'Astous
Annabelle Racine

Photographers
Richard Bernardin
Michel Touchette

Design Group
Paprika
Communications

Account Handler
Joanne Lefebvre

Marketing Executive
Thien Ta Trung

Client
Periphere

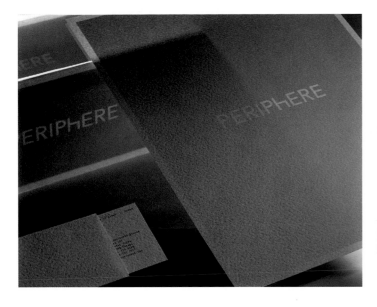

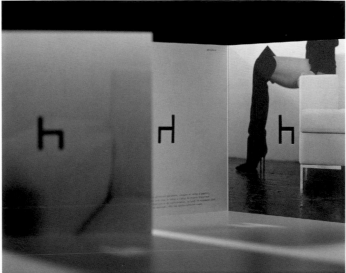

Between idea and reality, the forms, colours and communicative energy of a brand are woven together in a designer's quest for perfection. And sometimes the brand begins even before there is a final product in the showroom to put the brand on. Which is just what happened when Montreal's Paprika Communications created their own award-winning branding programme for the Periphere furniture collection. In a counter-intuitive creative leap, Paprika started out with the brand idea first and energised it emotionally to communicate the luxury and sensuality the Periphere line of sofas and tables represents... while the furniture itself was still in the prototype stage.

The result was a pure, minimalist yet contemporary style, bringing the brand to life at the rhythm of life itself. Paprika's visual materials were an intimate play of discretion and daring, for an aesthetically reserved yet emotionally charged art-of-living image. The very real expectations the brand identity created went a long way towards preparing critics and consumers alike for the Periphere collection's successful 2001 launch at the Musée d'art contemporain in Montreal.

Plato believed that ideas create realities. Paprika's approach to branding proves his philosophy. The sofa you think on, the table you dream at, are the here-and-now peripherals to a world of perfection that existed, at first – and not so very long ago – only in the mind.

Small Identity Schemes

Design Director
Garrick Hamm

Designers
Garrick Hamm
Gareth Beeson
Clare Poupard
Ruth Waddingham

Copywriters
Garrick Hamm
Richard Murray
Peter Hobden

Typographers
Gareth Beeson
Clare Poupard

Photographer
Andy Hall

Design Group
Williams Murray
Hamm

Account Handlers
Richard Murray
Kellie Chapple

Marketing Executives
Sophie Spence
Iain Newell

Client
Interbrew UK

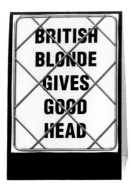

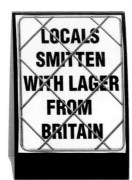

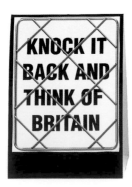

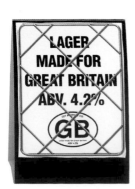

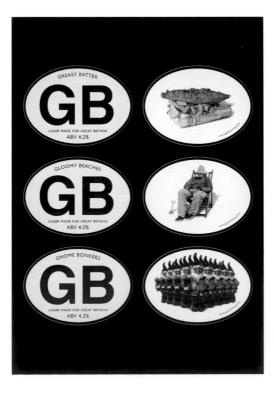

Williams Murray Hamm was commissioned by Interbrew to create a British Lager brand targeted at young consumers entering the market. 'Lager cadets' are typically young men, with a strong sense of national pride, who are out for a laugh with their mates.

The consultancy decided to base the brand around a truism: the sense of humour. The British love of irreverence and irony that clearly separates the UK from other famous lager-producing nations. It was felt to fit particularly well with a lager brand given that this humour really comes to the fore in pub life.

The identity is deliberately ironic in a world of highly-styled beer-pumps and sophisticated collateral material. The 'GB' branding is almost an 'anti-brand' statement. The tap is, quite literally, a fully working bathroom tap with a jubilee clip holding the branding. The beer mats feature quirky British things like garden gnomes and fish and chips. The tent cards are newspaper stands, and even the trade presenter is a pastiche of a tabloid newspaper.

Small Identity Schemes

Design Director
Steve Sandstrom

Designer
Steve Sandstrom

Photographer
Steve Sandstrom

Production Designer
Andrew Randall

Design Group
Sandstrom Design

Account Handler
Kirsten Cassidy

Marketing Executives
Edward Gustamante
David Cress

Client
Food Chain Films

As a television commercial production company, nearly all of the communications Food Chain Films does is with advertising agencies and their broadcast and creative staffs. Being fun and unusual adds to their recognition in a highly competitive field. Taking advantage of their name, the letterhead diagrams a "food chain" replacing the biology textbook examples with a typical commercial production process (featuring beef). Video tape (3/4" and 1/2") and DVD reels of Food Chain's directors are packaged in sleeves printed with images of cuts of beef and are then shrink-wrapped onto stock foam trays used by grocery store meat departments. Labels, inspired by grocery, carry information about what is on the tape and are applied to the outside of the plastic wrapping. Business cards for each employee have four different cuts of meat printed on the backs.

Medium Identity Schemes

Design Director
Michael Johnson

Designers
Michael Johnson
Luke Gifford
Sarah Fullerton

Typographers
Luke Gifford
Mike Pratley

Design Group
johnson banks

Marketing Executives
Sarah Gray
Gwyn Miles

Client
Victoria and Albert
Museum

Medium Identity Schemes

Design Director
Prof. Ivica Maksimovic

Designers
Rita Thinnes
Patrick Bittner

Copywriter
Germaine Paulus

Typographer
Rita Thinnes

Photographer
André Mailänder

Photographers
Rita Thinnes
Isabel Bach

Marketing Executive
Renate Dittgen

Client
Dittgen
Bauunternehmen

Our brief was to show that a construction company can perform sound and accurate work and at the same time display good taste.

A construction company with taste? Yes, why not?

It's called Dittgen, is headquartered in the peaceful little village of Schmelz and has a real talent for producing good roads, good sewer systems and good design.

That's how, amidst the aesthetic appeal of the road works, we made an unexpected appearance which gave the prejudiced average man on the street a slight cultural shock. After all, the modern building trade offers quite a bit more than just muscles, fresh air and unimaginative minds. A fact you just have to know. And something you're allowed to show.

Medium Identity Schemes

Design Director
John Bateson

Designers
Paul Ingle
Tanya Davies

Copywriter
Paul Ingle

Typographer
Paul Ingle

Photographer
Tim Flach

Design Group
Roundel

Account Handler
Esther Gibbons

Marketing Executive
Elisabeth Hindle

Client
Postwatch

Postwatch (The Consumer Council for Postal Services) is the newly created consumer watchdog for the deregulated postal service. It is funded by the Department of Trade and Industry to ensure the Royal Mail, Post Offices and Parcelforce provide the best possible service at the keenest prices to the consumer. Roundel were invited by Postwatch to develop a brand identity to include naming, promotional literature, advertising and web design.

The solution presents Postwatch as authoritative but approachable, trustworthy, independent and tough but fair, creating an appropriate tone of voice to talk to a varied audience. The identity visually interprets the brand descriptor, 'The watchdog for postal services' and is based on various amusing images of a dog.

The promotional material uses witty visual typography to convey the message to a wide public audience. Following a successful press launch Roundel, working to an agreed critical path, produced consumer literature and posters, regional promotional material, signing, collateral items and design guidelines.

Large Identity Schemes

Design Director
Harry Pearce

Designers
Jeremy Roots
Harry Pearce
Nicole Förster
Jenny Allen
Rachael Dinnis

Copywriters
Harry Pearce
Jeremy Roots

Typographers
Harry Pearce
Jeremy Roots

Photographer
Richard Foster

Design Group
Lippa Pearce Design

Marketing Executive
David Clayton-Smith

Client
Halfords

The brief was to design a complete corporate identity for the brand, covering all aspects. To modernise a tired and impractical set of basic elements and applications that were not reflecting the enormous advances Halfords had made over recent years. Halfords had become a company to embrace adventure and this had to be reflected in the new design.

The new logotype; colours were a complete departure from the original. The panel of the mark was retained but had a new, bold and energising colour – the expression of energy. The logo type conveyed the notion of an horizon (type on bottom edge) the 'O' tilted to suggest momentum forward. Subtext was also bolted onto the logo to indicate the new extended retail offers from the brand, and in a simple and emotive way, imagery became an important new tool in making Halfords new and extended retail services and offers known.

Large Identity Schemes

Design Director
Henri Ritzen

Designers
Henri Ritzen
Danny Kreeft

Photography
Marcel de Buck
Rafaël Philippen
Schütte Photography

Design Group
Studio Dumbar

Account Handler
Henri Ritzen

Client
Royal PTT Post
(Koninklijke PTT Post)

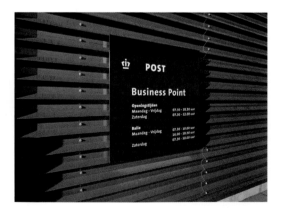

When PTT Post was designated as a 'royal' company by the Dutch government, Studio Dumbar was asked to design a new corporate visual identity with the objective of promoting this new status whilst communicating the traditional qualities associated with the company – reliable, accurate, innovative and dynamic.

Studio Dumbar developed a new visual identity for the Royal PTT Post that should be looked upon as 'visual behaviour'. All communication matters/means are being developed from one design concept.

The uniqueness of this project is that one visual language is used for the corporate identity (graphic design) as well as for the marketing communication (advertising, direct marketing). This way the client generates added value by connecting the two fields of corporate communication.

**Large Identity
Schemes**

Client
Banestyrelsen

Design Directors
Ole Lund
Jan Nielsen

Design Group
2GD/2GRAPHIC
DESIGN AS

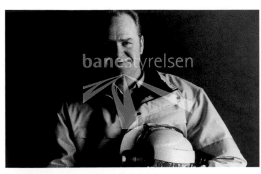
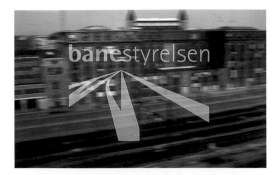

Corporate identity, which once was a matter of carving your name or trademark in people's consciousness, now operates with two strategies. One is about repetition. The other is about change.

The second is the most visible, for it has become a must in all the turbulence. We want everything new and the more we have the more we want. The signals have to be fresh, yet characteristic enough to be recognized. The brain has enough to do just discarding the irrelevant.

The Danish National Railways Agency's design must reflect the historical product, the permanent way. And yet it must also be part of the new network economy, communicate willingness to change and inspire talented people to come aboard and take the Agency into the future.

The new identity is foremost in the process, opening the way to the dialogue that is the prerequisite of understanding. Accordingly, it is not based on visual effects alone, but pulls communication in through colour and pictures that let go of the permanent way and bring humanity into focus.

A carefully defined set of graphical guidelines as a checklist for the quarterly revision follows, which keep the corporate identity on track. New initiatives are being considered; changes are being discussed and outmoded elements eliminated.

The Danish National Railways Agency has become a directional brand in a dynamic network whose cornerstones are commitment, knowledge and credibility.

**Symbols and
Logotypes**

Illustrator
Janet Kinghorn

Marketing Executive
Jerry Barnard

Design Director
Joanne Thomas

Design Group
The Jupiter Drawing
Room (South Africa)

Client
B&S Studios

Designer
Janet Kinghorn

Account Handler
Collette Cruywagen

Typographer
Janet Kinghorn

Symbols and Logotypes

Design Partner
Gillian Thomas

Design Director
Janet Neil

Designers
Jack Renwick
Dominic Wilcox

Design Group
The Partners

Project Manager
Rachel Butterworth

Chairman
Derek Seaward

Client
Association of Photographers

Symbols and Logotypes

Design Director
Phil Carter

Designers
Phil Carter
Neil Hedger

Typographers
Phil Carter
Neil Hedger

Illustrator
Neil Hedger

Design Group
Carter Wong Tomlin

Account Handler
Ruth Somerfield

Marketing Executives
Roger Mavity
Martin Nye

Client
Endeva

endeva

Symbols and Logotypes

Design Director
Phil Carter

Designers
Phil Carter
Nicola McClements
Nicky Skinner

Typographers
Phil Carter
Nicola McClements
Nicky Skinner

Illustrators
Colin Frewin
James Frewin

Production Manager
Sarah Turner

Design Group
Carter Wong Tomlin

Account Handler
Ruth Somerfield

Marketing Executive
Andrea Fiore

Client
Octagon Motorsports

Symbols and Logotypes

Designers
Sara Geroulis
Jonathan Warner
Jeff Goeke

Design Group
Turner Duckworth

Account Handler
Joanne Chan

Marketing Executive
Tom Pierson

Client
SETI Institute

Symbols and Logotypes

Designer
Gail Finlayson

Design Group
999 Design Group

Client
999 Design Group

BRANDS HATCH
SILVERSTONE
OULTON PARK
SNETTERTON
CADWELL PARK

SETI INSTITUTE

Symbols and Logotypes

Design Director
Jim Sutherland

Designer
Jim Sutherland

Typographer
Jim Sutherland

Design Group
hat-trick design

Marketing Executive
Clive Henn

Client
Strum

Symbols and Logotypes

Design Partner
Gillian Thomas

Design Director
Tracy Avison

Designers
Jack Renwick
Michael Paisley

Typographers
Jack Renwick
Michael Paisley

Illustrator
Robert Ball

Design Group
The Partners

Marketing Executives
Sally Urguhart
Fiona Halton

Client
Pilotlight

 city friends

Symbols and Logotypes

Design Director
Jonathan Ellery

Designer
Scott Miller

Typographer
Scott Miller

Design Group
Browns

Account Handler
Carrie Jewitt

Marketing Executive
Mark Kiddle

Client
National Interpreting Service

Nåtiønàl Intérprẽtinğ Sërviçê

Symbols and Logotypes

Design Directors
Ady Bibby
Craig Webster

Typographer
Bob Armstrong

Illustrator
Bob Armstrong

Design Group
True North

Account Handler
Martin Carr

Client
Glasscraft

PACKAGING

Left to Right:
Helen Stringer, Procter & Gamble • **Joanne Smith,** Lewis Moberly

PACKAGING

Top Row; *Left to Right:*
SIMON PORTEOUS, COLEY PORTER BELL • CLEM HALPIN, BRANDHOUSE WTS • STEVE GIBBONS, DEW GIBBONS
Bottom Row; *Left to Right:*
JONATHAN FORD, PEARLFISHER • GLENN TUTSSEL, TUTSSELS ENTERPRISE IG

Comment by Glenn Tutssel

Over three quarters of the 172 entries were voted out in the first round, failing the judges' criteria for a great idea, appropriate and well executed. A lot of them showed a severe lack of originality, creativity or craftsmanship. There was a plethora of entries in food and drink, but sadly little progress in structural innovation. In the fight for differentiation, shelf standout and brand impact have definitely left structural packaging behind. Typography and art direction lacked quality either due to quick turn-around prompted by tight budgets or sheer apathy. There is clearly a gulf between the creative consultancies and those who just churn it out without consideration for the message, the brand's value or its positioning. The Tŷ Nânt mineral water bottle stood out in the physical shape category for its clarity, freshness and ergonomic excellence. The other Nomination signalled the return of the big idea into branded packaging. They don't come much bigger than Heinz, and their range of tomato ketchup packs brought advertising and packaging together. With engaging copy-writing, this client reaches its audience with humorous – and brand-benefiting – messages, such as '14 billion French fries can't be wrong.'

Silver Award
for the most
outstanding
Brand Label Range
of Packaging

Design Directors
Mike Straznickas
Dave Reger

Designers
Mike Straznickas
Kevin Butler

Copywriters
Dave Reger
Jim Bosilijevac

Design Group
Leo Burnett (Chicago)

Account Handlers
Sara O'Mara
Lauren Haarlow

Marketing Executives
Brian Hansberry
Justin Lambeth

Client
H J Heinz Company

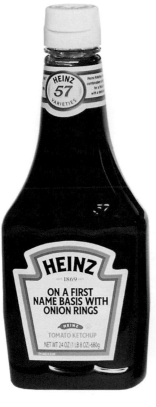
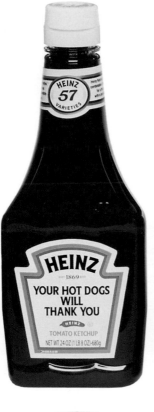
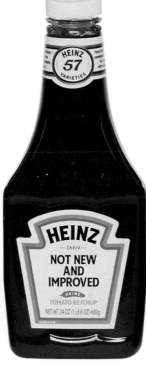
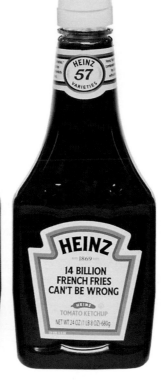
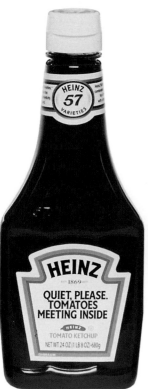
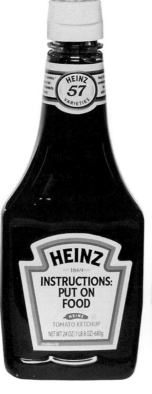
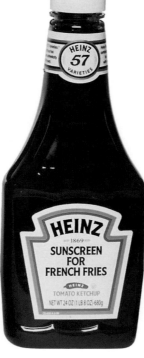
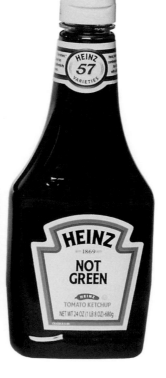

Silver Nomination
for the most
outstanding
Packaging
Physical Shape

Designer
Ross Lovegrove

Photographer
John Ross

Design Group
Lovegrove Studio

Client
Ty Nant

**Brand Label,
Individual Pack**

Design Director
Martin Grimer

Designer
David Jenkins

Typographer
David Jenkins

Design Group
Coley Porter Bell

Account Handlers
Alastair Jones
Maria Glynn

Marketing Executive
Gustavo Clauss

Client
Chivas Brothers

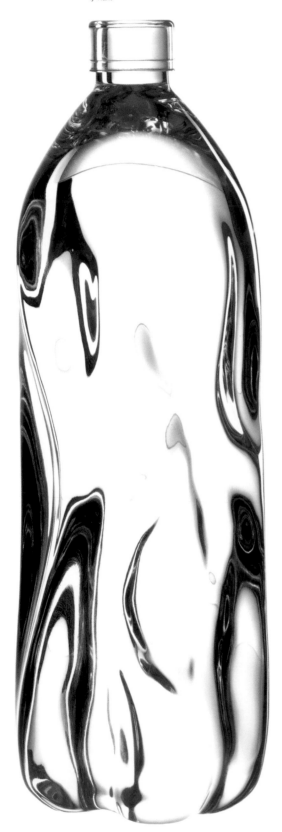

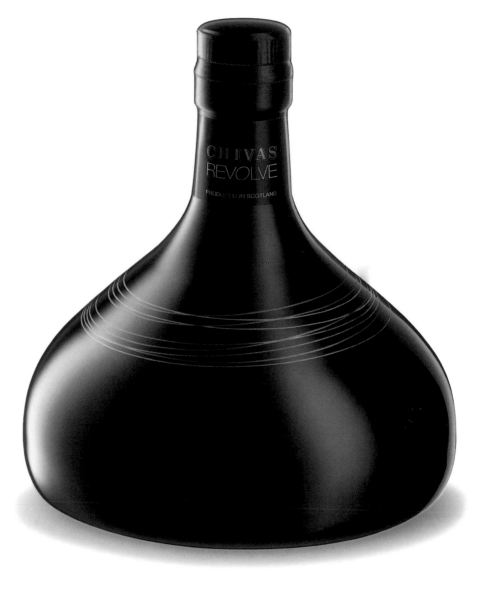

**Brand Label,
Individual Pack**

Design Directors
Mike Straznickas
Dave Reger

Designers
Mike Straznickas
Kevin Butler

Copywriters
Dave Reger
Jim Bosilijevac

Design Group
Leo Burnett (Chicago)

Account Handlers
Sara O'Mara
Lauren Haarlow

Marketing Executives
Brian Hansberry
Justin Lambeth

Client
H J Heinz Company

**Brand Label,
Individual Pack**

Design Director
Garrick Hamm

Designer
Stewart Devlin

Typographers
Bob Celiz
Stewart Devlin

Photographer
Jess Koppel

Design Group
Williams Murray Hamm

Account Handler
Kellie Chapple

Marketing Executive
Cathy Instone

Client
British Bakeries

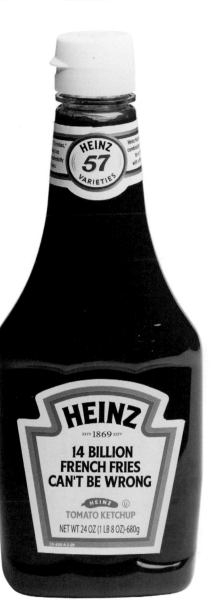

**Brand Label,
Individual Pack**

Design Director
Garrick Hamm

Designers
Ruth Waddingham
Clare Poupard

Copywriter
Peter Hobden

Typographer
Clare Poupard

Illustrator
Steve Pearce

Design Group
Williams Murray Hamm

Account Handler
Kellie Chapple

Marketing Executive
Tim Dowling

Client
Interbrew UK

**Brand Label,
Individual Pack**

Designers
Mark Farrow
Jonathon Jeffrey
Gary Stillwell
Nick Tweedie

Design Group
Farrow Design

Creative Director
Caroline Parent

Client
Levi Strauss UK

**Brand Label,
Individual Pack**

Creative Director
Graham Shearsby

Designer
Daniela Nunzi

Typographer
Daniela Nunzi

Illustrator
Chris Mitchell

Design Group
Design Bridge

Account Handler
Carsten Heldmann

Marketing Executive
Michael Wilkomm

Client
Peter Mertes

**Brand Label,
Individual Pack**

Design Director
Glenn Tutssel

Designers
Nick Hanson
Mark Paton

Typographers
Nick Hanson
Mark Paton

Illustration
W1 Arts

Design Group
Tutssels Enterprise IG

Account Handler
Paula Sheppard

Marketing Executive
Nicholas Morgan

Client
Guinness UDV

Own Brand,
Individual Pack

Design Group
Leo Burnett New Delhi

Design Director
Manas Nanda

Account Handler
Debarpita Banerjee

Designer
Deepak Dogra

Marketing Executive
Sanjay Sharma

Copywriter
Janmenjoy Mohanty

Client
Dabur India

Brand Label,
Range of Packaging

Photographer
Lesley Davies-Evans

Designers
Gordon Smith
Shuey Delaney

Design Group
Smith & Co

Marketing Executive
Rob Green

Copywriter
Paul Delaney

Client
Kenneth Turner London

**Brand Label,
Range of Packaging**

Design Director
Garrick Hamm

Designers
Garrick Hamm
Sarah Allen

Typographers
Garrick Hamm
Sarah Allen

Images
Natural History
Photographic Agency
Oxford Scientific Films
Dorling Kindersley
Getty Images

Design Group
Williams Murray Hamm

Account Handlers
Richard Murray
Rochelle Martyn

Marketing Executives
Mike Brehme
Lorraine Brehme

Client
Clipper Teas

**Brand Label,
Range of Packaging**

Creative Director
Steve Elliott

Designer
Ian Burren

Typographer
Ian Burren

Illustrator
Ian Burren

Design Group
Design Bridge

Account Handler
Robyn Stevenson

Marketing Executive
Jon Stang Volden

Client
Rieber & Son

**Brand Label,
Range of Packaging**

Creative Directors
Shaun Dew
Steve Gibbons

Designer
Suzanne Langley

Photographer
Joseph

Design Group
Dew Gibbons

Marketing Executive
Helen Stringer

Client
Procter & Gamble

**Brand Label,
Range of Packaging**

Design Director
Shaun Bowen

Creative Partner
Jonathan Ford

Designers
Sarah Butler
Lisa Simpson

Typographer
Sarah Butler

Design Group
Pearlfisher

Account Handler
Claire Franklin

Marketing Executive
Helena Bento

Client
Fima (Portugal)

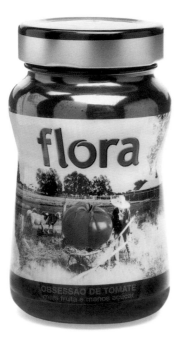
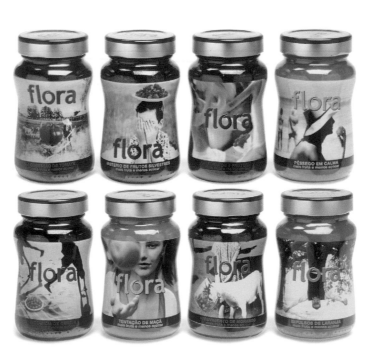

Brand Label,
Range of Packaging

Design Directors
David Beard
Mark Wickens

Designer
Melonie Maynard

Copywriters
Melonie Maynard
Friday O'Flaherty

Typographer
Melonie Maynard

Photographers
Matt Harris
Andy Grimshaw

Design Group
Brandhouse WTS

Account Handlers
Adrian Goldthorpe
Friday O'Flaherty

Marketing Executives
Chris Priest
David Brooks
Jan McGowan

Client
Kraft Foods

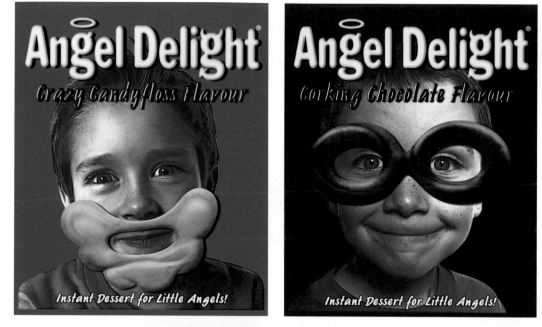
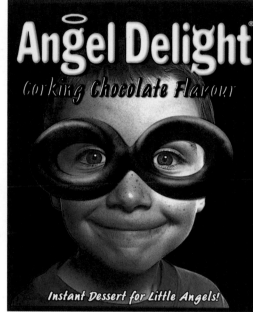

**Brand Label,
Range of Packaging**

Design Director
Glenn Tutssel

Designer
Polly French

Typographer
Polly French

Illustration
W1 Arts

Design Group
Tutssels Enterprise IG

Account Handlers
Beverly Law
Jim Burton

Marketing Executive
Paul Girling

Client
Setley Ridge Vineyard

**Brand Label,
Range of Packaging**

Design Director
Martin Grimer

Designers
Adam Ellis
Samantha Armes

Copywriters
Adam Ellis
Samantha Armes

Typographers
Adam Ellis
Samantha Armes

Illustrators
Adam Ellis
Samantha Armes

Design Group
Coley Porter Bell

Account Handlers
Rowan Harrison
David Lightman

Marketing Executive
Nina Leijerstam

Client
Cadbury Trebor Bassett

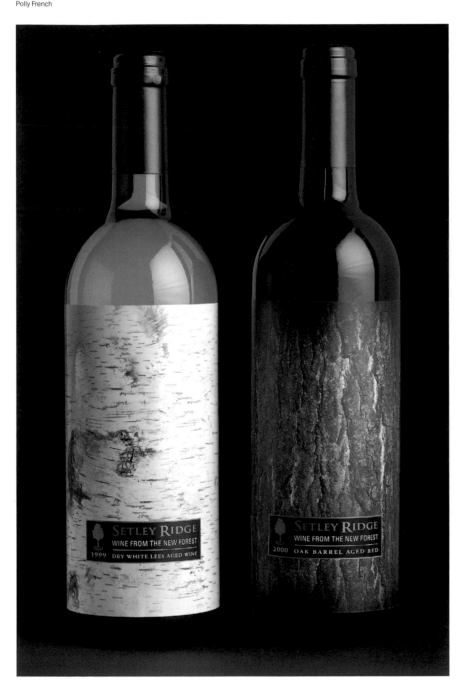

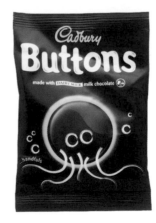
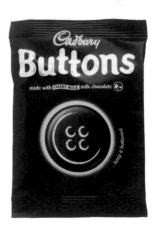

**Brand Label,
Range of Packaging**

Design Directors
Bruce Duckworth
David Turner

Designer
Mike Harris

Typographer
Mike Harris

Illustrator
Peter Ruane

Photographer
Sara Morris

Design Group
Turner Duckworth

Account Handler
Justine Stringer

Marketing Executive
Mary Powys-Lybbe

Client
Superdrug

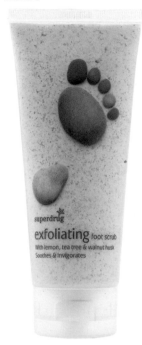
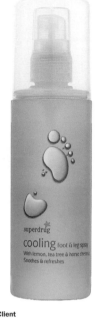

**Own Brand,
Range of Packaging**

Design Director
Trefor Thomas

Designer
Michelle Tranter

Copywriter
Rafiq Lehmann

Typographer
Michelle Tranter

Illustrator
David Day

Photographer
Alex Kai Keong

Design Group
Saatchi & Saatchi
(Singapore)

Account Handler
Eleanor Sia

Marketing Executive
Devin O Kimble

Marketing Executive
Billy Waters

Client
Brewerkz Restaurant &
Microbrewery

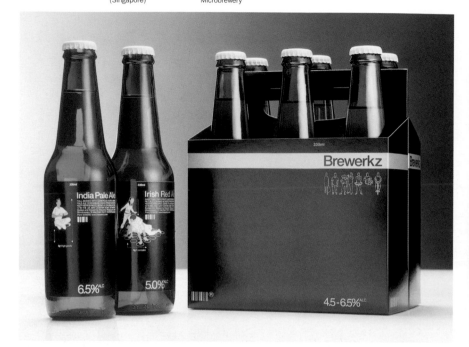

**Brand Label,
Range of Packaging**

Design Director
Mary Lewis

Designer
Mary Lewis

Illustrator
Mary Lewis

Copywriters
Isabel Figueiredo
Miguel Oliveira Pinto
Mary Lewis

Typographers
Mary Lewis
Ann Marshall

Design Group
Lewis Moberly

Account Handler
Lucy Rankin

Marketing Executive
Salvador Guedes

Client
Sogrape Vinhos de
Portugal

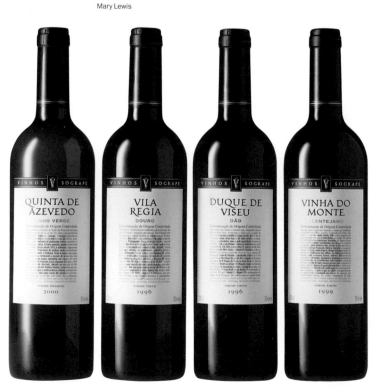

Own Brand,
Range of Packaging

Design Director
Joanne Thomas

Designers
Joanne Thomas
Graham Lang

Illustrator
Joanne Thomas

Design Group
The Jupiter Drawing
Room (South Africa)

Account Handler
Jacqui Howard-Tripp

Marketing Executive
Kathryn Sakalis

Client
Foschini

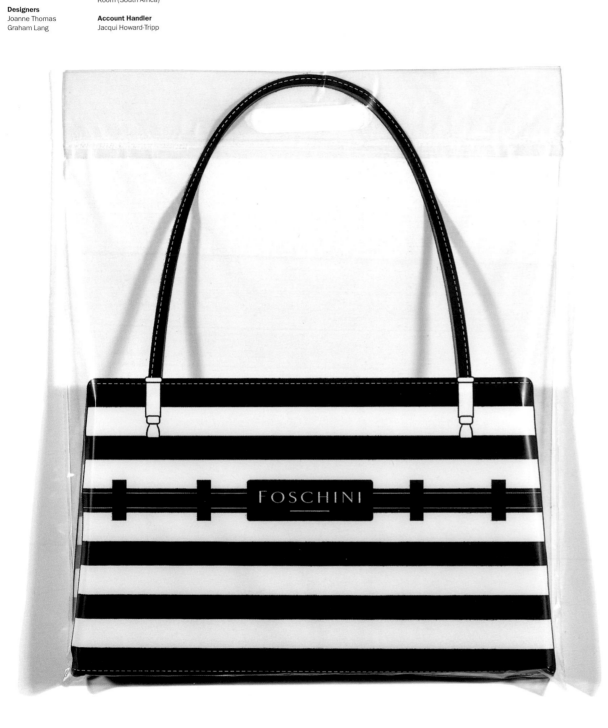

**Own Brand,
Range of Packaging**

Design Group
The Chase

Design Director
Richard Scholey

Marketing Executive
Philip Parker

Designers
Richard Scholey
Kevin Blackburn
Matt Brown
Simon Andrew

Client
Royal Mail

**Own Brand,
Range of Packaging**

Design Director
Glenn Tutssel

Designer
Mark Paton

Typographer
Mark Paton

Illustrator
Colin Shearing

Design Group
Tutssels Enterprise IG

Account Handler
Paula Sheppard

Marketing Executives
Maggie Hodgetts
Derek Strange

Client
Waitrose

**Own Brand,
Range of Packaging**

Design Director
Alison Tomlin

Designers
Alison Tomlin
Phil Carter

Typographer
Alison Tomlin

Photographer
Jonathan Knowles

Design Group
Carter Wong Tomlin

Account Handler
Ruth Somerfield

Marketing Executives
Greg Sehringer
Maggie Hodgetts

Client
Waitrose

GRAPHIC DESIGN

Top Row; *Left to Right:*
MARY LEWIS, LEWIS MOBERLY • **SUSANNA CUCCO**, CUCCO S.R.L • **GILLIAN THOMAS**, THE PARTNERS
Bottom Row; *Left to Right:*
HARRY PEARCE, LIPPA PEARCE DESIGN • **WIM CROUWEL** • **LUKE GIFFORD**, JOHNSON BANKS • **NOREEN MORIOKA**, ADAMSMORIOKA • **MARION ENGLISH**, SLAUGHTERHANSON

GRAPHIC DESIGN

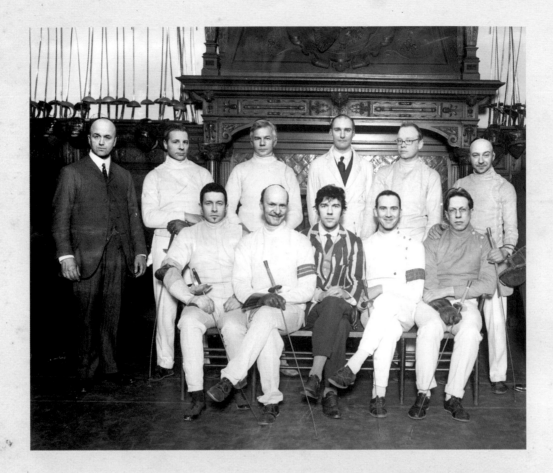

Comment by John Rushworth, Mary Lewis & Harry Pearce

Too much work impressed but did not inspire, and some strong ideas failed to follow through in execution. High points were few and usually occurred when an obvious cliché had been ignored or reinvested with a new interpretation. At the frivolous end of graphic design — letterheads, point-of-sale material, Christmas cards, wedding and birth announcements — the overall standard was average and we would caution designers to think more than twice before embarking on these projects. We applauded new emphasis on good copy (less type, more content) and the high standard of American and Dutch annual reports; UK counterparts are beginning to look formulaic. In music packaging, the Spiritualised CD cover was an elegant idea immaculately resolved and produced. Disappointingly though, the section seems to attract few entries. Other pieces setting the pace were the Francesco lo Savio Book for its rigorous restraint, Shot Up North for its relevant wit, and Identifying Courage for its powerful delivery. But our nominations went to the Fab brochure with its delightful, deadpan hero, and the pocket-sized Consolidated Paper promotion, with its wordy reflections. Both were immediately engaging, beautifully paced, highly considered and creatively driven. It was in fact 'the year of the little book' in which size became a defining idea. Another high point was the UNA year diary, rich in detail and hidden graphic stories. Elsewhere, the general lack of wit was countered by one more piece — 'the year of pain' calendar, with rings that bound the pages and body-pierced each monthly image.

Silver Award
for the most
outstanding Brochure
sponsored by
Premier Paper Group

Design Director
Michael Johnson

Designers
Harriet Devoy
Michael Johnson

Copywriters
Harriet Devoy
Michael Johnson

Typographer
Harriet Devoy

Photographer
Piers North

Modelling Consultant
Luke Gifford

Design Group
johnson banks

Marketing Consultant
J P K Hobson

Client
Smurfit Townsend Hook

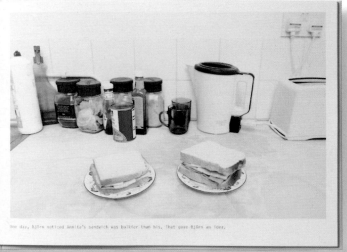

One day, Björn noticed Annita's sandwich was bulkier than his, that gave Björn an idea.

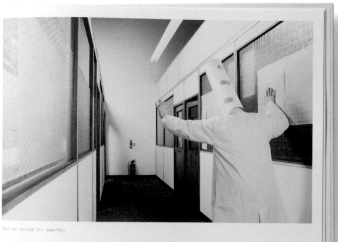

Then he tested its opacity.

Silver Award
for the most
outstanding
Music Packaging
sponsored by
Premier Paper Group

Designers
Mark Farrow
Gary Stillwell
Jonathon Jeffrey
Nick Tweedie
J Spaceman

Sculpture
Yoko by Don Brown
Courtesy of Sadie
Coles HQ London

Design Group
Farrow Design

Marketing Executives
Jo Power
Roma Martyniuk

Clients
Arista
Spaceman

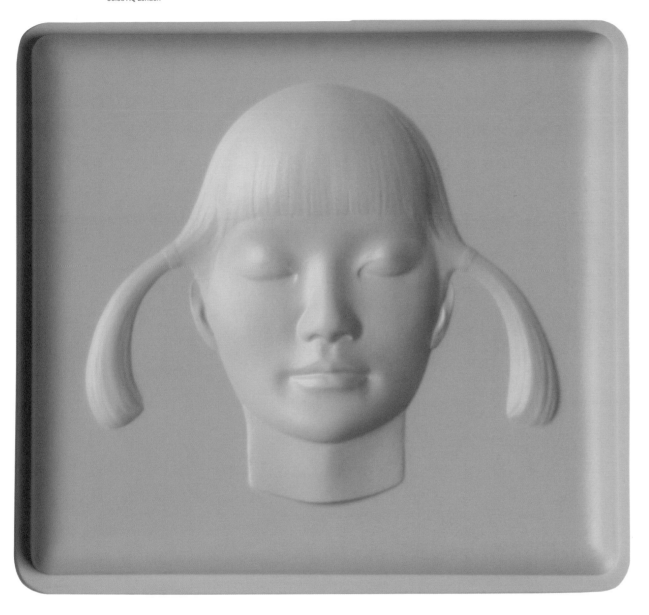

Silver Nomination
for the most
outstanding Brochure
sponsored by
Premier Paper Group

Design Director
Bill Cahan

Designers
Bob Dinetz
Mark Giglio
Kevin Roberson

Copywriters
Bob Dinetz
Mark Giglio
Kevin Roberson

Illustrators
Bob Dinetz
Kevin Roberson
Mark Giglio

Photographers
Bob Dinetz
Mark Giglio
Graham MacIndoe
Robert Schlatter
Lars Tunbjork
Ken Probst

Steve McCurry
Wade Goddard
Paul Chesley
Richard Nowitz
David Turnley
Glen Allison
Peter Brown

Design Group
Cahan & Associates

Account Handler
Katie Kniestedt

Marketing Executive
Ned Heidenreich

Clients
Stora Enso
Consolidated Papers

Silver Nomination
for the most
outstanding
Calendar
sponsored by
Premier Paper Group

Designers
André Cremer
Will de l'Ecluse

Copywriter
Meghan Ferrill

Typographer
André Cremer

Illustrator
André Cremer

Design Group
UNA (Amsterdam)
designers

Clients
Binder Hexpoor
Meghan Ferrill
UNA (Amsterdam)
designers
Veenman Printers

Silver Nomination
for the most
outstanding
Poster Campaign
sponsored by
Premier Paper Group

Design Director
Jonathan Ellery

Designers
Jonathan Ellery
Lisa Smith

Typographers
Jonathan Ellery
Lisa Smith

Photographer
Susan Meiselas

Design Group
Browns

Account Handler
Philip Ward

Marketing Executive
Ross Bradshaw

Client
Trebruk UK

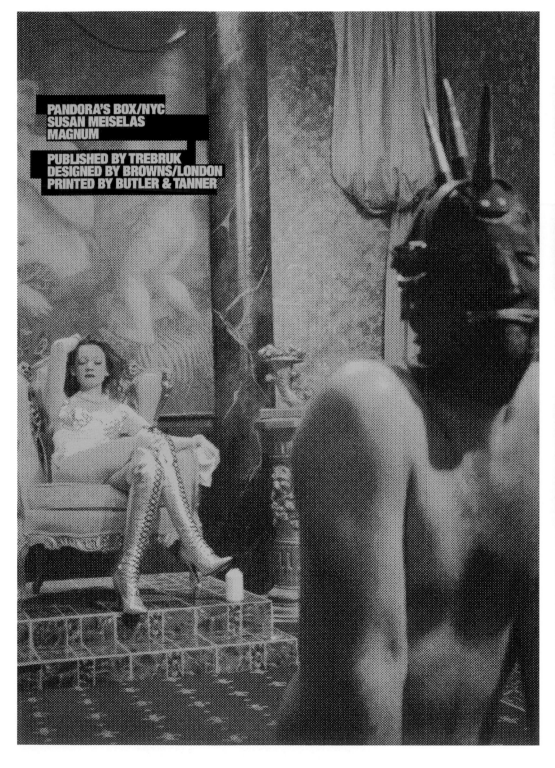

Silver Nomination
for the most
outstanding
Graphic Design
Any Other
sponsored by
Premier Paper Group

Creative Directors
Robert Saville
Mark Waites

Designers
Thomas Hilland
Luke Williamson

Copywriter
Ben Mooge

Typographers
Thomas Hilland
Luke Williamson

Advertising Agency
Mother

Account Handler
Anna Bird

Client
Mother

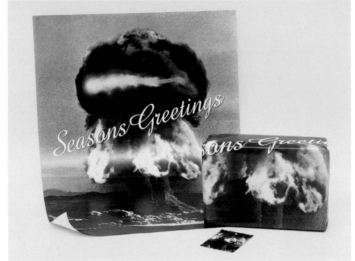

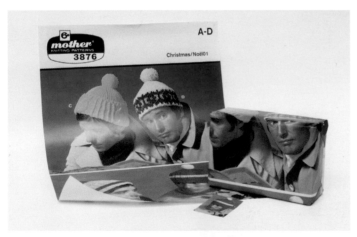

Silver Nomination
for the most
outstanding
Graphic Design
Any Other
sponsored by
Premier Paper Group

Concept
Cecilia Dufils
Marcus Bjurman

Art Directors
Cecilia Dufils
Marcus Bjurman

Copywriter
Jim Thornton

Typographer
Ian Hutchings

Creative Directors
Robert Saville
Mark Waites
Jim Thornton

Photographer
Steve Teague

Advertising Agency
Mother

Client
Mother

Technical Literature

Design Directors
Bryan Edmondson
John Simpson

Designers
Carsten Klein-Hitpass
Stuart Bailey

Typographer
Bryan Edmondson

Photographer
John Ross

Design Group
SEA Design

Account Handlers
Sam Nettleton
Leanne Botha

Marketing Executive
Geoff Burrows

Client
GF Smith

Brochures and Catalogues

Design Director
John Bateson

Designer
Paul Ingle

Illustrator
Ron Mercer

Design Group
Roundel

Marketing Executive
Ron Mercer

Client
Ron Mercer

Brochures and Catalogues

Design Director
Bill Cahan

Designers
Michael Braley
Sharrie Brooks
Bob Dinetz
Kevin Roberson
Gary Williams

Copywriters
Kevin Roberson
Bob Dinetz
Gary Williams

Illustrators
Gary Williams
Bob Dinetz

Photographers
Bob Dinetz
Kevin Roberson
Sharrie Brooks

Design Group
Cahan & Associates

Account Handler
Gwendolyn Rogers

Marketing Executive
Alice Twemlow

Client
AIGA (The American
Institute of Graphic Art)

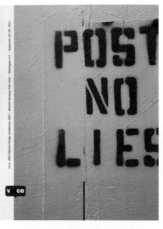

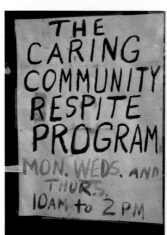

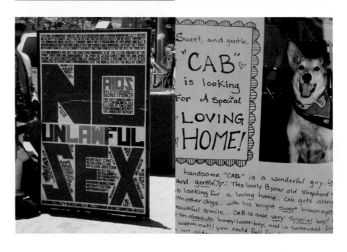

Brochures and Catalogues

Design Directors
Stuart Radford
Andrew Wallis

Designers
Stuart Radford
Andrew Wallis

Typographer
Stuart Radford

Design Group
Radford Wallis

Marketing Executive
Glen Marks

Client
Rex Features

Brochures and Catalogues

Design Director
Mark Bottomley

Designers
Mark Bottomley
Adam Lee

Typographers
Mark Bottomley
Adam Lee

Design Group
Origin

Client
National Centre for Business and Sustainability

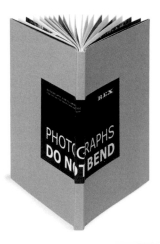

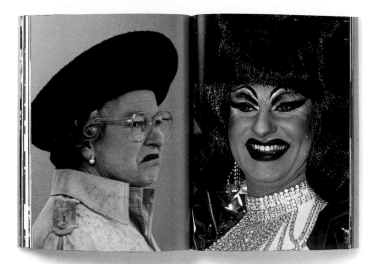

Brochures and Catalogues

Design Director
Marion English

Designers
Marion English
Pat Powell

Copywriters
Dan Monroe
Dave Smith
Sarah Devine
Kristin Henson

Typographer
Marion English

Photographers
Don Harbor
Mitch Epstein

Photo Illustrator
Doug Benson

Additional Photographs
The Alabama Memorial Foundation Archive

Design Group
Slaughter Hanson

Account Handler
Heidi Hallman

Marketing Executive
Della Fancher

Client
The Alabama Memorial Foundation

Brochures and Catalogues

Design Director
Frank Viva

Copywriter
Frank Viva

Illustrator
Frank Viva

Photographer
Ron Baxter Smith

Design Group
Viva Dolan Communications & Design

Marketing Executive
Annette Clayton

Client
Arjo Wiggins

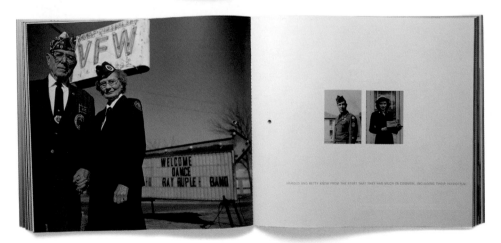

Brochures and Catalogues

Design Director
John Bateson

Designers
Paul Ingle
Richard Coward

Copywriter
Paul Ingle

Typographer
Paul Ingle

Photographers
Tim Auty
Richard Learoyd

Design Group
Roundel

Marketing Executives
Adrian Baker
Tony Baugh

Client
Doric Signs

Brochures and Catalogues

Design Director
Quentin Newark

Designer
Glenn Howard

Author
Lynda Relph-Knight

Photographer
Richard Morrison

Design Group
Atelier Works

Marketing Executive
John Haslam

Clients
Richard Morrison
GF Smith

Brochures and Catalogues

Design Director
Angus Hyland
Silvia Gaspardo-Moro

Designer
Charlie Smith

Design Group
Pentagram Design

Client
Peer

Annual Reports

Design Director
Phil Skegg

Designers
Phil Skegg
Dave Simpson

Copywriters
Mags Casey
Judith Foster

Typographers
Dave Simpson
Phil Skegg

Photographers
Jon Murray
Tim Sinclair

Production Manager
Matt Beardsell

Production
Paul Clarke

Design Group
Love

Account Handler
Phil Skegg

Marketing Executive
Mags Casey

Client
Greater Manchester
Youth Justice Trust

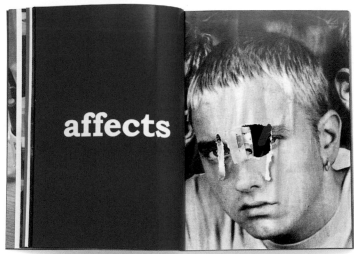

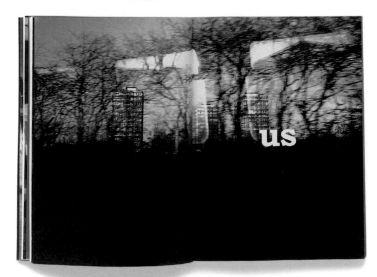

Annual Reports

Design Directors
Curt Schreiber
Jeff Walker

Designers
Scott Hickman
Michelle Platts

Photographer
Christian Witkin

Design Group
VSA Partners Chicago

Account Handler
Melissa Schwister

Marketing Executive
Terry Yoo

Client
IBM

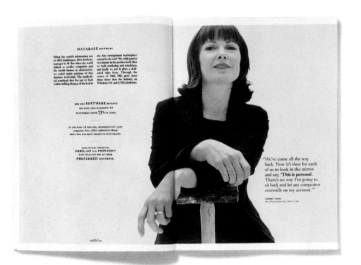

Annual Reports

Design Director
Bill Cahan

Designer
Gary Williams

Illustrator
Jason Holley

Photographers
Ann Giordano
Esther Henderson
Ray Manley
Robert Markow
John Sann

Design Group
Cahan & Associates

Account Handler
Natalie Linden

Marketing Executive
Jeannine Medeiros

Client
Maxygen

Annual Reports

Design Directors
Davor Bruketa
Nikola Zinic

Designers
Davor Bruketa
Nikola Zinic

Copywriters
Davor Bruketa
Nikola Zinic

Typographers
Davor Bruketa
Nikola Zinic

Photographer
Boris Matesic

Design Group
Bruketa&Zinic

Account Handlers
Boris Matesic
Ivan Serdarusic
Luka Saric
Marin Topic

Marketing Executive
Drenislav Zekic

Client
Podravka

Annual Reports

Design Director
Bill Cahan

Designer
Kevin Roberson

Copywriter
Tony Leighton

Illustrator
Steve Hussey

Photographers
Lars Tunbjork
Catherine Ledner
Steven Anlgren

Design Group
Cahan & Associates

Account Handler
Bella Banbury

Marketing Executive
Bob Knapp

Client
Gartner

Annual Reports

Design Directors
Andrew Gorman
Rob Riche

Designer
Rob Riche

Photographers
John Edwards
Paul Dixon

Artists
John Edwards
Paul Dixon
Rob Riche
Andrew Gorman

Design Group
Radley Yeldar

Account Handler
Robert Williams

Marketing Executives
Claire Jenkins
Jackie Stockman

Client
Gallaher Group

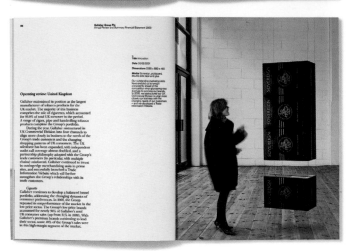

Annual Reports

Design Directors
Gareth Howat
David Kimpton
Jim Sutherland

Designers
Gareth Howat
David Kimpton
Jim Sutherland

Copywriters
Lindsay Camp
Jennie Butterworth

Typographers
Gareth Howat
Jim Sutherland

Photographer
Phil Starling

Design Group
hat-trick design

Marketing Executive
Jennie Butterworth

Client
Fairbridge

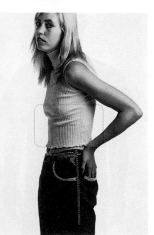

Annual Reports

Design Director
Bill Cahan

Designer
Michael Braley

Copywriters
Michael Braley
Thom Elkjer

Photographers
Jock McDonald
Graham McIndoe

Design Group
Cahan & Associates

Account Handler
Katie Kniestadt

Marketing Executive
Andrea McGhee

Client
Silicon Valley Bank

Annual Reports

Designers
Hans Bockting
Sabine Reinhardt

Typographer
Sabine Reinhardt

Themeatic Writer
Meghan Ferrill

Design Group
UNA (Amsterdam)
designers

Marketing Executive
Frans Van Hövell tot
Westerflier

Client
F Van Lanschot
Bankiers

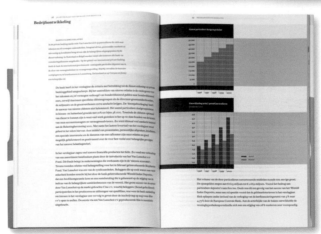

Annual Reports

Designers
Hans Bockting
Will de l'Ecluse
Sabine Reinhardt

Typographer
Sabine Reinhardt

Illustrator
Sabine Reinhardt

Photographer
Reinier Gerritsen

Design Group
UNA (Amsterdam)
designers

Marketing Executive
David Brilleslijper

Client
Delta Lloyd

Annual Reports

Design Directors
Andrew Thomas
Alex Mucha

Designers
Chung Chi Ying
Gan Mong Teng

Copywriter
Andrew Thomas

Illustrator
Michael Lui

Design Group
Equus Design
Consultants

Account Handler
Jaime Chua

Client
Craft Print International

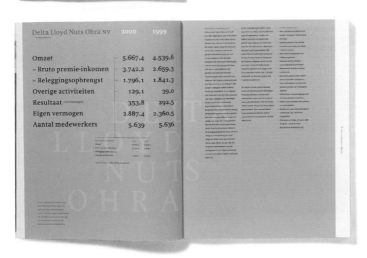

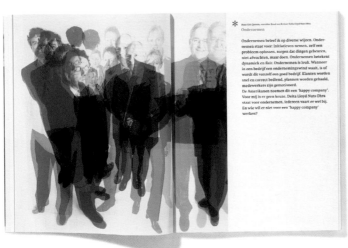

Direct Mail

Designer
Michael Johnson

Copywriter
Michael Johnson

Typographer
Michael Johnson

Illustrator
Michael Johnson

Design Group
johnson banks

Client
Campaign Against
Climate Change

Direct Mail

Design Directors
Ben Stott
Nick Finney
Alan Dye

Designer
Ben Stott

Photographer
Jon Osborne

Design Group
NB: Studio

Marketing Executive
David Brooke

Client
Knoll International

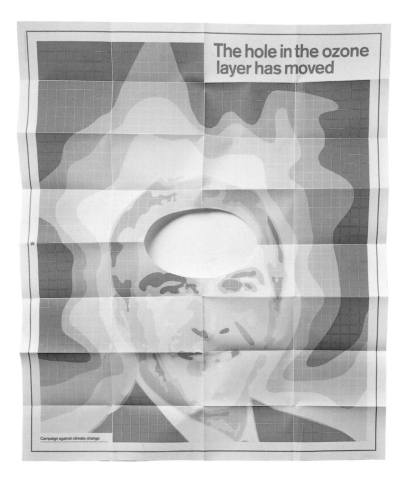

Direct Mail

Design Director
Glenn Harrison

Designer
David Revell

Copywriters
Glenn Harrison
David Revell
Tim Cole
Jonathan Coleman
Kieran Molloy

Typographer
David Revell

Illustrator
David Revell

Design Group
Tango Design

Account Handler
Vanessa Elliott

Client
Tango Design

Direct Mail

Design Director
Peter Silk

Designers
Graham Painter
James Phelan
Peter Silk

Copywriter
Peter Silk

Typographers
Graham Painter
James Phelan

Design Group
Silk Pearce

Marketing Executive
Susan Robinson

Client
Brown Cow

VALENTINE TABLECLOTH

Directions for use: Congratulations on acquiring your new Tango Valentine Tablecloth. The TVT* is an easy to use questionnaire carefully designed to help you gauge your communication effectiveness on this very special occasion. Simply respond to each of the selected prompts during the course of your evening, and choose the answer most appropriate to yourself. At the end of the evening, your progress can be compared with the results chart provided.

COMMUNICATION PRODUCTS FROM TANGO+

On Thursday 20 September 2001 Susan Robinson will be opening the stable doors of her new design company. Please come and help celebrate from 4.00 – 8.00pm at Conyngham Hall Stables, Knaresborough, North Yorkshire HG5 9AY

RSVP Susan Robinson
See back for contact details

brown cow

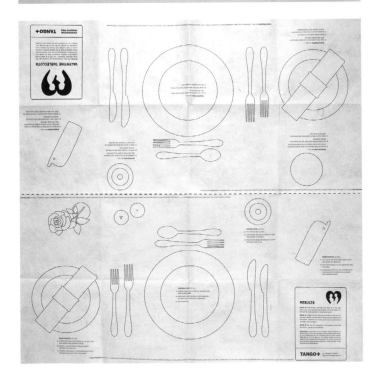

Direct Mail

Design Director
Jason Gregory
Mark Bonner
Peter Hale

Designer
Mark Bonner

Copywriters
Mark Bonner
Laura Woodroffe

Typographer
Mark Bonner

Design Group
GBH

Account Handler
Jo Bradshaw

Marketing Executives
Laura Woodroffe
Claire Fennelow

Client
D&AD

Direct Mail

Design Director
Mark Ross

Designers
Tom Shaughnessy
Mark Ross
Grant Mitchell

Typographers
Tom Shaughnessy
Mark Ross

Client
The Association
of Photographers
(Northern Office)

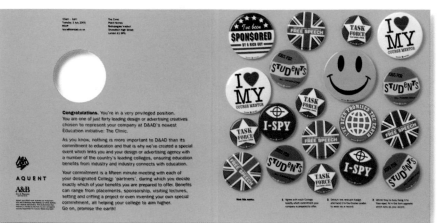

Direct Mail

Design Director
Adrian Shaughnessy

Designer
Mat Cook

Copywriter
John O'Reilly

Typographer
Martina Keller

Design Group
Intro

Account Handler
Sarah Barlow

Client
Eyestorm

Calendars

Design Director
Greg Quinton

Designer
Martin Lawless

Design Group
The Partners

Project Manager
Loris Clements

Managing Director
Patrick Wilson

Client
Thrislington Cubicles

Calendars

Design Directors
Tom Shaughnessy
Mark Ross

Designer
Grant Mitchell

Copywriter
Andrew Murdoch

Typographers
Mark Ross
Tom Shaughnessy
Grant Mitchell

Photographer
Tim Ainsworth

Marketin Executive
Gordon Mitchell

Client
Karl's Barbershop

Calendars

Design Director
Michael Reissinger

Designer
Barbara Schirmer

Copywriter
Kay Eichner

Photographer
Hans Starck

Client
Endless Pain Tattoo &
Piercing Studio

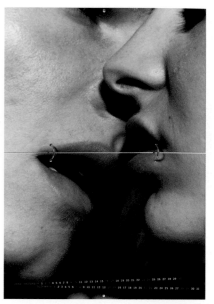
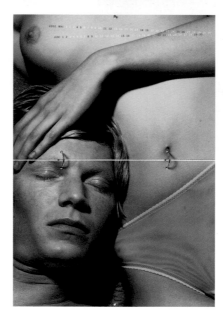
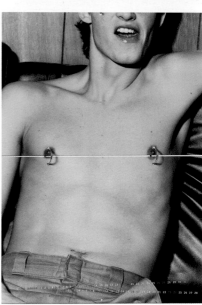

Calendars

Design Director
Thomas Wolfe

Copywriter
Reid Armbruster

Design Group
VSA Partners Chicago

Account Director
Melissa Waters

Director of Marketing
Cindy Stilp

Client
Fox River Paper
Company

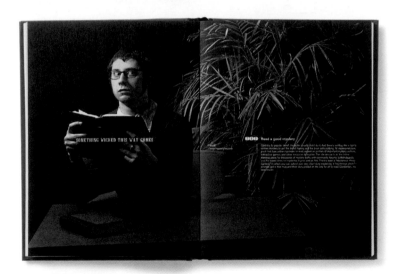

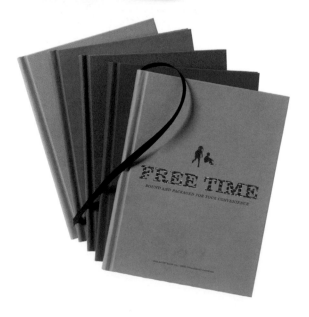

Calendars

Creative Director
Robert Mils

Art Director
Sandra Schweiger

Copywriters
Katherine Schwarz
Carolin Böhm

Account Handler
Monika Bertalanic

Marketing Executives
Rainer Knubben
Britta Winkelhahn
Elke Moews

Client
DaimlerChrysler
Services

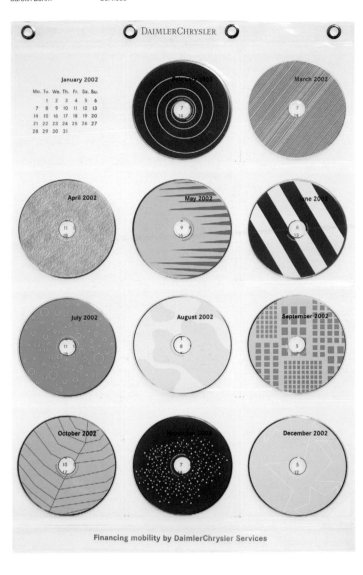

Self Promotional Items

Design Director
Graeme Arkell

Designers
Simon Hardy
Steve Williams

Copywriter
Trevor Beattie

Typographer
Tivy Davies

Photographer
Trevor Beattie

Account Handler
Bill Whatley

Client
TBWA\London

Self Promotional Items

Design Director
Kim Gehrig

Designer
Kim Gehrig

Copywriters
Caroline Pitu
Kim Gehrig

Typographer
Kim Gehrig

Illustrator
Kim Gehrig

Advertising Agency
Mother

Marketing Executives
Chris Palmer
Frank Budgen

Client
Gorgeous

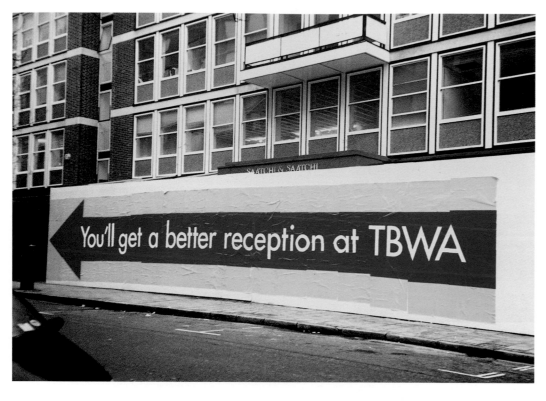

Self Promotional Items

Creative Directors
Uwe Marquardt
Kerrin Nausch

Designers
Mariko Neumeister
Michael Schacht

Account Handler
Andreas Cordt

Marketing Executive
Holger Jahn

Client
Jahn Furniture Design

Self Promotional Items

Design Director
Harry Pearce

Designer
Harry Pearce

Copywriter
Harry Pearce

Typographer
Harry Pearce

Design Group
Lippa Pearce Design

Client
Lippa Pearce Design

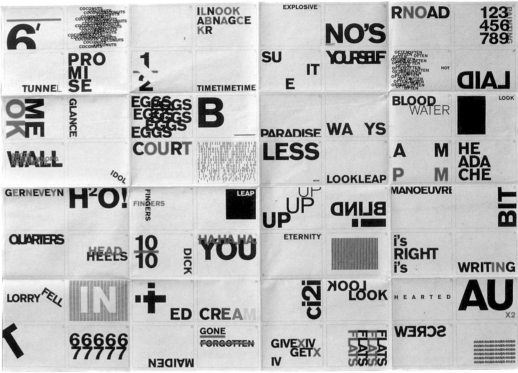

Self Promotional Items

Design Director
Richard Flintham

Designer
James Townsend

Copywriter
Andy McLeod

Account Handler
Charlotte Hurrell

Marketing Executive
Richard Reed

Client
innocent

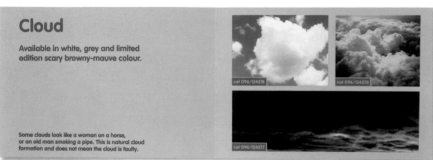

Cloud

Available in white, grey and limited edition scary browny-mauve colour.

Some clouds look like a woman on a horse, or an old man smoking a pipe. This is natural cloud formation and does not mean the cloud is faulty.

cat 096/124576

cat 096/124578

cat 096/124577

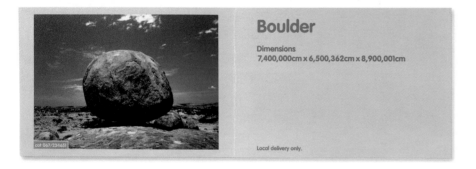

Boulder

Dimensions
7,400,000cm x 6,500,362cm x 8,900,001cm

Local delivery only.

cat 067/234651

Self Promotional Items

Design Director
David Hillman

Designers
David Hillman
Deborah Osborne

Illustrator
Ted Hammond

Design Group
Pentagram Design

Client
Pentagram Design

Why do you say that?

'You made a right cock-up of that'

'Scandal-monger got given the cold shoulder'

'Speeding traffic cop was hoist with his own petard'

'Non-executive directors have other irons in the fire'

Self Promotional Items

Design Director
Ben Casey

Designers
Ben Casey
James Graham
Andy Mairs

Typographer
Ben Casey

Design Group
The Chase

Account Handler
Clare Storey

Client
The Chase

Self Promotional Items

Design Directors
Senje Darbar
Ollie Perry

Designer
Senje Darbar

Copywriter
Ollie Perry

Clients
Senje Darbar
Ollie Perry

Self Promotional Items

Creative Directors
Robert Saville
Mark Waites

Designers
Thomas Hilland
Luke Williamson

Copywriter
Ben Mooge

Typographers
Thomas Hilland
Luke Williamson

Design Group
Mother

Account Handler
Anna Bird

Advertising Agency
Mother

Client
Mother

Posters, Individual

Art Director
Vicki Maguire

Copywriter
Vicki Maguire

Illustrator
Paul Slater

Typographer
Dave Wakefield

Creative Director
Steve Dunn

Advertising Agency
Ogilvy & Mather

Account Handler
Sophie Harwood Smith

Marketing Executive
Gerald Noone

Client
Severn Trent Water

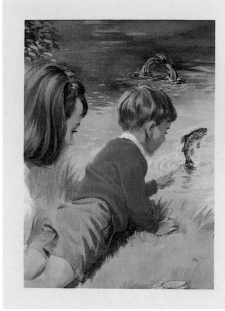

"Severn Trent's clean rivers have attracted hundreds of Kingfishers to the area," says Sally. "That'll please Dad," says Sam, "Mum says he likes common birds."

Severn Trent Water is jolly good for us all.

Posters, Individual

Art Director
Justin Tindall

Copywriter
Adam Tucker

Typographer
Pete Mould

Creative Director
Andrew Fraser

Advertising Agency
BMP DDB

Account Handler
Simon Lendrum

Marketing Executive
Marc Sands

Client
The Guardian

Posters, Individual

Art Director
Justin Tindall

Copywriter
Adam Tucker

Typographer
Pete Mould

Photographer
David Gill

Creative Director
Andrew Fraser

Advertising Agency
BMP DDB

Account Handler
Simon Lendrum

Marketing Executive
Marc Sands

Client
The Guardian

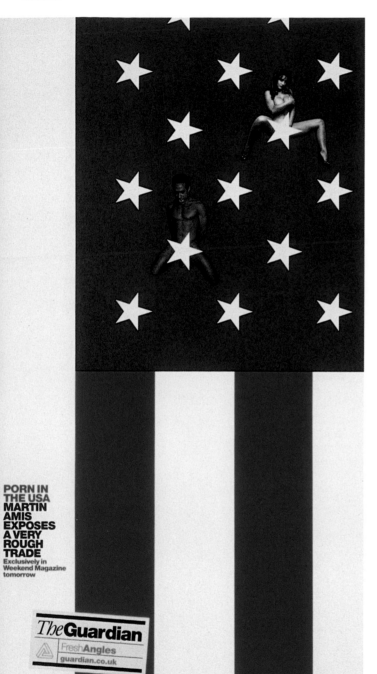

Posters, Individual

Design Directors
Steve Daniels
Dave Harrison

Designer
Steve Daniels

Copywriter
Dave Harrison

Typographer
Steve Daniels

Photographer
David Harriman

Advertising Agency
CheethamBell JWT

Account Handler
Amelia Preston

Marketing Executive
Peter Draper

Client
Manchester United
Football Club

Posters, Individual

Designer
Michael Johnson

Copywriter
Michael Johnson

Typographer
Michael Johnson

Illustrator
Michael Johnson

Design Group
johnson banks

Client
Campaign Against
Climate Change

Posters, Individual

Design Director
Angus Hyland

Designers
Angus Hyland
Charlie Smith

Design Group
Pentagram Design

Client
The British Council

Posters, Individual

Design Director
Angus Hyland

Designer
Angus Hyland

Design Group
Pentagram Design

Client
London College
of Printing

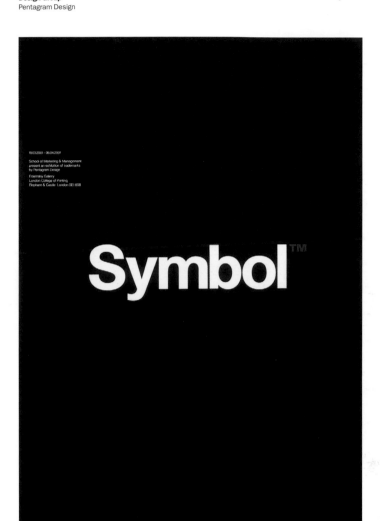

Posters, Individual

Design Director
Quentin Newark

Designer
Elaine Perks

Copywriter
Quentin Newark

Illustrator
Ben Kirchner

Photographer
Alan Batham

Design Group
Atelier Works

Client
University of Lincoln
Surrey Institute
of Art & Design

Posters, Individual

Design Director
Yukichi Takada

Designer
Yukichi Takada

Typographer
Yukichi Takada

Design Group
CID Lab

Client
W-clock

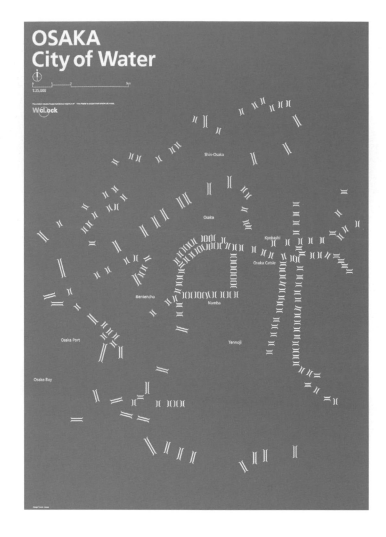

Posters, Individual

Design Director
Angus Hyland

Designers
Angus Hyland
Charlie Smith

Design Group
Pentagram Design

Client
The British Council

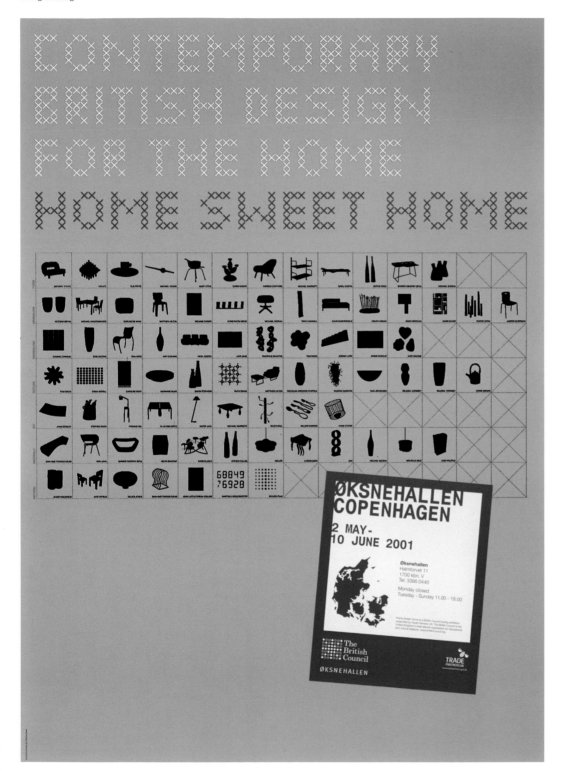

Posters, Campaigns

Designers
John Shachter
Hans Seeger

Copywriter
Scot Armstrong

Client
The Upright Citizens
Brigade Theater

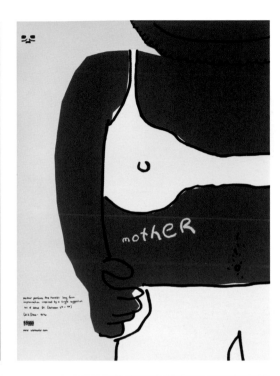

Posters, Campaigns

Design Director
Angus Hyland

Designer
Charlie Smith

Photographer
Lee Funnell

Design Group
Pentagram Design

Client
The British Council

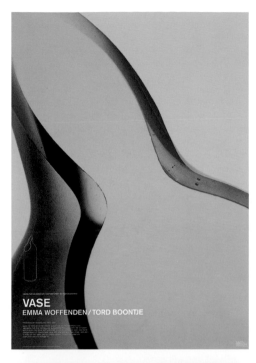

VASE
EMMA WOFFENDEN / TORD BOONTJE

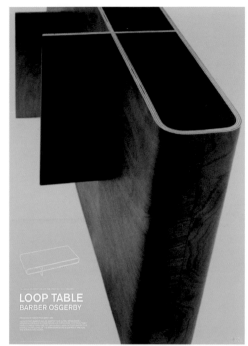

LOOP TABLE
BARBER OSGERBY

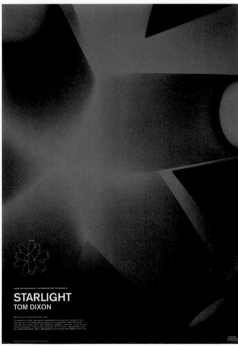

STARLIGHT
TOM DIXON

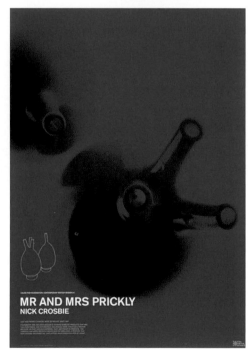

MR AND MRS PRICKLY
NICK CROSBIE

Posters, Campaigns

Art Directors
Andreas Kittel
Helena Redman

Creative Director
Anders Kornestedt

Illustrators
Anna Kask
Gavin Smart
Andreas Kittel
Helena Redman
Jessica Thoren

Design Group
Happy Forsman
& Bodenfors

Account Handler
Yngve Nygren

Marketing Executive
Linnea Kongbäck

Client
Röhsska Museet

Stolen av idag.

Trettioåtta stolar från de senaste fem åren.
15 februari–11 mars 2001
RÖhsska museet
Vasagatan 37–39, Göteborg
www.designmuseum.se

Stolen av idag.

Trettioåtta stolar från de senaste fem åren.
15 februari–11 mars 2001
RÖhsska museet
Vasagatan 37–39, Göteborg
www.designmuseum.se

Stolen av idag.

Trettioåtta stolar från de senaste fem åren.
15 februari–11 mars 2001
RÖhsska museet
Vasagatan 37–39, Göteborg
www.designmuseum.se

Stolen av idag.

Trettioåtta stolar från de senaste fem åren.
15 februari–11 mars 2001
RÖhsska museet
Vasagatan 37–39, Göteborg
www.designmuseum.se

Stolen av idag.

Trettioåtta stolar från de senaste fem åren.
15 februari–11 mars 2001
RÖhsska museet
Vasagatan 37–39, Göteborg
www.designmuseum.se

Posters, Campaigns

Design Director
Jonathan Ellery

Designers
Jonathan Ellery
Jamie Roberts

Typographer
Jonathan Ellery

Typographer
Jamie Roberts

Photographer
Bruce Gilden

Design Group
Browns

Account Handler
Philip Ward

Marketing Executive
Ross Bradshaw

Client
Trebruk UK

Posters, Campaigns

Creative Directors
Dave Dye
Sean Doyle

Art Director
Dave Dye

Copywriter
Sean Doyle

Typographer
Dave Wakefield

Marketing Executive
Jacqui Kean

Client
The Economist

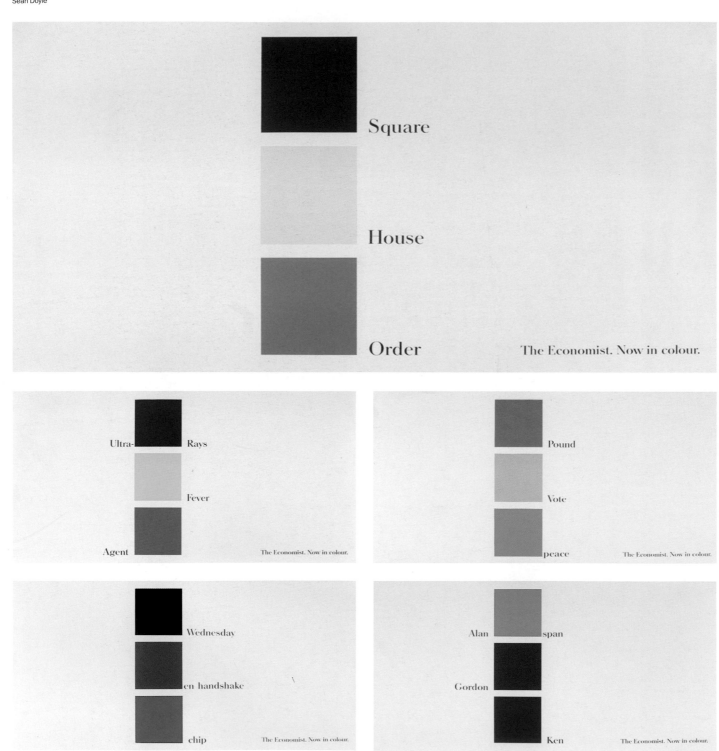

Stationery Ranges

Design Director
Sigi Mayer

Designer
Sigi Mayer

Typographer
Sigi Mayer

Copywriter
Sigi Mayer

Photographer
Kurt Groh

Design Group
Orange

Client
Kurt Groh

Stationery Ranges

Design Director
Isaac February

Designer
Gavin Bloys

Copywriter
Razzia Essack

Typographer
Gavin Bloys

Design Groups
Saatchi & Saatchi
(Cape Town)
Eye Design Studio

Account Handler
Juliet Matthews

Marketing Executive
Claire Rayner

Client
Claire Inc.

Compliment Slip 30"

FVO: *(Warm but confident delivery. Background music under throughout.)*
Hi there. It's me again. Claire from Claire Inc. Thank you for using my services.
You've been a super cool client. Until next time. Cheers for now.
SFX: *(Sound of clinking glasses.)*
FVO: Keep it handy - 083 260 2131 or clairebell1@hotmail.com
ANNCR: Claire Inc. Anything but background noise.

Business Card 30"

FVO: *(Warm but confident delivery.*
Background music under throughout.)
Hi there. It's me Claire from **Claire inc.** The producer in
Radio & Music Producer. The specialist in African Production
Specialist. And the flippin' as in flippin' hot person for the job.
SFX: *(Sound of telephone ringing.)*
FVO: Give me a buzz on 083 260 2131 or clairebell1@hotmail.com
ANNCR: Claire inc. Anything but background noise.

Letterhead 30"

FVO: *(Warm but confident delivery. Background music under throughout.)*
Hi there. It's me Claire from Claire inc. The producer in Radio & Music Producer.
The specialist in African Production Specialist. And the flippin' as in flippin' hot person for the job.
SFX: *(Sound of telephone ringing.)*
FVO: Give me a buzz on 083 260 2131 or clairebell1@hotmail.com
ANNCR: Claire inc. Anything but background noise.

Stationery Ranges

Designer
Bastiaan Rijkers

Copywriter
Gijsbregt Vijn

Copywriter
Andrea Janssen

Typographer
Bastiaan Rijkers

Illustrator
Bastiaan Rijkers

Design Group
Lemon Scented Tea

Account Handler
Axel van Weel

Marketing Executive
Gijsbregt Vijn

Client
Lemon Scented Tea

Stationery Ranges

Designer
Bastiaan Rijkers

Typographer
Bastiaan Rijkers

Design Group
Lemon Scented Tea

Account Handler
Axel van Weel

Marketing Executive
Richard Krabbendam

Client
Rijpe Appels

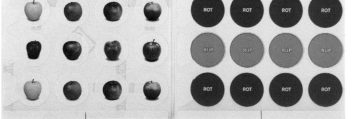

Stationery Ranges

Design Director
Klaus Hesse

Designer
Silke Heiburg

Client
Nowakteufelknyrim

Stationery Ranges

Design Director
Adam Whitaker

Designer
Adam Whitaker

Typographer
Adam Whitaker

Design Group
Duffy London

Account Handler
Tim Watson

Client
English

Individual Letterheads

Design Directors
Brian Eagle
Grenville Main
Scott Kennedy

Designer
Brian Eagle

Typographer
Brian Eagle

Illustrators
Scott Kennedy
Donna Cross
Brian Eagle

Design Groups
Unreal London
DNA Design

Account Handler
Brian Eagle

Client
Three Eyes Illustration

Point-of-Sale Material

Design Director
Graeme Arkell

Designers
Simon Hardy
Steve Williams

Copywriter
Trevor Beattie

Typographer
Tivy Davies

Photographer
Trevor Beattie

Account Handler
Bill Whatley

Advertising Agency
TBWA\London

Client
TBWA\London

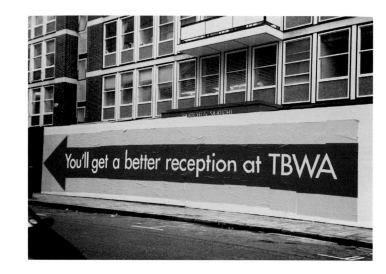

Individual Letterheads

Design Director
Joanne Thomas

Designer
Janet Kinghorn

Typographer
Janet Kinghorn

Illustrator
Janet Kinghorn

Design Group
The Jupiter Drawing
Room (South Africa)

Marketing Executive
Ruth Chowles

Client
Ruth Chowles

Point-of-Sale Material

Art Director
Bill Montgomery

Copywriter
John Patroulis

Photographer
Bill Montgomery

Advertising Agency
Big Time Advertising

Client
E-Wireless

Point-of-Sale Material

Executive Creative Director
Gerry Graf

Art Directors
Frank Anselmo
Jayson Atienza

Chief Creative Officer
Ted Sann

Advertising Agency
BBDO New York

Client
Guinness Bass Import Company

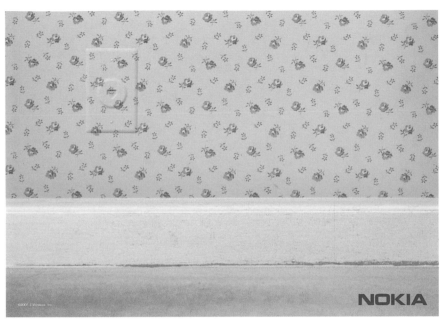

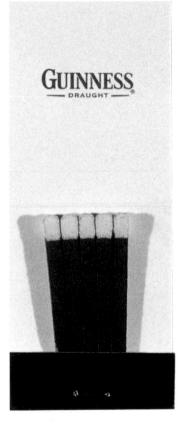

Point-of-Sale Material

Creative Directors
Ean-Hwa Huang
Szu-Hung Lee

Art Director
Oon-Hoong Yeoh
Ean-Hwa Huang

Copywriters
Joanne Ng
Szu-Hung Lee

Typographer
Oon-Hoong Yeoh

Illustrator
Oon-Hoong Yeoh

Photographer
Wing-Fai Looi

Advertising Agency
BBDO Malaysia

Account Handlers
Lucy Lo
Steven Pong
Angeline Teoh

Marketing Executives
S K Wong
Lawrence Ding

Client
KFC Holdings Malaysia

Any Other

Design Director
Pierre Vermeir

**Design Directors
(Client)**
Barry Robinson
Jane Ryan

Design Group
HGV Design
Consultants

Print Manager
Paul Burnett

Research
Philip Parker

Client
Royal Mail

1st

ECONOMIC SCIENCES
Nobel Prize 100th Anniversary

2nd

CHEMISTRY
Nobel Prize 100th Anniversary

40

PHYSIOLOGY OR MEDICINE
Nobel Prize 100th Anniversary

45

LITERATURE
Nobel Prize 100th Anniversary

E

PEACE
Nobel Prize 100th Anniversary

65

PHYSICS
Nobel Prize 100th Anniversary

Any Other

Design Directors
Jason Gregory
Mark Bonner
Peter Hale

Designer
Peter Hale

Typographer
Peter Hale

Illustrators
Peter Hale
Mark Bonner

Photography
Hungry Tiger

Design Group
GBH

Account Handler
Jo Bradshaw

Marketing Executives
Louise Fowler
Lloyd Kirton

Client
D&AD

Any Other

Design Partner
David Stuart

Designers
Greg Quinton
Rob Howsam
Robert Ball

Illustrator
Lee Hobbs

Design Group
The Partners

Project Director
Manfred Abraham

CEO
Mandy Pooler

Client
WPP The Channel

**Music Packaging
and Print Promotion,
Promotional Posters**

Design Director
Mat Cook

Designer
Mat Cook

Typographer
Mat Cook

Photographer
Toby Glanville

Design Group
Intro

Account Handler
Sonia Makkar

Marketing Executive
Annabelle Scott-Curry

Client
Polydor

**Music Packaging
and Print Promotion,
Promotional Posters**

Design Directors
Stephanie Nash
Anthony Michael

Designers
Stephanie Nash
Claudia Chase

Photographers
Mert Alas
Marcus Piggott

Design Group
Michael.Nash
Associates

Account Handler
Richard Hales

Marketing Executive
Annabelle Scott-Curry

Client
Polydor

Music Packaging and Print Promotion, Promotional Posters	**Copywriters** Tony Malcolm Darren Wright	**Advertising Agency** Malcolm Moore Deakin Hutson	**Client** MTV Networks UK & Ireland
Design Directors Guy Moore Tony Malcolm	**Typographer** Neil Craddock	**Account Handler** Ed Chilcott	
Designers Guy Moore Lucy Collier	**Photographer** Lucy Collier	**Marketing Executive** Fiona Battle	

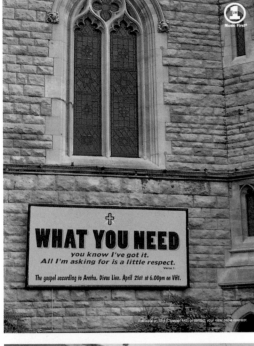

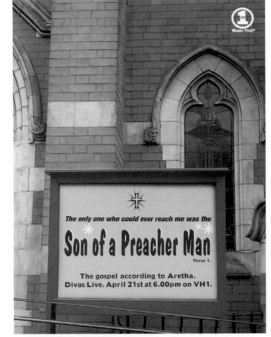

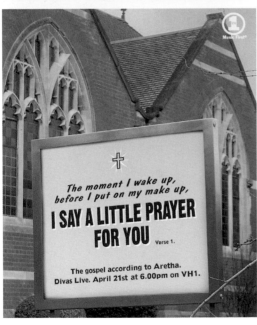

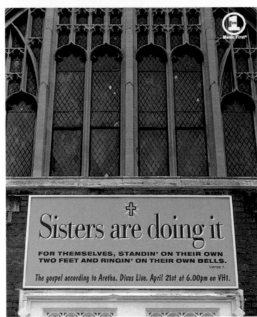

Music Packaging and Print Promotion, Individual Compact Discs, Tapes & Record Sleeves

Design Director
Mat Cook

Designer
Mat Cook

Typographer
Mat Cook

Photographer
Toby Glanville

Design Group
Intro

Account Handler
Sonia Makkar

Marketing Executive
Annabelle Scott-Curry

Client
Polydor

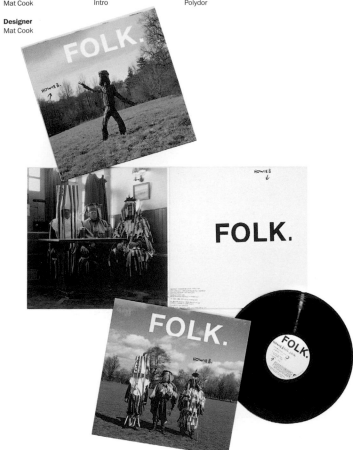

Music Packaging and Print Promotion, Individual Compact Discs, Tapes & Record Sleeves

Design Directors
Stephanie Nash
Anthony Michael

Designers
Stephanie Nash
Claudia Chase

Photographers
Mert Alas
Marcus Piggott

Design Group
Michael.Nash
Associates

Account Handler
Richard Hales

Marketing Executive
Annabelle Scott-Curry

Client
Polydor

Music Packaging and Print Promotion, Compact Discs, Tape & Record Sleeves Campaigns

Designers
Mark Farrow
Gary Stillwell
Jonathon Jeffrey
Nick Tweedie
J Spaceman

Sculpture
Yoko 2 and Yoko 5 by
Don Brown, courtesy of
Sadie Coles HQ
London

Photographer
John Ross

Design Group
Farrow Design

Marketing Executives
Roma Martyniuk
Jo Power

Clients
Arista
Spaceman

Music Packaging and Print Promotion, Compact Discs, Tape & Record Sleeves Campaigns

Design Director
David Malone

Designer
David Malone

Design Group
Malone Design

Client
Sony Music

WRITING FOR DESIGN

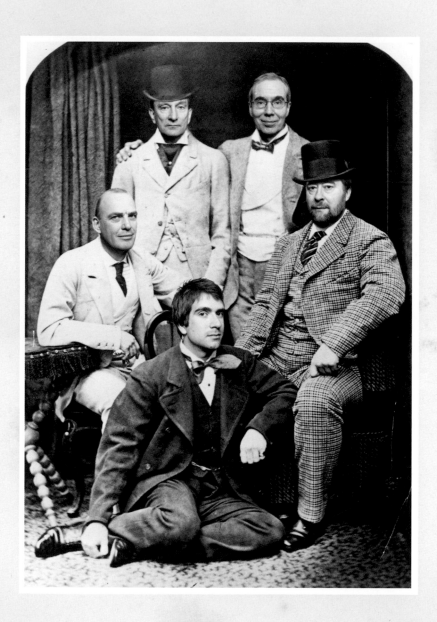

Top Row; *Left to Right:*
BARRY DELANEY • **JOHN SIMMONS**, INTERBRAND
Bottom Row; *Left to Right:*
ALAN PAGE, NWD GROUP • **DAN GERMAIN**, INNOCENT • **LYNDON MALLET**, HARCOURT MALLET

WRITING FOR DESIGN

Left to Right:
BERYL MCALHONE • NANCY BERNARD, NEUTRON LLC

Comment by Beryl McAlhone

.This is not yet a category like packaging or TV advertising – entries were all over the place, scattered across the whole terrain that designers work in – so there was not much judging like with like. Design is more lopsided than advertising in the way it handles both image and language. In agencies, the line is increasingly blurred, but parity is still a dream in design companies, where writers are usually freelances. This fact may be limiting entries in the category. Things will change. We expect, for example, a shift on brands towards recognition that the way you put words together affects how brands are understood. Meanwhile, bravo to the few who won through, and thanks for the enjoyable read.

WRITING FOR DESIGN SPONSORED BY THE GUARDIAN

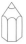

Silver Nomination
for the most
outstanding
Writing for Design
sponsored by
The Guardian

Copywriter
Dan Germain

Design Director
Richard Reed

Designers
Kevin Taylor
Jemima Myrddin-Evans

Client
innocent

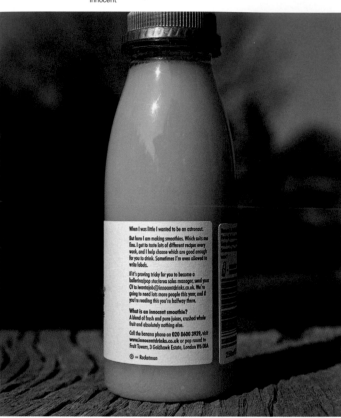

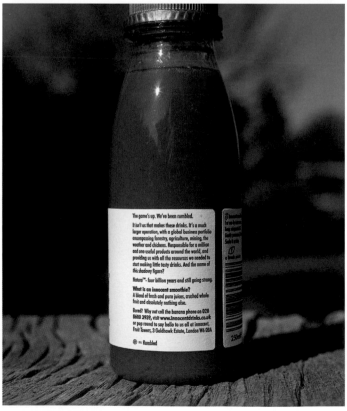

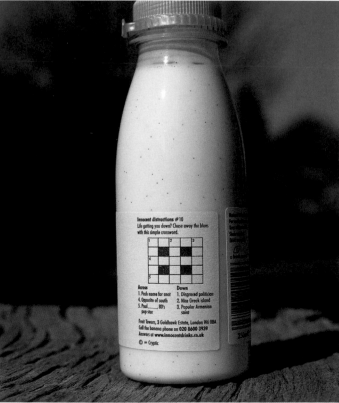

Writing for Design

Copywriter
Peter Roche

Creative Director
Daren Kay

Deputy Creative Director
Andy Barwood

Designer
Graeme Noble

Design Group
Tullo Marshall Warren

Account Handlers
Stephen Chandler
Simon Hughes

Marketing Executive
Marc Michaels

Client
COI/Royal Air Force

Writing for Design

Copywriters
John Simmons
Jackie Wills

Design Director
Jonathan Hubbard

Designers
Nikki Norman
Scott McGuffie

Illustrators
Nikki Norman
Neil Taylor

Design Group
Interbrand

Marketing Executive
Steve Miles

Client
Lever Fabergé

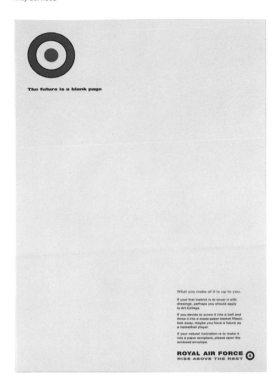

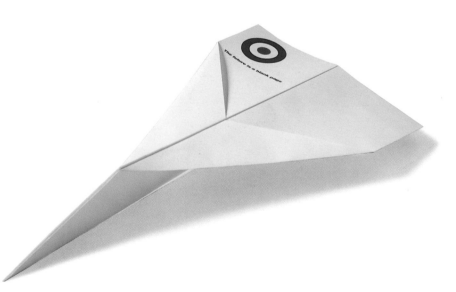

Writing for Design

Copywriter
Jessica Lehrer

Design Directors
Paul Shearer
Glenn Cole

Designer
Mario Guay

Typographers
Frederique Daubal
Mario Guay

Illustrator
Jasper Goodall

Photographer
Elaine Constantine

Design Group
Wieden + Kennedy
Amsterdam

Account Handlers
Julia Porter
Becky Barwick

Heads of Advertising
Phil McAveety
Stefan Olander

Brand Managers
Thierry de Ridder
Paolo Tubito

Client
Nike

Writing for Design

Copywriter
Jessica Lehrer

Design Directors
Paul Shearer
Glenn Cole

Designer
Judith Francisco

Typographers
Frederique Daubal
Judith Francisco

Illustrators
Jasper Goodall
Jason Brooks

Photographers
Robert Wyatt
Marc de Groot

Design Group
Wieden + Kennedy
Amsterdam

Account Handlers
Julia Porter
Becky Barwick

Heads of Advertising
Phil McAveety
Stefan Olander

Brand Managers
Thierry de Ridder
Paolo Tubito

Client
Nike

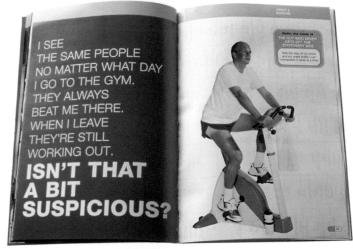

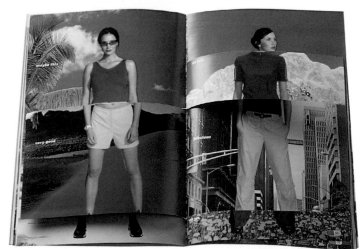

Writing for Design

Copy
IBM

Design Directors
Curt Schreiber
Jeff Walker

Designers
Scott Hickman
Michelle Platts

Photographer
Christian Witkin

Design Group
VSA Partners Chicago

Account Handler
Melissa Schwister

Marketing Executive
Terry Yoo

Client
IBM

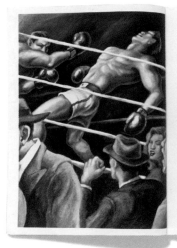

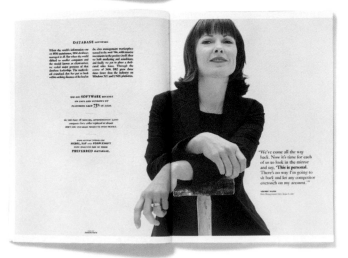

EDITORIAL & BOOK DESIGN

Top Row; *Left to Right:*
Sara Fanelli • **Karen Morgan**
Bottom Row; *Left to Right:*
Pearce Marchbank, Studio Twenty • **Lin Arigho**, Aricot Vert

EDITORIAL & BOOK DESIGN

Left to Right:
DAVID HAWKINS, UNTITLED • **FERNANDO GUTIÉRREZ,** PENTAGRAM DESIGN • **CAPTAIN'S MATE**

Comment by Fernando Gutiérrez

Our day of judging was marked by relative unanimity. There were some excellent pieces of work, and in particular, the jury were drawn towards the fashion magazine 'Mined', and the Paul Smith book, 'You Can Find Inspiration in Everything'. The designers and editors of Mined have pushed the boundaries in a frequently self-referential genre. The cover is truly brave, while overall the magazine communicates elegance, quality and luxury. Mined hasn't been designed to compete with the best-sellers, but to stand alone as a statement, a bold proclamation of what can be achieved when designers bend the rules in order to innovate and create. Paul Smith's book was obviously a labour of love, and exudes a colourful, vivacious and imaginative character. The complete opposite of Mined, it is eclectic and eccentric, a compendium of styles and approaches to design and packaging that fully reflects the editorial ethos of the book. It was a big hit with the jury. It would be good in future to see more active participation, especially from newspapers, magazines and publishing houses – dynamic and competitive industries, after all – who were poorly represented in this year's judging.

EDITORIAL & BOOK DESIGN SPONSORED BY PHAIDON PRESS

Silver Award for the most outstanding Complete Book sponsored by Phaidon Press

Design Director
Alan Aboud

Designers
Alan Aboud
Jonathan Ive
Maxine Law
Emma Jones
Mark Thomson
Ellie Ridsdale
Zoe Symonds

Design Group
Aboud.Sodano

Publisher
Violette Editions

Silver Award
for the most
outstanding
Complete Book
sponsored by
Phaidon Press

Design Director
Stefan G Bucher

Copywriter
Peggy Roalf

Director
Mark Heflin

Cover Photography
Craig Cutler

Design Group
344 Design LLC

Publisher
Amilus

Silver Award
for the most outstanding Complete Book sponsored by Phaidon Press

Design Director
Marion English

Designers
Marion English
Pat Powell

Copywriter
Dan Monroe

Copywriters
Dave Smith
Sarah Devine
Kristin Henson

Typographer
Marion English

Photo Illustrator
Doug Benson

Photographer
Don Harbor

Photography
Mitch Epstein

Design Group
Slaughter Hanson

Account Handler
Heidi Hallman

Marketing Executive
Della Fancher

Client
The Alabama Memorial Foundation

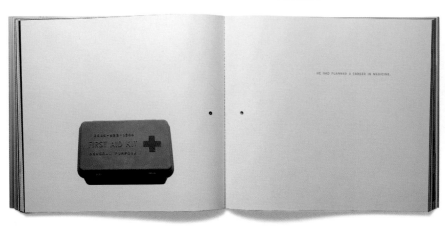

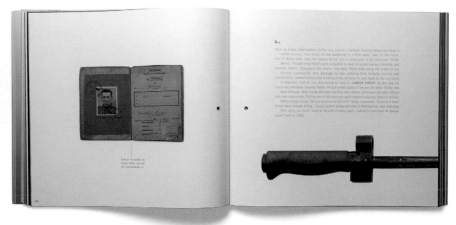

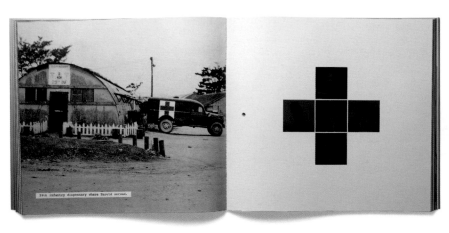

Silver Award
for the most
outstanding
Complete Magazine
sponsored by
Phaidon Press

Design Director
Andreas Laeufer

Designers
Greg Stogden
Jay Hess

Typographer
Andreas Laeufer

Marketing Executive
Vicky Stewart

Publishers
Masoud Golsorkhi
Andreas Laeufer
Tank Publications

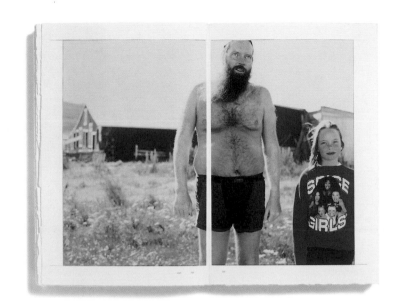

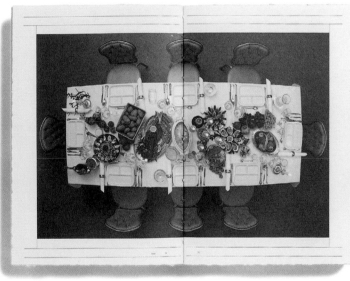

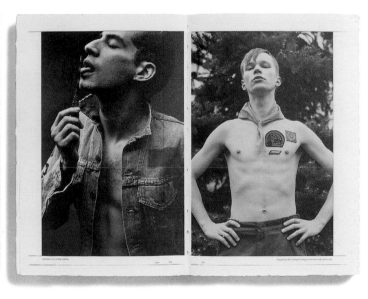

Book Covers

Design Director
Hanson Ho

Designers
Hanson Ho
Stanley Chek

Copywriters
Hanson Ho
Stanley Chek

Typographer
Hanson Ho

Design Group
H55

Client
H55

Book Covers

Design Director
Alan Aboud

Designers
Alan Aboud
Jonathan Ive
Maxine Law
Emma Jones
Mark Thomson
Ellie Ridsdale
Zoe Symonds

Design Group
Aboud.Sodano

Publisher
Violette Editions

Book Covers

Design Director
Robert Priest

Designer
Peter B Cury

Copywriter
Peggy Roalf

Director
Mark Heflin

Cover Illustration
Christoph Niemann

Design Group
Priest Media

Publisher
Amilus

Book Covers

Design Directors
Jason Gregory
Mark Bonner
Peter Hale

Designers
Jason Gregory
Mark Bonner
Peter Hale

Typographers
Jason Gregory
Mark Bonner
Peter Hale

Design Group
GBH

Account Handler
Jo Bradshaw

Marketing Executives
Louise Fowler
Lloyd Kirton

Publisher
Laurence King
Publishing

Client
D&AD

Book Covers

Designers
Andrzej Klimowski
Jeff Willis

Copywriter
David Bird

Typographer
Jeff Willis

Illustrator
Andrzej Klimowski

Publisher
Oberon Books

Client
National Theatre

Complete Books

Design Director
Nick Bell

Designers
Nick Bell
Alex Feldmann

Photographer
Martin Parr

Author
Val Williams

Editor
Neil Baber

Typographer
Alex Feldmann

Design Group
UNA (London)
designers

Publisher
Amanda Renshaw
Phaidon Press

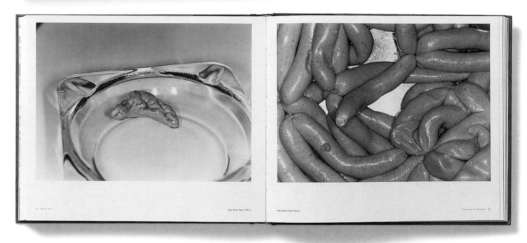

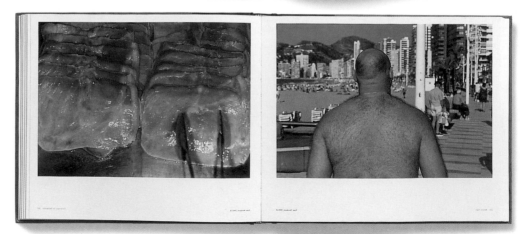

Complete
Books

Design Directors
Scott Williams
Henrik Kubel

Designers
Scott Williams
Henrik Kubel

Copywriter
Dr Stephen Bury

Typographers
Scott Williams
Henrik Kubel

Illustrator
Sarah Staton

Photography
Matthew Hollow
Rodney Todd-White
& Son

Design Group
A2-GRAPHICS/SW/HK

Marketing Executive
Brett Rogers

Client
The British Council

Complete Books

Design Director
Phil Cleaver

Designers
Karen Billingham
Darren Sherwood
Tim Moore
Robert Jones

Design Group
et al-design

Copywriter
Alastair Hamilton

Typographer
Phil Cleaver

Photographer
John Stone

Account Handler
Robert Jones

Marketing Executive
Anne Ashby

Publisher
The Arcadian Library
in association with
Oxford University Press

Lexicon of Phenomena and Information Association.
An Introductory Home Apparatus (Plastic Ono
Band) used assemblages of found materials
to make multiples. 1990s artists were prepared
to repeat artworks and employ ready-mades
— and they called both artist's multiples.

Traditionally, there had been the assumption
that the artist's multiple was three-dimensional,
and photographs, prints and books could not be
counted as multiples. The huge multiples output
of Joseph Beuys in the 1970s and 1980s undermined
this assumption. The 1990s took this critique
further. Paul Winstanley's Exhibition (2000), six
transfers on cast plastic, with images of Augéan
non-spaces — timeless and anonymous waiting
rooms and student lounges — offers purchasers
the opportunity to hang their own exhibition of
'paintings': a 1998 exhibition at the Tate itself
becomes a new artwork, a game or toy, a multiple
in an edition of 100. Mark Dickenson's Painting: 1
to 20 (1997) with its rows of numbers painted in
acrylic on canvas (perhaps a reference to 'painting
by numbers') is a painting as much as a multiple,
although there are 20 of them, almost identical.
The two/three dimensional dilemma is neatly
sidestepped by Dan Hays: his Sanctuary (2000)
with its perspex lenticular over a digital cibachrome
print is a two-dimensional 'painting' (I appreciate

Complete Books

Design Director
Jonathan Ellery

Designers
Jonathan Ellery
Jamie Roberts

Copywriter
Bruce Gilden

Publisher
Trebruk UK

Typographers
Jonathan Ellery
Jamie Roberts

Photographer
Bruce Gilden

Design Group
Browns

Account Handler
Philip Ward

Marketing Executive
Ross Bradshaw

Client
Trebruk UK

Complete Books

Design Director
Quentin Newark

Designer
Glenn Howard

Author
Stuart Hall

Design Group
Atelier Works

Editor
Neil Baber

Publisher
Phaidon Press

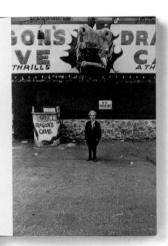
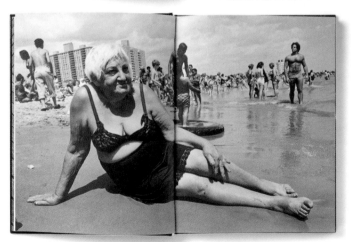

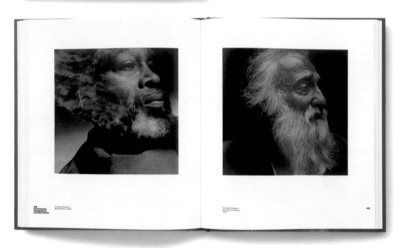
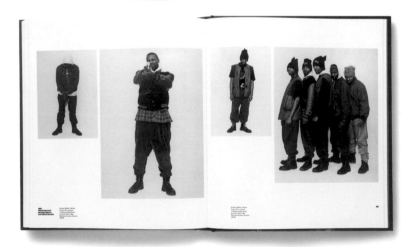

Complete Books

Design Directors
Joel Van Audenhaege
Franck Sarfati
Olivier Stenuit

Typographer
Joel Van Audenhaege

Photographers
Daniel Quesney
Eugene Atget

Design Group
Signes Particuliers

Publisher
Arp Editions

Complete Books

Design Director
Stefan Sagmeister

Designer
Hjalti Karlsson

Writer
Peter Hall

Typographers
Stefan Sagmeister
Hjalti Karlsson

Cover Photography
Kevin Knight

Design Group
Sagmeister

Publisher
Booth-Clibborn Editions

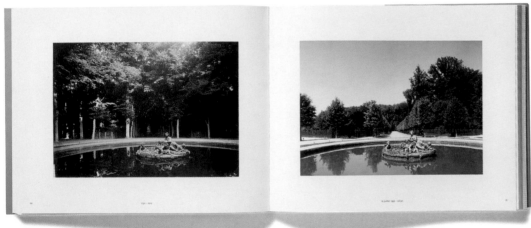

Complete Books

Design Director
Jonathan Ellery

Designers
Jonathan Ellery
Lisa Smith

Copywriter
Susan Meiselas

Typographers
Jonathan Ellery
Lisa Smith

Photographer
Susan Meiselas

Design Group
Browns

Account Handler
Philip Ward

Marketing Executive
Ross Bradshaw

Publisher
Trebruk UK

Complete Books

Design Director
Jurek Wajdowicz

Designers
Lisa LaRochelle
Jurek Wajdowicz

Copywriters
Emerson, Wajdowicz
Studios
The Rockefeller
Foundation

Photographers
Antonin Kratochvil
Gilles Peress
Carolina Salguero
Larry Towell
Alex Webb

Design Group
Emerson, Wajdowicz
Studios

Publisher
The Rockefeller
Foundation

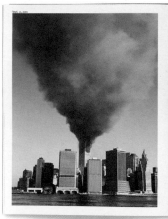

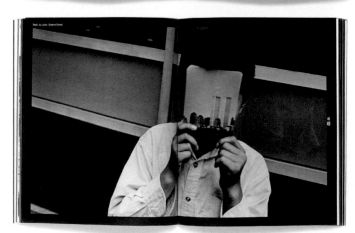

Complete Books

Design Director
Paul West

Designer
Paul West

Copywriters
Bob Gruen
Chris Salewicz
The Clash

Typographer
Paul West

Photographer
Bob Gruen

Design Group
Form

Publisher
Vision On

Complete Books

Design Director
Stephen Doyle

Designer
Rosemarie Turk

Copywriter
A S Byatt

Photographer
Victor Schrager

Design Group
Doyle Partners

Publisher
Graphis

Client
Victor Schrager

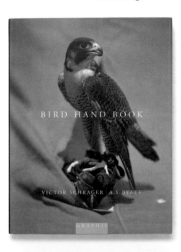

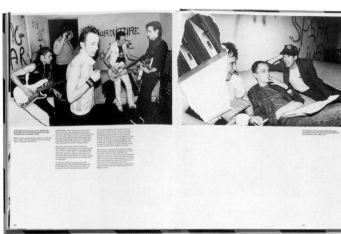

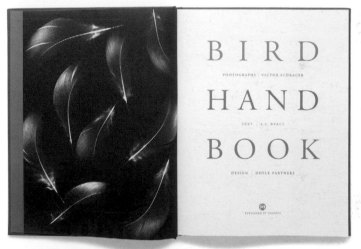

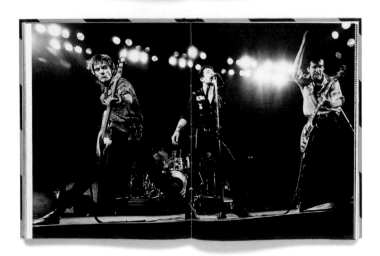

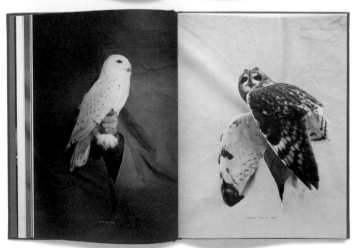

Complete Books

Design Directors
Joel Van Audenhaege
Franck Sarfati
Olivier Stenuit

Typographer
Joel Van Audenhaege

Photographers
Andre Jasinski
Jean-Paul Brohez

Design Group
Signes Particuliers

Publisher
Maison D'Erasme La
Lettre Volee

Complete Books

Design Director
Alan Fletcher

Designer
Alan Fletcher

Authorial Content
Alan Fletcher

Typographer
Alan Fletcher

Illustrator
Alan Fletcher

Design Group
Alan Fletcher

Publisher
Phaidon Press

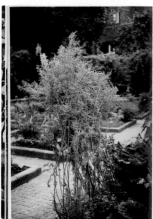

Complete Books

Design Directors
Jason Gregory
Mark Bonner
Peter Hale
Simon Esterson

Designers
Jason Gregory
Mark Bonner
Peter Hale
Sam Blok

Typographers
Jason Gregory
Mark Bonner
Peter Hale

Photographer
Paul Tozer

Design Groups
GBH
Esterson Lackersteen

Account Handler
Jo Bradshaw

Marketing Executives
Louise Fowler
Lloyd Kirton

Publisher
Laurence King
Publishing

Client
D&AD

Magazine Covers

Design Director
Shem Law

Designer
Shem Law

Publisher
Ashley Munday

Photographer
Andy Earl

Client
Radio Times

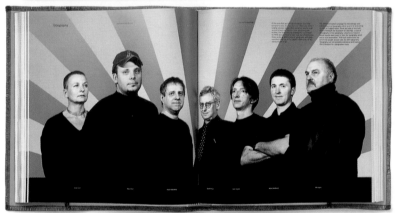

Magazine Covers

Creative Director
Mark Porter

Designer
Mark Porter

Photographer
Rob Howard

Client
The Guardian

Magazine Covers

Creative Directors
Mark Porter
Roger Browning

Design Directors
Mark Porter
Roger Browning

Designers
Mark Porter
Fraser McDermott
Roger Browning

Photographers
Sean Smith
Guang Niu

Client
The Guardian

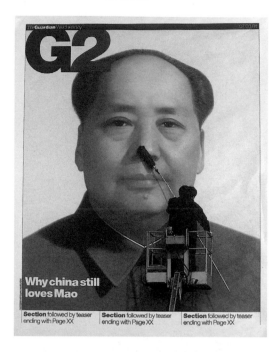

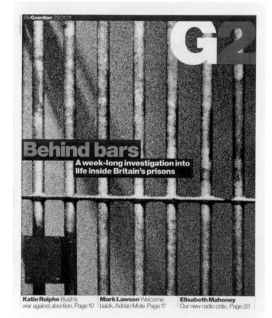

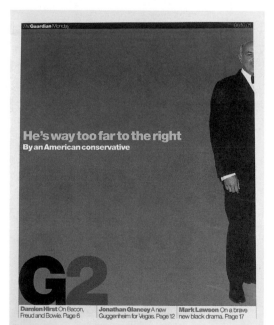

Magazine Covers

Design Director
Jeremy Leslie

Designer
Jeremy Leslie

Editors
Jan Burney
Andrew Losowsky

Illustrator
Austin@New

Photography
Corbis
EPA

Account Handler
Alex Silcox

Marketing Executive
Paivi Martikainen

Publisher
John Brown Publishing

Client
M-Real

Magazine Covers

Creative Director
Scott King

Designer
Patrick Duffy

Photographer
Donald Christie

Publisher
Jon Swinstead

Magazine Features

Design Directors
Masoud Golsorkhi
Andreas Laeufer

Designer
Marcus Codrington-Fernandez

Copywriter
Brian Millar

Typographer
Dave Robinson

Photographer
Daniel Brooke

Design Group
Myrtle

Publisher
Tank Publications

Client
Mined

Complete Magazines

Design Director
Gerard Saint

Designer
Gerard Saint

Editor
Martin Raymond

Creative Directors
Christopher Sanderson
Marie-Christine
Viannay

Typographer
Gerard Saint

Photographers
John Midgley
Sandro Sodano
Coppi Barbieri
Rick Pinkcombe

Illustrators
Jody Barton
Jasper Goodall

Design Group
Big Active

Publisher
Metropolitan
Publishing

Client
Viewpoint (London)

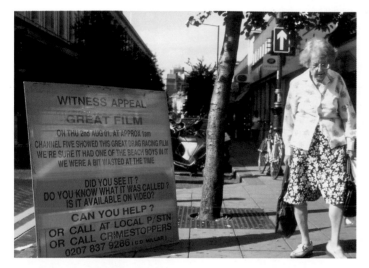

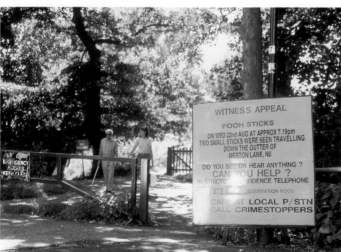

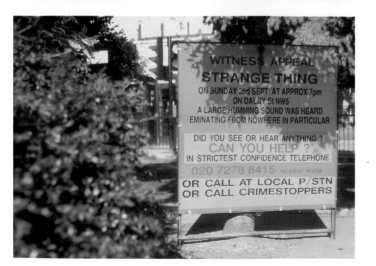

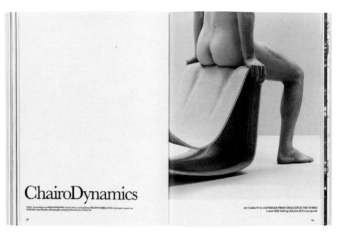

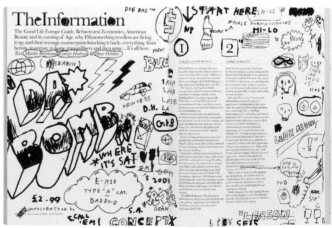

Complete Magazines

Design Directors
Johannes Plass
Paul Neulinger

Designers
Daniel Bognar
Christian Dworak
Marion Fink
Steffi Tomasek

Illustrators
Daniel Bognar
Christian Dworak

Design Group
Mutabor Design

Account Handler
Johannes Plass

Marketing Executive
Peter Groschupf

Publisher
G + J Corporate Media

Client
Peter Groschupf Brand
Communications for
Premier Automotive
Group

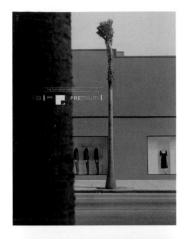

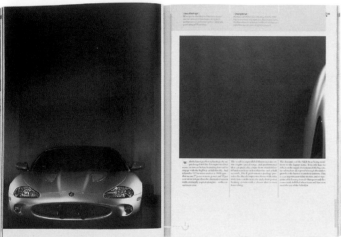

Complete Magazines

Design Directors
Johannes Plass
Paul Neulinger

Designers
Christian Dworak
Jessica Hoppe

Illustrators
Christian Dworak
Jessica Hoppe
Mats Gustafson

Design Group
Mutabor Design

Account Handler
Johannes Plass

Marketing Executive
Peter Groschupf

Publisher
G + J Corporate Media

Client
Peter Groschupf Brand
Communications for
Premier Automotive
Group

Complete Magazines

Design Director
Nick Bell

Designers
Nick Bell
Kim Petersen
Silke Klinnert
Axel Feldmann
Pia Wall

Typographers
Conor Mangat
Magnus Rakeng

Illustrator
Jasper Goodall

Editor
John L Walters

Design Group
UNA (London)
designers

Publisher
Quantum Business
Media

Complete Magazines

Design Director
Nick Bell

Designers
Nick Bell
Kim Petersen
Silke Klinnert
Axel Feldmann
Pia Wall

Typographers
Conor Mangat
Magnus Rakeng

Illustrator
Jasper Goodall

Editor
John L Walters

Design Group
UNA (London)
designers

Publisher
Quantum Business
Media

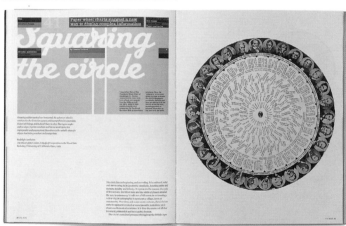

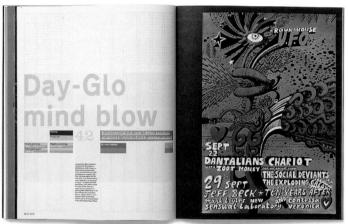

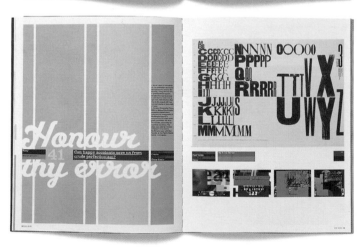

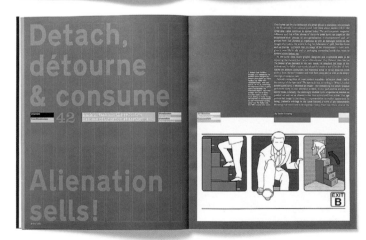

Complete Magazines

Design Director
Garth Walker

Contributors
Conrad Botes
Scott Robertson
Alex Sudheim
William Rae
Brandt Botes

Rikus Ferreira
Anton Visser
Garth Walker
Dale Halvorsen
Nick Paul
Jacki Kaye
Sheila Dorje

Design Group
Orange Juice Design

Account Handler
Garth Walker

Publisher
Orange Juice Design

Complete Magazines

Designers
Agathe Jacquillat
Tomi Vollauschek

Design Group
FL@33

Client
FL@33

Complete Magazines

Design Director
Adam Brown

Design Group
01.02

Publisher
Andi Engel

Client
Artificial Eye

Complete Magazines

Design Director
Ben Segal

Designer
Seth Zucker

Publisher
David Shear

Copywriters
Saskia Cornes
Douglas Coupland
N. Rain Noel
Zoë Ryan
Hilde Sandeik

Photographers
Erik Brekke
Menno Kök
Dah Len
Graham MacIndoe
Peter Medilek
Eva Mueller
Bill Owens
Lila Subramanian
Edel Verzijl
Andrew Zuckerman

Design Group
Tank NY

Account Handler
Marcie Panmet

Marketing Executives
Gail Schultz
Daniel Guss

Client
Totem

Liam

Jason Wood talks to
Stephen Frears

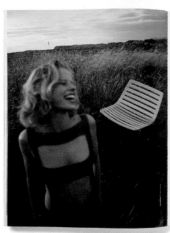

25

Artificial Eye

04 **enthusiasm**

**Current and
forthcoming releases**

Contents

All started to laugh, but Vanya started to cry.

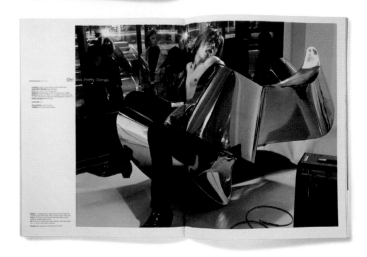

Complete Magazines

Design Director
Fernando Gutiérrez

Designer
Morgan Sheasby

Creative Editors
Adam Broomberg
Oliver Chanarin

Editor-in-chief
Renzo di Renzo

Design Group
Pentagram Design

Publisher
Colors Magazine

Clients
Benetton Group SPA
Fabrica Research
Centre

PRODUCT DESIGN

NICK OAKLEY, NEW CONCEPTS INTEL CORPORATE TECHNOLOGY GROUP

PRODUCT DESIGN

TOP ROW; *Left to Right:*
DICK POWELL, SEYMOUR POWELL • CHRIS CHRISTOU, FUTURE CREATIVE
BOTTOM ROW; *Left to Right:*
CLIVE GRINYER, DESIGN COUNCIL • SEBASTIAN BERGNE, BERGNE: DESIGN FOR MANUFACTURE • MARK DELANEY, SAMSUNG DESIGN EUROPE • ANDY DAVEY, TKO DESIGN

Comment by Dick Powell

Nowhere is trust in a brand destroyed more rapidly than in a product that doesn't deliver, doesn't work, or worse, breaks down. But well designed products continually remind you of their excellence. Apple have long understood this, investing heavily in an emotional ergonomy that rewards constantly. So it's another year with a heavy Apple crop, every bit as tasty as previous years, and therefore no surprise to see three award winners. The G4 laptop, the iBook, and now the iPod; these products reward on many levels — more manufacturers should care enough to engineer to their level of detail. iPod's interface is as well thought out as the hardware, and this is one of Apple's strengths as one of the few companies that controls both. Apple aside, it was a strong year with considerable breadth. It was refreshing to see Plateau, a cantilever workbench that is redefining how people work. Muji's CD player is conceptually great, but doesn't deliver adequate sound. Finally, it was notable that many entries came from in-house design teams — evidence perhaps that manufacturers are beginning to realise that no amount of branding can compensate for a poorly designed product.

PRODUCT DESIGN SPONSORED BY KEEN

Gold Award
for the most
outstanding
Product
for Leisure
sponsored by
Keen

Silver Award
for the most
outstanding
Product
for Leisure
sponsored by
Keen

Designers
Bart Andre
Danny Coster
Daniele de Iuliis
Richard Howarth
Jonathan Ive
Steve Jobs

Duncan Kerr
Matthew Rohrbach
Doug Satzger
Cal Seid
Christopher Stringer
Eugene Whang

Manufacturer
Apple Computer

Design Group
Apple Design Group

Client
Apple Computer

iPod
The iPod is the first MP3 player to hold 1,000 songs, 5 gigabytes of data, have an 8 hour battery and only weigh 6.5 ounces. The iPod is a truly portable device which is very simple to use.

When the iPod is first plugged into the user's Macintosh, all of the songs are automatically downloaded into the iPod at the speed of about 10 seconds per CD of music. Additionally, the iPod automatically charges over the same FireWire cable whenever connected to a Macintosh. The same cable connected to the supplied power adapter will also allow charging, minimising on the number of cables and ports needed. The iPod is capable of up to 20 minutes of skip protection and comes with a rechargeable Lithium Polymer battery enabling 10 hours of continuous playback. The icon of the device was defined by the utility of the interface.

The polycarbonate/ABS twin-shot resin top snaps into the polished stainless steel bottom without the need for any additional fastners.

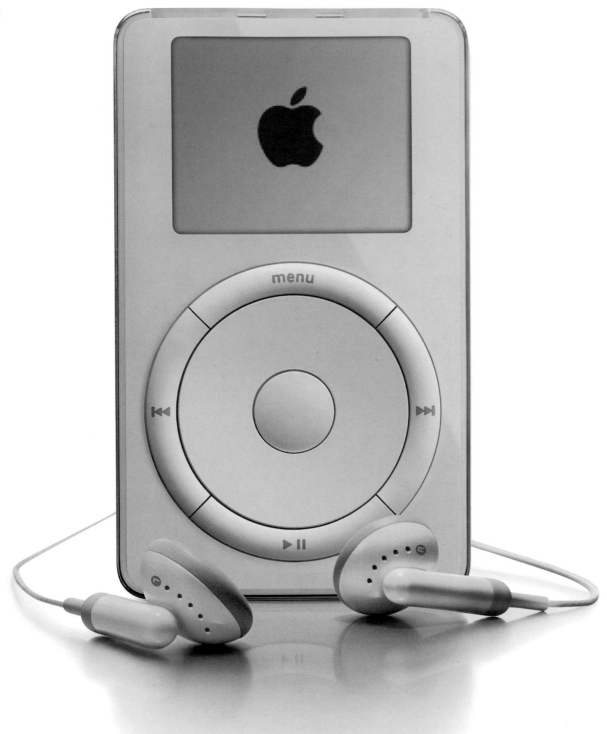

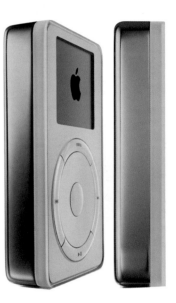

Silver Award
for the most
outstanding
Product for Work
sponsored by
Keen

Designer
Jonathan Crinion

Technical Designers
Sergio Malorni
Gary Bennett

Photography
©Keith Parry

Manufacturer
Staverton

Client
Staverton

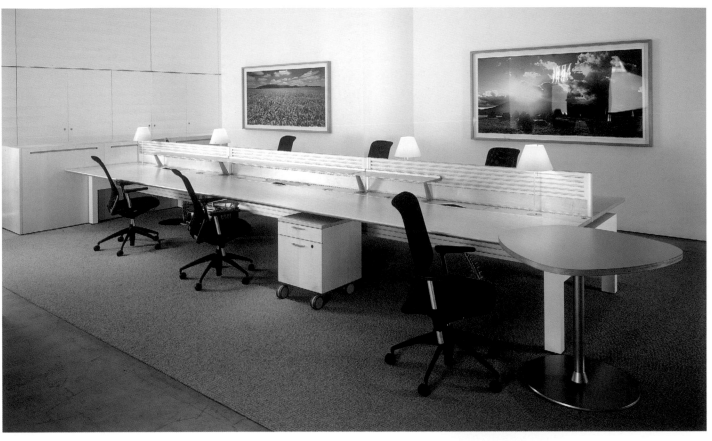

Plateau

The Plateau table system removes the clutter and excess material of multiple desks to provide a clean and elegant base for teams of people who work together on a permanent daily basis or for remote workers whose visits are irregular or ad hoc. It is a barrier-free platform, offering generous personal space, that helps promote greater interaction and open communication amongst team members.

The single, aluminium support beam can run up to six metres between leg ends without any interruption, allowing flexibility in the number of workspaces allotted on either side of the table. Longer spans can be reached with the introduction of a smaller intermediate leg.

Power and data access along the central zone is simple and unobtrusive, both above and below the desktop.

Personalisation is easily accommodated within the group hub with height-adjustable modules and the use of screens, shelves, mobile storage and lighting.

Users can come and go, or move around with their personal effects, but Plateau remains the underlying support.

Silver Award
for the most
outstanding
Product for Work
sponsored by
Keen

Designers
Bart Andre
Danny Coster
Daniele de Iuliis
Richard Howarth
Jonathan Ive
Steve Jobs

Duncan Kerr
Matthew Rohrbach
Doug Satzger
Cal Seid
Christopher Stringer
Eugene Whang

Manufacturer
Apple Computer

Design Group
Apple Design Group

Client
Apple Computer

iBook

The new iBook is a full-featured notebook computer that is so small and light it qualifies as a sub-notebook.

The iBook measures only 11.2 x 9.1 x 1.35 inches and only weighs 4.9 pounds, squeezing a full array of features normally found only in more expensive high-end notebooks. Features include a choice of optical drives including a Combo drive which enables the user to watch DVD movies as well as listen to and burn their own CDs on the road. The new iBook has a super high resolution XGA display that measures 12.1 inches, a compact 5-hour Lithium-Ion battery with an LED 'fuel gauge' that shows how much battery life is left, as well as integrated Airport antennas for wireless networking. Since the new iBook was designed specifically with the consumer and education market in mind, durability was a key concern. Polycarbonate was chosen for the enclosure due to it's high impact resistance and critical components such as the hard drive are shock-mounted. Many of the elements that are easily broken such as the i/o door, external buttons and latches have been removed, leaving clutter free surfaces. Even the sleep state indicator has been hidden behind the front surface, becoming visible only when the unit is asleep and gently cycling from dim to bright. The single, sturdy metal hinge swings the display open to rest unexpectedly far away from and below the keyboard level, which makes the product feel larger and more open when it's in use, and conversely very compact when it's closed.

Silver Award
for the most
outstanding
Product for Work
sponsored by
Keen

Designers
Bart Andre
Danny Coster
Daniele de Iuliis
Richard Howarth
Jonathan Ive
Steve Jobs

Duncan Kerr
Matthew Rohrbach
Doug Satzger
Cal Seid
Christopher Stringer
Eugene Whang

Manufacturer
Apple Computer

Design Group
Apple Design Group

Client
Apple Computer

Titanium PowerBook G4
The Titanium PowerBook G4 was created with the goal of being the lightest and thinnest full-featured notebook on the market.

New materials and processes were investigated, the culmination of which resulted in an enclosure made from formed Titanium, which for its thickness provided the greatest strength and stiffness. The Titanium 'skins' combined with a carbon fibre frame resulted in an exceptionally stiff and light product.

The Apple PowerBook G4 Series sets new standards for portable design and performance. These innovative notebook systems out-perform comparable competitive systems both in processing performance as well as the utility provided by the full array of features including a slot load DVD drive, full I/O and a 5 hour Lithium-Ion battery.

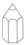

Silver Nomination
for the most
outstanding
Product for the Home
sponsored by
Keen

Designer
Naoto Fukasawa

Manufacturer
Muji

Design Group
IDEO Tokyo

Client
Muji

Muji CD Player
This CD Player was not initially designed for manufacture, but was part of an exploration into intuitive consumer products – 'Without Thought' – a collaboration between Naoto Fukasawa, Head of IDEO Tokyo and DMN (Diamond Design Management Network). The products that emerged from the workshop were exhibited in Tokyo. The CD Player was designed by Naoto Fukasawa.

The CD Player reflects the essential design approach of the workshop – to respond to people's emotional and practical needs with designs that are simple yet touch the senses. The rotating compact disc player is reminiscent of a fan. As if a breeze is delivered with the sound. The power cord is the pull-string on/off switch. The sound emits from the surround and volume and forward/reverse controls are placed on the top edge.

The Japanese retailer Muji and SPA (a specialty store retailer of private label apparel) are marketing the product in Japan, Europe and the USA. The product retails at £79.00 in Muji stores in the UK.

Silver Nomination
for the most
outstanding
Product for Transport
sponsored by
Keen

Chief Designer
Bart Hildebrand

Manufacturer
BMW AG

Design Group
Mini Design Team

Client
BMW AG

Mini Cooper

The MINI family has gained a third member. Hot on the heels of the successful launch of MINI One and MINI Cooper. Its predecessor re-wrote the history books in 1961 and, with stunning looks, a performance to match and unrivalled driving dynamics and equipment levels, the MINI Cooper S is looking to do the same.

The 'heart' of the MINI Cooper S sees state-of-the-art supercharger and intercooler technology position the car as the most powerful performance model in its class, breaking the magical 100 bhp per litre mark. However, power is pointless if the car isn't a great drive and MINI Cooper S takes the MINI's fun factor to a higher level with a heady mix of technology and engineering. The uprated engine is perfectly tuned to a brand new 6-speed gearbox. Meanwhile a long wheelbase, wide tracks and low centre of gravity see MINI Cooper S glued to the tarmac.

MINI Cooper S is the safest small car on the road with big-car levels of active and passive safety, backed up with MINI's incredibly stiff bodyshell that is two to three times more rigid than the competition. It will also be instantly recognisable as the top-of-the-range MINI. The exterior gives a clear, yet subtle impression of the car's power and agility, whilst the interior oozes quality and offers outstanding levels of standard and optional equipment.

The great drive, stunning styling, use of high-quality materials and high levels of standard equipment position MINI Cooper S as a genuinely special car in the small car market. It is a car not just for the enthusiast, but also the buyer simply looking for a practical, small car to stir the soul. MINI One and MINI Cooper have laid down a superb benchmark. MINI Cooper S is set to take the Oxford-built new MINI family to another level, with all the potential to become a classic car, just like its older brother.

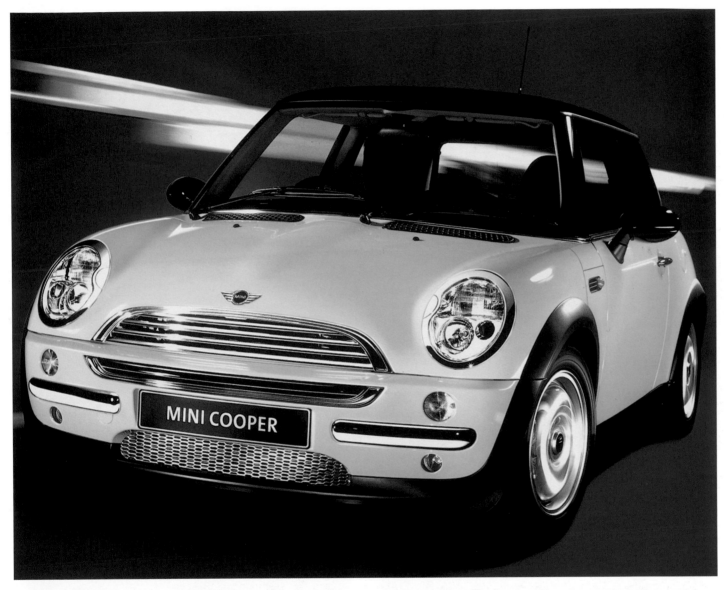

Products for the Home

Designer
Sam Hecht

Technical Designer
Sam Hecht

Manufacturer
Netgem SA

Prototype Engineering
Simon Leach

Photography
Tom Miller

Design Group
IDEO London

Account Handler
Sam Hecht

Client
Netgem SA



Products for the Home

Designers
Clive Goodwin
Matt Garwood

Technical Designer
Kim Young-Joon

Manufacturer
Samsung Electronics

Design Group
Samsung Design
Europe

Client
Samsung Electronics

Netbox Internet / TV Remote Control

Netgem, a French manufacturer of internet television modules, asked for a design of a new remote control that differentiated it from regular TV remotes, for the fact that its functioning and length of use, was quite different.

Made entirely of infra-red transmittable polycarbonate, it uses translucency of the material as its function. The product's seamlessness of material is achieved by making the whole product out of IR compatible plastic, thus removing parts in manufacturing and lowering cost, and also creating a new formation for such a product, where split lines and connections are minimal. It stands up, and fits in the hand using a twisted form through 90 degrees. A new way of holding the remote was investigated because unlike a regular TV remote, this product is being used for much longer periods of time.

24" LCD Monitor

The Rubens 24" LCD monitor is one of the first flat screen technology products manufactured specifically with the needs of the professional and domestic consumer in mind. In the design of this product, Samsung Design Europe has developed a visual language that is professional, communicates high-end technology, but is also applicable to a high quality domestic home entertainment set-up.

The main driver for the design was versatility. This product's use ranges from a status symbol upon a CEO's desk, to contract exhibition installation, to the centrepiece of a high-end domestic home entertainment centre.

The aluminium stand functions not only as a desktop support, but can also be used to mount the screen to the wall or suspend it from a ceiling. The speakers can be freestanding, or using connector pieces can be mounted alongside the screen.

Products for the Home

Designers
Adrian Caroen
Dick Powell
Richard Seymour

Manufacturer
Aqualisa

Design Group
Seymour Powell

Technical Designers
Paul Newcombe
Tracy Shepherd
Joss Langford
Dan Flicos

Marketing Executive
Martyn Denny

Client
Aqualisa

Aqualisa Quartz Shower

Quartz is Aqualisa's new electro-thermostatic shower system that has been designed for minimum intrusion into the showering environment, high performance and ease of use and installation.

Quartz uses a completely new architecture. The slim-line shower controls are connected by low voltage data cable to a remotely sighted electro-thermostatic mixer and processor that can be located either below the bath, in the loft or the airing cupboard. This allows the controls to be simply surface mounted or with the 'off the wall' version be an integral part of the shower rail.

The control is designed to be extremely simple to use. The push button start, stop has back lighting that pulses until the shower is at the right temperature.

A push button boost control allows you to increase the flow, and an indexed rotary control allows accurate temperature change.

The careful design of the Quartz control has resulted in a combination of simplicity of use and installation with aesthetic appeal.

Seymour Powell worked closely with the design engineers from Aqualisa and the Generics group.

Products for the Home

Designer
Andrew Stokes

Manufacturer
Richardson Sheffield

Design Group
Richardson Sheffield

Client
Richardson Sheffield

Balance Kitchen Knives
Balance is a fully forged knife range from Richardson Sheffield. It employs manufacturing techniques that are widely known to produce the best knives but takes a radical slant on the knive's handle design and ergonomics.

Chefs always talk about knives having good balance, Balance knives takes this literally! Each blade is counter balanced according to it's use and size by a stainless steel end cap in the handle, thus making it the first knife ever to be truly perfectly balanced. In addition balance has an unusual handle shape to assist people to hold the knife in the correct way making it a joy to use!

To complement the knives and accentuate the form there is an equally innovative take on knife storage. An ash column houses the blades whilst the handles nestle into a neoprene strip on a perspex base. There are magnets set into the perspex which pulls the handles into the neoprene with a beautifully satisfying feeling.

Products for the Home

Designers
Jim Dawton
Richard Smith
Dick Powell
Bernd Koëhler

Technical Designer
Gérard Cornet

Manufacturer
Rowenta France

Design Group
Seymour Powell

Marketing Executive
Michel de Siqueira

Client
Rowenta France

Rowenta Ambia Vacuum Cleaner
Our brief was to design a super compact vacuum cleaner to replace an existing, long established, Rowenta product named Dymbo. Whether the product should be evolutionary or revolutionary was not defined, it must, however, be both 'Dymbo' and 'Rowenta'.

We concluded that Rowenta DNA was embodied in logical geometry, economy of line, simplicity of surface and teutonic attention to detail and quality.

We pushed Rowenta for a revolutionary approach, reconfiguring the architecture into a more vertical format, moving the handle from the front of the product to a 'dorsal' position on top. We strove for an innovative feature that would benefit the user, and at the same time set the product apart, in keeping with the original Dymbo back in 1994.

Our solution was to design a fragrance device that plugs into the rear of the cleaner. Within the device is a ceramic tablet that can be loaded with any liquid fragrance or oil. The levels of perfume filling the room is adjusted by rotating a dial.

The perfume device is just one element of a complete design solution for a vacuum cleaner, launched in 2001, that is redefining the super compact market.

Products for Work

Designers
Perry King
Santiago Miranda

Manufacturer
Luxo Borens AB

Client
Luxo Borens AB

Smoothlight
Smoothlight is an elegant and innovative
pendant luminaire, combining uplighting with
decorative downlighting.

The fitting is designed for general illumination in
offices and other public spaces. It provides indirect
light reflected not only from the ceiling but also from
the central reflector mounted vertically between the
two light sources. This configuration guarantees
correct levels of illumination of the office
environment with the added advantage of a varied
direction of light to help create direction and
perspective that are so important for well-being
in the work space.

Smoothlight has an open design with two T5
fluorescent lamps at either side, providing uniform
indirect illumination. The centre of the light
fitting has a distinctive blade form that reflects
the lamps on either side and produces a gentle
and attractive downlight.

Available in three lengths, each length can be
supplied in a twin lamp or four lamp version. With
the four lamp version it is possible to use a single
light fitting where two would normally be required.
Smoothlight can also be supplied for continuous
row mounting.

Manufactured from high quality aluminium, it is
available in white or aluminium-grey. The central
section is an anodised aluminium.

**Products for Health
and Leisure**

Designers
Stefan Augustin
Mike Ninil

Technical Designer
Rudi Mueller

Manufacturer
BMW AG

Design Group
BMW Design Team

Client
BMW AG

StreetCarver
With this newly developed longboard, gliding and
floating along the road, something that has hitherto
only been the stuff of dreams, is now a large step
closer to reality. A flexible board, similar to a
snowboard, and a unique four-wheel steering
technology makes the road surface feel like
something approaching deep off-piste snow, or a
foaming surfer's wave.

The StreetCarver has redefined mobility. BMW
has discovered yet another facet of the joys of driving
and offers quite an experience. It is secured on
sound foundations, namely the companie's
expertise in the field of high-tech and design.

In the beginning there was a vision. The aim was
to enable gliding along the road. Indeed, with it's
progressive steering, the StreetCarver really does
behave like a snowboard or surfboard, in that it is
possible to change direction suddenly by shifting
your centre of gravity, what is known as 'carving'.
Despite spectacular manoeuvres, controlled driving
enjoyment is guaranteed. At higher speeds, the
driver's own weight sees to it that the StreetCarver
always returns to a stable position.

The excellent driving characteristics are
attributable to, among other things, an original
component from the BMW 5 Series chassis, a
hinged bracket, which has been integrated into the
StreetCarver's aluminium chassis. Road contact is
maintained by low-profile polyurethane wheels. If the
tyre wears beyond a certain depth, wear indicators
become visible. The two-part aluminium outer rim
can be dismantled easily, thus making it possible to
change the tyre without any difficulty.

Products for Work	Photography	Interaction Design	Project Leader
	Lee Funnell/Domus	Heather Martin	Roberto Fraquelli
Designer			
Sam Hecht	**Prototyping**	**Research and**	**Marketing Executive**
	Roger Penn	**Development**	Marysia Woroniecka
Technical Designer		Rem Koolhaas	
Steve O'Connor	**Interaction**	Markus Schaefer	**Client**
	Engineering		Prada (New York)
Manufacturer	Richard Turnidge	**Design Group**	
IDEO Europe		IDEO London	

Prada Staff Devices

A new set of products that allow Prada staff members to choreograph an in-store sales experience has been designed. These technological devices are designed as precision tools for specific use in Prada store environments – the first being at the New York Guggenheim. Their ability to read and relay information quickly and easily denotes a specifically Prada way of doing things.

The Prada Staff Device, Recharging Trolley, Staff Clips and Customer Cards are designed with a functional sensibility, where their aesthetic is evaluated for its ability to integrate with other parts of the store system. The tool, like a torch, is not owned by an individual, but is instead accessible to all staff as needed. The device also has a built in laser pointer, to allow staff members to point to items in the store that are a distance away, elegantly. The use of radio frequency (RF) tagging on garments, Staff Clips, Customer Cards, ubiquitous screens and in-store displays allows for the management of 'invisible' information and the orchestration of an interactive Prada customer experience. In addition to its aesthetic value, each RF tag is individually encoded, allowing access to stored information such as a certificate of authenticity, garment details, date and location of purchase, buyer's ID and price. The Prada experience continues beyond the walls of the store.

INTERACTIVE & DIGITAL MEDIA

Left to Right:
ALEXANDRA JUGOVIC, HI-RES! • **MAXINE GREGSON**, ARNOLD INTERACTIVE

INTERACTIVE & DIGITAL MEDIA

Top Row; *Left to Right:*
JOHN WARWICKER, TOMATO • RICHARD SMITH, JANNUZZI SMITH • GRANT ORCHARD, STUDIO AKA

MIDDLE ROW; *Left to Right:*
JOOP RIDDER, PROFORMA • YANNIS MARCOU, ITRAFFIC • JEAN-ANDRE VILLAMIZAR, TANK UK • RICHARD DOUST, CENTRAL SAINT MARTINS COLLEGE OF ART AND DESIGN • SIMON WATERFALL, POKE

BOTTOM ROW; *Left to Right:*
NEALE JOHNSON, METROPOLIS DVD • NIALL SWEENEY, PONY • DALJIT SINGH, DIGIT

Comment by Richard Smith & John Warwicker

On the evidence of this year's submissions, the boundaries of this category were not so much redefined as repainted. The familiar visual gimmicks were much in evidence, used to gloss over dull or poorly conceived content. The principles of excellence are easy to evaluate: What experience was intended? How was it constructed? Does it fulfil its objective? More importantly, does it engage the spirit enough to transcend the medium and inspire? The exceptions did, including the Ensenda and Habitat websites and the Mercedes A-Class CD-Rom. But most of what we saw fell short of adequate. The word 'saw' is telling while sound is used to such gratuitous effect. The Diesel and Ralf Wengenmayr sites did most to alleviate the tinnitus of online 'bleeps' and 'swishes' and confirm the value of sound as content in its own right. Elsewhere, thoughtlessness abounds. Content and navigation often appear to have been conceived as separate undertakings, although Habitat and Wengenmayr proved that they can be simply and effectively interwoven. The Barbican's 'Jam' site was refreshing and playful, even if it did generate friction between interface and interfaced. The requirement now is surely for more inventiveness driven by a greater sense of purpose.

INTERACTIVE & DIGITAL MEDIA SPONSORED BY WEBOPTIMISER

Silver Nomination for the most outstanding Consumer Website sponsored by Weboptimiser

Creative Directors
Patrick Baglee
Wilbert Das
Erik Kessels
Johan Kramer

Design Directors
Richard Holley
Trevor Chambers

Technical Director
John Hatfield

Interactive Designer
Peter Aston

Graphic Designer
Peter Aston

Programmers
Mark Dawber
Wayne Pascoe

Copywriter
Patrick Baglee

Photographer
Jean Pierre Khazem

Account Handler
James King

Design Group
EHS Brann

Marketing Executive
Bob Shevlin

Client
Diesel Creative

www.stayyoung forever.com

Silver Nomination for the most outstanding Consumer Website sponsored by Weboptimiser

Creative Director
Michael Volkmer

Design Director
Heike Brockmann

Screen Designers
Melanie Lenz
Elke Grober

Flash Composing
Samuel Ruckstuhl

Programmers
Peter Reichard
Samuel Ruckstuhl

Head of Project
Michael Volkmer

Project Manager
Natascha Becker

Design Group
Scholz & Volkmer, Intermediales Design

Client
Ralf Wengenmayr

www.ralfwengen mayr.com

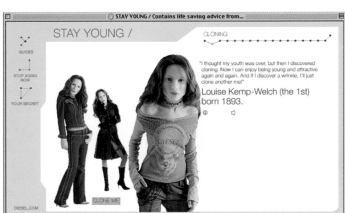

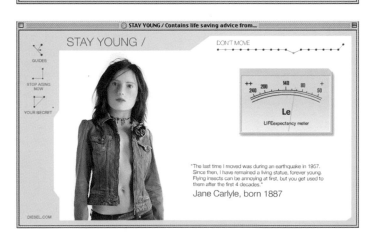

Silver Nomination
for the most
outstanding
CD-ROM
sponsored by
Weboptimiser

Creative Director
Michael Volkmer

Design Director
Heike Brockmann

Interactive Designers
Michael Dralle
Dominik Lammer
Philipp Bareiss
Elke Grober
Katherin Schüler
Anne Wichmann

Programmer
Peter Wolfrum

Copywriter
Katharina Schlungs

Project Manager
Christian Müller

Video Producer
DAS WERK, Digitale
Bildbearbeitungs

Creative Director
Ralf Ott

Editor
Timo Fritsche

2D Artists
Carolin Vedder
Till Heim

Henry Artist
Achim Schuhmacher

Project Managers
Christian Müller
Sonja Conrad

3D Artist
Diane Preyer

3D Animators
Tim Leydecker
Diane Preyer

Music Composers
J Jochen Helfert
Mark A Frank

Cover Design
Jutta Ottmann

Design Group
Scholz & Volkmer,
Intermediales Design

Marketing Executive
Susanne Vetter

Client
DaimlerChrysler AG

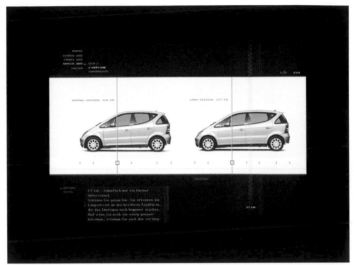

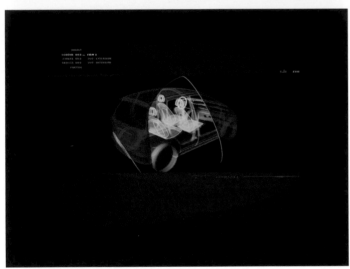

Silver Nomination
for the most
outstanding
Consumer Website
sponsored by
Weboptimiser

Creative Director
Daljit Singh

Design Director
Brad Smith

Technical Director
Orlando Mathias

Interactive Programmer
Thomas Poeser

Graphic Designer
Chris Barnes

Programmer
Mikkel Askjaer

Graphic Designers
Matt Rice
Jon Shaw
Stuart Jackson
Kevin Helas
Hege Aaby
Mickey Stretton
Adam Williams

Copywriter
David Redhead

Video Producer
Jon Shaw

Music Composer
Owen Lloyd

Design Group
Digit

Account Handler
Claire Dimeloe

Marketing Executive
Rachel Day

Client
Habitat

www.habitat.net

Silver Nomination
for the most
outstanding
Interactive & Digital
Media, Any Other
sponsored by
Weboptimiser

Design Group
Airside

Curator
Jane Alison

Client
Barbican Art Galleries

www.onlinejam.co.uk

Silver Nomination
for the most
outstanding
Business to Business
Website
sponsored by
Weboptimiser

Creative Directors
Kevin McCarthy
Scott Ex Rodgers

Design Directors
Andrew Lau
Larry Yannes

Interactive Designers
Mark Arcenal
Nicholas Macias

Copywriter
John Mattingly

Copywriter
John Egan

Sound Engineer
Jerome Wilson

Producer
Sila Soyer

Design Group
a.k.a. Euro RSCG

Account Handler
Morgan Hudson

Account Handler
Lesley Weller

Account Handler
Nicola Mummery

Marketing Executive
Chris Mannella

Client
Ensenda

www.ensenda.com

Consumer Websites

Creative Director
Andrew Mason

Design Directors
Andrew Mason
Andy Tonkin

Technical Directors
Matt Greenhalgh
Fabio Fabrizio
Andrew Leszczynski

Interactive Designers
Andy Tonkin
Stephen Hamilton

Copywriter
Phil Rigg

Illustrators
Andrew Mason
Andy Tonkin

Production Company
Zentropy Partners

Design Group
Zentropy Partners

Account Handlers
Tim Watson
Tim Reeve
Tom Wason

Marketing Executive
Jan-Erik Hasselström

Client
Nestlé Belbilux

www.nesquik.co.uk

Consumer Websites

Creative Directors
Calle Sjönell
Tim Hearn

Art Directors
Ysabel zu Inhausen
und Knyphausen
Johan Mogren
Jakob Westman

Technical Directors
Didde Brockmann
Felix Af Ekenstam

Programmer
Felix Af Ekenstam

Copywriters
Fredrik Lundgren
Nathan Cooper

Illustrator
Fido Film

3D Animation
Fido Film

Web Design
Linus Niklasson

**Production
Companies**
St Luke's Sweden
Fido Film
Moonwalk STHLM

Design Group
Moonwalk STHLM

Account Handlers
Robert Thorgren
Nicole van Rooij-
Ekström

Marketing Executive
Annika Kreipke

Client
Speedy Tomato

www.moonwalk.se/
eng/campaign/mons
terwithoutamouth

Online Games

Creative Directors
Nathan Lauder
David Rainbird

Graphic Designer
David Rainbird

Programming
Noise Crime

Design Group
Fibre

Account Handler
Dan Holliday

Marketing Executive
Leslie Dance

Client
Motorola

www.txtmtch.com

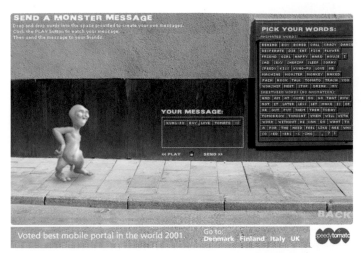

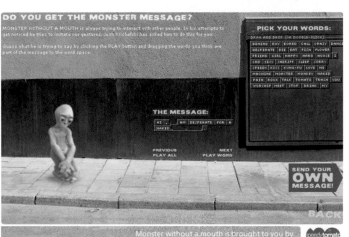

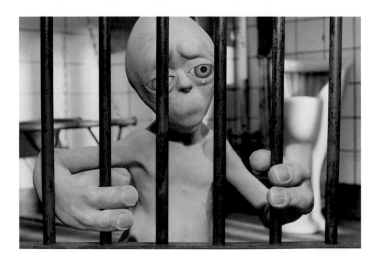

CD-ROM, DVD, Kiosks and Installations

Creative Director
Vassilios Alexiou

Design Director
Lars Eberle

Technical Director
Vassilios Alexiou

Interactive Designers
Lars Eberle
Vassilios Alexiou
Luis Alberto Martinez
Riancho

Graphic Designers
Lars Eberle
Carsten Schnedier
Andrea Feigl
Stefan Georgi

Programmers
Vassilios Alexiou
Luis Alberto Martinez
Riancho
Paul Hopton

Typographer
Carsten Schnedier

Photographers
Sonja Mueller
John Holden
Lars Eberle

Video Producer
Fillipos Arvanitakis

Sound Engineer
Vassilios Alexiou

Production Company
Less Rain

Design Group
Less Rain

Client
Less Rain

ENVIRONMENTAL DESIGN

& ARCHITECTURE

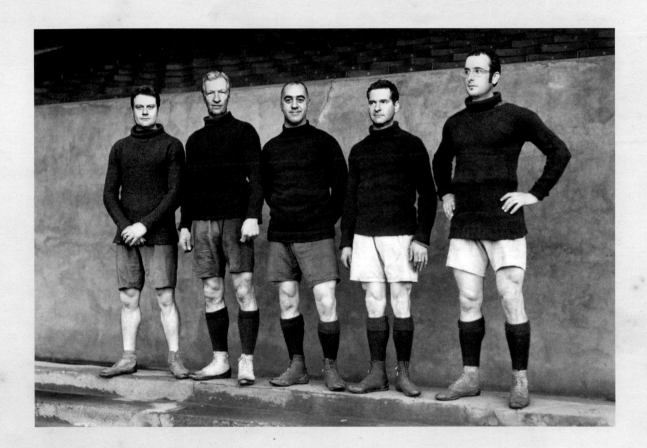

Left to Right:
BEN HAYES, ORMS • **VERNON SWABACK**, SWABACK PARTNERS • **RASSHIED DIN**, DIN ASSOCIATES
RICHARD HYWEL EVANS, RICHARD HYWEL EVANS ARCHITECTURE AND DESIGN • **PATRICK MCKINNEY**, BEN KELLY DESIGN

Comment by Rasshied Din

The general standard of work this year was good. Design for the Workplace and Design for Retail were probably the weakest categories. However, several projects stood out in each section, over and above their counterparts, fulfilling the D&AD criteria for exemplary design solutions, showing creativity, appropriateness, and good execution. Our decision was unanimous on what we felt to be the best projects. As usual with environmental awards, the knowledge and direct experiences of the judges counts for much, and this was vital in leading us towards our final selections, as it is almost impossible to judge an environment that you have not actually seen. I am concerned that some projects will be placed at a disadvantage during the gold judging. It is very hard to compare a few slides with a piece of sexy product design.

ENVIRONMENTAL DESIGN & ARCHITECTURE SPONSORED BY THE DESIGN COUNCIL

Silver Award
for the most
outstanding
Retail Design
sponsored by
Design Council

Designers
Tom Emerson
Steph Macdonald
Lee Marsden

Manufacturers
Johanna Daimer Felts
Ize

Shopfitter
John Perkins Projects

Design Group
6a Architects

Structural Engineer
Jane Wernick
Associates

Quantity Surveyor
Dobson White Boulcott
Chartered Surveyors

Project Manager
Dobson White Boulcott
Chartered Surveyors

Graphic Design
Fuel

Marketing Executive
Jethro Marshall

Client
oki-ni

oki-ni
Since opening in September 2001, oki-ni has offered
the fashion market a fresh relationship between
consumer and product. Limited edition clothes by
global and independent brands are available only
on-line from oki-ni.

6a architects won the commission to design the
flagship store with an installation based concept
that emphasises the tactile and social opportunities
of clothes shopping. Low piles of felt replace the
traditional arrangement of shelving and rails and
define oki-ni's physical landscape; the generous felt
surfaces are both display and furniture creating a
place where resting and socialising play a critical
part in the discovery of new products.

With all transactions conducted on-line, the point
of sale is also missing. Instead discreet laptops act
as a sales interface, gently assimilated amongst
products and visitors.

Three large windows on Savile Row reveal a felt
landscape within a gently sloping oak tray inserted
into the existing concrete shell. The fan shaped tray
is independent of its site leaving a series of
mysterious spaces between the low walls and the
shell concealing changing room and stairs. Clothes
hang from the sides of the oak tray with domestic
familiarity. With only the lightest of means, the raw
concrete is transformed by the oak and felt into an
enticing retreat into luxury.

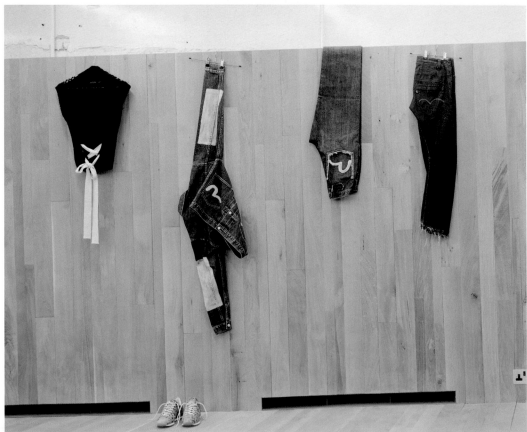

Silver Award
for the most
outstanding
Design for Leisure
sponsored by
Design Council

Director in Charge
Chris Wilkinson

Project Architect
Marc Barron

Architects
Matt Appleton
Marc Barron
John Coop
Graham Gilmour
Bosco Lam
James Parkin
Chris Poulton
Sebastien Ricard
John Smart

Structural Engineer
Connell Mott
MacDonald

Exhibition Designer
Event
Communications

Quantity Surveyor
Deacon and Jones

Services Engineer
Buro Happold

Main Contractor
Schal

Steelwork Contractor
Billington Structures

Lighting Design
Spiers and Major

Photography
Edmund Sumner
Benedict Luxmoore

Public Relations
Caro Communications

Design Group
Wilkinson Eyre
Architects

Client
The Magna Trust

The Magna Project

Magna is a Millennium Commission funded building that re-uses the redundant steelworks at Templeborough, Rotherham to create a hands-on science adventure centre organised around the Aristotelian elements – Earth, Air, Fire and Water.

The enormous main sheds at the steelworks have been stripped of extraneous ancillary buildings, the existing profiled metal skin has been repaired and the whole has been painted black to protect and unify the exterior.

The interior of the shed is an awe-inspiring space with a scale and grandeur only hinted at by the exterior.

Four new partitions house the exhibits and provide environmentally controlled conditions. The form, location and construction of these pavilions relate to the respective elements and together with the existing artefacts, retained from the steel making processes, combine to make a new composition. Visitors may explore these pavilions and the main shed with the horizontal walkway links and vertical circulation elements located at the refurbished Transformer house in the centre of the space.

The new elements, consisting of The Air Pavilion, The Water Pavilion, The Fire Pavilion and The Earth Pavilion, are steel-framed structures supported from the massive stanchions that previously supported the crane gantry rails.

The project opened to the public in April 2001, and has proved a popular success with over 100,000 visitors in the first six weeks.

Silver Award
for the most
outstanding
Design for Leisure
sponsored by
Design Council

Architects
Jestico + Whiles

Designer
Christian Liaigre

Design Group
Christian Liaigre
S.a.r.l.

Shopfitter
Pat Carter Shopfitting

Client
Hakkasan

Hakkasan

'Hakkasan', the latest restaurant by Alan Yau, founder of Wagamama and Busaba, opened to wide acclaim for its dazzling interior and innovative cuisine.

Jestico + Whiles, working with French designer Christian Liagre, have fused a distinctly modern aesthetic with traditional Chinese motifs.

Situated in an anonymous back-street off Tottenham Court Road, London, the discreet entrance is signalled by a red silk lantern suspended from a green, riven slate canopy.

Past the doorway, one descends a slate-clad staircase, lit with inset ruby red studs, to a reception lined in ebonised wood and illuminated cobalt blue glass walls.

The cavernous space beyond contains the vibrant restaurant and bar and intimate lounge. The 130 seats of the restaurant are enclosed by filigree screens of antique lacquered panels lit by silk lanterns suspended from a metal mesh ceiling. The piece de resistance, a 17m long bar of illuminated blue glass and slatted screens stretches the length of the restaurant. Behind, a top-lit wall of random, coursed, honed slate forms a dramatic back-drop. Away from this, the informality of the lounge is complemented by a burnished wood ceiling and sumptuous silk embroidered leather seating.

'Ravishing' said Fay Maschler. And the food's not bad either.

Silver Nomination
for the most outstanding Applied Graphic Design sponsored by Design Council

Designer
Matt Wingfield

Design Group
Matt Wingfield Studio

Manufacturer
Tony Golding at Vital Solutions

Client
Harvey Nichols

Marketing Executive
Janet Wardley

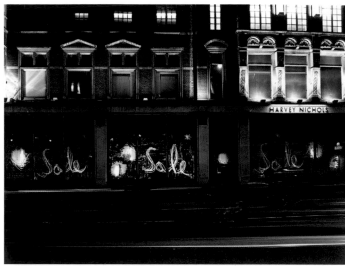

Scribble Sale

The Harvey Nichols window 'Scribble Sale' was designed to announce the January Sale of 2001. It comprised of a campaign for three stores – Knightsbridge, Leeds and Riyadh.

The main Knightsbridge windows saw a black digital wallpaper on the inside of the glass, creating a nostalgic, scratched away effect. Each window had a hand scratched 'sale' message (digitally reproduced), which illuminated against a fluorescent ground, creating a live neon glow.

Inspiration was reminiscent of a child, with wax crayons under black chalky paint. This created a hand drawn identity and method to brand and advertise the event of sale in-store.

This window was a response to the standard graphical way of presenting 'sale', challenging it and creatively communicating the 'sale' message.

Silver Nomination
for the most outstanding Applied Graphic Design sponsored by Design Council

Designers
Eddie Opara
Matt Checkowski

Creative Director
Mikon van Gastel

Art Director
Sara Marandi

Head of Production
Saffron Kenny

Producer
Lisa Villamil

Animators
Emily Wilson
Fabian Tejada

Photography
Larry Bercow

Co-ordinator
Brian Kludas

Client
Morgan Stanley

745 7th Avenue Signage

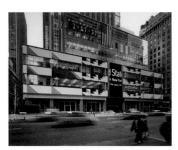

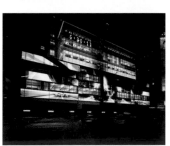

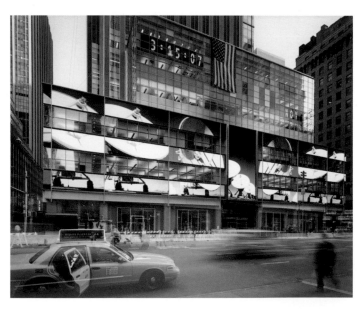

Retail Design

Designers
Ian Caulder
Penny Ward

Shopfitter
John Richard
Shopfitters

Design Group
Caulder Moore Design
Consultants

Client
Giulio Cinque

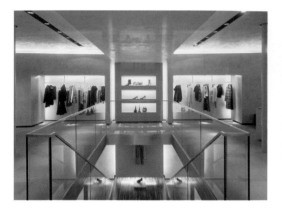

Giulio

The design creates an exhibition of the items of clothing within a stunning, sophisticated environment where they float as surreal artforms.

The clean open frontage combined with the classic colonnade dramatically projects the raw inner structure. Strong lighting creates a surreal sculptured effect to the monolithic blocks of unfinished structure, which appear to float away from the fabric of the building. The walls are angled back drawing your eyes through to the central focus of the shop, where a solid slab floats across the ceiling and disappears down into the basement. From this focus, stairs of solid limestone tread suspended between glass sides and descend to a platform of raw timber.

The feeling of the store is atmospheric and moody, raw finishes used in a refined way contrast with the status of the product. Ceiling, walls, doors, all surfaces and fixtures are in raw Italian grey plaster with a hard silver grey limestone floor, finished by Italian Artisans. This deliberate understatement contrasts with the desirable nature of the merchandise, this contradiction establishes a unique tension between environment and product.

The design reinforces the trend in the designer sector for unique, personalised environments. The trend towards anonymous minimalism has given way to a considered, crafted individual sense of space.

Retail Design

Designers
Lorenzo Apicella
Johanna Molineus
Zlatko Haban

Shopfitter
Wates Interior

Design Group
Pentagram Design

Account Handler
Mag Segretario

Marketing Executive
Simon Potts

Client
Boots the Chemists

Pure Beauty Stores

In November 2000, Pentagram was appointed by Boots to design a new inclusive beauty emporium, providing the consumer with a wardrobe of brands to choose from, and they will be aimed primarily at working women for whom beauty shopping is a part of everyday life.

Colour palettes were developed with Michael. Nash Associates and were chosen to signal the different beauty zones in the store, complementing the individual identities of the brands on offer.

A range of light, feminine colours identify the various in-store 'zones', and these colours, along with the Pure Beauty logotype (suspended between the panes of glass in the front window) lend an ethereal quality to both the brand and the interiors. This allows individual brands and zones to 'float' within the cohesive, neutral envelope of the environment.

Pure Beauty features open areas with transparent, luminous colours that are reflected and refracted within expressive, ambient lighting. A consistent scheme of shelf edge up-lighting and down-lighting has been employed to highlight products, while colour change lights have been positioned over the 'beauty bar', suggesting natural roof-lighting in the heart of the store. Materials are of the highest quality throughout, including toughened clear and etched glass, polished stainless steel ad lacquered shop fittings.

Pure Beauty has been designed to express elegance, communicating an inclusive, vivacious tone. The environment is that of a meeting place, a destination, setting Pure Beauty apart from other retail outlets. Pentagram has created an environment that projects rather than democratises the myriad of major brands on offer, framing them powerfully within the overall Pure Beauty brand identity.

Retail Design

Designer
Heather Martin

Design Group
IDEO London

Client
Prada

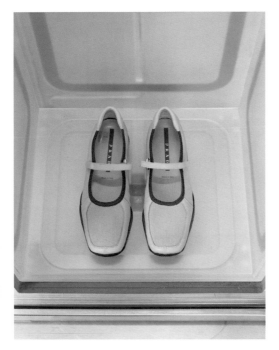

Prada New York Dressing Room
Prada wanted to explore leading edge technology for the benefit of their customers to enhance the customer experience.

IDEO worked with Rem Koolhaas and a great many partners to design, develop and implement the in-store technology.

Seven dressing rooms were installed in the new Prada Epicenter at 525 Broadway, New York. The use of technology is innovative and based on user needs.

'The Intelligent Closet': When garments are placed in the closet a radio frequency 'reader' activates an RFID tag on each garment making the closet a tangible 'pointer' to the 35,000 items stored on the database. The information is shown on a touch screen that might show sketches, photos or video footage from a fashion show.

The 'Magic Mirror' on the opposite wall is a mirrored wall with a large plasma screen embedded. When the customer turns around to get a back view, a camera programmed to sense movement displays the image with a 4 second delay allowing views from all angles.

The sliding doors are made from Privalite glass. When the room is unoccupied the doors are transparent, when occupied fully opaque. The opening of the doors and their degree of translucency are controlled by the customer by pressing a floor switch.

Retail Design

Designers
David Davies
Mark Staton
Jason Pollard
Charles Allan

Manufacturer
Spade Well

Shopfitter
Spade Well

Design Group
FutureBrand

Account Handler
David Hensley

Marketing Executive
Reno Cheng

Client
DBS Bank

DBS Bank Singapore
FutureBrand helped the client to identify its brand values as Asian; innovative, customer focused and above all to be known as the leading financial services brand in Asia. The brief was to now bring the brand to life within a retail environment.

The new concept turns the world of high street banking on its head. The entire environment has been designed around the customers' needs and aspirations, as opposed to the operational requirements of the bank.

The interior highlights these aspirations with zones that are based around the bank's products and services, designed to create an environment that enhances customers' lifestyle needs. The zones are also supported by photographic images of the customer rather than bank adverts, enhancing the sense of empowerment the bank can offer the individual.

As well as helping to reposition the client's brand, the new environment encourages customers to stay within the branch for longer. All the time that people are within the environment, they are being sold to. Promotional displays and product graphics/POS are strategically placed to engage customers at most pause points. It has been possible to achieve higher sales by understanding how customers shop within the banking environment and how to communicate to them both passively and proactively.

Design for Leisure

Designers
Richard Brett
Sarah Baboo
Chris Church

Shopfitter
ARB Shopfitters

Design Group
US Designers

Marketing Executive
Rod Pearson

Client
Urban First

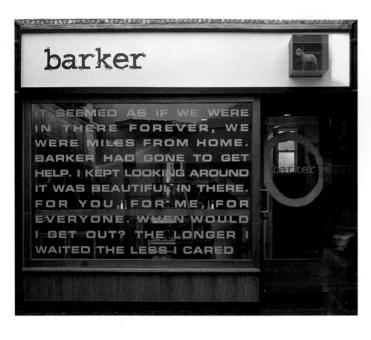

Barker Cafe
The brief was to reinvent 'Barkers'– a family business – as a more contemporary café to compete against the "corporate" coffee shops, whilst retaining the values of a traditional English café catering for the quirky Brighton locals.

We docked the name to 'Barker', created an identity, a bull terrier with a stylized coffee cup stain around his left eye. Packaging and environmental graphics further enhance this personality.

The exterior attracts the onlooker with a taste of the adventures of 'Barker'. A brief fictional extract scripted across the glazing and proud 'Barker' himself within a semi-translucent yellow kennel. The identity and space define the culture of the client and the café: warm, fun, friendly and individual.

The interior evokes traditional café values with functional styling and materials. Walls, ceiling and furniture are made from oak planks. Contrasting colour defines the multi-purpose space with the textured resin floor providing a durable contrast to the cleaner surfaces.

Barker is a café with an engaging character. The mixture of cute dog, charming story and warm natural materials entice, encouraging people to talk. A lot.

Design for Leisure

Designers
Thomas Heatherwick
Kieran Gaffney

Manufacturers
Julian Graham
Impact Finishers

Design Group
Thomas Heatherwick
Studio

Concept Engineers
Toby Maclean
Ron Packman

Executive Engineers
Jody Pearce
Barry Dobbins

Project Managers
David Flight
Nathan Bryant

Lighting Design
Eric Maddocks

Marketing Executive
Peter Rogers

Client
Stanhope
(on behalf of MEC)

Paternoster Vents
The re-development of Paternoster Square, next to St Paul's Cathedral in London, is a high-profile project in a sensitive location.

A public space is formed within this re-development where the new buildings are laid out around an underground electricity substation. This substation requires a cooling system, but the client was not satisfied with the existing proposal for a single large vent and wanted to find a way to meet the technical demands without reducing the surrounding area to a corridor.

Two holes were found to exist in the concrete slab covering the substation, so the design proposed making two outlet vents, allowing people to circulate better within the space, and setting the inlet ducts into grilles in the surface of the space, reducing the vent's footprint.

The sculptural form of each vent came from experiments with folding A4 sheets of paper. The scaled up form retains these proportions.

To make each 11 metre high structure, 63 isosceles triangles were cut from 8mm stainless steel plate and welded together. The surface finish was achieved by blasting the metal with tiny glass beads.

Design for Leisure

Design Group
Jestico + Whiles

Shopfitter
Sherlock Interior
Contracting

Client
Eco West End

Innecto

Jestico + Whiles' brief was for a fresh interpretation of a modern Italian restaurant, and to create warm intimate spaces while retaining the proportions of a high, deep concrete shell.

The main frontage to Baker Street, London, is of fully opening 4m high panels of amber glass in burnished steel frames.

Within, four spaces are clearly defined, offering a hierarchy of formality as the guest moves deeper into the space.

The pre-dining area is clad in honed limestone, through which an elliptical stair to the basement is punched.

Beyond, three overlapping shells woven loosely from American black walnut strips define the first dining area. Irregular holes in this weave reveal glimpses of concrete shell, painted a warm amber, and illuminated by a soft wash of low level light.

Behind a servery of backlit yellow glass, the distant movement of the chefs and the flickering flame of an open-hearth oven animate the space.

Adjacent to the main restaurant space, a more intimate cave of polished plaster defines a smaller dining area.

A staircase of blued steel leads to the cocktail bar. Here, an elliptical, inclined plaster wall creates a tapering drum, with perimeter bench seating of heavy stitched coach hide.

Design for Leisure

Design Groups
Feilden Clegg Bradley
Architects LLP
Atelier One
Atelier Ten
Grant Associates

Manufacturer
Carpenter Oak &
Woodland

Client
The Earth Centre

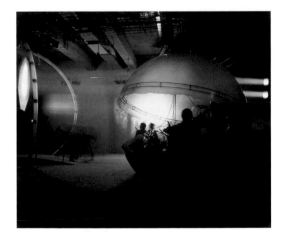

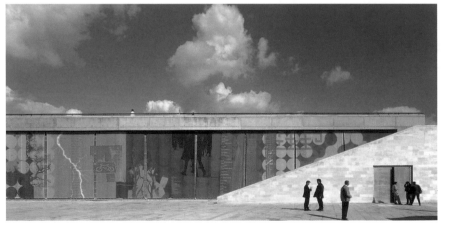

Earth Centre

Designed and built to a very rapid timetable, this £7 million scheme demonstrates low energy/low impact design and an innovative use of sustainable materials.

The scheme consists of two major built forms. The Planet Earth Gallery is essentially underground, buried behind a rampart wall of stone, rammed earth and concrete. The other element is a lightweight timber and glass pavilion building which houses a bakery, cafe, meeting room and information centre, and provides an outlook over and across the site.

Linking the two entrance buildings, the extensive solar canopy supports the largest array of photovoltaic cells in the UK. Designed with Atelier One (Structural Engineers) and constructed by Carpenter Oak & Woodland, the canopy is a distorted timber space frame of round wood poles of Scottish Larch with galvanised steel connectors. The elaborate geometry created by the trapezoidal frame and the almost random supporting columns form a dynamic contrast with the purity and the simplicity of the adjacent building forms.

The 975m² canopy is roofed with a total of 45,200 photovoltaic cells, providing approximately 20% of the annual electrical consumption of the entrance buildings.

The Earth Centre was one of the first landmark projects to achieve Millennium funding, and to achieve realisation.

Exhibition Design

Designers
Morag Myerscough
Simon Pickford
Chris Merrick
Ben Kelly

Design Group
Studio Myerscough

Curator
Alice Rawsthorn

Client
Design Museum

Web Wizards

"The problem with designing a show like Web Wizards", explains Morag Myerscough, "is that all the creative work is shown on small Apple Mac monitors. Our job was to fill the rest of the space with sympathetic and inspiring graphics that encouraged visitors to look at the screens but also provided them with some explanation, inspiration and a sense of the creative work itself."

The web designers; Joshua Davis, Amit Pitaru and James Paterson, Daniel Brown, Yugo Nakamura, Tomato Interactive and Peter Saville, have consistently produced the most innovative sites in recent years. The brief from curator Alice Rawsthorn was to show the work of this new generation of web design stars who are idolised within their industry but little known outside. The design was made to show a journey that visited several individual spaces, each created to explain the individual designer's work. Each area was interpreted through the choice of colour, typeface, large wall projections of the work, sound and applied graphics. The whole design was intended to contrast with the work by being low tech – type applied to the wall by hand, sign writing, breeze blocks as plinths and untreated wood furniture. Interconnected graphics on the floor linked each of the spaces. The design of the typeface for the actual Web Wizards logo was an original design by Studio Myerscough.

Collaborations with other designers provided the furniture and other pieces. Ben Kelly designed the wood tables, wire benches by Shin and Tomoko Azumi, the Isu stool by Hiroshi Tsunoda, Bench 2000 by William Plunkett and paper cushions by Georg Baldele.

Exhibition Design

Designers
Roger Mann
Craig Riley

Design Group
Casson Mann

Contractor
Peter Burrows

Project Managers
Richard Greenwood
Jane Greenwood
Rebecca Lambert

Graphic Design
Frith Kerr
Amelia Noble

Curators
Libby Sellers

Restructure
Helen Jones

Lighting Design
Jonathan Howard

Structural Engineer
Neil Thomas

Client
Design Council

Great Expectations

Commissioned by the Design Council, Great Expectations is a touring exhibition of the best of contemporary British design. Its primary aim is to generate successful partnerships between creative industries in the UK and the business audience of North America – dialogues between Britain and the US, designers and business, exhibition and visitor.

The concept is a grand banquet – a place where acquaintances are made, plans forged and deals done. The hundred design stories selected for inclusion in the exhibition are displayed as a feast on a fifty metre long glowing table.

The Great Expectations banquet is mid-flow, chairs arranged informally, according to the dynamics of conversation. Visitors come to the table and become fellow guests – engage with the exhibits, interact with the on-screen directories, and overhear conversations between other guests (recorded conversations with a number of the exhibitors are integrated into the chairs).

Remnants of place settings – white resin casts of dinner table cutlery and crockery – give the vast table a sense of human scale and suggest the presence of other guests.

For its installation/venue in Grand Central, the ambience of the hall was completely altered by filling the high space with a slowly changing cycle of intense coloured light – emphasising the brilliant white glow of the table. Unexpected sounds from a commissioned sound-scape bought together the disparate sound sources.

The table was pulled apart in the middle, but linked by a white fabric tablecloth, whipped-up to form a 17 metre canopy for all visitors to pass underneath. The two halves of the table are currently touring separately – one half on North America, and the other in the Far East.

Exhibition Design

Designers
Rick Duffy
Joyce Mast
Wayne Susag
Lydia Esparza
Leslie Black

Patti Callahan
Jamie Callahan
Allan Chochinov
Stu Constantine
Eric Ludlum
Mary Phillipuk
Mark Sexton
John Boesche

Shopfitters
Xibitz
Clune Construction
Agio Imaging
Intaglio Visual Arts and
Technologies

Design Groups
Joyce Mast Graphic
Design
Genesis Team -
Herman Miller
Kreuck and Sexton
Architects

Account Handler
Deb Keen

Marketing Executive
Rick Duffy

Client
Herman Miller

**Herman Miller Chicago Showroom Neocon
2001 – Graphics & Architecture**
The Herman Miller, Inc. National Design Center in
Chicago is intended to serve as one of the corporate
flagship selling spaces. The facility is both a
permanent display and sales office for the Chicago
and Midwest market region, as well as the
company's venue for NeoCon, the largest annual
industry gathering in North America of customers,
architects and interior designers. The design
objective was to update and enhance Herman
Miller's image as the premier provider of "great
places to work." Displaying the latest advances in
sophisticated, functional and aesthetically forward
furnishings, the company's award-winning furniture
is set against a sensuous backdrop of layered
materials, colour, light and technology that
demonstrates the company's commitment to
workplace performance through holistic and
integrated architecture, interior and graphic design.

Exhibition Design

Design Director
Kenny Holmes

Creative Director
Derek Johnston

Senior Designers
Michael Rance
Emma Capron
Howard Berkley
Nina Langley
Neil Barnes

Design Group
Landor Associates

Metal Work
Hands On Interactive

Lighting
Elektra Lighting

Project Manager
Thomas Mixdorf

Contractor
Photobition Event
Solutions

**Corporate Affairs
Director**
Sandy Henney

Client Director
Christian Schroeder

Client
Thames Water

Thames Water Exhibition
Water has become one of RWE's core businesses
since its recent acquisition of Thames Water.
 A high-profile presence at the 2001 Berlin World
Water Congress offered the perfect opportunity for
this leading multi utility provider to present its vision
for the future.
 The 4-day event attracted audiences from the
water industry around the world.
 The congress was attended by the same
delegates each day, so the challenge was to create
an exhibition that not only became a key destination,
but also encouraged the audience to return to the
stand on a daily basis.
 Landor's solution was to create an installation-
style format that housed noticeably fresh content
in a different structure on each of the days.
 The fixed backdrop to the stand featured a vast
illuminated map of the world, created from glasses
of clear and coloured water.
 Thematically, the emphasis was on how water
affects society based on four themes: 'global',
'partnership', 'future' and 'opportunities'.
Each theme was fleshed out on one of the
consecutive days.

Exhibition Design

Designers
Bob Baxter
Helen Abadie
Jon Goodbun

Graphic Designers
Lucy Carter
Robert Carter

Lighting Design
Ian Scott

Shopfitter
Devonshire House
Associates

Design Group
At Large

Client
The British Museum

Unknown Amazon
Archaeologists have begun to uncover the ancient cultural traditions of Brazil's tropical forest, a vast area where people have lived for more than 10,000 years, developing sophisticated art styles long before European contact with the Americas.

Unknown Amazon reveals this lost culture with more than two-hundred archaeological finds. The juxtaposition of archaeological and ethnographic objects emphasises both the continuity and change between ancient and modern cultures. By including examples of contemporary Amazonian societies more can be imagined about the past. The continuity is clear – these are people shaped by ritual, myth and music. But the Amazonian concept of life is more flexible than our own; timescales are overlaid, characters move backwards and forwards between worlds and the supernatural coexists with the real. To explore this multi-layered reality the designers had to reject all European evocations of 'jungle' and address the full range and complexity of tropical forest culture. Although nature's influence dominates the design, At large have produced an exhibition that reflects an Amazonian way of knowing the world – something far removed from the Western mindset.

Design for the Workplace

Designers
Chris Cawte
Alex McCuaig

Design Group
MET Studio Design

Manufacturer
Stage Technologies

Shopfitter
C-Beck

Client
Lucent Technologies

Lucent Technologies Centre of Excellence
MET Studio Design were briefed by communications giant Lucent Technologies to create a theatrical centrepiece for its new 'Centre of Excellence' in Nürnberg, in order to sell Lucent's business-to-business 'briefing' expertise and vision to a global client base.

MET Studio Design approached the project by stressing that Lucent's messages are all about communication services, rather than products – moving the accent away from grey boxes to the idea of a jewel box; creating a mosaic of communication and perception to stimulate imaginations as much as explain the company's complex technologies.

The new theatre is a 9m-wide translucent oblate sphere, uplit in red from beneath a glazed surrounding apron, in the middle of a darkened space full of whirring lights and audio effects. Plasma screens are silhouetted against the sphere whilst, beneath, a starfield appears to extend into infinity.

The floor revolves and the entrance segment closes whilst a prologue, comprising audio, lighting and video on a hemispherical 'spitz' screen, begins. Tailor-made presentations play out on a bank of suspended plasma screens, creating a feeling of depth as they come into view from the darkness beyond, against a background of pulsing LED lights set into the inner face of the framework.

Design for the Workplace

Architect
Fletcher Priest Architects

Contractor
Dean & Bowes

Project Manager
APS Project Management

Consulting Engineer
Dewhurst Macfarlane

Services Engineer
Ernest Griffiths & Sons

IT Consultant
Secom

Shell Architect
Tate & Hindle Design

Cost Consultants
Stephens & Company
APS Project Management

Client
Sony Computer Entertainment Europe

Sony Computer Entertainment Europe Headquarters

Sony Computer Entertainment Europe's headquarters in Golden Square houses around 200 people who develop PlayStation. They manage and oversee global marketing and sales activity in over 90 countries.

There is a multi-use space on the lower ground floor with capacity for up to 250 guests attending and taking part in launches and conferences as well as efficient office space on six upper floors. The forms, colour and finishes subtly reflect PlayStation and communicate directly and indirectly to occupants and the wider PlayStation community.

The timber floor of the entrance space folds to wrap the lift core, forming a screen through which there are views onto Golden Square; the responsive translucent cladding of another wall wraps around the reception desk. It is a flexible space that begins to assume virtual characteristics.

The lower ground floor extends out into a lightwell that has been transformed into an 'all weather' garden and a 'ground floor' meeting room is suspended unexpectedly in an existing lower ground floor double height space.

Design for the Workplace

Project Architect
Peter Maxwell

Architects
John Nordon
Kathryn Findlay

Design Group
Ushida Findlay (UK)

Suppliers
Benson Sedgwick Engineering
Inflate

Demiurge
Georgeson
Lasar Contracts
Wave
Interiors

Quantity Surveyor
MPA

Marketing Executives
Yemisi Mokuolu
Shane Galtress

Client
claydonheeley-jonesmason

claydonheeleyjonesmason Reception

The most striking room within the claydonheeleyjonesmason offices is the reception with its flowing steel ribbons that both control the space and offer endless options to how it can be occupied and perceived. It is at once fun and poetic encouraging playfulness and reflection. It responds to the client's desire for something memorable, something unlike you've ever experienced before. Yet there is more to it than a desire to make such a statement. There is a real generosity about the reception. It can be seen and enjoyed by passers-by from their cars as they wait in traffic and inside it has the atmosphere of a public space not unlike that of a museum court or an art gallery.

Colour features heavily in the design of the offices with each floor defined by planes of blue rubber flooring. This suggests a direct connection to the natural elements, with the floor appearing continuous as if it becomes part of the sky. The new reception continues this concern where rolled steel ribbons are coloured to reflect the surroundings; the silver imitates the Thames, while orange performs a highlight, in addition to being the corporate colour. The strands become a mechanism to delineate zones of occupancy (cafe, reception, and client waiting). This creates a multitude of flowing spaces without resorting to tired solutions.

Design for the Workplace

Designers
Martyn Bullock
Claire Kinna
Sasha Kemp-Potter

Shopfitter
Overbury

Design Group
Redjacket Design
Consultants

Client
Revlon International

Revlon International Offices
The brief was to create a modern, innovative work-space out of a 1,000 sq m converted warehouse, that would accommodate 80 people and meet Revlon's specific needs as a leading cosmetics supplier.

Redjacket's approach to the project was to parallel the needs of Revlon with the physical attributes of the space. The working hub of the business, marketing, sales and administration sits within a deep planned, flat roofed area that has minimal natural light. Stretching across the whole length of the building is a linea length of storage hidden by false sliding doors in differing tones of Revlon red.

The public face of Revlon, the reception area, meeting rooms, mezzanine café and showroom occupy approximately 80% of the floor plate below three naturally lit pitched roofs. This dramatic space also includes a 'theatre/conference' facility, which seats up to 80 people.

The backbone of the plan, a 40m catwalk links the office areas, reception and showroom and assists the subdivision of the functions. It culminates with meeting rooms at each end.

Applied Graphic Design

Designers
Penny Sykes
Clare Wigg
Phillip Wong

Shopfitter
BAF Graphics

Design Group
Carter Wong Tomlin

Marketing Executive
Tim Rivett

Client
Royal Mail

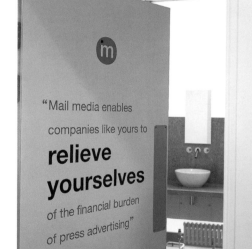

Royal Mail, Mail Media Centre
Rarely taken seriously as a medium in the past, direct mail continues to make a resurgence in an increasingly fractured and competitive media arena. In order to accelerate its growth and promote its use, Royal Mail has created the Mail Media Centre.

A centre of excellence – showcasing the best practice, providing reference materials and in-depth marketing data – the centre's specific target audience is large advertisers and their agencies who dominate the decision making in selection of media buying.

Designed with this discerning audience in mind, the graphics applied to the building sets out to establish a personality for the centre which is distinct from the conservatism normally associated with the Royal Mail. Quotations endorsing the effectiveness of mail media are used extensively throughout the building to put the building in context with its purpose. A touch of wit is added by using relevant words within these quotations to link them to the spaces in which they are applied. And indeed, in the case of those which adorn the toilets, humour too.

Applied Graphic Design

Designers
Kim Hartley
Paul Skerm

Artworker
Micky Milano

Manufacturer
Service Graphics

Design Group
Four IV Design
Consultants

Account Handler
Louise Barnard

Marketing Executive
Philip Thomas

Client
Mulberry

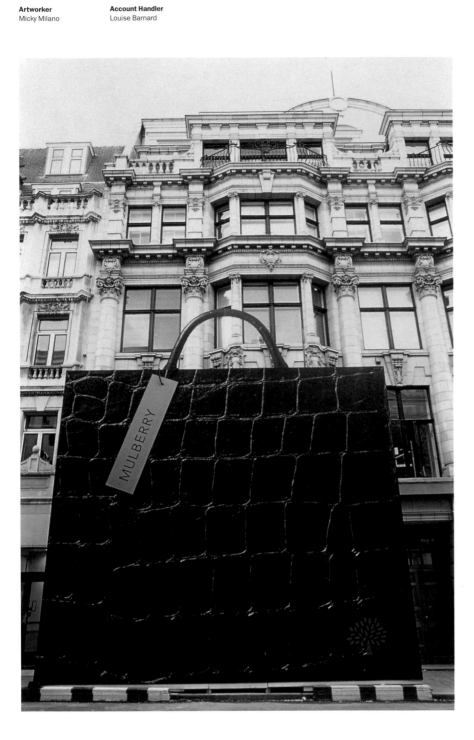

A Handbag has Landed on Bond St.
The hoarding was designed to raise awareness and create intrigue around the new Mulberry store about to open on New Bond Street. FOUR IV designed a giant Mulberry handbag hoarding using the infamous Congo leather synonymous with the brand as the overall texture. The handbag was made complete by a giant size leather handle. The handbag was also used as a vehicle to launch the new Mulberry identity, also designed by FOUR IV.

The timing of the installation was crucial: it coincided with London Fashion Week, ensuring the right people saw Mulberry was about to change. The size (two storeys high) helped create impact as it was instantly noticed from the top of New Bond Street.

MIXED MEDIA

Top Row; *Left to Right:*

CHAS BAYFIELD, ARKWRIGHT • **ALISON JACKSON,** ALISON JACKSON PHOTOGRAPHY • **DAVID HOBBS,** MILES CALCRAFT BRIGINSHAW DUFFY

Bottom Row; *Left to Right:*

MICHAEL CROWE, OGILVY • **WALTER AMERIKA,** FHV\BBDO • **ED PRICHARD,** MRM PARTNERS WORLDWIDE • **STEVE TURNER,** MILK

MIXED MEDIA

Left to Right:
MARK WAITES, MOTHER • **KIM PAPWORTH**, WIEDEN+KENNEDY UK • **JAY POND-JONES**, HHCL AND PARTNERS

Comment by Mark Waites

Mixed Media has got to be the toughest category in the competition. A Silver Award proves the creatives have done an outstanding job with the TV, radio, print, outdoor and the rest. The work has probably won or challenged in each of those individual categories. So it should be the one to win. Too often this year we saw campaigns that were outstanding in one department but let down in others. Nike Run London and Land Rover were the only campaigns where high standards were kept up across the board. In the case of Nike, that meant great ambient and internet stuff which got the work a well-earned nomination.

MIXED MEDIA SPONSORED BY ROYAL MAIL • PUBLIC SERVICE & CHARITIES SPONSORED BY BMP DDB FOR GREAT ORMOND STREET HOSPITAL

Silver Nomination
for the most
outstanding
Mixed Media Campaign
sponsored by
Royal Mail

Art Directors
Andy Smart
Chris Groom

Copywriters
Roger Beckett
Matt Follows

Illustrator
Andy Smith

Typographer
Richard Hooker

Creative Directors
Tony Davidson
Kim Papworth

Director
Andy Smith

Producer
Jonathan Butcher

Production Company
Private View
Productions

Advertising Agency
Wieden + Kennedy UK

Animator
Andy Smith

Agency Producer
Rob Steiner

Editor
Andy Smith

Lighting Camera
Tim J M Green

Music
Snuff

Account Handler
Edward Donald

Marketing Executive
Jack Gold

Client
Nike

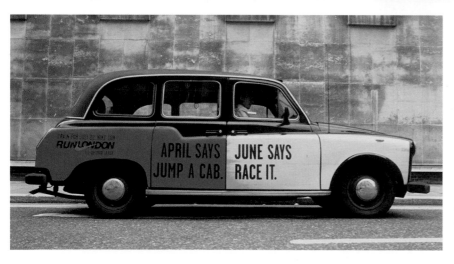

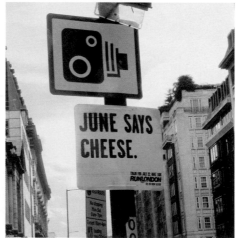

 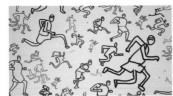 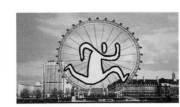

Run London
This commercial follows an animated character as he goes from a lazy slob with his feet up in April, to a 'keen but weak' runner in May, to a psycho nutter runner in June. We end with a title which reads, 'Train for July 22. Nike 10k. Run London'.

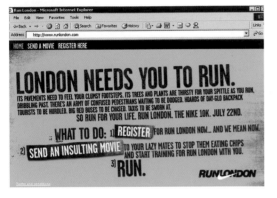 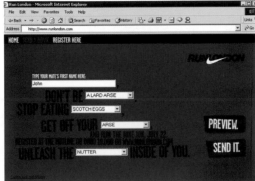

April
MVO: April is lazy. April says running is too hard. April says your car is your best friend. April says slippers are better than running shoes. April stands on the right, sits in the pub, lies on the sofa. April says loosen your belt. April says go on get a minicab home. April says Primrose Hill should have escalators. April says cod and chips twice. April says walk don't run. April hurts. Defy April. Train for July. For information on Nike training runs visit www.runlondon.com

May
MVO: May is full of doubt. May tries… but not too hard. May runs in the dark, dribbles snot, steps in dog poo. May hides your running shorts. May says take a breather. May forgets to set your alarm clock. May's got a hundred reasons why you shouldn't run. May says next week, next month, next year. May says you ran for the bus, job done. May says take another breather. May says ooh no sunny days only. May says easy does it. May runs in circles, trips over tourists, takes the short cut through Hyde Park. May likes flat roads, thick socks, long rests. May says go shopping instead. May gives up. Beat May.

June
MVO: June says run today. June says do some miles. June races buses, chases dogs, eats bananas, swears at cars. June tells you it's only spitting when its pouring. June says 10 laps. June says guess what you're doing this lunchtime? June drags you across fields, covers you in mud, pulls you up hills. June says 20 laps. June chases you up the Mile End Road, leaping dustbins, dodging cars. June says 30 laps. June whispers gently in your ear 'don't stop', 'don't stop'. June says here we go again. Enjoy June. Train for July. For information on Nike training runs visit www.runlondon.co.uk

Campaigns

Art Directors
Richard Denney
Richard Dennison

Copywriters
Dave Henderson
Mike Boles
Derek Payne

Photographers
Nick Georghiou
Ashton Keiditsch
Hugh Johnson

Typographers
Ryan Shellard
John Tisdall

Creative Directors
Robert Campbell
Mark Roalfe

Director
Malcolm Venville

Producer
Daniel Todd

Production Company
Therapy Films

Advertising Agency
Rainey Kelly Campbell
Roalfe/Y&R

Agency Producer
Amanda Goodship

Editor
Rick Russell

**Lighting
Cameraperson**
Ben Butler

Music Composer
Peter Lawlor

Account Handler
Douglas Thursby-
Pelham

Marketing Executive
Anthony Bradbury

Client
Land Rover

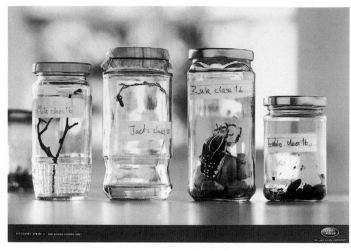

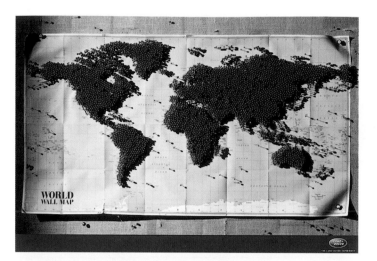

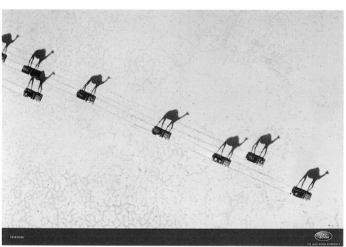

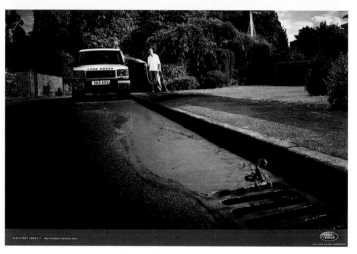

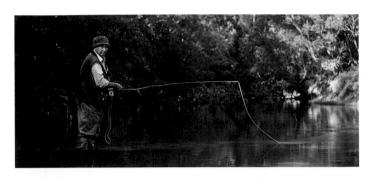

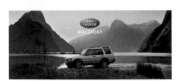

Fishing

We see an older man fly-fishing on a peaceful stretch of river. A younger man turns up and they nod a greeting to each other. After a while the older guy looks across and is astonished to see the other man has stripped naked. He watches as the man wades into the river and begins spear fishing. A title asks 'Been anywhere interesting lately?' before we see the Land Rover Discovery in an exotic waterside location.

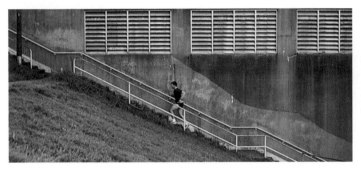

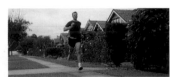

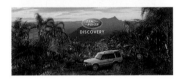

Joggers

We follow a man out on his morning run through various suburban landscapes, up a long flight of steps, through a park and by some railway arches. Eventually he stops in a typical street, sweating profusely, and reaches into a plant border in someone's garden. Then, as a neighbour watches, he yanks out a large leaf and takes a drink from the stem. A title asks 'Been anywhere interesting lately?' and we then see a Land Rover Discovery in an exotic rainforest location.

RADIO ADVERTISING

Top Row; *Left to Right:*
AMBER CASEY, BMP DDB • MANDY WHEELER, MANDY WHEELER SOUND PRODUCTIONS
Bottom Row; *Left to Right:*
LITTLE LORD FAUNTLEROY • GERARD EDMONDSON, McCANN-ERICKSON MANCHESTER • GAVIN KELLETT, SAATCHI & SAATCHI • STEVE PUNT

RADIO ADVERTISING

Left to Right:
DAVID PRIDEAUX, RAPIER • **JAMES SAUNDERS,** JUNGLE • **JOHN LLOYD,** SPECTRE

Comment by John Lloyd

This was not a vintage year for radio. Although there was some excellent work, the jury felt many entries should never have been submitted and there was little to commend the middle ground. We were unable to detect any new or emerging creative trends. We also put in a plea for fewer parodies, and for more international work – though some increase in the latter was in evidence. Too many radio entries are mere re-treads of TV work, with little original use of the form. For this and its superb production values, there was unanimous enthusiasm for the Bud Light campaign, winner of the Silver Award. Here, radio advertising preceded TV and was the superior of the two. High point of judging was the quality of debate among jurors. Low point was an interminable campaign for a brand of light bulbs which shall remain nameless... mainly because it was instantly forgettable. Agencies should coax more talented creatives to try their hand at radio. As a training ground for writers it is second to none. And in terms of reach, they should note that for the first time since the 1960's, more people listen to radio than watch TV in 2002.

RADIO ADVERTISING CAMPAIGNS SPONSORED BY EARDRUM • RADIO ADVERTISING CRAFTS SPONSORED BY SHELL LIKE
PUBLIC SERVICE & CHARITIES SPONSORED BY BMP DDB FOR GREAT ORMOND STREET HOSPITAL

Silver Award
for the most
outstanding
Campaign
sponsored by
Eardrum

Copywriters
Bob Winter
John Immesoete

Group Creative Director
John Immesoete

Creative Directors
Bill Cimino
Mark Gross

Chief Creative Officer
Bob Scarpelli

Agency Producer
Chris Bing

Recording Engineer
Dave Gerbosi

Music Composer/Arranger
Sandy Torano

Advertising Agency
DDB Chicago

Account Handler
J T Mapel

Marketing Executive
Andy Goeler

Client
Anheuser Busch

Mr Horsedrawn Carriage Driver

Announcer: Bud Light Presents…
Real Men of Genius.

Singer: Real Men of Genius.

Announcer: Today we salute
you… Mr. Horse Drawn
Carriage Driver.

Singer: Mr. Horse Drawn
Carriage Driver!

Announcer: You start your day
with a tip, tip! and a
cheerio!, which is odd because
you're from Brooklyn.

Singer: Jolly Old Brooklyn!

Announcer: While most people
sit behind a desk, you proudly
sit two feet behind a four-
legged manure factory.

Singer: Oooh!

Announcer: No one knows the
guts it takes to ride the
subway to work dressed as a
foppish dandy from the
eighteenth century.

Singer: Hey foppish dandy!

Announcer: Blaring horns,
profanity, vicious insults all
met with a courtly tip of your
stovepipe hat.

Singer: Cheerio!

Announcer: So crack open an
ice cold Bud Light, Buggy Boy.
(SFX: Bottle open) Because the
way you say giddy-up, makes us
say whoa.

Singer: Whoa! Whoa! Whoa!

Announcer: Bud Light Beer.
Anheuser-Busch.
St. Louis Missouri.

Mr Camouflage Suit Maker

Announcer: Bud Light Presents…
Real American Heroes.

Singer: Real American Heroes.

Announcer: Today we salute
you… Mr. Camouflage Suit
Maker.

Singer: Mr. Camouflage
Suit Maker!

Announcer: Your amazing skills
of deception can trick a deer
into thinking we're just a
tree out for a walk, or a shrub
having a cup of coffee.

Singer: Shrub having coffee!

Announcer: Tirelessly you
perfect your artistry. The
squiggly black line. The blob.
The slightly larger blob.
All in spectacular shades
of… green.

Singer: green, green, green!

Announcer: Thanks to you we
look fabulous in or out of the
forest — with a suit that can
be easily accessorized with
face paint and a few twigs.

Singer: Dressed to kill.

Announcer: So crack open
an ice cold Bud Light,
Mr. Camouflage Suit Maker.
(SFX: Bottle open.) Because
when it comes to blending in,
you really stand out.

Singer: Mr. Camouflage Suit
Makerrrrrr.

Announcer: Bud Light Beer.
Anheuser-Busch.
St. Louis Missouri.

Mr Professional Figure Skater

Announcer: Bud Light Presents…
Real American Heroes.

Singer: Real American Heroes.

Announcer: Today we salute
you… Mr. Professional
Figure Skater.

Singer: Mr. Professional
Figure Skater!

Announcer: While lesser
men strapped on skates and
played hockey, you donned
skin-tight leotards and a
teeny cowboy hat and learned
"figure eights."

Singer: Goin' round and round.

Announcer: You practiced and
practiced. Hoping, knowing
someday… you'd be good enough
to wear a giant puppet costume
and skate in an "ice show."

Singer: Welcome to the big
time!

Announcer: Skate perfectly and
you're a crowd pleaser. Mess
up and fall on your butt and
you're still a crowd-pleaser.

Singer: Oh!

Announcer: So crack open an
ice cold Bud Light, oh titan
of the tights. (SFX: Bottle
open.) You may never wear a
medal, but sequins are
shiny too.

Singer: Mr. Professional
Figure Skater.

Announcer: Bud Light Beer.
Anheuser-Busch.
St. Louis Missouri.

Silver Nomination
for the most outstanding Direction sponsored by Shell Like

Directors
Hugh Todd
Adam Scholes

Production Company Director
Nicola Warman-Johnston

Recording Engineer
Ian Hargest

Copywriters
Hugh Todd
Adam Scholes

Producer
Nicola Warman-Johnston

Production Company
Shell Like

Advertising Agency
Saatchi & Saatchi

Account Handlers
Jamie Lewis
Andy Bell

Marketing Executive
Paul Philpott

Client
Toyota (GB)

Over 40 Seconds

Copywriters
Bill Cimino
Mark Gross

Group Creative Director
John Immesoete

Creative Directors
Bill Cimino
Mark Gross

Chief Creative Officer
Bob Scarpelli

Agency Producer
Chris Bing

Recording Engineer
Dave Gerbosi

Music Composer/Arranger
Sandy Torano

Advertising Agency
DDB Chicago

Account Handler
J T Mapel

Marketing Executive
Andy Goeler

Client
Anheuser Busch

Meeting

SFX: Office ambience (throughout).

MVO 1: What time's the client coming Dave?

MVO 2: Two o'clock.

MVO 1: That's OK we've got ages yet.

MVO 2: Yeah, have you heard how he speaks (putting on ridiculous high-pitched voice) 'Hello Dave and how are you today?'

MVO 1: (giggling, also putting on ridiculous high-pitched voice) 'I'm very well Peter and how are you?'

MVO 2: That's it (more giggling) 'I'm very well and how are you today?'

MVO 1: 'I'm very well Peter and how are you? No really how are you…'

SFX: Door opening.

MVO 2: Shh, Shh.

MVO 1: (oblivious)…'And how are yooou? And how are you? And how are you? How are you? How…'

SFX: A long, uncomfortable pause.

Client: (in his own ridiculous high-pitched voice) Hello David, how are you?

MVO: The Toyota Avensis with electronic traffic avoidance system. Be careful. You might get there too early.

Mr Public Restroom Toilet Paper Refiller

Announcer: Bud Light Presents… Real American Heroes.

Singer: Real American Heroes.

Announcer: Today we salute you… Mr. Restroom Toilet Paper Refiller.

Singer: Mr. Restroom Toilet Paper Refiller.

Announcer: Without your undying commitment, we might find ourselves trapped in a stall armed only with our newspaper.

Singer: Oh I need you now!

Announcer: Like a brave soldier you storm hostile territory delivering much needed supplies to your men.

Singer: Oh!

Announcer: Should you leave one roll or two? Or perhaps that giant ten pound super roll.

Singer: Keep rolling!

Announcer: While others rest. You can't. Because somewhere there's a guy with his pants around his ankles doing the bunny hop in search of a fresh roll.

Singer: Hop, hop, hop!

Announcer: So crack open an ice cold Bud Light, master of the men's room. (SFX: bottle open) Because if you don't do your business. We can't do ours.

Singer: Is there anybody out there?

Announcer: Bud Light Beer. Anheuser-Busch, St. Louis Missouri.

Over 40 Seconds

Copywriters
Hugh Todd
Adam Scholes

Directors
Hugh Todd
Adam Scholes

Production Company Director
Nicola Warman-Johnston

Producer
Nicola Warman-Johnston

Recording Engineer
Ian Hargest

Production Company
Shell Like

Advertising Agency
Saatchi & Saatchi

Account Handlers
Jamie Lewis
Andy Bell

Marketing Executive
Paul Philpott

Client
Toyota (GB)

Over 40 Seconds

Copywriter
Dave Bell

Art Director
Jim Bucktin

Creative Directors
Nick Bell
Mark Tutssel

Agency Producer
Adam Furman

Recording Engineer
Tony Rapaccioli

Production Company
The Tape Gallery

Advertising Agency
Leo Burnett London

Account Handler
Charlotte Cottrell

Marketing Executive
John Hawkes

Client
McDonald's

Meeting

SFX: Office ambience
(throughout).

MVO 1: What time's the client
coming Dave?

MVO 2: Two o'clock.

MVO 1: That's OK we've got
ages yet.

MVO 2: Yeah, have you heard
how he speaks (putting on
ridiculous high-pitched
voice) 'Hello Dave and how are
you today?'

MVO 1: (giggling, also putting
on ridiculous high-pitched
voice) 'I'm very well Peter
and how are you?'

MVO 2: That's it (more
giggling) 'I'm very well and
how are you today?'

MVO 1: 'I'm very well Peter
and how are you? No really how
are you…'

SFX: Door opening.

MVO 2: Shh, Shh.

MVO 1: (oblivious)…'And how
are yooou? And how are you?
And how are you? How are you?
How…'

SFX: A long, uncomfortable
pause.

Client: (in his own ridiculous
high-pitched voice) Hello
David, how are you?

MVO: The Toyota Avensis with
electronic traffic avoidance
system. Be careful. You might
get there too early.

Toiletries

Jack Charlton:

Intensive facial cleansing
cream.

Gentle exfoliating mousse
for a man's skin.

Pore cleansing facial
treatments.

Pre-shave peppermint oil.

Apres-rasage soothing
cucumber cream pour homme.

Revitalised facial spray.

Anti-wrinkle gel.

Vitamin-enriched gentle
cleansing lotion for
sensitive skin formulated
by dermatologists to meet a
man's specific needs…

What!… come on fellas, get
a grip and get yourselves down
to McDonald's for a 99p
Omelette McMuffin with bacon
and cheese, specially
formulated for men.

At participating restaurants
but only for a limited time.

Over 40 Seconds

Copywriter
John Immesoete

Group Creative Director
John Immesoete

Creative Directors
Bill Cimino
Mark Gross

Chief Creative Officer
Bob Scarpelli

Agency Producer
Chris Bing

Recording Engineer
Dave Gerbosi

Music Composer/Arranger
Sandy Torano

Advertising Agency
DDB Chicago

Account Handler
J T Mapel

Marketing Executive
Andy Goeler

Client
Anheuser Busch

Campaigns

Copywriters
Roger Beckett
Andy Smart

Agency Producer
Rob Steiner

Recording Engineer
Rob Townsend

Production Company
Eardrum

Advertising Agency
Wieden + Kennedy UK

Account Handler
Edward Donald

Marketing Executive
Jack Gold

Client
Nike

Mr Supermarket Free Sample Guy

Announcer: Bud Light Presents… Real Men of Genius.

Singer: Real Men of Genius.

Announcer: Today we salute you… Mr. Supermarket Free Sample Guy

Singer: Mr. Supermarket Free Sample Guy!

Announcer: Though man dreads few things more than a trip to the supermarket, you offer us hope and sometimes a free mini-weenie.

Singer: Love that freebie weenie!

Announcer: What exactly do you have? Aerosol cheese products, deep-fried morsels? Who cares? If it's on a toothpick and it's free, it could be plutonium and we'd eat it!

Singer: It's all good baby!

Announcer: For a guy wearing oven mitts and an apron, you're alright.

Singer: You're a star.

Announcer: So crack open an ice cold Bud Light, titan of the the toothpick. (SFX: Bottle open.) Because you put the free in freedom.

Singer: Let it be free…

Announcer: Bud Light Beer. Anheuser-Busch. St. Louis Missouri.

April

MVO: April is lazy. April says running is too hard. April says your car is your best friend. April says slippers are better than running shoes. April stands on the right, sits in the pub, lies on the sofa. April says loosen your belt. April says go on get a minicab home. April says Primrose Hill should have escalators. April says cod and chips twice. April says walk don't run. April hurts. Defy April. Train for July. For information on Nike training runs visit www.runlondon.com

May

MVO: May is full of doubt. May tries… but not too hard. May runs in the dark, dribbles snot, steps in dog poo. May hides your running shorts. May says take a breather. May forgets to set your alarm clock. May's got a hundred reasons why you shouldn't run. May says next week, next month, next year. May says you ran for the bus, job done. May says take another breather. May says ooh no sunny days only. May says easy does it. May runs in circles, trips over tourists, takes the short cut through Hyde Park. May likes flat roads, thick socks, long rests. May says go shopping instead. May gives up. Beat May.

June

MVO: June says run today. June says do some miles. June races buses, chases dogs, eats bananas, swears at cars. June tells you it's only spitting when its pouring. June says 10 laps. June says guess what you're doing this lunchtime? June drags you across fields, covers you in mud, pulls you up hills. June says 20 laps. June chases you up the Mile End Road, leaping dustbins, dodging cars. June says 30 laps. June whispers gently in your ear 'don't stop', 'don't stop'. June says here we go again. Enjoy June. Train for July. For information on Nike training runs visit www.runlondon.co.uk

Public Service and Charities, Individual

Copywriter
Troy Longie

Agency Producers
Lynda Crotty
Jenee Schmidt

Recording Engineer
Greg Geitzenauer

Advertising Agency
Clarity Coverdale Fury

Account Handler
Rob Rankin

Marketing Executive
Lynn Kenagy

Client
Minnesota Partnership
For Action Against
Tobacco (MPAAT)

Public Service and Charities, Individual

Copywriters
Jaime Diskin
Barbara Ossner

Agency Producer
Georgia Barnes

Recording Engineer
James Martell

Production Company
Sound Resevoir

Advertising Agency
Young & Rubicam,
Sydney

Account Handler
Austin Simms

Marketing Executive
Val Badham

Client
SPELD

Evelyn

FVO: My name is Evelyn Hodnett. I'm from Crystal, Minnesota. I sound like this because I smoked for many years and got cancer in my throat. So I had to have my larynx removed when I was just 44 years old. Now, I have a dime-sized hole in my neck. And it took me one long, trying year to learn how to talk like this. Cigarettes may have taken away my vocal cords. But I still have a voice. If you smoke, please stop. Call the Minnesota Tobacco Helpline, 1-877-270-STOP. Talk to one of their counsellors today. While you still can.

Spaces

Computer generated voice:

When you suffer from dyslexia, it is sometimes difficult to see the spaces between words in a sentence.

To show you how this might affect your ability to read, let's listen to the commercial again, with the spaces removed.

(Voice then reads commercial as though it was one word.)

Whenyousufferfromdyslexiaitis sometimesdifficulttoseethespa cesbetweenwordsinasentence.

As you can see it becomes quite hard, but it can be treated.

The SPELD association of New South Wales can tell you whether your child has dyslexia and can offer teaching methods that best suit your child's needs.

For more information, please call nine four one six nine one hundred.

Children with dyslexia are not disabled, they just have a different way of thinking.

At the SPELD association we offer a different way of learning.

Public Service and Charities, Campaigns

Copywriters
Roger Baldacci
Mike Martin
Rich Mackin

Creative Director
Roger Baldacci

Chief Creative Officer
Ron Lawner

Group Creative Directors
Peter Favat
Alex Bogusky

Agency Producers
Ben Raynes
Karen Kenney

Advertising Agency
Arnold Worldwide

Recording Studio
Soundtrack

Recording Engineer
Mike Secher

Account Handler
Azurae Chambers

Marketing Executive
Beverly Kastens

Client
American Legacy Foundation

Infect Truth

Receptionist: Good Morning Phillip Morris.

Sam: How ya doing? Um, I guess you can just transfer me to the new flavour division.

SFX: Ringing.

Woman: Consumer Affairs.

Sam: Hi, I was on the website and it says you put ammonia in your cigarettes for flavor, so we just thought that ammonia that's a tasty idea, but we have some new flavour suggestions maybe you would want to jot them down.

Woman: Um.

Jon: We're thinking of maybe kerosene. Or ah, what else did we come up with? Um, Gas?

Sam: Window washing fluid, um, any kind of household product. That's like a whole line we're thinking maybe.

Jon: How about bleach, wouldn't that be a good flavour?

Sam: What if…

Woman: (Interrupts) I don't know. That is your opinion Sir. I cannot answer that Sir. I'm not an ingredient specialist.

Jon: Can you transfer us to an ingredient specialist?

Woman: There is no such thing as an ingredient specialist Sir, the information…

Sam: So you don't think that this is going to fly?

Woman: Um, I can't say sir, it doesn't hurt to try.

Sam: Alright, thanks a lot.

Woman: You're very welcome. Have a nice weekend.

Jon: You too.

Sam: Bye.

SFX: Dial tone.

WREN: Stay on the line and truth will assist you.

Dog Walker

Receptionist: Good afternoon, Lorilarrd.

Nate: Hello ma'am. My name's John and I was hoping I could talk to someone about a business idea. I think your company may benefit from.

Receptionist: What is… um… the nature of this business though.

Nate: Oh I'm glad you asked. I'm a professional dog walker by trade.

Receptionist: Uh huh.

Nate: And… and my dogs, well they pee a lot, usually on like fire hydrants and people's flower beds. I thought, that's a total waste of quality dog urine. And why not collect it and sell it to you tobacco people.

Receptionist: Hmm…

Nate: Well see dog pee is full of urea, and that's one of the chemicals you guys put into cigarettes. And I was just hoping to make a little extra spending cash. Under the table. You know what I'm sayin'.

Receptionist: Let me connect with the consumer department.

Nate: …I could send you some samples. Let's see I've got chihuahua, golden retriever… I got some high-test rotweiller pee — it's all good stuff.

Receptionist: All right hold on.

SFX: Ringing.

Guy: Mike Lavoi? (unitelligible)

Nate: Hello sir. Uh my name is John, I have a business idea. A pee proposal.

SFX: Click of phone hanging up, dial tone.

Teen: Um hello?

SFX: Beeping sound.

ANNCR: You have reached the truth.

Hearse Sponsorship

Woman: Thank you for calling Phillip Morris Consumer Affairs how may I assist you today sir?

Nate: I have an idea that maybe your tobacco company would be interested in. It's sort of a business proposition.

Woman: OK, we don't accept any unsolicited ideas or suggestions, Sir.

Nate: Well, what if you sorta sponsored hearses?

Woman: Pardon?

Nate: Like, imagine your logo like all over a hearse, you know? And then think of all the people…

Woman: (Interrupts) Oh, absolutely not Sir, we simply don't want you to have access to any of our promotions Sir.

Nate: Well, think of all the people that would see your logo at funerals… plus I know guys like to sponsor auto racing. So it seems like a perfect fit. It would be like a pace car for the funeral procession.

Woman: I'm sorry ?

Nate: We could have the casket bearers wear t-shirts.

Woman: Again sir, we do not accept any unsolicited ideas.

Nate: OK, what do you think about the idea?

Woman: I choose not to make any type of comment on that Sir. I thank you for your call this afternoon.

Nate: Have a good afternoon.

Woman: You too sir.

Nate: Thank you.

Woman: Goodbye.

WREN: You have reached the truth.

MUSIC VIDEOS

Top Row; *Left to Right:*
ANTOINE BARDOU-JACQUET, H5 • GARTH JENNINGS, HAMMER & TONGS • JARVIS COCKER
Bottom Row; *Left to Right:*
RICHARD RUSSELL, XL RECORDINGS • GARY KNIGHT, FINAL CUT • JAMES MANN, GLASSWORKS • CINDY BURNAY, RSA/BLACK DOG FILMS

MUSIC VIDEOS

Left to Right:
DILLY GENT · CAROLE BURTON-FAIRBROTHER, VIRGIN RECORDS

Comment by Dilly Gent

What makes a good video is a simple idea executed well. This year's nominations showed a great deal of competence within the craft disciplines but sometimes the idea was less successful. People need to remember the relevance of music in a music video. The Breathe video for Telepop was an outstanding use of cinematography, Star Guitar for The Chemical Brothers was a fresh idea and Spinning Plates for Radiohead was an excellent example of a soundtrack being re-mixed effectively for video. The jury felt that a low budget sub-category should come back at D&AD because new young directors have access to far smaller budgets. We liked Par-t-One for cinematography, all impressed by the execution within the framework of less budget. Judging would be fairer if the disparity between entries was resolved in terms of budget.

Gold Award
for the most
outstanding
Direction

Silver Award
for the most
outstanding
Direction

Silver Nomination
for the most
outstanding
Special Effects

Director
Michel Gondry

Special Effects
Twist

Producers
Dan Dickenson
Julie Fong

Artist
Chemical Brothers

Editor
Twist

Production Company
Partizan

Video Commissioner
Carole Burton-
Fairbrother

Record Company
Virgin Records

Star Guitar
Chemical Brothers

Music Videos

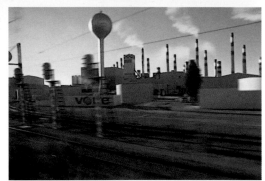

Silver Award
for the most
outstanding
Animation

Accepted in
Direction

Animator
Numero 6

Director
Numero 6

Producers
Dan Dickenson
Charlotte le Pot

Artist
Super Furry Animals

Production Company
Partizan

Editor
Walter Moroit

Video Commissioner
Adam Dunlop

Record Company
Sony UK

It's Not The End Of The World
Super Furry Animals

Silver Nomination
for the most
outstanding
Direction

Silver Nomination
for the most
outstanding
Cinematography

Director
Traktor

**Lighting
Cameraperson**
Tim Maurice-Jones

Producer
Philippa Smith

Artist
Fatboy Slim

Production Company
Partizan

Editor
Rick Russell

Special Effects
Jean Clement Soret

Video Commissioner
John Hassay

Record Company
Skint Records

Ya Mama
Fatboy Slim

Silver Nomination
for the most
outstanding
Direction

Director
Traktor

Producer
Philippa Smith

Artist
Basement Jaxx

Production Company
Partizan

Editor
Rick Russell

Special Effects
Jean Clement Soret

**Lighting
Cameraperson**
Tim Maurice-Jones

Video Commissioner
John Hassay

Record Company
XL Recordings

Where's Your Head At
Basement Jaxx

Silver Nomination
for the most
outstanding
Cinematography

Lighting Cameraperson
James Whitaker

Director
Jordan Scott

Producer
Keeley Gould

Artist
Telepopmusik

Set Designer
Paul Martin

Editor
Gary Knight

Production Company
Black Dog Films

Video Commissioner
Valentine Heliot

Record Company
EMI Music France

Breathe
Telepopmusik

Silver Nomination
for the most
outstanding
Cinematography

Lighting Cameraperson
Nick Sawyer

Directors
Sam Brown
Paul Gore

Producer
Suzie Morton

Artist
Par-I-One

Editor
Art Jones

Production Company
Flynn Productions

Video Commissioner
Katie Francis

Record Company
Parlophone Records

I'm So Crazy,
Par-T-One

Silver Nomination
for the most
outstanding
Animation

Animator
Duran

Directors
Antoine Bardou-
Jacquet
Ludovic Houplain
Herve de Crecy

Producer
Charlotte le Pot

Artist
Playgroup

Special Effects
Marie Guignard

Editor
Walter Moroit

Production Company
Partizan

Video Commissioner
Nathalie Noennec

Record Company
Source Records

Number One
Playgroup

Silver Nomination
for the most
outstanding
Special Effects

Accepted in Animation

**Post Production
Companies**
The Mill
Pictures on the Wall

Animator
Johnny Hardstaff

Flame Artists
Phil Crowe
Barnsley
Paul Marangos
Neil Davies
Dave Houghton
Paul Harrison

Flame Assistant
Salima Needham

Motion Control
George Theophanous
Ray Moody
Jay Mallet

3D Animation
Aron Hjartarson
Ben Smith
Paul McGeoch
Dave Woolard

Director
Johnny Hardstaff

Producer
John Payne

Artist
Radiohead

Production Company
Black Dog Films

Editor
J D Smyth

**Lighting
Cameraperson**
Stephen Blackman

Video Commissioner
Dilly Gent

Record Company
Parlophone Records

Push Pulk Revolving Doors / Like Spinning Plates
Radiohead

Silver Nomination
for the most
outstanding
Editing

Editor
John McManus

Director
Walter Stern

Producer
Laura Kanerick

Artist
Massive Attack

Set Designer
John Bramble

Production Company
Academy

Special Effects
Sean Broughton

**Lighting
Cameraperson**
Daniel Landin

Video Commissioner
Carole Burton-
Fairbrother

Record Company
Virgin Records

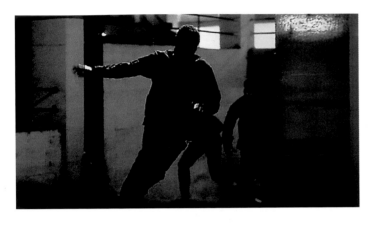

Angel
Massive Attack

Direction

Also accepted in
Cinematography

Director
Dawn Shadforth

**Lighting
Cameraperson**
John Mathieson

Producer
Cindy Burnay

Artist
Kylie Minogue

Production Company
Black Dog Films

Editor
Dawn Shadforth

Special Effects
Dan Williams
Glyn Tebbutt
Tim Rodgard
David Kiddie
Paul Dickson

Video Commissioner
Faith Holmes

Record Company
Parlophone Records

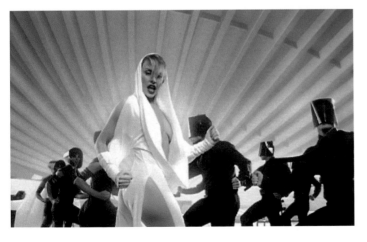

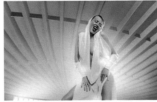

Can't Get You Out Of My Head,
Kylie Minogue

Direction

Directors
Mike Maguire
Tom Kuntz

Producer
Richard Weager

Artist
The Avalanches

Set Designer
Roger Swanborough

Production Company
Independent Films

Off-line Editor
Swordfish

On-line Editor
Rushes

Lighting Cameraperson
Jake Polonsky

Video Commissioner
Richard Skinner

Record Company
XL Recordings

Frontier Psychiatrist
The Avalanches

Direction

Director
Thomas Hilland

Artist
Röyskopp

Production Company
Toxic

Advertising Agency
Mother

Editor
Knut Helgeland

Record Company
Wall Of Sound

Eple
Röyksopp

Direction

Director
Michel Gondry

Producers
Dan Dickenson
Charlotte le Pot

Artist
Radiohead

Production Company
Partizan

Special Effects
Olivier Gondry

Lighting Cameraperson
Jean Louis Bompoint

Video Commissioner
Dilly Gent

Record Company
Parlophone Records

Knives Out
Radiohead

Animation

Animators
John Willens
John Harmer

Director
Tim Hope

Producer
Sophie Bryne

Artist
Coldplay

Production Company
Passion Pictures

Editor
Stuart Hutcheson

Video Commissioner
Faith Holmes

Record Company
Parlophone Records

Don't Panic
Coldplay

Animation

Director
Shynola

Producer
Paul Fennelly

Artist
Radiohead

Production Company
Oil Factory

Editor
Shynola

Special Effects
Shynola

Lighting Cameraperson
Shynola

Rostrum Cameraperson
Shynola

Video Commissioner
Dilly Gent

Record Company
Parlophone Records

Pyramid Song
Radiohead

Animation

Animators
Antoine Bardou-Jacquet
Ludo & Hervé

Directors
Antoine Bardou-Jacquet
Ludo & Hervé

Producer
Charlotte le Pot

Artist
Super Furry Animals

Production Company
Partizan

Special Effects
Duran

Video Commissioner
Adam Dunlop

Record Company
Sony UK

Juxtaposed
Super Furry Animals

Animation

Animators
Pete Candeland
Dave Antrobus
Chris Hauge

Designer
Jamie Hewlett

Assistant Animators
Dave Burns
Molly Sanderson
Michael Douglas
Rufus Dayglo
Nicola Perkiss

Tracers
Sam Spacey
Angelina Da Silva

CG Animators
Chris Hemming
Stuart Hall

Directors
Pete Candeland
Jamie Hewlett

Producer
Sophie Byrne

Executive Producers
Andrew Ruhemann
Tom Astor

**Production
Co-ordinator**
Martin Wiseman

Artist
Gorrilaz

Production Company
Passion Pictures

Editor
Stuart Hutcheson

Video Commissioner
Faith Holmes

Record Company
Parlophone Records

Clint Eastwood
Gorrilaz

Special Effects

Special Effects
Pierre Le Garrec

Director
Antoine Bardou-
Jacquet

Producer
Charlotte le Pot

Artist
Air

Set Designer
Baptiste Glaymann

Production Company
Partizan

Editor
Sam Danesi

**Lighting
Cameraperson**
David Ungaro

Video Commissioner
Karine Pierret

Record Company
Source Records

How Does It Make You Feel?
Air

Editing

Editor
John McManus

Director
David Mould

Producer
Verity White

Artist
Feeder

Production Company
Academy

Special Effects
Rachel Mills

Video Commissioner
Tess Wight

Record Company
Echo Records

Just A Day
Feeder

TELEVISION & CINEMA GRAPHICS

MARINA WILLER, WOLFF OLINS

TELEVISION & CINEMA GRAPHICS

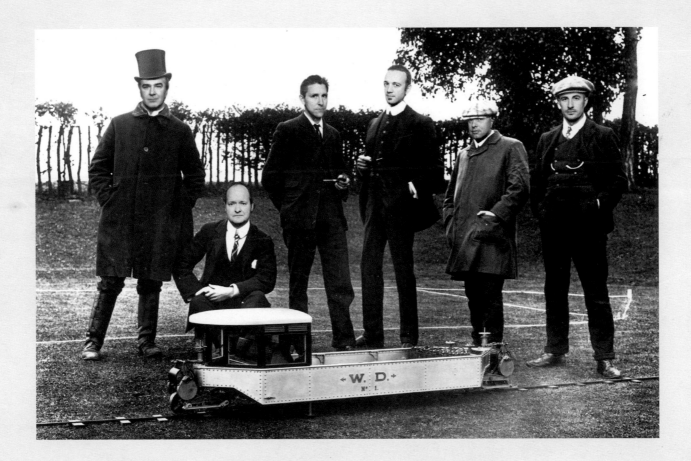

Left to Right:
ROB KELLY, THE CLINIC PRODUCTION • **ROBERT MACHIN**, FUTURE BRAND • **GARY HOLT**, LAMBIE-NAIRN
JASON FISHER JONES, RAZORFISH • **ROB HARVEY**, LOLA • **PHILIP HUNT**, STUDIO AKA

Comment by Gary Holt

2002 was not a vintage year. D&AD's judging criteria are based on great ideas that are well executed and appropriate. Many entries hit one or two of these, but few hit all three, hence that 'D&AD magic' was rare. Those that did hit all three shone. They included 'Vapour Trail', which stood out through its sheer simplicity; it's good to see that less can still be more. And 'Eggcentric' universally appealed to the jury as a well executed idea that was appropriate.

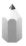

Silver Award
for the most
outstanding
Brand Identity

Designer
Chris Turner

Creative Directors
Warren Beeby
Tony Brook
Jon Stevens

Design Group
Spin

Client
Channel Four

Vapour Trail

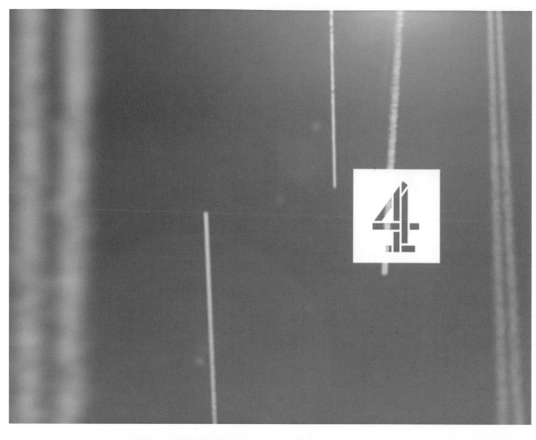

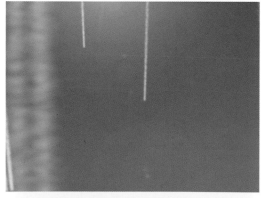

Silver Nomination
for the most outstanding Promotions, Stings, Programme Junctions

Graphic Designers
Tom Carty
Tony Malcolm
Guy Moore

Director
Tom Carty

Copywriters
Tony Malcolm
Gary Ruby

Art Directors
Guy Moore
Nick Williamson

Creative Directors
Tony Malcolm
Guy Moore

Producer
Ciska Faulkner

Set Designers
Cath Kossner
Neil McCarrick

Editor
Rick Russell

Lighting Cameraperson
Peter Thwaites

Music Composers
Tom Kenyetta
Peter Raeburn
The Industrial Egg Orchestra

Sound Designers
Johnnie Burn
Peter Raeburn

Production Company
Gorgeous

Advertising Agency
Malcolm Moore
Deakin Hutson

Account Handler
Ed Chilcott

Marketing Executive
Virginia Monaghan

Client
MTV Networks Europe

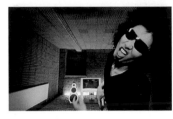

Eggcentric
An obsessed individual indulges in an egg eating fest. Scrambled, fried, boiled, poached and whisked up into a nog. His fridge is jam-packed with eggs. His flat is decorated with egg shell framed posters and floating egg shell candles, his Dog 'Ronan' laps up a bowlful of scrambled eggs, his fish tank is adorned with boiled eggs, his chess set pieces are eggs in egg cups, his girlfriend, served a heart shaped poached egg, hands him a wrapped box of eggs as a present.

Why?

So he can use the egg boxes to soundproof his flat to enjoy MTV Hits and Robbie Williams cavorting in his underpants to 'Rock DJ' at full volume without disturbing the neighbours.

The end line reinforces what we have witnessed: 'MTV Hits. As mad about pop as you are.'

Brand Identity

Graphic Design
Rheea Aranha

Directors
Rheea Aranha
Graham McCallum

Creative Director
Graham McCallum

Executive Producer
Richard Churchill

Producer
Venetia Berry

Animator
Rheea Aranha

Editor
Pierre Fletcher

**Lighting
Cameraperson**
Tony May

Production Company
Kemistry

Design Group
Kemistry

Account Handler
Guy Hewitt

Creative Director
Brett Foraker

Client
Film Four

Film Four Extreme

Title Sequences

Director
Nick Livesey

Production Manager
Trevor Williams

Inferno Operators
Phil Crowe
David Houghton
Neil Davies
Ralph Mayers

Post Production Coordinator
Melanie Wickham

Editor
Jim Weedon

Assistant Editor
Trish Fuller

Sound Designer
Nick Smith

Production Company
RSA Films

Client
MGM/UA

Hannibal

Promotions / Stings / Programme Junctions

Director
Ringan Ledwidge

Copywriter
Sean Doyle

Art Director
Dave Dye

Creative Director
Peter Souter

Producer
Edel Erickson

Editor
Andrea MacArthur

Lighting Cameraperson
Ray Coates

Production Company
BBC Broadcast

Advertising Agency
Abbott Mead
Vickers.BBDO

Client
BBC TV

Looting

**Promotions / Stings /
Programme Junctions**

Graphic Designer
Terry Lewis

Art Director
Simon Earith

Producer
Andrew Flack

Animator
Terry Lewis

Production Company
Radar TV

Client
Radar TV

Banzai TV Graphics

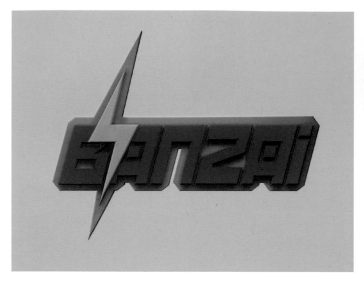

**Promotions / Stings /
Programme Junctions**

Director
Hank Perlman

Copywriter
Ed Edwards

Art Director
Dave Masterman

Creative Directors
Richard Flintham
Andy McLeod

Producer
Julia Fetterman

Set Designer
David Lee

Editor
Steve Gandolfi

**Lighting
Cameraperson**
Doug Cooper

Sound Designer
Andy Humphreys

Production Company
Hungry Man

Advertising Agency
Fallon London

Account Handler
Chris Hirst

Marketing Executive
James Wood

Client
BBC Radio 1

Split Up
Three friends behave like they're at a live concert, even though they're only listening to it on the radio at home.
 The line at the end is 'A Summer of Live Music. Radio 1'.

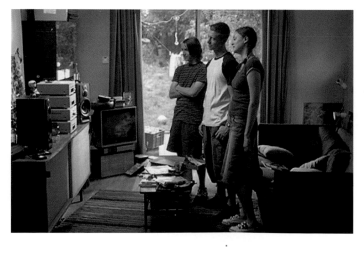

Television
Sponsorship Credits

Director
Peter Truckel

Copywriter
Simon Brooks

Art Director
Simon Brooks

Creative Director
Nick Bell

Producer
Claire Taylor

Editor
Matthew Felstead

Flame Artists
Jason Watts
Phil Crowe

Flame Assistant
Jamie Scott

Telecine
Adam Scott

Post Producer
Liz Browne

**Post Production
Company**
The Mill

Production Company
Big Bang Productions

Advertising Agency
Leo Burnett London

Account Handler
Caroline Queffeleant

Client
Procter & Gamble

Daz Dogs

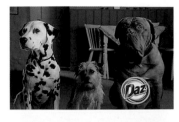

TELEVISION & CINEMA ADVERTISING

TOP ROW; *Left to Right:*

MARCUS VINTON, SPRING LONDON • CHARLES CRISP, LOWE • DAVID ALEXANDER, BANKS HOGGINS O'SHEA FCB • HAL CURTIS, WIEDEN+KENNEDY USA

LEON JAUME, WCRS • TONY DAVIDSON, WIEDEN+KENNEDY UK • DEREK APPS, LOWE • JOANNA WENLEY, BMP DDB • CATHY GREEN, STARK FILMS

BOTTOM ROW; *Left to Right:*

HELEN LANGRIDGE, HELEN LANGRIDGE ASSOCIATES • MADELEINE SANDERSON, PARTIZAN • JOHN O'KEEFE, BARTLE BOGLE HEGARTY • ADAM KEAN • BEN PRIEST, TBWA\LONDON

DUNCAN MARSHALL, SAATCHI & SAATCHI • ANDY MCLEOD, FALLON LONDON

TELEVISION & CINEMA ADVERTISING

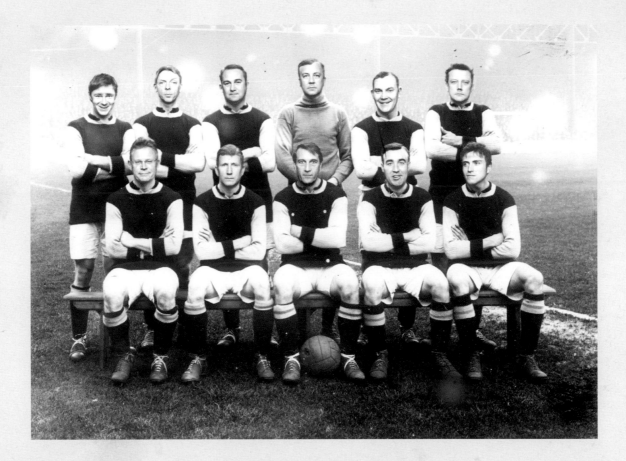

Top Row; *Left to Right:*
IVAN ZACHARIAS, STINK • JOHN MERRIMAN, MUSTOE MERRIMAN LEVY • ROONEY CARRUTHERS, VCCP • MARK TUTSSEL, LEO BURNETT CHICAGO
TREVOR MELVIN • RUSSELL RAMSEY, BARTLE BOGLE HEGARTY
Bottom Row; *Left to Right:*
TIM MELLORS, GREY WORLDWIDE • PAUL ROTHWELL, GORGEOUS • BILL GALLACHER, M&C SAATCHI • GREG MARTIN, LEO BURNETT • ALAN MOSLEY, MOTHER

Comment by Adam Kean, Tim Mellors & John O'Keeffe

It's hard work watching eight million commercials in a single day but by and large, we did a fair job. Everyone was conscientious and stayed awake. And in the end, the best stuff got through. No seismic shifts in creative thinking were evident. But there were some beautifully crafted, often very funny – and surely effective – ads, particularly from across the pond. When it comes to Nominations, there was a wide spread of different opinion, so only a few actually got enough votes to make it. There is some outstanding work. Some ads are unlucky not to get nominated. This was another very good year for television and cinema. Levi's 'Twist' was in the tradition of past Volvo and Guinness winners – universally acclaimed in several categories. Fox Sports showed how broad the appeal of slapstick humour can be worldwide when it's done with panache and style. One observation. No public service and charities work is nominated. Is it harder for these ads, as people have come to regard them as 'easier briefs'? And another. Why does the best work get done for sports and youth brands? It would be nice to see agencies apply the same creative standards to all clients.

TELEVISION ADVERTISING SPONSORED BY THE MILL • CINEMA ADVERTISING SPONSORED BY PEARL & DEAN
PUBLIC SERVICE & CHARITIES SPONSORED BY BMP DDB FOR GREAT ORMOND STREET HOSPITAL

Silver Award
for the most outstanding Television Commercial up to 60 seconds sponsored by The Mill

Silver Nomination
for the most outstanding Cinema Commercial sponsored by Pearl & Dean

Accepted in Television Commercials Over 60 seconds

Director
Frank Budgen

Copywriter
Mark Hunter

Art Director
Tony McTear

Creative Director
Russell Ramsey

Producer
Paul Rothwell

Set Designer
Mark Guthrie

Production Company
Gorgeous

Advertising Agency
Bartle Bogle Hegarty

Agency Producer
Andy Gulliman

Post Producer
Liz Browne

Flame Artists
Barnsley
Chris Knight
Jason Watts

Flame Assistants
Gavin Wellsman
Salima Needham

Telecine
Adam Scott

3D Artist
Russell Tickner

Post Production Company
The Mill

Editor
Paul Watts

Lighting Cameraperson
John Lynch

Music Composers
Pepe Deluxe
Bartle Bogle Hegarty
Warren Hamilton

Music Researcher
Peter Raeburn

Sound Designer
Warren Hamilton

Account Handler
Annicka Locket

Marketing Executive
Robert Hanson

Client
Levi Strauss Europe,
Middle East & Africa

Twist
We join a group of teenagers as they arrive at a roadside grill after a long journey. As they begin to stretch their legs we quickly notice they have the ability to twist their limbs in unbelievable ways. Title: Levi's Engineered Jeans. Twisted to fit.

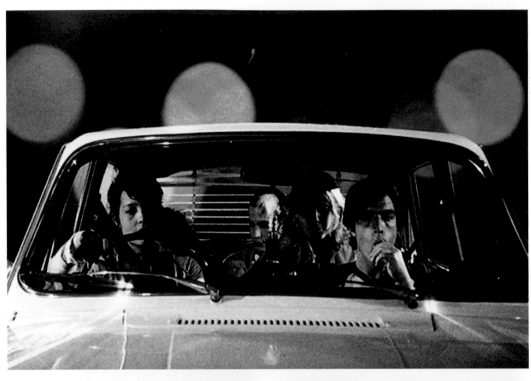

**Leaf Blower /
Nail Gun / Boat
Silver Award**
for the most
outstanding
Television Commercial
Campaign
sponsored by
The Mill

**Leaf Blower
Silver Nomination**
for the most
outstanding Television
Commercial up to
30 seconds
sponsored by
The Mill

Accepted in Television
Commercials up
to and including
20 seconds

Director
Baker Smith

Copywriters
Jeff Labbé
Eric King
Scott Wild

Art Directors
Jeff Labbé
Eric King

Creative Director
Chuck McBride

Producers
Bonnie Goldfarb
Lauren Bayer

Set Designer
Michael Deal

Production Company
Harvest Productions

Advertising Agency
TBWA/Chiat/Day
(San Francisco)

Agency Producer
Betsy Beale

Editors
Paul Martinez
Hank Corwin

**Lighting
Cameraperson**
John Stainer

Sound Design
Jeff Payne

Account Handler
Chris Witherspoon

Marketing Executives
Mark Fortner
Eric Markgraf
Neil Tiles

Client
Fox Sports

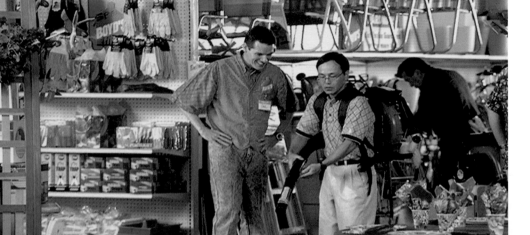

Leaf Blower
We open in the hardware section of a department store in the late 1980's to see a sales guy approach a customer who's trying out a new leaf blower. The salesman asks, 'why don't you shut her down and we'll talk price?' The customer goes to hit the stop switch, but the mechanism falls off. The leaf blower sputters and suddenly begins to blow heavily followed by flames. The panicked customer aimlessly runs around the hardware department spewing flames on the nearby patio furniture as other shoppers flee the area.

We cut to a card which reads, 'Beware Of Things Made In October.'

We cut to a distracted worker on an assembly line at a leaf blower factory. His eyes are glued to the 88' Kirk Gibson Dodgers Vs. A's home-run. Our worker loosely attaches a spark plug to the leaf blower as he watches baseball.

We super over picture, 'MLB Playoffs are coming.' and a Fox Logo.

Beware of things made in October.

Nail Gun
Silver Nomination
for the most
outstanding Television
Commercial up to
30 seconds
sponsored by
The Mill

Accepted in Television
Commercials up
to and including
20 seconds

Nail Gun
We see a guy in his open garage with a new nail gun.
He carefully positions the nail gun against a shelf
he's building and pulls the trigger. Nothing happens.
He peers down its barrel and pulls the trigger once
more. Nothing happens. Confused, he places the
nail gun down, takes the instructions and heads to
the phone to call customer support. Suddenly the
nail gun shoots a bunch of nails into the wall next to
his head. The guy scrambles for cover as his wife
enters the garage. She too immediately drops as
nails are fired her way. Our guy crawls yelling, 'get
down, get down!'
 Through the open garage door we see a neighbour
and a dog drop for cover. Kids across the street run
from the flying nails.
 We cut to a card which reads, 'Beware Of Things
Made In October.' We cut to a distracted worker on
the assembly line in the nail gun factory with his eyes
glued to the 2000 Yankees/Mets Subway Series.
The worker completely misses a nail gun as it
passes by, leaving the motor unattached.
 We super over picture, 'MLB Playoffs are coming.'
and a Fox Logo.

Beware of things made in October.

Boat
Accepted in Television
Commercials up
to and including
30 seconds

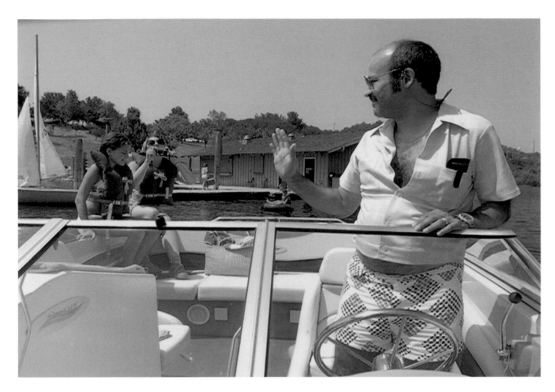

Boat
We open to see a 1970's family in their new boat. Dad goes to put the boat in gear, but the throttle mechanism comes off the side of the boat. He stares at the dismantled throttle. That moment, the boat goes into gear at full speed sending mom and daughter into the water as dad falls to the rear of the boat.

Dad struggles back to the front of the speeding boat. He grips the steering wheel to turn the boat away from a floating dock, but the steering wheel comes off the dashboard. Sunbathers dive off the dock for safety. Dad grabs his life preserver and leaps from the out of control boat.

We cut to a card which reads, 'Beware Of Things Made In October.'

We cut to see two distracted factory workers at a boat factory with their eyes glued to the Red Sox vs. Reds as Carlton Fisk hits a home run. Both factory workers sloppily assemble the boat as they watch baseball.

We super over picture, 'MLB Playoffs are coming.' and a Fox Logo

Tag
Silver Award
for the most
outstanding
Television Commercial
Over 60 seconds
sponsored by
The Mill

Tag / Shade Runner /
Tailgating
Accepted in Television
Commercial
Campaigns

Directors
Frank Budgen
Tom Carty

Copywriters
Kash Sree
Mike Byrne

Art Directors
Andy Fackrell
Monica Taylor

Creative Directors
Dan Wieden
Hal Curtis
Jim Riswold

Producer
Alicia Bernard

Production Company
Gorgeous

Advertising Agency
Wieden + Kennedy
USA

Agency Producer
Andrew Loevenguth

Editors
Russell Icke
Emily Denois
Lucas Eskin

Music
David Whittman
Spooky

Account Handler
Byron Oshiro

Client
Nike

Tag
Tag follows a young man's adventure through a downtown city after he has been unexpectedly deemed 'it' by an unwelcome touch on his shoulder. He starts his morning routine at a magazine/newspaper kiosk and then realises he has been 'tagged'. People around him suddenly scatter away from his sight line and potential touch. They scramble down subways, onto busses, into locked cars and hunch behind mailboxes and lampposts. As his frustration mounts because of his inability to tag someone else, the spot ends with him walking up to an unsuspecting target (the only one to seemingly know that he is not 'it') and chasing him off of the screen. This spot uses a city as an urban playground for this memorable childhood game.

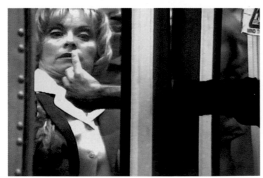

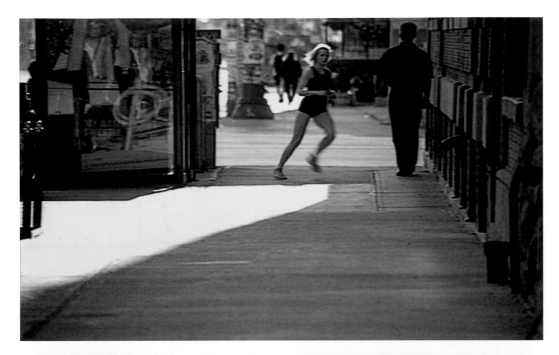

Shade Runner
This commercial features a young woman out for her daily run, doing everything and anything possible to avoid catching a glimpse of the sunlight. She runs down alleyways, under overpasses, through tunnels, in the shadows of buildings/landmarks and even through the moving darkness created by passing trucks, construction cranes and overhead airplanes. She's turned her own personal workout into a creative form of self expression… a form of play.

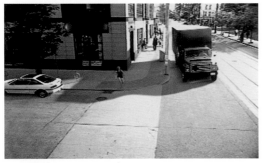

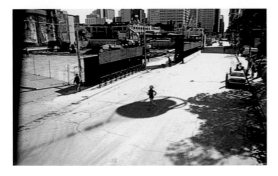

shade running

Tailgating

Tailgating opens on a young kid bouncing a basketball in the aisle while riding the bus. As he exits, the boy follows closely ('tailgates') on the heels of another passenger, still dribbling. The man peers over his shoulder at the annoyance behind him, but continues on. The kid follows while avoiding all obstacles, dribbling over pedestrians, through a yellow cab, all while doing amazing dribbling skills on the heels of his selected target. Finally, the man has had enough. He heads into an alley, trying to save face he goes for the ball. The skilled youth plays with the man, egging him on even further. The man is totally stifled, but continues to try and get the ball, only embarrassing himself further as the spot ends.

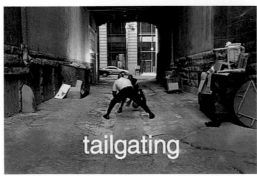

Silver Nomination
for the most outstanding Television Commercial Up to 60 seconds sponsored by The Mill

Accepted in Television Commercials Up to 40 seconds and in Cinema Commmercials

Director
Frank Budgen

Copywriter
Tony Barry

Art Director
Vince Squibb

Creative Director
Paul Weinberger

Producer
Paul Rothwell

Set Designer
Gavin Bocquet

Production Company
Gorgeous

Advertising Agency
Lowe

Agency Producer
Charles Crisp

Editor
Russell Icke

Lighting Cameraperson
Alwin Kuchler

Music Composer
Toby Anderson

Sound Designer
Nigel Crowley

Modelmaker
Asylum Models

Account Handler
Ben Moore

Managing Director
Jeremy Bowles

Marketing Executive
David Neale

Client
Reebok UK

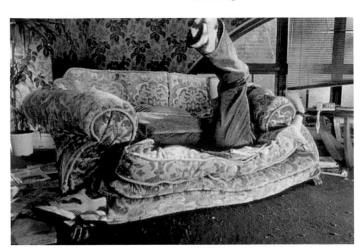

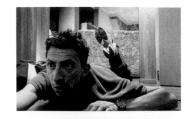

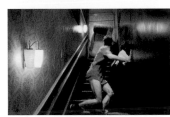

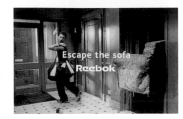

Sofa
We open with a guy sitting on a sofa in his front room. He gets up to go to the gym.

Suddenly, without warning, the sofa springs to life, grabbing our guy and holding him in a bear hug. It then flips the guy, sending him crashing to the floor. We now watch as a huge fight ensues. But this is no namby pamby tussle from 'Bedknobs and Broomsticks', this is 'World of Leather' meets 'Fight Club'. The sofa body slams our guy then hurls him across the room. Our guy tries to escape but the sofa hauls him back. Pulling off his trousers in the process. The guy fights back, picking up the sofa and hurling across the room. He grabs his gym bag and tumbles down the stairs. He looks up in horror just as the sofa launches itself down the stairs in hot pursuit. The sofa gets wedged in the door frame and comes to a grinding halt. Our guy makes a grab for his bag and legs it out the front door. We end with the sofa spinning furiously, trying every angle to squeeze down the stairs.

Cut to a title, it reads: Escape the sofa
Fade up Reebok logo.

Silver Nomination
for the most outstanding Television Commercial up to 60 seconds sponsored by The Mill

Director
Fredrik Bond

Copywriter
Yan Elliott

Art Director
Luke Williamson

Creative Directors
Robert Saville
Mark Waites

Producer
Helen Williams

Production Company
Harry Nash

Advertising Agency
Mother

Agency Producers
Hayley Irow
Matt Buels

Editor
Tim Thornton-Allen

Lighting Cameraperson
Carl Nilsson

Account Handler
Paul Adams

Marketing Executive
Richard Kingsbury

Client
Campbells Grocery Products

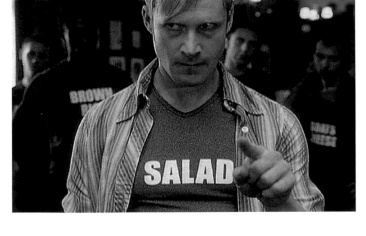

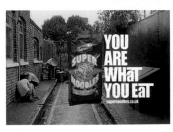

Face-Off
We open on a group of people playing pool in a bar. Suddenly a different bunch confronts them and it soon becomes apparent that they are two distinctly different groups of people – the no-nonsense SuperNoodle gang and the Poncy Salad Boys.

A mock West Side Story fight ensues which sees the Salad boys, with their perfect pirouetting punches, being overshadowed by the down to earth, clumsy, uncoordinated, SuperNoodle gang.

The gangs then split as the police arrive. The poncey salad boys manage to make it over the fence, while the Supernoodle gang are left scurrying around.

The spot ends with the line: You Are What You Eat.

**Freestyle Basketball
Silver Nomination**
for the most outstanding Television Commercial up to 60 seconds sponsored by The Mill

Accepted in Television Commercials Over 60 seconds

**Freestyle Basketball /
Freestyle Football /
Freestyle Skateboard**
Accepted in Television Commercial Campaigns

Freestyle Football
Accepted in Television Commercials up to and including 30 seconds, in Television Commercials up to and including 60 seconds and in Cinema Commercials

Freestyle Skateboard
Accepted in Television Commercials up to and including 30 seconds

Directors
Charles Randolph-Wright
Paul Hunter

Copywriter
Jimmy Smith

Art Directors
Paul Shearer
Hal Curtis

Creative Directors
Glenn Cole
Hal Curtis

Producers
Kate Sutherland
Kerstin Emhoff

Production Companies
@radical.media
HSI Productions

Advertising Agencies
Wieden + Kennedy
Amsterdam
Wieden + Kennedy
USA

Agency Producers
Jasmine Kimera
Vic Palumbo

Editor
Adam Pertofsky

Sound Design
Jeff Elmassian

Account Handlers
Jenny Campbell
Kay Hoffman
Lee Davis
Rebecca van Dyck

Marketing Executives
Stefan Olander
Paolo Tubito
Richard Mulder
Todd Pendelton

Client
Nike

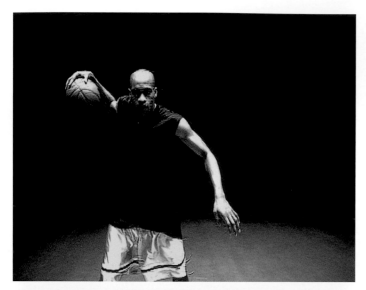

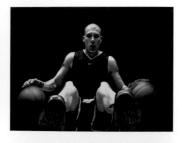

Freestyle Basketball
The title of the campaign says it all: Free & style. No distractions, no camera tricks or special effects. Just athlete and basketball.

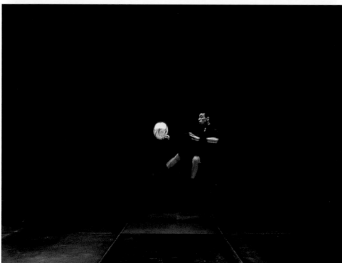

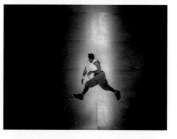

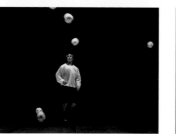

Freestyle Football
The title of the campaign says it all: Free & style. No distractions, no camera tricks or special effects. Just athlete and football.

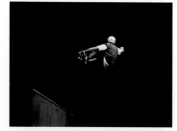

Freestyle Skateboard
The title of the campaign says it all: Free & style. No distractions, no camera tricks or special effects. Just athlete and skateboard.

Silver Nomination
for the most outstanding Television Commercial Over 60 seconds sponsored by The Mill

Silver Nomination
for the most outstanding Cinema Commercial sponsored by Pearl & Dean

Director
Ivan Zacharias

Copywriter
Vince Squibb

Art Director
Vince Squibb

Creative Director
Paul Weinberger

Producer
Nick Landon

Production Company
Stink

Advertising Agency
Lowe

Agency Producer
Sarah Hallatt

Editors
Filip Malasek
Paul Watts

Lighting Cameraperson
Jan Velicky

Music Composer
Anne Dudley

Sound Designer
Nigel Crowley

Account Director
Matt Edwards

Managing Director
Jeremy Bowles

Marketing Executives
Jo Franks
Karen Waring

Client
Interbrew UK

Doctor
A doctor does all he can to help the sick during a cholera outbreak. But, despite his saintly behaviour, the villagers shun him in fear that he may have contracted the disease. However, any worries of contamination are soon forgotten on seeing a chance to sample his precious beer.

Television Commercials up to and including 10 seconds

Director
Morgan Hutchins

Copywriter
Wayne Robinson

Art Director
Matt Collier

Creative Director
Alistair Wood

Producer
Alex Heathcote

Set Designer
Richard Maris

Production Company
Hutchins Film Company

Advertising Agency
J Walter Thompson

Agency Producer
Eira Ellis

Editor
Paul Naisbitt

Lighting Cameraperson
Malcolm McLean

Sound Designer
Nigel Crowley

Account Handler
Emma Stewart-Smith

Marketing Executive
Andrew Harrison

Client
Nestlé Rowntree

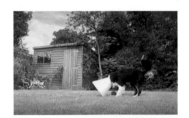

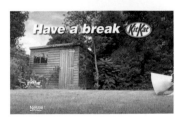

Lampshade
A dog in a back garden wears one of those veterinary lampshades that are used after surgery. He continuously tries to pick up a ball, but the large lampshade prevents him from doing so.

Television Commercials up to and including 10 seconds

Director
Matt Palmer

Copywriter
Samantha Begg

Art Director
Cameron Hoelter

Creative Director
Danny Searle

Producers
Elly Toft
Paul Friedman

Set Designer
Neville Stevenson

Production Company
Flying Fish

Advertising Agency
Clemenger BBDO
Sydney

Agency Producers
Jo Howlett
Rebekah Lawson

Editor
Sam Brunette

Lighting Cameraperson
Richard Scott

Sound Designer
Andrew Stevenson

Account Handler
Jenny Scott

Account Planner
Paul Payne

Marketing Executive
John Batistich

Client
The Smith's Snackfood
Company

Bus
This commercial opens on a kid sitting on a bus. He sits with his back to the driver. He takes out a pack of Twisties Shots and throws his head back to take a mouthful. As he does his head hits the bus driver's head, knocking him out. The driver slumps over. The kid sits unaware. We cut to outside the bus and watch it veer out of control.

Television Commercials up to and including 20 seconds

Directors
Emma Hill
Tony Rogers

Copywriter
Emma Hill

Art Director
Tony Rogers

Creative Director
Antony Shannon

Set Designer
McGregor Knox

Production Company
Clemenger BBDO
Melbourne

Advertising Agency
Clemenger BBDO
Melbourne

Agency Producer
Zaylee Saydam

Editor
Richard Hamer

Lighting Cameraperson
David Stevens

Sound Designer
David Harrison

Account Handler
Nici Henningsen

Marketing Executives
Tony Hall
Edwina McCooey

Client
AXA Australia Health
Insurance

Hollywood
A girl in a limousine is on holiday in LA, and is being filmed by her boyfriend. She points up excitedly at the Hollywood sign. Cut to show the limo winding it's way up to the sign in the Hollywood Hills. Cut to the girl standing right under the 'H' waving at camera. We hear the cracking of timber as the 'H' falls towards her. Before her boyfriend can warn her, she is driven into the ground with a sickening crunch.
Dissolve to the super: HBA. Health Insurance.

Television Commercials up to and including 20 seconds

Also accepted in Television Commercials up to and including 60 seconds

Director
Rocky Morton

Copywriter
Andy McLeod

Art Director
Richard Flintham

Creative Directors
Richard Flintham
Andy McLeod

Producer
Cathy Hood

Production Company
Partizan

Advertising Agency
Fallon London

Agency Producer
Kirsty Burns

Editor
Steve Gandolfi

Lighting Cameraperson
John Mathieson

Sound Designers
Warren Hamilton
Johnnie Burn

Account Handlers
Chris Hirst
Karina Wilsher

Marketing Executive
Chris Hawken

Client
Skoda

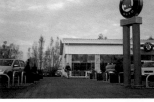
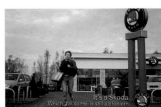
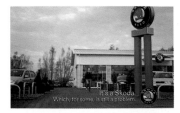

Coffee
We see a wide shot of the outside of a Skoda showroom. Through the glass, we can just about make out a woman talking to a salesman. After a while the door bursts open and we see the woman running away from the showroom as fast as she can.
 The line at the end is 'It's a Skoda, which, for some, is still a problem.'

Television Commercials up to and including 20 seconds

Also accepted in Television Commercials up to and including 60 seconds

Director
Rocky Morton

Copywriter
Andy McLeod

Art Director
Richard Flintham

Creative Directors
Richard Flintham
Andy McLeod

Producer
Cathy Hood

Production Company
Partizan

Advertising Agency
Fallon London

Agency Producer
Kirsty Burns

Editor
Steve Gandolfi

Lighting Cameraperson
John Mathieson

Sound Designers
Warren Hamilton
Johnnie Burn

Account Handlers
Chris Hirst
Karina Wilsher

Marketing Executive
Chris Hawken

Client
Skoda

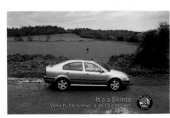

Lay By
A Skoda salesman is taking a potential customer for a drive in a Skoda Octavia. When the salesman pulls into a layby to let him drive, the customer runs away as fast as he can across a field.
 The line at the end is 'It's a Skoda, which, for some, is still a problem.'

Television Commercials up to and including 20 seconds

Director
Chris Smith

Copywriter
Sherry Hawkins

Art Director
Verner Soler

Creative Directors
Neal Foard
Doug Van Andel

Producer
Susanne Preissler

Production Company
Independent

Advertising Agency
Saatchi & Saatchi
(Los Angeles)

Agency Producer
Elaine Adachi

Editor
Gordon Carey

Sound Designer
Steve Sauber

Account Handler
Paul Imhoff

Marketing Executive
Steve Sturm

Client
Toyota Motor Sales

Dog
The New Toyota Celica looked more aggressive than its predecessor, but in terms of actual performance, it was the same old car. The challenge was to make its new looks enough of a story to get people excited. We solved the problem with a fresh execution of an ancient strategy: 'looks fast standing still'. By literally leaving the car motionless and having observers mistakenly assume it was moving, we made our point and had some fun. Sure, it was fun had at the expense of animals and old people, but that's not beneath us.

Television Commercials up to and including 20 seconds

Director
Noam Muro

Copywriter
Chad Berry

Art Directors
John Trahar
Mike Ferrer

Creative Director
Mark Ray

Group Creative Directors
Brent Ladd
Steve Miller

Producer
Shawn Lacy Tessaro

Production Company
Biscuit

Advertising Agency
GSD&M

Agency Producer
Jessica Coats

Editor
Travis Akin

Traffic
Mario Gil

Account Handler
Amy Carpenter

Advertising Manager
Jena Atchison

Client
Southwest Airlines

Checker
A guy is shopping in a supermarket. A checker turns on the light at his register and announces, 'I'm open over here.' The shopper grabs a pineapple from his cart and whips it at the checker, catching him unaware. It hits him in the chest and knocks him to the floor.
 Super: Must be football season.
 Logo: Southwest
 Proud sponsor of the NFL

Television Commercials up to and including 30 seconds

Director
Paul O'Brien

Copywriter
Jon Elsom

Art Director
Ken Sara

Creative Directors
Malcolm Green
Gary Betts

Producer
Lottie Cooper

Production Company
Framestore

Advertising Agency
DLKW

Agency Producer
Caroline Angell

Animator
Paul O'Brien

Editor
Paul O'Brien

Client
Hoverspeed

Rocket
DKLW's task was to encourage people to choose Hoverspeed over any other form of cross-channel travel, by communicating that the new, sexy, Seacat fleet is the fastest, most exciting way across the Channel.

Television Commercials up to and including 30 seconds

Director
Charlie Stebbings

Copywriter
Simon Hardy

Art Director
Steve Williams

Creative Director
Trevor Beattie

Producer
Dominic Seymour

Set Designers
Charlie Stebbings
Dominic Seymour

Production Company
Park Village
Productions

Advertising Agency
TBWA\London

Agency Producer
Nicole Edwards

Editor
Kate Owen

Lighting Cameraperson
Charlie Stebbings

Music Composer
Patrick Hawes

Sound Designer
Owen Griffiths

Account Handler
Andrew Hogan

Marketing Executive
Nick Canning

Client
News Group
Newspapers

Lovely Pair
A melancholic piano plays over a montage of Page 3's very finest jugs, melons, hooters and baps.

Television Commercials up to and including 30 seconds

Director
Craig Gillespie

Copywriter
Dean Buckhorn

Art Director
Harvey Marco

Creative Directors
David Lubars
Bob Moore

Producer
Brian Latt

Production Company
MJZ

Advertising Agency
Fallon Minneapolis

Agency Producer
Joseph Grundhoefer

Editors
Jonathan Del Gatto
Erin Virgin

Lighting Cameraperson
Adam Kimmel

Music Composers
T-Bone Burnett
Comma

Sound Designer
Ken Dahlinger

Account Handler
Lee Newman

Marketing Executive
Kathy Collins

Client
The Lee Apparel
Company

Barbershop
This commercial is part of a humorous campaign that encourages people to 'Be like Buddy Lee.' It begins with a young African-American man seated in a barber chair clutching a photograph of Buddy, the Lee Jeans corporate spokesdoll. The young man has just gotten his hair cut exactly like the doll's. He looks odd, but seems pleased with the results. In fact, he is so pleased, he offers the photo to another patron who also gets a Buddy cut. Unfortunately, this patron looks absolutely dreadful.

Television Commercials up to and including 30 seconds

Director
Jon Hollis

Copywriters
Ben Priest
Peter Reid

Art Directors
Brian Campbell
Carl Broadhurst

Creative Director
Trevor Beattie

Producer
Dominic Freeman

Set Designer
Amanda McArthur

Production Company
Dominic Freeman

Advertising Agency
TBWA\London

Agency Producer
Diane Croll

Special Effects
Jon Hollis

Editor
Jon Hollis

Lighting Cameraperson
Tony Brown

Sound Designer
Warren Hamilton

Account Handler
Gavin Thompson

Marketing Executive
David Patton

Client
Sony Computer
Entertainment Europe

Chasing Rabbits
A household dog dreams of chasing rabbits while he's asleep. His legs run faster and faster as the dream gets more intense. He's in his Third Place, why not visit yours?

Television Commercials up to and including 30 seconds

Director
Chan Man Chung

Copywriters
Craig Davis
Daniel Lim
Renee Lim

Art Directors
Maurice Wee
Francis Wee

Creative Director
Craig Davis

Production Company
The Film Factory

Advertising Agency
Saatchi & Saatchi
Hong Kong

Agency Producer
Lara Bowden

Editor
Teddy Touches

Music Composer
Click Music

Account Handler
Cecilia Wong

Marketing Executive
Philip Tong

Client
China Light & Power

Classroom
Kids in class rush to answer the teacher's questions, except for a boy who just sits quietly thinking very hard with a computer loading bar across his forehead.
 Teacher: Who's the President of the United States?
 Class: George Bush!
 Teacher: Very good!
 Teacher: And the President of China? Who's that?
 Class: Jiang Zemin!
 Teacher: Excellent!
 Teacher: And the British Prime Minister?
 Class: Tony Blair!
 Teacher: Well done!
 School's over and the boy's computer loading bar is complete. He finally has the answer to the first question.
 Boy: George Bush!
 Super: Kids can learn faster than 56K.
 Super: Oxygen Broadband

Television Commercials up to and including 30 seconds

Director
Vince Squibb

Copywriter
Vince Squibb

Art Director
Vince Squibb

Creative Director
Charles Inge

Producer
Mary Francis

Set Designer
Niamh Coulter

Production Company
Paul Weiland Film Company

Advertising Agency
Lowe

Agency Producer
Tracey Johnston

CG Animator
Alastair Hearsum

Animation Director
Alyson Hamilton

Editor
Paul Watts

Lighting Cameraperson
Roger Pratt

Account Handler
Matt Edwards

Marketing Executive
Andy Groves

Client
Nestlé Rowntree

Kiosk
Our customer is somewhat embarrassed by the promotional gift that comes free with his Aero chocolate bar.
 Despite the hula-hooping mouse's desperate attempts to please, the man remains unimpressed, telling the newsagent he can keep it.

Television Commercials up to and including 30 seconds

Director
Hank Perlman

Copywriter
Ed Edwards

Art Director
Dave Masterman

Creative Directors
Richard Flintham
Andy McLeod

Producer
Julia Fetterman

Production Company
Hungry Man

Advertising Agency
Fallon London

Agency Producer
Kate Sturgess

Editor
Steve Gandolfi

Lighting Cameraperson
Doug Cooper

Music
Stereophonics

Account Handler
Chris Hirst

Marketing Executive
James Wood

Client
BBC Radio 1

Split Up
Three friends behave like they're at a live concert, even though they're only listening to it on the radio at home.

The line at the end is 'A Summer of Live Music. Radio 1'.

Television Commercials up to and including 30 seconds

Advertising Agency
Young & Rubicam
Mattingly

Production Company
Ghost

Client
Melbourne Comedy Festival

Moon
Two policemen are sitting in their car at an intersection, waiting for the lights to change. We hear the sound of a loud car stereo as a young man pulls up beside them in his beaten up old car. They exchange a glance, but the cops decide not to bother with him. After a moment he edges his car forward a little, bringing the rear window into view. His mate in the back seat has his exposed bum hanging out the window. Just as the cops begin to react we cut to a super – There's a time and a place for comedy. The Melbourne Comedy Festival.

**Television
Commercials up
to and including
30 seconds**

Director
Traktor

Copywriter
Sam Cartmell

Art Director
Jason Lawes

Creative Director
Charles Inge

Producer
Philippa Smith

Production Company
Partizan

Advertising Agency
Lowe

Agency Producer
Charles Crisp

Editor
Rick Lawley

**Lighting
Cameraperson**
Joseph Yacoe

Account Handler
Lauren Ince

Marketing Executive
Earl Quenzel

Client
Priceline.co.uk

Car Hire
We see a Priceline customer and his family arrive to pick up their hire car.
VO: Priceline lets you name your own price for car hire. Unfortunately in America, a few people who paid less assumed they got less.
We watch as the man approaches a cheap looking car and tries to unlock it with the key fob. He turns round with surprise as he actually unlocks the posh car behind him. The man refuses to believe the posh car is his and insists on trying to open the inferior motor instead. The family becomes increasingly confused as they walk back and forth between the two.
VO: Priceline would like to avoid such incidents occurring in the UK.

**Television
Commercials up
to and including
30 seconds**

Directors
Dom Hawley
Nic Goffey

Copywriter
Alan Hannawell

Art Director
Tim Cole

Creative Directors
Tom Gilmore
Rich Tlapek

Producer
Jay Wakefield

Production Company
Oil Factory

Advertising Agency
GSD&M

Agency Producer
Jeff Johnson

Editor
Angelo Valenica

Account Handlers
Kent Simon
Jeff Orth

Marketing Executive
Jon Podany

Client
PGA Tour

Gutter
Open on a rooftop in a suburban neighborhood. A golf ball flies into frame and bounces off the satellite dish and rolls down the roof and into the gutter. We follow the ball through its long journey of gutters and downspouts until finally the balls roll out onto the front lawn and stops perfectly at the feet of PGA Tour professional David Toms, who takes his club back and hits it again. We watch the ball bounce off the dish one more time.
Title card: PGA Tour logo. These guys are good.

Television Commercials up to and including 30 seconds

Directors
Mike Maguire
Tom Kuntz

Associate Creative Directors
Geoff McCartney
Dick Tracy

Group Creative Director
John Immesoete

Chief Creative Officer
Bob Scarpelli

Producer
Geoff Cornish

Production Company
Propaganda Films

Advertising Agency
DDB Chicago

Group Executive Producer
Greg Popp

Editor
Carlos Arias

SVP, Group Account Director
Steve Jackson

VP, Marketing
August A Busch IV

Client
Anheuser Busch

Letting Go
A guy slouches on the kitchen floor, whispering sweet nothings to his girl friend over the phone. 'I don't want to hang up,' he coos. 'No you hang up first,' he begs. Next he tells her, 'on the count of three we'll hang up together. One… two…' Suddenly the phone line is ripped from the wall by one of his unamused friends waiting for him to join the domino game.

Television Commercials up to and including 40 seconds

Director
Daniel Kleinman

Copywriter
Neil Lancaster

Art Director
Dave Price

Creative Director
Dave George

Producer
Bertie Miller

Production Company
Spectre

Advertising Agency
McCann - Erickson Manchester

Agency Producer
Sara Clementson

Editor
Steve Gandolfi

Lighting Cameraperson
Ivan Bird

Account Handler
Simon Buchanan

Marketing Executive
Leigh Taylor

Client
Durex (SSL International)

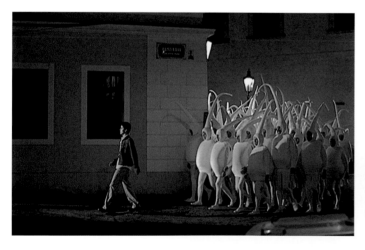
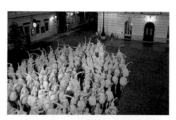 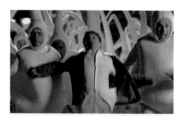

Square
A young man heads off on a date. He is followed by a multitude of men dressed as sperm. On seeing his girlfriend, the sperm cannot restrain themselves. Our man is knocked to the floor as the sperm men flood across a public square; only to be trapped inside a gigantic condom. The lovers wander off together, leaving the sperm men in a latex hell.

**Television
Commercials up
to and including
40 seconds**

Director
Lenard Dorfman

Copywriter
Andy McLeod

Art Director
Richard Flintham

Creative Directors
Richard Flintham
Andy McLeod

Producer
Ciska Faulkner

Stylist
John Bush

Production Company
@radical.media

Advertising Agency
Fallon London

Agency Producer
Kirsty Burns

Editor
Sam Sneade

**Lighting
Cameraperson**
Ivan Bird

Sound Designer
Johnnie Burn

Account Handlers
Chris Hirst
Karina Wilsher

Marketing Executive
Chris Hawken

Client
Skoda

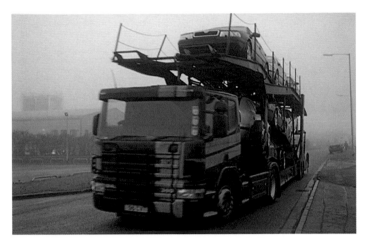

Transporter
A car transporter pulls up outside a Skoda garage. The delivery man starts unloading the cars.

But when he sees the cars, he thinks they can't possibly be Skodas. He starts loading them up again, annoyed.

The line at the end is 'The new Octavia. It's a Skoda, Honest.'

**Television
Commercials up
to and including
40 seconds**

Director
Lenard Dorfman

Copywriter
Ed Edwards

Art Director
Dave Masterman

Creative Directors
Richard Flintham
Andy McLeod

Producer
Ciska Faulkner

Stylist
John Bush

Production Company
@radical.media

Advertising Agency
Fallon London

Agency Producer
Kirsty Burns

Editor
Sam Sneade

**Lighting
Cameraperson**
Ivan Bird

Sound Designer
Johnnie Burn

Account Handlers
Chris Hirst
Karina Wilsher

Marketing Executive
Chris Hawken

Client
Skoda

Forensic
A detective drops in on the forensics lab, to see what information they can tell him about a car.

Although the forensics guy can tell him in meticulous detail about the vehicle's recent movements and several characteristics of its driver, when it comes to the make of the car he's at a loss.

The line at the end is 'The new Octavia. It's a Skoda, Honest.'

Television Commercials up to and including 40 seconds

Director
Traktor

Copywriter
John Donnelly

Art Director
Ken Grimshaw

Creative Director
Jaspar Shelbourne

Producer
Philippa Smith

Set Designer
Robbie Freud

Production Company
Partizan

Advertising Agency
J Walter Thompson

Agency Producer
Paul Fenton

Editor
Rick Russell

Lighting Cameraperson
Tim Maurice-Jones

Music Composer
Joe & Co

Sound Designer
Warren Hamilton

Account Handler
Nik Keane

Marketing Executive
Ed Pilkington

Client
Guinness UDV

Parking
This commercial features a Bajan family having trouble 'parking' their boat at a crowded jetty. They pass a space that's too small. They see a boat annoyingly taking up two spaces. At last, they see a fishing boat departing from the far side of the jetty. They try to steer into the vacant space, only to be beaten by a little old man in a rowing boat who nips in quickly.

This is simply to point out that if the Caribbean's took their lives this seriously, Malibu rum would never have been invented.

The family finally finds a place to 'park'… only to be handed a ticket by a Bajan traffic warden.

Television Commercials up to and including 40 seconds

Director
Traktor

Copywriter
Trevor De Silva

Art Director
Paul White

Creative Director
Jaspar Shelbourne

Producer
Philippa Smith

Set Designer
Robbie Freud

Production Company
Partizan

Advertising Agency
J Walter Thompson

Agency Producer
Paul Fenton

Editor
Rick Russell

Lighting Cameraperson
Tim Maurice-Jones

Music Composer
Joe & Co

Sound Designer
Warren Hamilton

Account Handler
Nik Keane

Marketing Executive
Ed Pilkington

Client
Guinness UDV

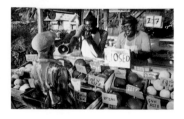

Melons
Caribbeans take life as seriously as the rest of the world.

Two melon vendors adopt and discuss ways of improving customer service. Including a queuing system, offering internet shopping, even line extensions such as lo-cal, lite, classic etc. Unfortunately they neglect to serve any of their existing customers.

Malibu. Seriously easy going.

Television Commercials up to and including 40 seconds

Director
Rocky Morton

Copywriters
Rob Jack
Ewan Paterson

Art Directors
Ewan Paterson
Rob Jack

Creative Directors
Dave Buchanan
Mike Hannett

Producer
James Tompkinson

Set Designer
Nick Ellis

Production Company
Partizan

Advertising Agency
BMP DDB

Agency Producer
Lucinda Ker

Editor
Rick Russell

Lighting Cameraperson
Simon Archer

Account Handler
Chris Brown

Marketing Executive
David George

Client
Volkswagen UK

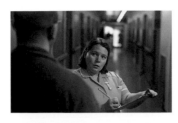

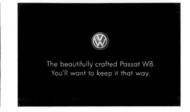

Operation
A man realises that after his operation someone else is going to have to drive his pristine new Passat W8 home. So he pretends he has had breakfast and therefore can't undergo the operation. His wife is bemused, as she knows full well that he didn't. An argument on the subject develops between them in front of the exasperated staff nurse. The commercial ends with the line: The beautifully crafted new Passat W8. You'll want to keep it that way.

Television Commercials up to and including 40 seconds

Director
Rocky Morton

Copywriters
Rob Jack
Ewan Paterson

Art Directors
Ewan Paterson
Rob Jack

Creative Directors
Dave Buchanan
Mike Hannett

Producer
James Tomkinson

Set Designer
Nick Ellis

Production Company
Partizan

Advertising Agency
BMP DDB

Agency Producer
Lucinda Ker

Editor
Rick Russell

Lighting Cameraperson
Simon Archer

Account Handler
Chris Brown

Marketing Executive
David George

Client
Volkswagen UK

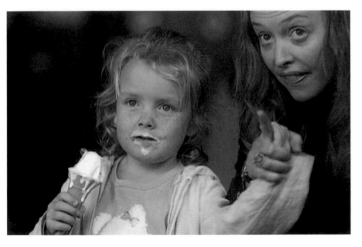

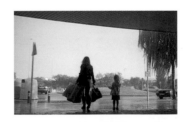

Ice Cream
A mother and her daughter are waiting in the rain to be picked up after a full day shopping. The daughter is eating an ice cream that is beginning to run down her hand. The father appears in his pristine new Passat, he sees the ice cream in his daughter's hand and continues on his way; leaving them in the rain. The daughter asks, 'Where's daddy going?' 'Don't know, he knows where to pick us up' replies the mother. The commercial ends with the line: The beautifully crafted new Passat W8. You'll want to keep it that way.

Television Commercials up to and including 40 seconds

Director
Traktor

Copywriter
Caroline Pay

Art Director
Kim Gehrig

Creative Directors
Robert Saville
Mark Waites
Jim Thornton

Producer
Philippa Smith

Set Designer
Tom Hartman

Production Company
Partizan

Advertising Agency
Mother

Agency Producers
Zoe Bell
Hayley Irow

Editor
Russell Icke

Lighting Cameraperson
Tim Maurice-Jones

Sound Designer
Owen Griffiths

Marketing Executive
Richard Kingsbury

Client
Campbells Grocery Products

Marathon
Marathon runners stop for refreshment to find that water has been replaced by Cup a Soup, and we follow the chaotic results. They fight over their favourite flavour, wait ages for kettles to boil, trip over electric cords and throw cups of Minestrone all over their heads.

Television Commercials up to and including 60 seconds

Director
Jon Hollis

Copywriter
Tara Ford

Art Directors
David Dao
Karen Selby

Creative Director
Trevor Beattie

Producer
Caspar Delaney

Production Company
@radical.media

Advertising Agency
TBWA\London

Agency Producer
Lou Pegg

Animators
Jon Hollis
Judy Roberts

Editor
Jon Hollis

Lighting Cameraperson
Tony Brown

Sound Designer
Raja Sehgal

Account Handler
Kieron Monahan

Marketing Executive
David Patton

Client
Sony Computer Entertainment Europe

Flea Circus
A scientist demonstrates how to make a flea circus.
He explains the process as he shows us: 'Training fleas requires a glass jar with a lid. The fleas are placed inside the jar and the lid is then sealed. They are left undisturbed for three days. Then when the jar is opened the fleas will not jump out. In fact, the fleas will never jump higher than the level set by the lid. Their behaviour is now set for the rest of their lives. And when these fleas reproduce, their offspring will automatically follow their example.'
Super: Escape the circus and live beyond the limits of the imaginary lid.

**Television
Commercials up
to and including
60 seconds**

Director
Craig Gillespie

Copywriter
Dean Buckhorn

Art Director
Eric Cosper

Creative Directors
David Lubars
Peter McHugh

Producers
Brian Latt
Lisa Rich

Production Company
MJZ

Advertising Agency
Fallon Minneapolis

Agency Producer
Rob Van de
Weteringe Buys

Editor
Eric Zumbrunnen

**Lighting
Cameraperson**
Adam Kimmel

Sound Designer
Steve Sauber

Account Handler
Maggie Shea

Marketing Executive
Brad Jakeman

Client
Citigroup

College Tuition
This commercial takes place late at night in a suburban home. A father is repeatedly waking up his teenage son. He uses various means, ranging from loud vacuum cleaners to placing his son's hand in a bowl of warm water. In the end, we reveal the reason for Dad's strange behaviour. The son is scheduled to take his university entrance exams in the morning and the father is obviously hoping to avoid this expense by making sure the boy is exhausted. The announcer offers up CitiBank's financial advice as a better way to save for college tuition.

**Television
Commercials up
to and including
60 seconds**

Directors
Tom Kuntz
Mike Maguire

Copywriter
Gavin Kellett

Art Director
Nik Studzinski

Creative Director
David Droga

Producer
Rupert Smythe

Set Designer
Marco Belluzzi

Production Company
Independent

Advertising Agency
Saatchi & Saatchi

Agency Producer
Sally-Ann Dale

Editor
Rick Lawley

**Lighting
Cameraperson**
Stephen Keith-Roach

Music Composer
Jonathan Goldstein

Sound Designer
Ian Hargest

Account Handlers
Norma Clarke
Richard Canterbury

**European Marketing
Manager**
Giorgia Longoni

Client
Monster.com

Conference
A bored young man sees the boss of a rival company at a conference. The voice in his head points out that as he's always wanted to work for her, he should go to her.

As he arrives, she's halfway through telling a joke, so the voice reminds him of Rule Number One. Laugh. As she reaches the punchline, he begins to laugh with all his might.

In the real world however, we should be wary of the voices. For career advice worth listening to, or to find our ideal job, we should visit monster.co.uk

Television Commercials up to and including 60 seconds

Director
Nick Lewin

Copywriter
Tim Charlesworth

Art Director
Michael Kaplan

Creative Directors
Ewan Paterson
Rob Jack

Producer
Carol Skinner

Production Company
Cowboy Films

Advertising Agency
BMP DDB

Agency Producer
Maggie Blundell

Edit House
Cut & Run

Lighting Cameraperson
Jess Hall

Music Composer
Don Robertson

Account Handler
Jon Busk

Marketing Executive
Catherine Woolfe

Client
Volkswagen UK

Whatever
All over the world, drivers have religious icons, lucky charms and mascots dangling in their cars, in the belief that they will protect them. A Polo driver has a VW key ring.
Title: We all find strength in something.

Television Commercials up to and including 60 seconds

Also accepted in Cinema Commercials

Director
Fredrik Bond

Copywriter
Jeremy Craigen

Art Director
Joanna Wenley

Creative Director
Andrew Fraser

Producer
Helen Williams

Set Designer
Dominic Watkins

Production Company
Harry Nash

Advertising Agency
BMP DDB

Agency Producer
Michael Parker

Animator
Henson's Creature Shop

Editor
Rick Russell

Lighting Cameraperson
Ben Seresin

Music Composer
Leftfield

Sound Designer
Rowan Young

Account Handler
Jon Busk

Marketing Executive
Catherine Woolfe

Client
Volkswagen UK

Demon Baby
In an Eastern European hospital, a nurse follows a mysterious trail of destruction. The cause turns out to be a strange baby with super human strength.
Title: Lupo. Volkswagen's tough little baby.

Television Commercials up to and including 60 seconds

Director
Frederic Planchon

Copywriters
Jeremy Craigen
Clive Pickering

Art Director
Neil Dawson

Creative Directors
Jeremy Craigen
Joanna Wenley

Producer
Rupert Smyth

Production Company
Academy

Advertising Agency
BMP DDB

Agency Producer
Anni Cullen

Editor
Mark Langley

Lighting Cameraperson
Patrick Durooux

Music Composer
Peter Raeburn

Account Handler
Philip Heimann

Marketing Executive
Tom Morris

Client
American Airlines

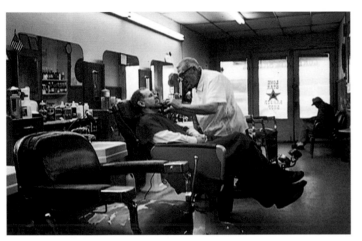

Seats
In a small town, somewhere in America, we see that various seats (from a barber shop's chair to a swing) have been replaced by airline seats.
VO: We've taken out over 7,000 seats to give you more room.

Television Commercials up to and including 60 seconds

Director
Brian Buckely

Copywriters
Mark Waites
Yan Elliott
Caroline Pay

Art Directors
Luke Williamson
Kim Gehrig

Creative Directors
Robert Saville
Mark Waites

Producer
Kevin Byrne

Production Company
Hungry Man

Advertising Agency
Mother

Agency Producer
Sarah Case

Editor
Andrea Macarthur

Lighting Cameraperson
Adam Beckman

Music Composer
Joe & Co

Sound Designer
Owen Griffiths

Account Handler
Nick Hussey

Marketing Executive
Richard Harris

Client
Coca Cola GB

Emergency
We open on a teenage boy in a supermarket. He decides to pick a Doctor Pepper out of the cooler – after all 'What's the worst that could happen?'
The fridge door shatters sending bottles of Doctor Pepper cascading on top of him. This in turn disrupts some dippers and body lotions from the top the of the refrigerators.
Things get worse as the Emergency Services declare they have to 'cut him out of his pants'. He is hauled out of the supermarket and paraded up the street in front of a gathering crowd. Before long a camera crew have arrived from the local TV station and our boy is being broadcast nation-wide. He is beamed into the households of thousands and recognised by class mates and will never be allowed to forget the day he was christened 'Butt Naked Boy'!
Doctor Pepper – What's the worst that could happen?

Television Commercials up to and including 60 seconds Also accepted in Cinema Commercials	**Director** Jonathan Glazer **Copywriter** Antony Goldstein **Art Director** Gavin Lester **Creative Director** Stephen Butler	**Producer** Simon Cooper **Executive Producer** Nick Morris **Set Designer** Chris Oddy **Production Company** Academy	**Advertising Agency** Bartle Bogle Hegarty **Agency Producer** Andy Gulliman **Visual Effects Supervisor** Mark Nelmes	**Editor** Sam Sneade **Lighting Cameraperson** Dan Landin **Music Composer** Handel	**Music Arranger** John Altman **Sound Designer** Johnnie Burn **Music Consultant** Peter Raeburn **Account Handler** Derek Robson	**Marketing Executive** Kenny Wilson **Client** Levi Strauss Europe, Middle East & Africa

Odyssey

A man hurtles through a string of solid walls. He's joined by a girl running in parallel. They crash out the building, land on a tree and run up it into the night sky.

Television Commercial Campaigns

Director
Roman Coppola

Copywriter
Jeremy Postaer

Art Director
Tia Lustig

Creative Directors
Rob Smiley
Chuck McBride

Production Company
The Director's Bureau

Advertising Agency
TBWA/Chiat/Day
(San Francisco)

Agency Producer
Betsy Beale

Editor
David Herman

Sound Design
Eleven

Client
The Gameshow
Network

Marsupial / Sputnik / Botulism
The point of view is that of the television's; Answers to a question unasked are spat out repeatedly in that moment of universal gameshow anticipation where the need to demonstrate your superiority to a confounded contestant compels you to say meaningless words over and over again in ever increasing contempt toward idiots, generally. Alas, they cannot hear you.

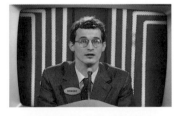

Television Commercial Campaigns	Blue Plastic Thingy	Plasticine	Fluff	Director	Producer	Advertising Agency	Editor	Marketing Executive
	Accepted in Television Commercials up to and including 20 seconds	Accepted in Television Commercials up to and including 40 seconds	Accepted in Television Commercials up to and including 40 seconds	Paul Gay	Jason Kemp	Abbott Mead Vickers.BBDO	Alaster Jordan	Kerris Bright
				Copywriter Nick Worthington	**Set Designer** Mark Lavis	**Agency Producer** Kate Taylor	**Lighting Cameraperson** Benoit Delhomme	**Client** Dulux
				Art Director Paul Brazier	**Production Company** Outsider	**Animation** 3 Bears	**Account Handler** Tom Nester-Smith	
				Creative Director Peter Souter				

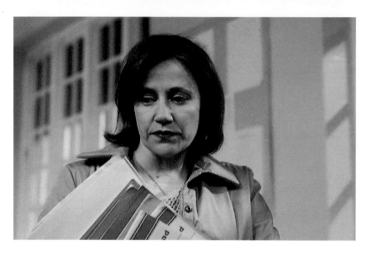

Blue Plastic Thingy

A young woman is browsing in a chandlers. The shopkeeper asks if he can help, but she says she's just looking. Then she spots something. It's a colourful blue toggle. She clearly wants it, grabs it and gives it a tug. There's an explosion; she's pulled the handle on a self-inflating 24 man life raft. The raft inflates pinning her to the glass window and filling the shop.

Title: You find the colour, we'll match it. Dulux.

Plasticine

Three 'morph' style plasticine characters are enjoying a cup of tea, when they hear a door shut. They freeze. We see nervous smiles on their faces as footsteps get closer. We then see that the plasticine characters are in a small display in a school corridor. A teacher is approaching. She notices the colourful plasticine figures and, after checking no one is watching, pulls the head off one of the little plasticine men. She gazes at the colour, a deep red, then pops it in her bag.

Title: You find the colour, we'll match it.

We cut back to see the havoc she's created; the headless plasticine man is crashing helplessly around the cardboard box set. His two friends then attempt unsuccessfully to fashion a new head for him.

Title: You find the colour, we'll match it. Dulux.

Fluff

Music: Always something there to remind me.

A young woman leads a young man into an upstairs bedroom at a party. She pulls him on to the bed, then proceeds to unbutton his shirt. She runs her hand down his torso, then stops. Her eyes widen; she's seen something amazing.

He looks down to see what it is she's marvelling at and watches her pull a little green ball of fluff out of his belly button. She gazes at the colourful ball of fluff, then gets up leaving the young man half naked on the bed.

Title: You find the colour, we'll match it. Dulux.

Survival Course

A group of women are on a survival course in the country. Their instructor warns them of the dangers of eating poisonous berries, and instructs them only to eat what she eat. They proceed to eat various berries. The instructor then sees some unusual purple berries. She picks one and gazes at it. The rest of the group pick them too, and pop them into their mouths. The instructor then puts the berry in her jacket pocket.

Title: You find the colour, we'll match it.

The group try to spit out the poisonous berries.

Title: You find the colour, we'll match it. Dulux.

Television Commercial Campaigns

Director
Ringan Ledwidge

Copywriter
Sean Doyle

Art Director
Dave Dye

Creative Director
Peter Souter

Producer
Edel Erickson

Production Company
BBC Broadcast

Advertising Agency
Abbott Mead
Vickers.BBDO

Editor
Andrea Macarthur

Lighting Cameraperson
Ray Coates

Account Handler
Matthew Abbott

Client
BBC Broadcast

Race
A newsreader says 'That's the end of the news', and competitors in the news clip stop what they're doing.
The title reads: BBC News 24. 'Because the news never ends'.

Riot
A newsreader says 'That's the end of the news', and rioters in the news clip simply stop what they're doing.
The title reads: BBC News 24. 'Because the news never ends'.

Looting
A newsreader says 'That's the end of the news', and looters in the news clip simply stop what they're doing.
The title reads: BBC News 24. 'Because the news never ends'.

Court

A newsreader says 'That's the end of the news', and Politicians and Reporters in the news clip simply stop what they're doing.

The title reads: BBC News 24. 'Because the news never ends'.

Warzone

A newsreader says 'That's the end of the news', and soldiers in the news clip simply stop what they're doing and a begin a game of football.

The title reads: BBC News 24. 'Because the news never ends'.

Television Commercial Campaigns

Treat
Accepted in Television Commercials up to and including 30 seconds

Director
Chris Palmer

Copywriter
Tony Barry

Art Director
Damon Collins

Creative Director
Paul Weinberger

Producer
Suza Horvat

Set Designer
Kave Quinn

Production Company
Gorgeous

Advertising Agency
Lowe

Agency Producer
Charles Crisp

Editor
Paul Watts

Lighting Cameraperson
Fraser Taggart

Sound Designer
Joe & Co

Account Handler
Matt Edwards

Marketing Executives
Iain Newell
Madeleine Colaco

Client
Interbrew UK

Blackmail
Heineken mercilessly blackmails its viewers into buying their product, using god-awful celebrities crooning the Carpenters classic 'Close to You'.

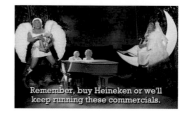

We Mean It
Heineken mercilessly blackmails its viewers into buying their product, using god-awful celebrities crooning the Carpenters classic 'Close to You'.

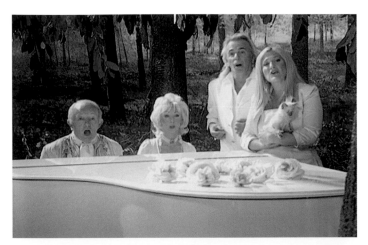

Nearly There
Heineken mercilessly blackmails its viewers into buying their product, using god-awful celebrities crooning the Carpenters classic 'Close to You'.

Keep buying Heineken.

Treat
Heineken mercilessly blackmails its viewers into buying their product, using god-awful celebrities crooning the Carpenters classic 'Close to You'.

Television Commercial Campaigns	Construction Accepted in Television Commercials up to and including 30 seconds	Director Traktor	Creative Director Eric Silver	Advertising Agency Cliff Freeman & Partners	Editor Gavin Cutler	Marketing Executives Anthony von Mandl Glenn Wong

Copywriters
William Gelner
Ian Reichenthal

Producer
Traktor

Agency Producer
Ed Zazzera

Sound Designer
Marc Healy

Client
Mike's Hard Lemonade

Art Directors
Guy Shelmerdine
Scott Vitrone

Production Company
Partizan

Animator
Quiet Man

Account Handler
Shana Brooks

Construction
A construction worker falls off a steel girder and is impaled upon a big iron pole. When a co-worker suggests getting medical attention, the construction worker opts for a Mike's Hard Lemonade instead.

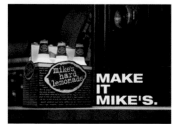
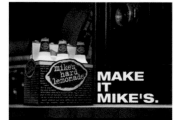

Lumberjack
A lumberjack is chopping a log with an axe when he accidentally chops his foot off. His hard day suddenly becomes better when his foreman suggests buying him a Mike's Hard Lemonade.

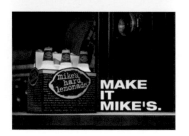

Seaquarium
An aquarium maintenance worker holds a dead fish over the water when a killer whale jumps up and bites his arm off. He is consoled by a co-worker who suggests getting a Mike's Hard Lemonade.

Television Commercial Campaigns	**Art Director** John Gellos	**Set Designer** Jody Asnes	**Agency Producers** Rick Debbie William Morrison	**Account Handler** Rebecca Edsall	
Directors Gregg Wasiak John Gellos	**Creative Directors** John Gellos Gregg Wasiak	**Production Company** The Concept Farm		**Marketing Executive** Dawn Berkowitz	
Copywriter Gregg Wasiak	**Producers** Rick Debbie William Morrison	**Advertising Agency** The Concept Farm	**Editor** Craig Lamson	**Client** A&E International Division	
			Lighting Cameraperson David Morabito		

Boxing

The spot opens on the historic 1938 title bout between Max Schmeling and Joe Louis. We see the two fighters exchanging blows as the pace builds with great anticipation. The fight continues, and we notice our photographer hanging over the edge of the canvas looking on eagerly. As he positions himself to get the perfect shot, something goes wrong with his camera. He turns the camera towards himself for closer inspection, and the flash accidentally goes off, blinding him momentarily. He falls back with a dazed look in his eyes. At this exact moment, we see Schmeling lay the famous knockout blow to Louis, dropping him to the canvas. Our photographer has missed the historic moment, as the rest of the audience around him jump to their feet in excitement. We see Joe Louis (and our cameraman) in a daze as the referee counts him out.
Super: In case you missed it the first time.
Logo: The History Channel

Coronation

The spot opens in 1953 with the young Princess Elizabeth on the throne, moments before she is to be crowned Queen of England. We cut around the cathedral and see various members of the royal court on hand for the grand ceremony. We see two particularly regal gents, chins up, proudly looking on. With great anticipation, the crown is raised into the air above Elizabeth's head. Just before the crown is placed, we cut to our gents. One of them accidentally drops his headpiece and, while reaching down to pick it up, hits his chum in the nether regions with his sceptre. He doubles over in pain at the precise moment the royal crown touches the Queen's head, completing the coronation. The room erupts with cheers. Realising he missed the moment, he tries to keep a stiff upper-lip while he feigns excitement, and holds back the agony.
Super: In case you missed it the first time.
Logo: The History Channel

Moon Landing

The spot opens at mission control, NASA, 1969. The engineers are dutifully at their posts, anxiously watching the large screen as Neil Armstrong is leaving the capsule. We cut around the room and see that all eyes are fixed on Armstrong's slow, nail-biting descent down the ladder. We see our young engineer take a quick sip of coffee to quench the tension. The suspense mounts. As Neil starts the historic dismount, we cut to our technician who, while adjusting controls, knocks over a cup of coffee into his lap. While he's recovering from the spill, we hear Neil reciting his famous line, 'That's one small step for man...' As the rest of the room erupts in joy our technician slowly picks his head up realising that he has missed the 'giant leap for mankind' everyone hugs and shakes hands. He pretends to join in, embarrassed that he has missed the moment of a lifetime.
Super: In case you missed it the first time.
Logo: The History Channel

**Television
Sponsorship Credits**

Director
James Pilkington

Copywriter
Jon Fox

Art Director
Rik Brown

Creative Director
Russell Ramsey

Producer
Hermas Lassalle

Production Company
Velocity Films

Advertising Agency
Bartle Bogle Hegarty

Agency Producer
Toby Clifton

Editor
Bruce Townsend

Account Handlers
Kevin Doherty
Ben King

**Lighting
Cameraperson**
Giles Nuttgens

Sound Designer
Johnnie Burn

Marketing Executive
Ken Robertson

Client
Paddy Power

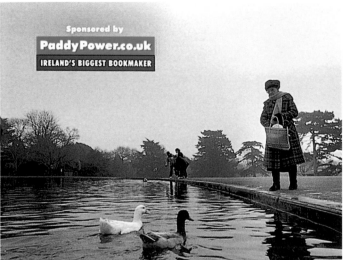

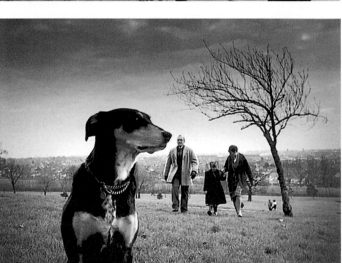

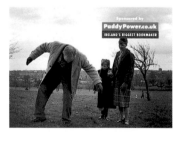

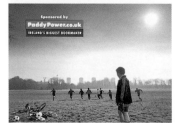

**Ducks / Dog / Pick Me / Grannies /
Crisps / Joggers**
How the world looks more interesting when seen through the eyes of a betting man. In each scenario odds are given on a likely winner.

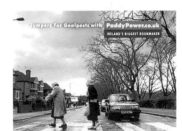

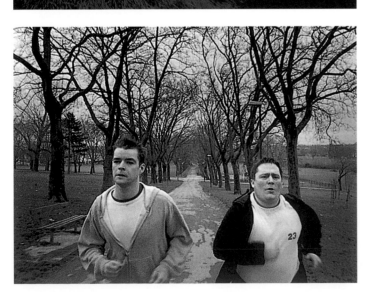

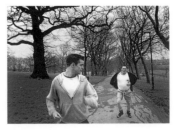

Television Sponsorship Credits	**Producer** Richard Chambers	**Account Handler** Simon Lendrum
Copywriter Dean Webb	**Production Company** The Mill	**Sound Designer** Graham Elston
Art Director Dean Webb	**Advertising Agency** BMP DDB	**Marketing Executive** Marc Sands
Creative Director Andrew Fraser	**Agency Producer** Richard Chambers	**Client** The Guardian

The Guardian Film Four Idents
A series of idents highlighting various film cliches that we didn't realise we were aware of. For example, 'No matter how straight the road, people always steer like maniacs', and 'You never hear the helicopter until you see the helicopter'.

Public Service and Charities

Director
Michael Moore

Copywriter
Stu Cooperrider

Art Director
Steve Tom

Creative Director
Stu Cooperrider

Chief Creative Officer
Ron Lawner

Group Creative Director
Peter Favat

Producer
Bill Weems

Production Company
Redtree Productions

Advertising Agency
Arnold Worldwide

Agency Producer
Jim Vaughan

Editor
Adam Parker

Editorial Company
Jigsaw

Cinematographer
Brian Danitz

Telecine
Moving Images

Colorist
Tim Massick

Marketing Executive
Dr Greg Connolly

Client
Massachusetts Department of Public Health

Tim / Dave / Kevin / Brian
Second-hand smoke contains over 40 different carcinogens and kills more than 3,000 peole in the USA every year. Why not then, interview real people who work everyday with these toxins to demonstrate just how seriously they are regarded by those who know them. This was a great opportunity to point out just how cavalier the tobacco industry is in ignoring the dangers.

Public Service and Charities

Director
Mark Powell

Copywriter
Adam Barker

Art Director
Lori Canalini

Creative Directors
Adam Barker
Lori Canalini

Producer
Maggie Speak

Production Company
Cyclops Films

Advertising Agency
Marketforce

Agency Producer
Debra Allday

Editor
John Fragomeni

Lighting Cameraperson
Paul Cutter

Sound Designer
Ric Curtin

Account Handler
Karen Della Torre

Marketing Executive
Denise Sullivan

Client
Cancer Foundation

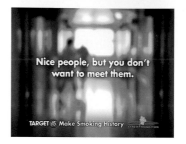

You Don't Want To Meet Us
This commercial introduces you to all the people you would meet if you developed cancer from cigarette smoking. People like the cardiothoracic surgeon who would operate on you, the radiation oncologist who would administer your chemotherapy, the chaplain who would help you come to terms with dying, and others.
They are real people and introduce themselves directly to the camera in a polite, friendly way that belies their feelings of frustration and sadness at having to care for real cancer patients who could have avoided the suffering by not smoking.
We then see a graphic that reads:
'Nice people, but you don't want to meet them. Keep smoking and you just might'.

Public Service and Charities

Director
Brian Connolly

Copywriter
Paul Domenet

Art Director
Brian Connolly

Creative Director
David Droga

Advertising Agency
Saatchi & Saatchi

Agency Producers
Sally-Ann Dale
Sam Myers

Animator
The Moving Picture Company

Sound Designer
Ian Hargest

Account Handler
Patrick Larsimont

Marketing Executive
Glyn McIntosh

Client
Quit

Click to Quit
We see a download panel as if we were looking at a computer screen. The bar begins moving across until it has the same graphic shape as a cigarette. The cursor clicks on the 'QUIT' panel. The QUIT name and web address appears in another panel at the bottom of the screen.

**Public Service
and Charities**

Director
Joe Pytka

Copywriters
Thomas Hayo
Gianfranco Azena
Peter Kain

Art Director
Thomas Hayo

Creative Director
Thomas Hayo

Producer
Kathy Rhodes

Production Company
Pytka

Advertising Agency
Bartle Bogle Hegarty
(New York)

Agency Producer
Mary Cheney

Account Handler
Ashley Jacobs

Marketing Executive
Heidi Arthur

Client
Ad Council

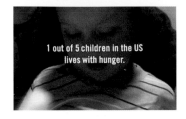

Ketchup Soup

This commercial follows a woman who looks like a working-class mother. It begins in a crowded fast food restaurant. The woman walks up to the counter, she looks around, perhaps a little nervous. She then reaches for something and puts it in her bag, making sure no one has seen her. We then see her in another restaurant, doing the same thing. Next, she's in her kitchen. She has some water boiling in a pot. She takes the stuff out of her bag and puts it on the counter. We see that she has stolen a bunch of ketchup packets. She starts opening the packets, and squeezing them into the water. She stirs it a little, then pours it into bowls. She serves it to her three young children. It is obvious they don't really want to eat it, but apparently, they have no choice.

Titles on the screen read '1 out of 5 children in the US lives with hunger. The sooner you believe it, the sooner we can end it. Call 1-800-FEED-KIDS'

**Public Service
and Charities**

Director
Steve Hudson

Copywriters
Steve Hudson
Victoria Fallon

Art Directors
Steve Hudson
Victoria Fallon

Creative Director
Peter Souter

Producer
Barbara Simon

Production Company
COI Communications

Advertising Agency
Abbott Mead
Vickers.BBDO

Editor
Joe McNally

**Lighting
Cameraperson**
Mark Chan

Sound Designer
750 mph

Account Handler
Anna Sheehan

Clients
COI/Department
of Health

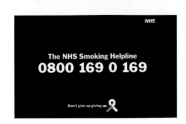

Rebecca

This commercial features a 13 year old girl called Rebecca. She talks openly about her father's cancer which was caused by smoking. Holding an unseen picture of him, she comments on how he has physically changed since the diagnosis. Wiping away a tear she advises people not to smoke.

**Public Service
and Charities**

Director
Gillian Wearing

Copywriter
Nigel Roberts

Art Director
Paul Belford

Creative Directors
Nigel Roberts
Paul Belford

Online Producer
Caroline Slade

Executive Producer
Kim Knowlton

Production Company
COI Communications

Advertising Agency
Ogilvy & Mather

Editor
Andrea MacArthur

**Lighting
Cameraperson**
Barry Ackroyd

Account Handler
Zoe Smith

Marketing Executive
Gill Stuart

Clients
COI/The Home Office

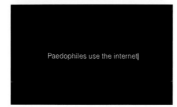

You Never Know
We hear a young boy's voice as he describes his love of football and collecting shiny badges. But as the camera pans down we see it is in fact a man in his mid thirties who is talking. We see his mouth move and hear the child's words coming from his mouth.

**Public Service
and Charities**

Director
Chris Palmer

Copywriter
Jerry Gallaher

Art Director
Clive Yaxley

Creative Directors
Bill Gallacher
Paul Hodgkinson

Producer
Susa Howat

Production Company
Gorgeous

Advertising Agency
M&C Saatchi

Agency Producer
Kayt Magrobi

Editor
Johnathan Scarlet

**Lighting
Cameraperson**
Ian Foster

Sound Designer
Johnnie Burn

Account Handler
Damian Collins

Marketing Executive
Piara Powar

Client
Kick Racism Out
Of Football

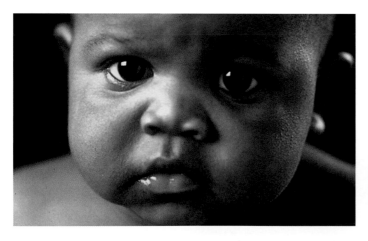

Dear White Fella
This ad is set to a poem read by Benjamin Zephaniah.

It shows a series of events seen from a black person's perspective as the poem explains that the black guy stays black throughout his life – when he's in the sun, when he's cold, ill or old.

We then see the same scenes from a white guy's perspective as the poem explains that he turns red, yellow, blue, green and grey in the same situations.

And asks how he has the cheek to call black people coloured.

Public Service and Charities

Director
Kevin Thomas

Copywriter
Simon Dicketts

Art Director
Fergus Fleming

Creative Director
Simon Dicketts

Producer
Tracy Garfield

Set Designer
Ashling Johnson

Production Company
Thomas/Thomas

Advertising Agency
M&C Saatchi

Agency Producer
Barbara Simon

Editor
Bryan Dyke

Lighting Cameraperson
Bob Pendar-Hughes

Sound Designer
Spencer Eagles

Account Handler
Richard Alford

Marketing Executives
Graham Hooper
Malcolm Lemmer

Clients
COI/The Home Office

Lennox

The situation is as follows: A man has beaten up his wife. She looks vulnerable which makes us feel naturally sympathetic towards her. She is bruised, and cut. However, rather than seeming to welcome our presence, the reverse is true. She is trying to assure us that nothing is amiss 'it was all an accident'. 'It's fine.' Clearly it isn't.

The husband who is in the background obviously has some sort of hold over her.

He says nothing.

He just sits there with a smug confidence of a man who thinks he's going to get away with it.

Public Service and Charities

Director
Kevin Thomas

Copywriter
Mike Boles

Art Director
Jerry Hollens

Creative Directors
Mike Boles
Jerry Hollens

Producer
Philippa Thomas

Production Company
Thomas/Thomas

Advertising Agency
Rainey Kelly Campbell
Roalfe/Y&R

Agency Producer
Helen Durkin

Editor
Bryan Dyke

Lighting Cameraperson
Bob Pendar-Hughes

Account Handler
Brian Sheppard

Marketing Executive
Maggie Baxter

Client
Womankind Worldwide

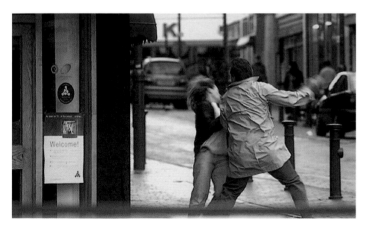

One In Four

A man walks down a street counting the women he passes. Whenever he reaches 'four' he either hits or verbally assaults the women. A voice tells us '1 in 4 women in the UK will suffer violent abuse by men.'

Finally he walks down a residential road. By the time he reaches 'three' he is at a house door. He unlocks it and goes in. The voice concludes 'Usually it's hidden behind closed doors'.

Super: Wear a ribbon on White Ribbon Day, November 25th. Womankind Worldwide.

**Public Service
and Charities**

Director
Stuart Douglas

Copywriter
Nick Worthington

Art Director
Paul Brazier

Creative Director
Peter Souter

Producer
Adam Lyne

Production Company
@radical.media

Advertising Agency
Abbott Mead
Vickers.BBDO

Agency Producer
Francine Linsey

Editors
Stuart Douglas
Tom Sparks

**Lighting
Cameraperson**
Tony Brown

Sound Designers
Johnnie Burn
Warren Hamilton

Account Handlers
Sue Garrard
Lucy Nelson

Marketing Executives
Tony Allsworth
Richard Meakin

Client
COI/DETR

Kill Your Speed
We see a car travelling down an ordinary suburban street. It's filmed in extreme slow motion. The car suddenly starts to brake and smoke comes from the front tyres.

VO: At just 5mph over the 30mph limit, how much further does it take to stop?

The voiceover begins to count the feet one by one as the car ploughs on.

VO: One foot, two feet, three feet, four feet, five feet… At 17 feet the car hits a young boy crossing the road. The count continues until the car finally stops after an extra 21 feet.

VO: Think. Slow Down.

Public Service and Charities

Director
Pedro Romhanyi

Copywriter
Bob Cianfrone

Art Director
Paul Keister

Creative Director
Alex Bogusky

Producer
Gareth Francis

Executive Producer
Billy Poveda

Production Company
Oil Factory

Advertising Agency
Crispin Porter & Bogusky Advertising

Agency Producer
David Rolfe

Lighting Cameraperson
Jeff Cutler

Editor
Tony Kearns

Assistant Editor
John Mamana

Editing Producers
Alan Olem
Karen Scott

Post Producers
Doug Sherin
Mary O'Gara

Colorist
Bob Festa

Henry Artist
Vicki North

Post Production Company
Riot

Visual Effects Artist
Vicki North

Music Composer
David Yazbek

Music Arranger
Peter Lurye

Sound Designer
Mathew Schoefeld

Sound Design Producer
Brian Banks

Client
Florida Department of Health

Focus On The Positive

The spot opens with handheld, reality-style video. A group of teenagers walk into the headquarters of a tobacco company and confront the CEO. A teen asks the CEO, 'Why don't you tell people there's arsenic in cigarette smoke?'. The CEO pauses, then responds, 'Why don't you… all just focus on the positive?' He breaks into a Broadway-style musical routine, accompanied by the teens.

As the teens and CEO try to put a positive spin on the tobacco industry's business practices, we see tobacco company employees make confetti out of shredded secret documents; doctors sing cheerfully as they remove a diseased lung from a patient; and cadavers rise up in a morgue to sing and dance.

Lyrics include the doctor singing: 'So what if we remove a lung?… You shouldn't be depressed… It's really for the best… It's something off your chest.' Coroners look at a cadaver and sing: 'His tumor was malignant… But look, he's not indignant.' A teenage girl sings: 'Every 8 seconds a smoker dies, it's become routine… But let's stay focused on the positive…Those 7 seconds in between.'

The spot ends back in the tobacco company office, where we revert back to the real world and handheld video. The CEO calls for security to take the teens away.

TELEVISION & CINEMA ADVERTISING
NON-ENGLISH LANGUAGE

Left to Right:
THAM KHAI MENG, OGILVY & MATHER, ASIA PACIFIC • **DONALD GUNN** • **MOHAMMED KHAN,** ENTERPRISE NEXUS

TELEVISION & CINEMA ADVERTISING
NON-ENGLISH LANGUAGE

Left to Right:
MARCELLO SERPA, ALMAP BBDO • **MICHAEL CONRAD,** LEO BURNETT WORLDWIDE • **JOHN HEGARTY,** BARTLE BOGLE HEGARTY

Comment by Marcelo Serpa

I've always believed the true strength of D&AD lies in the fact that it is British and that it represents British design and advertising creativity judged to be the best by a British jury. As I'm not British – and none of our work is, either – I have long thought it would make about as much sense to submit a piece of work to D&AD as it would for Manchester United to play in the Brazilian league. But now, with the introduction of this new category, I believe the strength of English-language advertising will be preserved while allowing a healthy comparison with work being done around the world. Judgement went lightly – perhaps because the jury was made up of such heavyweights from several different schools. But in the end, it was a great exercise in humility for each of us. What seems brilliant to people in one country may be seen as totally stupid in another. Of the 450 pieces, there was some sort of consensus about just 17. Four were nominated and none was considered brilliant. It was a start. A good start.

Silver Nomination
for the most outstanding Television Commercial up to 20 seconds

Director
Simon Bross

Copywriter
Tony Hidalgo

Art Directors
Jorge Aguilar
Ruben Bross

Creative Director
Tony Hidalgo

Producer
Alberto Bross

Production Company
GB Y Asociados

Advertising Agency
Leo Burnett Mexico

Agency Producer
Amy Kagan

Editor
Raul Luke

Music Composer
Pedro Alberto Cardenas

Sound Design
Pac Audio

Account Handler
Teresa Sordo

Marketing Executive
Carlos Martinez

Client
Sealy Mattress Company

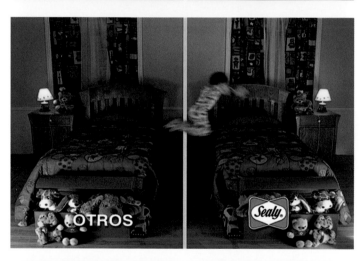
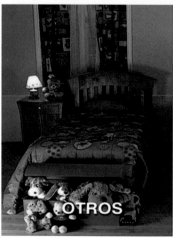
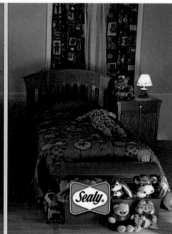

Boy
A superb parody of the side-by-side demo format. We see a split screen view of two identical bedrooms. A little boy is bouncing energetically on a mattress on the left side of the picture. A super tells us that this represents rival brands. On the right side, the mattress is a Sealy. Suddenly the boy jumps from one bed to the other, making a mockery of the split screen rule. As soon as he lands on the Sealy mattress, he falls asleep. The comic timing is immaculate.
 Super: Your rest deserves a Sealy.

Silver Nomination for the most outstanding Television Commercial up to 30 seconds

Director
Kasper Wedendahl

Copywriter
Joakim Nielsen

Art Director
Michael Robert

Creative Director
Michael Robert

Producer
Rikke Katborg

Set Designer
Søren Skjaer

Production Company
Bullet

Advertising Agency
Robert/Boisen

Agency Producer
Dorte Tellerup

Lighting Cameraperson
Michael Sørensen

Sound Designer
Bosse

Account Handler
Dorte Tellerup

Marketing Executive
Lars Steen

Client
Interflora

Tool Shop
A man is standing with both a small and a huge drill in a tool shop. His wife appears and surprises him by letting him have the huge drill as she puts the small one back on the shelf.

Super: The power of flowers. Interflora

Silver Nomination
for the most
outstanding
Television Commercial
up to 60 seconds

Director
Axel Laubscher

Copywriter
Janne Brenda Lysø

Art Director
Stian Johansen

Producer
Annelie Lindstrøm

Production Company
EPA International

Advertising Agency
Leo Burnett Oslo

Agency Producer
Richard Patterson

Account Handler
Bente Kvam

Client
McDonald's

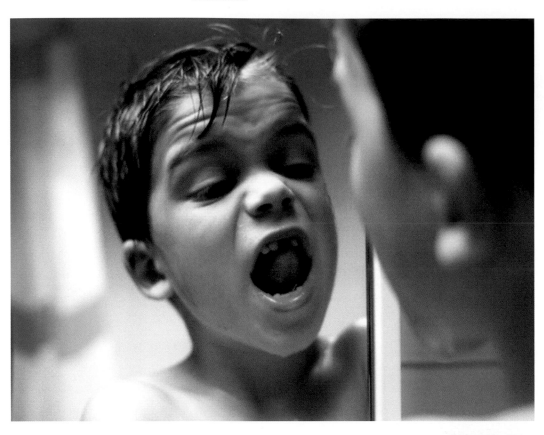

Toothfairy
A boy stays at his grandfather's, loses a tooth and gets a coin for the tooth from the toothfairy, while the grandfather smiles secretly. The boy spends the tooth money on a burger at McDonald's. When the grandfather wakes up the next morning, his false teeth have been switched for many coins and the boy smiles secretly.

Silver Nomination
For the most
outstanding
Cinema Commercial

Director
Matthijs van
Heijningen Jr.

Copywriter
Poppe van Pelt

Art Direction
Diederick Hillenius

Producer
Saskia Kok

Set Designer
Ken Chu

Production Company
Bonkers B.V

Advertising Agency
TBWA\Campaign
Company

Agency Producer
Miriam Buise

Editor
Jono Griffith

**Lighting
Cameraperson**
Joost van Gelder

Sound Design
Wim Vonk Sound

Account Handlers
Michiel Vogels
Joost Hosman

Marketing Executive
Ton Gobes

Client
Delta Lloyd

Parade
In this commercial a citizen of a totalitarian
communist country has to practice for a military
parade in celebration of the great leader. Being fed
up with the system after a day's practice, he decides
not to go. A decision with great consequences.

Television Commercials, up to and including 20 seconds

Director
Leong Mun Yik

Copywriters
Jed Donohoe
Enda Nasution
Dyah Aryani

Art Directors
Roy Wisnu
Pasha Yudhadibratha

Creative Directors
Roy Wisnu
Jed Donohoe

Producer
Stella Seow

Set Designer
Waiki

Production Company
Square Box Cinetech Productions

Advertising Agency
Ogilvy & Mather Jakarta

Agency Producer
Hani Sumarsono

Off-line Editor
Adrian

Lighting Cameraperson
Tong Shing Ka

Music Composer
Dameria & Doti

Sound Design
Two Dees

Account Handlers
Oda Sekolastika
Rima Alatas
Sisca Wulandari

Marketing Executive
Heiko Schipper

Client
Nestlé Indonesia

Introduction
A relative is being introduced to the family's children in ascending order of age. As each child shakes his hand, they crush it with progressively more force. After the third child he is unable to bear the pain any longer. He smiles weakly at the oldest boy and simply waves hello.

Television Commercials, up to and including 20 seconds

Director
Andreas Heinger

Copywriters
Ricardo 'Chester'
Roberto Pereira

Art Director
Luiz Sanches

Creative Directors
Marcello Serpa
Eugênio Mohallem

Producer
Ana Flavia Bernardes

Production Company
Andreas Heinger

Advertising Agency
AlmapBBDO

Agency Producer
Egisto Betti

Music Composer
Play It Again

Account Handlers
Wilson Pereira
Denise Nogueira

Marketing Executives
Manu Melotte
Lilian Miranda

Client
Sara Lee

Cup
The commercial shows that Pilao is such a strong coffee that it doesn't lose its colour, even when mixed with milk.

Television Commercials, up to and including 30 seconds

Director
Martin Koolhoven

Copywriter
Zwier Veldhoen

Art Directors
Sanne Braam
Zwier Veldhoen

Creative Directors
Michael Jansen
Bas Korsten

Producers
Stefany Rietkerk
Marco Both

Production Company
Artcore

Advertising Agency
Result DDB

Agency Producers
Marloes van Den Berg
Pirke Bergsma

Editor
J P Luijsterburg

Lighting Cameraperson
Menno Westendorp

Sound Design
Peter Warnier

Account Handler
Ruby Lemm

Client
Volkswagen

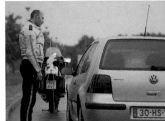

Motoragent
A policeman has stopped a Golf and is standing next to it. He signals the driver to open his window, by making a rotating movement with his hand. He has a fairly stern expression on his face. The driver does not seem at all impressed, and just shakes his head as if to say, Sorry, I can't. The look on the driver's face is honest and naive.

The policeman now really urges the driver to open his window, and makes the turning movement again. But the man stubbornly continues to shake his head.

Title: Electric windows. Standard on every Golf.

VO: Volkswagens are more complete than you think.

Title: Volkswagen. Who else?

Television Commercials, up to and including 30 seconds

Directors
Maurício Guimarães
Luciano Zuffo

Copywriter
Rita Corradi

Art Director
Jose Roberto Dielboux

Creative Director
Tião Bernardi

Producer
Dueto Team

Production Company
Dueto Filmes

Advertising Agency
Young & Rubicam
(São Paulo)

Agency Producers
Rachel Folino
Celso Groba

Editor
Alessandro Satori

Lighting Cameraperson
Chiquinho Oliveira

Music Composer
Dr. DD
Raw

Account Handlers
Fernando Luz
Daniel Jotta

Marketing Executives
Geraldo Leite
Guilmere Stutzman

Client
ANJ - Brazillian
Newspaper
Association

Personalities
The movie shows a sequence of people reading a newspaper. Depending on the position that the newspaper is held, we see printed photographs of famous people in the newspaper juxtaposed on the faces of readers, forming one person.

VO: Every day you discover and learn from them. You are surprised by them.

They make you think, change, evolve.

They get you excited, angry, happy, full of hope. You might agree with them, or not. But you will never be indifferent

Super: Newspapers. Making you a much more interesting person.

Television Commercials, up to and including 30 seconds

Director
Oceanic Chan

Copywriter
Joji Jacob

Art Directors
Benson Toh
Norman Tan

Creative Director
Norman Tan

Producer
Winnie Tang

Set Designer
Calvin Hui

Production Company
The Film Factory

Advertising Agency
J Walter Thompson
(Singapore)

Agency Producer
Tania Montgomery

Editor
Johnny Chan

Lighting Cameraperson
Oceanic Chan

Sound Designer
Luk Man Ho

Account Handlers
Diana Thomas
Ignacio Rosario

Marketing Executive
Roongnapa Terakul

Client
Advance Agro

No Jam
The film shows several sheets of paper emerging from a photocopier with nothing but the picture of a slice of toast on them.

After a while the legend 'No Jam' appears on screen. A voice over explains that Double A paper is guaranteed not to get stuck in the photocopier. Double A paper logo then appears on screen.

Television Commercials, up to and including 40 seconds

Director
Lawrence Hamburger

Copywriters
Valerie Larrondo
Mathew Blanning

Creative Director
Anne De Maupeou

Producer
Robert Herman

Production Company Director
Stink

Advertising Agency
CLM/BBDO

Agency Producer
Pierre Marcus

Lighting Cameraperson
Darran Tiernan

Sound Designer
Barrera Prod

Account Handler
Valerie Accary

Marketing Executive
Frederic Guyot

Client
Midas

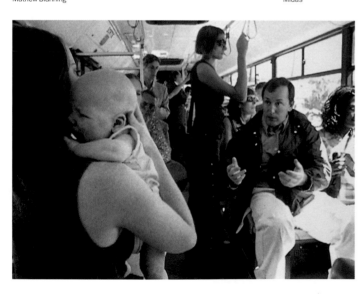
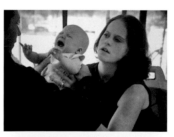

The Baby
The commercial starts with a bus full of people. Amongst the passengers is a young woman holding a screaming baby. The crying is obviously getting on the nerves of the other passengers. A man sitting near her offers to help and gestures to her to hand over the baby. He taps the baby's tummy, presses his feet and pulls on his toes, as if examining him. The sound of the baby's cries change as the man does this, and they become a constant crying sound. The man nods, as if pleased with himself, and hands the baby back to the mother, who is visibly very surprised by the scene she has just witnessed. The man gets off the bus and walks off.

The woman is even more embarrassed by the new noise the baby is now making. The people left on the bus are even more annoyed than before.

A Midas man's work is never done.
Super: Tune ups – 265 Francs.

Television Commercials, up to and including 60 seconds

Director
Fabian Bielinski

Copywriters
Christian Camean
Javier Mentasti

Art Directors
Juan Cabral
Santiago Chaumont

Creative Directors
Maxi Anselmo
Sebastian Wilhelm

Producer
Guillermo Pilosio

Set Designer
Sebastián Orgambide

Production Company
Argentinacine

Advertising Agency
Agulla & Baccetti

Agency Producers
Hernan Carnavale
Veronica Zalinkevicius

Editor
Gerardo Perez

Lighting Cameraperson
Victor Gonzalez

Music Composer
Symphony

Sound Design
Symphony

Account Handlers
Mariano Mataloni
Veronica Hidalgo

Marketing Executives
Martin Larumbe
Fernando Mollica

Client
Telecom Argentina

Yawn
The commercial starts at a dance club entrance. We see a group of three girls leaving the club. One of them starts yawning and slightly covers her mouth with her hand. The club's bouncer sees her and starts yawning. The camera travels and we see a rubbish collector truck passing right in front and one of the employees starts yawning. There is an accident on the street. We see policemen and television cameras. One of the policeman sees the man on the rubbish truck and yawns. The cameras film him and show this image on air. A man who is jogging passes in front of a home appliance store and sees this image on TV and starts yawning. A dog, sitting at the gate of an apartment, sees the jogger passing and yawns. The driver of a car passing by, who comes from a fancy-dress ball, sees the dog and starts yawning. The camera follows him until the gate of a house. The housekeeper sees him and starts yawning right when the same girl that started the contagious yawn chain at the club's entrance, gets home. She waves at the housekeeper and starts yawning again.
Super: Communicate. Is simple. Telecom.

Television Commercials, up to and including 60 seconds

Director
Suthon Petchsuwan

Copywriters
Wimonwan Sangwattanaphan
Kris Spindler

Art Director
Pijarinee Kamolyabutr

Creative Director
Korn Tepintarapiraksa

Production Company
Matching Studio

Advertising Agency
Ogilvy & Mather (Thailand)

Agency Producer
Yuthapong Varanukockchoke

Account Handler
Pongsuree Asanaseng

Client
Central Garment

Torture
In a narrow alleyway behind her house, a young woman is washing her boyfriend's Wrangler jeans. She finds a mystery phone number in one of the pockets, but she manages to keep her temper and continue. In another pocket she finds yet more evidence of his infidelity when she pulls out a red bra. She finally loses control of her temper and tries to beat the hell out of the Wranglers.

Because she knows whose fault it really is. She knows the Wranglers made her boyfriend more appealing to the opposite sex. But does she know that beating a pair of durable Wranglers doesn't damage them, but only makes them even more appealing?

Television Commercials, up to and including 60 seconds

Director
Tarsem

Copywriters
Alexandre Peralta
Cassio Zanatta

Art Director
Giba Lages

Creative Director
Marcello Serpa

Producers
Frank Sherma
Dominic Delaney

Production Company
@radical.media

Advertising Agency
AlmapBBDO

Agency Producer
Brian Mitchell

Lighting Cameraperson
Paul Laufer

Music Composer
David Honowitk

Account Handler
Ricardo Taunay

Marketing Executive
Antonio Lucio

Client
Pepsi

Beckham
Beckham has been substituted. We see him walking down the the tunnel, feeling depressed. Inside the tunnel, there's a boy drinking from a can of Pepsi. Beckham passes by him with a weary expression and asks for a sip. The boy hands him the can. Beckham drinks. The boy then asks Beckham for his shirt in exchange. When Beckham complies, the boy reveals why he wanted the shirt. And that makes the player even more depressed.

**Television
Commercials, over
60 seconds**

Director
David Kung

Creative Director
Kuo Ching

Production Company
David Kung Film

Advertising Agency
Results Advertising
Taiwan

Agency Producer
Monica Huang

Account Handlers
Tyson Deng
Bernie Liu

Marketing Executive
Max Chu

Client
Taiwan Secom Security

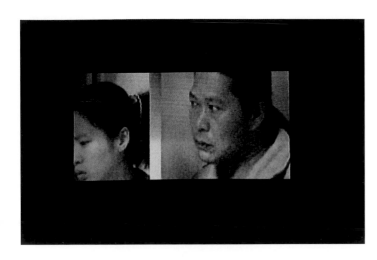

The Hidden Crisis
To make target users feel the 'crises are
always nearby'.
It uses the tense relationship between a thief and
a homeowner to compare the daily stress of living
and the urgent need for a home security system.

Television Commercials, Over 60 seconds

Director
Carlos Manga Junior

Copywriter
Miguel Bemfica

Art Directors
Paulo Bemfica
Paulo Diehl

Creative Directors
Erh Ray
Jader Rossetto
Pedro Cappeletti

Producer
Moises Pancia

Production Company
Vertical Filmes

Advertising Agency
DM9DDB

Agency Producer
Nivio de Souza

Lighting Cameraperson
Lauro Escorel

Sound Design
Voices

Account Handler
Vlademir da Silva

Marketing Executive
Julio Neves

Client
MASP - São Paulo
Museum of Art

Faces
A guy is making faces. He takes the hand of the friend next to him and passes it over his own face. The camera zooms back and reveals that his friend is blind. The camera zooms back a bit more and we see that there's a cubist painting by Picasso next to them. Only then do we realise that, by making those faces, he's trying to get his blind friend to 'see' the painting.
 Camera card: Picasso at the São Paulo Museum of Art. No one should miss it.

Cinema Commercials

Director
Brian Beletic

Copywriter
Aude Mee

Art Director
Sylvain Thirache

Creative Director
Pascal Gregoire

Producer
Brian Carmody

Executive Producer
Arno Moria

Production Companies
Satellite Films
Les Telecreateurs

Advertising Agency
Leagas Delaney Paris

Agency Producer
Marie Massis

Editor
Katz

Account Handler
Sandra Conan

Marketing Executive
Martin Simonsson

Client
IKEA France

Tidy up.

IKEA
If not for yourself, at least for the others.

Little Car
A very little boy, four years old, plays with little cars. He pushes back and forth a little car, making the noise of the engine with his mouth. Then we discover the little boy playing with a vibrator as if it was one of his little toys. After that, he turns the vibrator on by accident. Surprised, it makes him laugh.
 Title : Tidy up.
 Packshots of storage furniture appear.
 Title : IKEA. If not for yourself, at least for the others.

Public Service and Charities, Individual

Director
Frans Bromet

Copywriter
Bas Engels

Art Director
Lysbeth Bijlstra

Producers
Evelyne Draayer
Albert Klein Haneveld

Production Company
Bromet & Dochters

Advertising Agency
TBWA\Campaign
Company

Agency Producer
Fatima Engelhard

Editor
Mirna Ligthart

**Lighting
Cameraperson**
Frans Bromet

Sound Designer
Wim Vonk Sound

Account Handler
Evelin Ollongren-
Claassen

Marketing Executive
Cees Meijer

Marketing Executive
Shireen Eyer

Client
Consumer Safety
Institute

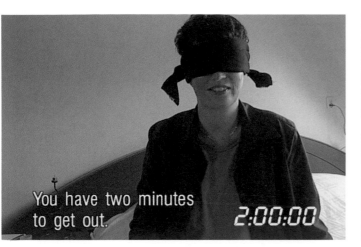

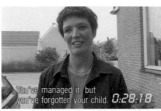

Child
Most fires at home happen at night. In general you've got 2 minutes to leave the house. What would you do?
 In an unexpected situation some people panic and even forget their child.

TELEVISION & CINEMA
ADVERTISING CRAFTS

Top Row; *Left to Right:*
PAT JOSEPH, THE MILL • LIBBY BROCKHOFF, CARMICHAEL LYNCH, USA
Bottom Row; *Left to Right:*
ANTHEA BENTON, PARTIZAN • JOHN LYNCH

TELEVISION & CINEMA
ADVERTISING CRAFTS

Top Row; *Left to Right:*
LAURENCE QUINN, ABBOTT MEAD VICKERS.BBDO • WILL FARQUHAR • PAUL WEILAND, PAUL WEILAND FILM COMPANY • JOHN SMITH, THE WHITEHOUSE POST PRODUCTION

Bottom Row; *Left to Right:*
ED ROBINSON, SAATCHI & SAATCHI • TOT TAYLOR • RICHARD PACKER, INDEPENDENT FILMS

Comment by Paul Weiland

I write this after the event. The awards have been dispatched. The winners are happy. The nominees devastated, and with good cause. Once again work that deserved to get a pencil received nothing. Why are our juries so mean spirited? Has there ever been a year when the Academy refused to give an Oscar. Or the Olympic Gold was not given because someone had previously run faster? Let us stop comparing work with the past. Judge the work on its own merit. If I was a kid just starting out, I would not be encouraged. I'd probably throw my hands in the air and give up.

DIRECTION SPONSORED BY SVC • USE OF MUSIC SPONSORED BY BMG MUSIC PUBLISHING
ANIMATION AND SPECIAL EFFECTS BOTH SPONSORED BY FRAMESTORE CFC

Gold Award
for the most
outstanding
Direction
sponsored by
SVC

Silver Award
for the most
outstanding
Direction
sponsored by
SVC

Silver Award
for the most
outstanding
Special Effects
sponsored by
Framestore CFC

Silver Nomination
for the most
outstanding
Use of Music
sponsored by
BMG Music Publishing

Silver Nomination
for the most
outstanding
Editing

Accepted in
Cinematography

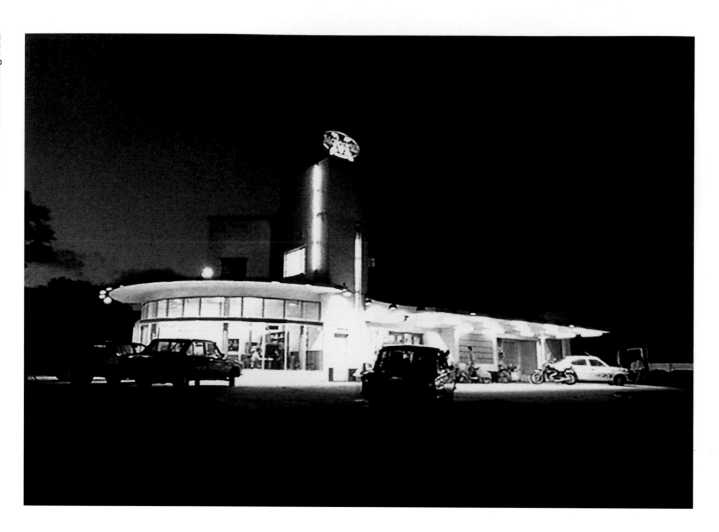

Director	**Flame Assistants**	**Post Production**	**Creative Director**	**Advertising Agency**	**Music Composers**	**Account Handler**
Frank Budgen	Gavin Wellsman	The Mill	Russell Ramsey	Bartle Bogle Hegarty	Pepe Deluxe	Annicka Locket
	Salima Needham				Warren Hamilton	
Post Producer		**Editor**	**Producer**	**Agency Producer**	Bartle Bogle Hegarty	**Marketing Executive**
Liz Browne	**Telecine**	Paul Watts	Paul Rothwell	Andy Gulliman		Robert Hanson
	Adam Scott				**Music Researcher**	
Flame Artists		**Copywriter**	**Set Designer**	**Lighting**	Peter Raeburn	**Client**
Barnsley	**3D Artist**	Mark Hunter	Mark Guthrie	**Cameraperson**		Levi Strauss Europe,
Chris Knight	Russell Tickner			John Lynch	**Sound Designer**	Middle East & Africa
Jason Watts		**Art Director**	**Production Company**		Warren Hamilton	
		Tony McTear	Gorgeous			

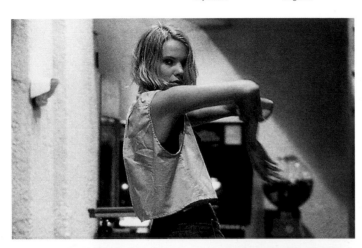

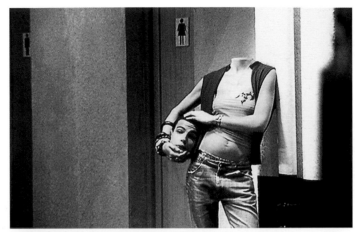

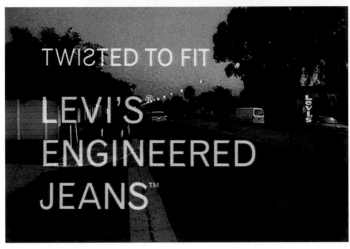

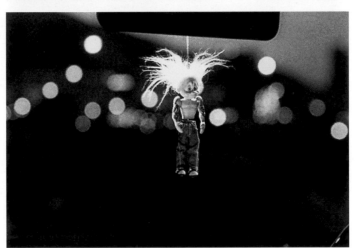

Twist
We join a group of teenagers as they arrive at a roadside grill after a long journey. As they begin to stretch their legs we quickly notice they have the ability to twist their limbs in unbelievable ways.
Title: Levi's Engineered Jeans. Twisted to fit.

Silver Award
for the most outstanding Direction sponsored by SVC

Silver Nomination
for the most outstanding Editing

Silver Nomination
for the most outstanding Modelmaking

Accepted in Special Effects

Director
Frank Budgen

Editor
Russell Icke

Modelmaker
Asylum Models & Effects

Copywriter
Tony Barry

Art Director
Vince Squibb

Creative Director
Paul Weinberger

Producer
Paul Rothwell

Set Designer
Gavin Bocquet

Production Company
Gorgeous

Advertising Agency
Lowe

Agency Producer
Charles Crisp

Lighting Cameraperson
Alwin Kuchler

Music Composer
Toby Anderson

Sound Designer
Nigel Crowley

Managing Director
Jeremy Bowles

Account Handler
Ben Moore

Marketing Executive
David Neale

Client
Reebok UK

Sofa
We open with a guy sitting on a sofa in his front room. He gets up to go to the gym. Suddenly, without warning, the sofa springs to life, grabbing our guy and holding him in a bear hug. It then flips the guy, sending him crashing to the floor. We now watch as a huge fight ensues. But this is no namby pamby tussle from Bedknobs and Broomsticks, this is World of Leather meets Fight club. The sofa body slams our guy then hurls him across the room. Our guy tries to escape but the sofa hauls him back. Pulling off his trousers in the process. The guy fights back, picking up the sofa and hurling across the room. He grabs his gym bag and tumbles down the stairs. He looks up in horror just as the sofa launches itself down the stairs in hot pursuit. The sofa gets wedged in the doorframe and comes to a grinding halt. Our guy makes a grab for his bag and legs it out the front door. We end with the sofa spinning furiously, trying every angle to squeeze down the stairs.
Cut to a title:
It reads: Escape the sofa.
Fade up REEBOK logo.

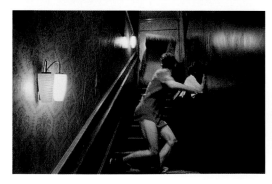 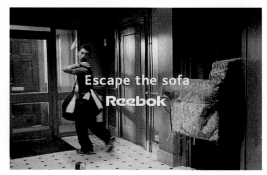

Silver Award
for the most
outstanding
Cinematography

Silver Nomination
for the most
outstanding
Direction
sponsored by
SVC

**Lighting
Cameraperson**
Jan Velicky

Director
Ivan Zacharias

Copywriter
Vince Squibb

Art Director
Vince Squibb

Creative Director
Paul Weinberger

Producer
Nick Landon

Production Company
Stink

Advertising Agency
Lowe

Agency Producer
Sarah Hallatt

Editors
Filip Malasek
Paul Watts

Music Composer
Anne Dudley

Sound Designer
Nigel Crowley

Managing Director
Jeremy Bowles

Account Director
Matt Edwards

Marketing Executives
Jo Franks
Karen Waring

Client
Interbrew UK

Doctor
A doctor does all he can to help the sick during a
cholera outbreak. But, despite his saintly behaviour,
the villagers shun him in fear that he may have
contracted the disease. However, any worries of
contamination are soon forgotten on seeing a
chance to sample his precious beer.

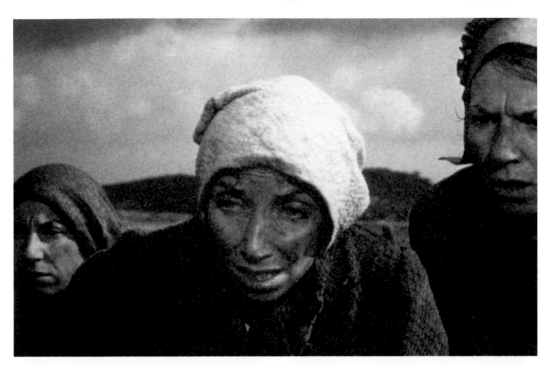

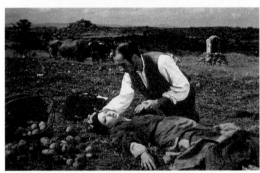

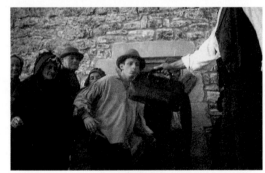

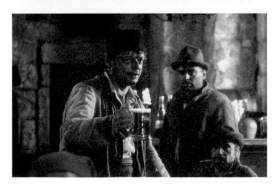

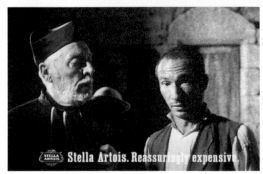

Silver Award
for the most
outstanding
Use of Music
sponsored by
BMG Music Publishing

Silver Award
for the most
outstanding
Sound Design

Sound Designer
Jeff Elmassian

Director
Charles Randolph-
Wright

Copywriter
Jimmy Smith

Art Director
Paul Shearer

Creative Director
Glenn Cole

Producer
Kate Sutherland

Production Company
@radical.media
(New York)

Advertising Agency
Wieden + Kennedy
Amsterdam

Agency Producer
Jasmine Kimera

Editor
Adam Pertofsky

Account Handlers
Jenny Campbell
Kay Hoffman

Marketing Executives
Stefan Olander
Paolo Tubito

Client
Nike

Freestyle Football
The title of the spot says it all: Free & Style.
No distractions. No camera tricks or special
effects. Just athlete and football.

Silver Award
for the most outstanding Animation sponsored by Framestore CFC

Silver Award
for the most outstanding Sound Design

Accepted in Direction

Animators
Rob Fellows
Tim Hope

Sound Designers
Tim Hope
Nigel Crowley

Art Director
Graham Cappi

Creative Director
Trevor Beattie

Director
Tim Hope

Copywriter
Graham Cappi

Producer
Cara Speller

Set Designer
Bartek Kubiak

Production Company
Passion Pictures

Advertising Agency
TBWA\London

Agency Producer
Tracie Stokes

Editors
Tim Hope
Kevan O'Brien

Music Composers
Frei Manuel Cardoso
Gilles Gobeil

Account Handlers
Tom Hull
Helen Kimber

Marketing Executive
David Patton

Client
Sony Computer Entertainment Europe

Wolfman
Inspired after watching Little Red Riding Hood on telly an astronomer's fantasy comes true. He is transformed into a dribbling, rocket-riding, planet smashing, sun-punching Werewolf. This demonstrates PlayStation's power to transport game players to 'The Third Place'. A place where you can be whoever and do whatever, whenever you like.

Silver Award
for the most
outstanding
Editing

Accepted in Direction

Editors
John Smith
Jim Weedon

Director
Laurence Dunmore

Copywriter
Lorenzo De Rita

Art Director
Dean Maryon

Creative Director
Lorenzo De Rita

Producer
Amanda Tassie

Production Company
RSA Films

Advertising Agency
180

Agency Producer
Esther Hielkert

**Lighting
Cameraperson**
Alex Melman

Music Composer
Billenger Marsman

Sound Designer
Billenger Marsman

Account Handler
Enrico Balleri

Marketing Executive
Neil Simpson

Client
Adidas

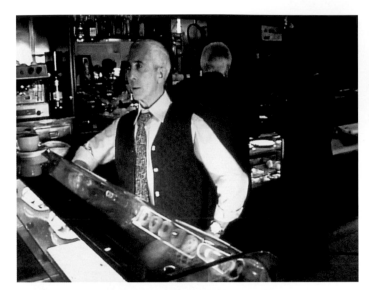

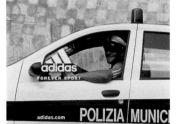

Martina
In this commercial, we hear from several witnesses how Martina Hingis uses her tennis skills to help clear a traffic jam in Italy and to restore calm. Her actions help demonstrate that Adidas shoes can help you be cool. The commercial concludes that 'Adidas makes you better'.

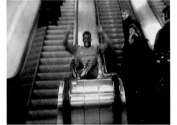

Ato
In this commercial, witnesses tell us how Ato Boldon's sprinting prowess brightens up the lives of commuters on the Prague underground. His impact on the commuters' spirits demonstrates that Adidas shoes can help you be light. The commercial concludes that 'Adidas makes you better'.

Jonah
In this commercial, witnesses recount how Jonah Lomu and some of his All Black team mates use their rugby skills to come to the aid of passengers at a train station in Ireland. They carry bags, help old ladies and return lost children to their mothers. Their actions help demonstrate that Adidas shoes can help you be supportive. The commercial concludes that 'Adidas makes you better'.

Silver Award
for the most
outstanding
Sound Design

Silver Nomination
for the most
outstanding
Use of Music
sponsored by
BMG Music Publishing

Sound Designer
Jeff Elmassian

Director
Charles Randolph-
Wright

Copywriter
Jimmy Smith

Art Director
Paul Shearer

Creative Director
Glenn Cole

Producer
Kate Sutherland

Production Company
@radical.media
(New York)

Advertising Agency
Wieden + Kennedy
Amsterdam

Agency Producer
Jasmine Kimera

Editor
Adam Pertofsky

Account Handlers
Jenny Campbell
Kay Hoffman

Marketing Executives
Stefan Olander
Paolo Tubito

Client
Nike

Freestyle Skateboard
The title of the spot says it all: Free & Style.
No distractions. No camera tricks or special
effects. Just athlete & skateboard.

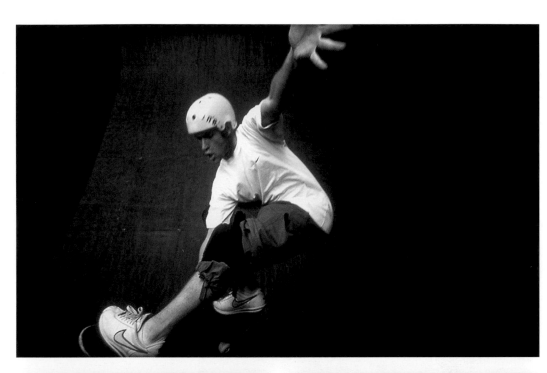

Silver Nomination
for the most
outstanding
Direction
sponsored by
SVC

Directors
Tom Kuntz
Mike Maguire

Copywriter
John Immesoete

Art Director
Mark Gross

Creative Directors
Mark Gross
Bill Cimino

Producers
Colin Hickson
Dana Balkin

Production Company
Propaganda Films

Advertising Agency
DDB Chicago

Agency Producer
Greg Popp

Editor
David Hicks

Client
Anheuser Busch

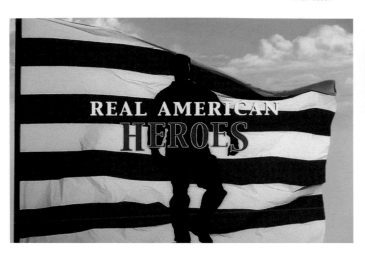

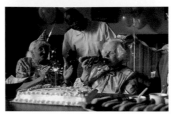

Hot Dog
Budweiser pays tribute to the genius of one of
mankind's greatest unsung heroes. In this case,
it's the guy who invented the foot long hot dog.

Silver Nomination
for the most
outstanding
Direction
sponsored by
SVC

Silver Nomination
for the most
outstanding
Cinematography

Silver Nomination
for the most
outstanding
Use of Music
sponsored by
BMG Music Publishing

Silver Nomination
for the most
outstanding
Sound Design

Accepted in Editing

Director
Fredrik Bond

**Lighting
Cameraperson**
Ben Seresin

Sound Designer
Rowan Young

Editor
Rick Russell

Copywriter
Jeremy Craigen

Art Director
Joanna Wenley

Creative Director
Andrew Fraser

Producer
Helen Williams

Set Designer
Dominic Watkins

Production Company
Harry Nash

Advertising Agency
BMP DDB

Agency Producer
Michael Parker

Animator
Henson's Creature
Shop

Music Composer
Leftfield

Account Handler
Jon Busk

Marketing Executive
Catherine Woolfe

Client
Volkswagen UK

Demon Baby
In an Eastern European hospital, a nurse follows a
mysterious trail of destruction. The cause turns out
to be a strange baby with super-human strength.
Title: Lupo. Volkswagen's tough little baby.

Silver Nomination
for the most outstanding Direction sponsored by SVC

Silver Nomination
for the most outstanding Special Effects sponsored by Framestore CFC

Accepted in Cinematography and Use of Music

Director
Jonathan Glazer

Visual Effects Supervisor
Mark Nelmes

Lighting Cameraperson
Dan Landin

Copywriter
Antony Goldstein

Art Director
Gavin Lester

Creative Director
Stephen Butler

Producer
Simon Cooper

Executive Producer
Nick Morris

Set Designer
Chris Oddy

Production Company
Academy

Advertising Agency
Bartle Bogle Hegarty

Agency Producer
Andy Gulliman

Editor
Sam Sneade

Music Composer
Handel

Music Arranger
John Altman

Sound Designer
Johnnie Burn

Music Consultant
Peter Raeburn

Account Handler
Derek Robson

Marketing Executive
Kenny Wilson

Client
Levi Strauss Europe, Middle East & Africa

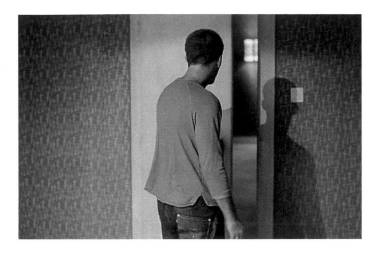

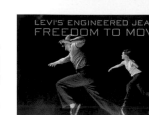

Odyssey
A man hurtles through a string of solid walls. He's joined by a girl running in parallel. They crash out the building, land on a tree and run up it into the night sky.

Silver Nomination
for the most outstanding Cinematography

Silver Nomination
for the most outstanding Use of Music sponsored by BMG Music Publishing

Director of Photography
Danny Hiele

Director
Gregor Nicholas

Copywriter
Jimmy Siegel

Art Directors
Michael Gambino
Ron Palumbo

Chairman
Ted Sann

Chief Creative Officer
Ted Sann

Executive Creative Director
Jimmy Siegel

Creative Supervisor
Michael Gambino

Production Company
@radical.media
(New York)

Advertising Agency
BBDO New York

Agency Producer
Grant Gill

Editor
Sabrina Huffman

Account Handler
Nicole Merrick

Client
VISA USA

Broadway Tribute
The heritage and tradition of New York's theatre land is represented by black and white images cut to an acappella rendition of the track 'Give My Regards To Broadway'.

Silver Nomination for the most outstanding Use of Music sponsored by BMG Music Publishing

Director
Nick Lewin

Copywriter
Tim Charlesworth

Art Director
Michael Kaplan

Creative Directors
Ewan Paterson
Rob Jack

Producer
Carol Skinner

Production Company
Cowboy Films

Advertising Agency
BMP DDB

Agency Producer
Maggie Blundell

Edit House
Cut & Run

Lighting Cameraperson
Jess Hall

Music Composer
Don Robertson

Account Handler
Jon Busk

Marketing Executive
Catherine Woolfe

Client
Volkswagen UK

Whatever
All over the world, drivers have religious icons, lucky charms and mascots dangling in their cars in the belief that they will protect them. A Polo driver has a VW key ring.
Title: We all find strength in something.

Silver Nomination for the most outstanding Animation sponsored by Framestore CFC

Animators
Alastair Hearsum
Tim Watts

Director
Vince Squibb

Copywriter
Vince Squibb

Art Director
Vince Squibb

Creative Director
Vince Squibb

Producer
Mary Francis

Set Designer
Niamh Coulter

Production Company
Paul Weiland Film Company

Advertising Agency
Lowe

Agency Producer
Charles Crisp

Editor
John Smith

Lighting Cameraperson
Brian Tufano

Music Composer
Guo Yi

Sound Designer
Gary Walker

Account Handler
Matt Edwards

Marketing Executive
Martin Wiltshire

Client
Nestlé Rowntree

Aero Delivery Man
A deliveryman enters with a box containing the hundred promotional mice that accompany new Honeycomb Aero.

The enraged newsagent reveals his shop is already infested with mice, the unwanted leftovers of Aero's last disastrous foray into merchandising.

The deliveryman attempts to calm him, claiming this latest batch of Taiwanese give-a-ways are somewhat improved.

Reaching into the box he reveals one of the new mice, which instantly bursts into oriental song.

Alas, the newsagent's joy is short lived – his next customer faints the moment she lays eyes on the warbling rodent.

Aero. All bubble. No squeak.

Silver Nomination
for the most outstanding Animation sponsored by Framestore CFC

Lead Animator
Todd Akita

Director
Todd Mueller

Copywriter
Bart Cleveland

Creative Director
Bart Cleveland

Production Company
Psyop

Advertising Agency
Sawyer Riley Compton

Agency Producer
Danica Walker

Flame Artist
Eben Mears

2D Artist
Colin Barton

Illustrator
Paul Dallas

Director of Photography
Ben Dolphin

Client
Partnership For A Drug-Free America

Brain
We wanted to create a visceral psychotic vision of a young mind vaporizing in the confluence of inhaled narcotics. The challenge in creating this spot was how to visually communicate a feeling of drug induced paranoia, agitation and ultimately the shattered mental-scape.

To achieve this look we poured colored inks over carved-glass illustrations and filmed it at high speeds to maintain the organic flow.

This spot originated from a print campaign based on Paul Dallas' illustrations.

Silver Nomination
for the most outstanding Editing

Editor
Kirk Baxter

Director
Chris Palmer

Copywriters
Simon Mainwaring
Bill Fitzloff

Art Directors
Jayantha Jenkins
Bill Karow

Producer
Suza Howat

Production Company
Gorgeous

Advertising Agency
Wieden + Kennedy
USA

Agency Producer
Andrew Loevenguth

Lighting Cameraperson
Ben Seresin

Client
Nike

Offroad
Open on a misty winding mountain road. Lance Armstrong is leading a pack of competitive racers riding high-end road bikes.

At a switchback Lance veers straight off the paved road on to a muddy trail. The riders behind him follow like lemmings.

Instantly, riders at the back lose control on the rough terrain and plow into the trees. And while Lance skillfully negotiates his way through the forest, other riders hurtle straight down the fall line of the muddy hill, jack-knifing into the ground and cartwheeling into the air.

Lance glances back at the last rider still holding on. He bunny-hops over a mud-slick and darts down a particularly steep section of a hill. The remaining rider attempts the same only to end up in the stream below.

Cut to the paved road at the end of the trail. Lance shoots out of the trees and we see Lance continue down the paved mountain road… alone.

Silver Nomination
for the most outstanding Special Effects sponsored by Framestore CFC

Post Production
The Mill

Lead Flame Artist
Jason Watts

Flame Artist
Chris Knight

Telecine
Adam Scott

Flame Assistants
Matt Wilmshurst
Gavin Wellsman
Richard de Carteret

Post Producer
Helen Weil

Director
Daniel Barber

Copywriter
Jo Moore

Art Director
Simon Robinson

Creative Director
Leon Jaume

Producer
Matthew Brown

Set Designer
Johnny Green

Production Company
Rose Hackney Barber

Advertising Agency
WCRS

Agency Producer
James Letham

Editor
Rick Russell

Lighting Cameraperson
Ben Davis

Music
Boards of Canada

Account Handler
Simon Peck

Marketing Executive
Phil Horton

Client
BMW (GB)

Pool

We open on a girl standing on the edge of a diving board at night. Below all we see is a BMW 7 Series parked in the pool. There is no water whatsoever, the pool is empty. The girl dives off the board but when she reaches the empty pool she reacts as if it is full of water. The girl swims around the car and looks inside. We see inside the car as the voiceover tells us there's no keys, no gear stick, no handbrake and that the BMW believes you don't need to see everything to know it's there. The car drives out of the pool leaving the girl floating in air as if there really was water there.

The endline reads: The New BMW 7 Series. A New Way To Drive.

Silver Nomination
for the most outstanding Special Effects sponsored by Framestore CFC

Special Effects
Alex Frisch

Director
Kinka Usher

Copywriter
Bill Bruce

Art Director
Doris Cassar

Chief Creative Officer
Ted Sann

Senoir Creative Director
Bill Bruce

Production Company
House of Usher Films

Advertising Agency
BBDO New York

Agency Producer
Hyatt Choate

Editor
Tom Muldoon

Account Handlers
Cathy Israelevitz
Lauren Radossich

Client
Pepsi/Mountain Dew

Ram

A young guy coming back from the woods discovers he has a 500 pound long horn ram standing between he and his Dew.

After butting heads, the guy stumbles off with his prize – the Dew.

Silver Nomination
for the most
outstanding
Sound Design

Sound Design
The Brothers Ross

Director
Rupert Sanders

Copywriter
Richard Foster

Art Director
John Horton

Creative Director
Peter Souter

Producer
Paul McPadden

Production Company
Outsider

Advertising Agency
Abbott Mead
Vickers.BBDO

Agency Producer
Lindsay Hughes

Editor
Neil Smith

**Lighting
Cameraperson**
Jess Hall

Account Handler
Ian Pearman

Marketing Executive
Susie Moore

Client
mmO2

Here, There, Everywhere
The commercial juxtaposes two opposite worlds.
We see a world of hustle and stress. We hear a world
of peace and tranquillity. Genie Mobile Internet gives
you more of the world you want, and less of the world
you don't want.

Direction

Director
Syd Macartney

Copywriters
David Lyle
Julie-Anne Baille

Art Directors
David Lyle
Julie-Anne Bailie

Creative Directors
David Lyle
Julie-Anne Bailie

Producer
Ruck Strauss

Production Company
Rawi Macartney Cole

Advertising Agency
McCann - Erickson
Belfast

Agency Producer
Julie-Anne Bailie

Editor
Rick Russell

**Lighting
Cameraperson**
John Lynch

Music Composers
Starbek / Bowie/
Burton / Tenille

Sound Design
Amber Music

Account Handlers
Robert Lyle
John Brolly

Marketing Executives
Jim Rankin
Gavin Freeman

Clients
Department of
Environment
National Safety
Council

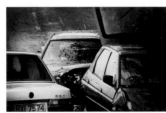

Damage
A carefree, romantic day out turns to tragedy when
an unbelted, rear seat passenger becomes a
multiple killer – all set to the ironic lyrics of 'Body to
Body' as the young bodies collide violently inside the
car. The unbelted missile repeatedly crushes his
girlfriend as the vocals chillingly reflect 'Do that to
me one more time, once is never enough from a man
like you.'

Direction

Also accepted in
Special Effects

Director
Stuart Douglas

Copywriter
Nick Worthington

Art Director
Paul Brazier

Creative Director
Peter Souter

Producer
Adam Lyne

Production Company
@radical.media
(London)

Advertising Agency
Abbott Mead
Vickers.BBDO

Agency Producer
Francine Linsey

Editors
Stuart Douglas
Tom Sparks

**Lighting
Cameraperson**
Tony Brown

Sound Designers
Johnnie Burn
Warren Hamilton

Account Handlers
Sue Garrard
Lucy Nelson

Marketing Executives
Tony Allsworth
Richard Meakin

Client
COI/DETR

Kill Your Speed
We see a car travelling down an ordinary suburban
street. It's filmed in extreme slow motion. The car
suddenly starts to brake and smoke comes from
the front tyres.
　VO: At just 5mph over the 30mph limit, how much
further does it take to stop? The voiceover begins to
count the feet one by one as the car ploughs on.
　VO: One foot, two feet, three feet, four feet, five
feet… At 17 feet the car hits a young boy crossing
the road. The count continues until the car finally
stops after an extra 21 feet.
　VO: Think. Slow Down.

Direction

Also accepted in
Cinematography

Director
Kevin Thomas

Copywriter
Ben Priest

Art Director
Brian Campbell

Creative Director
Trevor Beattie

Producer
Philippa Thomas

Production Company
Thomas Thomas Films

Advertising Agency
TBWA\London

Agency Producer
Tracie Stokes

**Lighting
Cameraperson**
Bob Pendar-Hughes

Editor
Bryan Dyke

Music Composers
Peter Orm
Paul Orm

Account Handlers
Gavin Thompson
Chris Willingham
Tom Hull

Marketing Executive
David Patton

Client
Sony Computer
Entertainment Europe

Bambi
A truck travelling at speed crashes into a cute, baby
deer. As this happens in the Third Place, the laws of
physics are reversed and the car is destroyed.

Direction

Director
Fredrik Bond

Copywriter
Mike Boles

Art Director
Jerry Hollens

Producer
Helen Williams

Production Company
Harry Nash

Advertising Agency
Rainey Kelly Campbell
Roalfe/Y&R

Agency Producer
Simon Devine

Editor
Tim Thornton-Allen

**Lighting
Cameraperson**
Carl Nilsson

Client
COI/Energy
Efficiency Trust

Bad Boiler
A worn-down-looking man, woman and teenage daughter are in their kitchen having breakfast when their boiler starts hurling insults at them.

Bad boiler (to man): Baldy… baldilocks and the three hairs.

He tries to ignore it.

Bad boiler (to woman): Ergh! Look at the state of you love, I wouldn't want to meet you on a dark night. (To girl) Hello supermodel, got a boyfriend yet? Nah, I wouldn't hold your breath neither. Ergh!

The poor girl flees the room. The mother is hysterical. She has reached breaking point.

Mother: Stop it!

Her husband comforts her. The boiler just laughs.

VO: If your boiler's behaving badly, then it's not Energy Efficient.

Cut to new Energy Efficient boiler. The family are now happy.

VO: Next time get a nice energy saving one, It'll use a third less gas. Be good, be Energy Efficient.

Cut to the Energy Efficient logo.

Direction

Director
Fredrik Bond

Copywriter
Bobby Pearce

Art Director
Chris Brignola

Creative Director
Matt Vescovo

Producer
Helen Williams

Set Designer
Happy Masey

Production Company
Harry Nash

Advertising Agency
Fallon New York

Agency Producer
Nancy Gentry

Editor
Gavin Cutler

**Lighting
Cameraperson**
Adam Kimmel

Account Handler
Victor Kimble

Client
Conseco

Airport
A family waits at the airport for the arrival of their grandparents.

However, we see that this elderly couple didn't ride in the plane like the rest of the passengers but, instead, travelled inside the family's luggage. They are greeted as they come down the chute of the luggage carousel.

Announcer: How will you make your money last when you retire?

Conseco offers a wide variety of retirement products that can help.

Direction

Director
Fredrik Bond

Copywriter
Bobby Pearce

Art Directors
Chris Brignola
Matt Vescovo

Creative Director
Kevin Roddy

Producer
Helen Williams

Set Designer
Happy Masey

Production Company
Harry Nash

Advertising Agency
Fallon New York

Agency Producer
Nancy Gentry

Editor
Gavin Cutler

**Lighting
Cameraperson**
Adam Kimmel

Account Handler
Victor Kimble

Client
Conseco

Organ Grinder
A woman stops to listen to an organ grinder playing music. Just as she is about to give the organ grinder's monkey some change, the monkey, instead, hands her a wad of cash. The woman is shocked to discover that the monkey is actually her dead husband who has been reincarnated.
Announcer: How will you support your family after you pass away?
Conseco's life Insurance can give your loved ones a regular monthly paycheque.

Direction

Director
Fredrik Bond

Copywriter
Yan Elliott

Art Director
Luke Williamson

Creative Directors
Robert Saville
Mark Waites

Producer
Helen Williams

Production Company
Harry Nash

Advertising Agency
Mother

Agency Producers
Matt Buels
Hayley Irow

Editor
Tim Thornton-Allen

**Lighting
Cameraperson**
Carl Nilsson

Account Handler
Paul Adams

Marketing Executive
Richard Kingsbury

Client
Campbells Grocery
Products

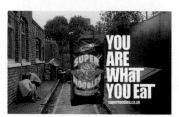

Face-Off
We open on a group of people playing pool in a bar. Suddenly a different bunch confronts them and it soon becomes apparent that they are two distinctly different groups of people – the no-nonsense SuperNoodle gang and the Poncey Salad Boys.
A mock West Side Story fight ensues which sees the Salad Boys, with their perfect pirouetting punches, being overshadowed by the down to earth, clumsy, uncoordinated, SuperNoodle gang.
The gangs then split as the police arrive. The Poncey Salad Boys manage to make it over the fence, while the Supernoodle gang are left scurrying around.
The spot ends with the line: You Are What You Eat.

Direction

Also accepted
in Editing

Director
Steve Reeves

Copywriters
Laurence Quinn
Mike Nicholson

Art Directors
Mark Norcutt
Daryl Corps

Creative Director
Tony Cox

Producer
Tim Marshall

Set Designer
Claire Clarkson

Production Company
Another Film Company

Advertising Agency
Abbott Mead
Vickers.BBDO

Agency Producer
Simon Monhemius

Editor
Paul Watts

**Lighting
Cameraperson**
Alex Melman

Sound Designer
Warren Hamilton

Account Handler
Vikki O'Connor

Marketing Executive
Katrina Lowes

Client
BT

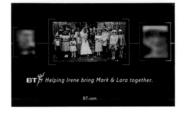

Wedding

We open on a family watching TV. Mum comes in and tells them to keep quiet as she is about to call her sisters in Antigua.

We then cut to see mum helping her daughter with her wedding dress. On the bed, we see her son using his laptop. Mum says, 'Oh, I must e-mail your auntie and tell her not to wear peach'.

We cut to the auntie putting a peach dress into her suitcase.

Then we see mum phoning grandad, but he is engaged so she leaves him a message.

We cut to the big day. The whole family rush out the door and squeeze into a long gold limousine. The ceremony and reception then follows.

VO: We have more ways to help you bring people together than anyone else.

We finish on a wedding photo of the two families.

Super: BT. Bringing the Williams and the McDermott's together.

Direction

Directors
Dom & Nic

Copywriters
Rob Turner
Nick Hutton

Art Directors
Rob Turner
Nick Hutton

Creative Director
Trevor Beattie

Producer
John Madsen

Set Designer
Chris Oddy

Production Company
Outsider

Advertising Agency
TBWA\London

Agency Producer
Judy Clements

Editor
Struan Clay

**Director of
Photography**
Steve Chivers

Music Composer
Mark Campbell

Sound Designer
James Saunders

Account Handler
Gavin Thompson

Marketing Executive
David Patton

Client
Sony Computer
Entertainment Europe

Overboard

Two shark fishermen are out to sea in a beaten-up boat. The engine is cut and one of them throws shark bait into the sea. We see a huge bloodied trail behind the boat. The other fisherman then emerges on deck with two rods. Much to his horror, his colleague strips off and dives overboard into the bloodied water.

Title fades up: You can tell who's been there.

Fade to endframe: PS2. THE THIRD PLACE.

Direction

Director
Dante Ariola

Copywriter
Brett Craig

Art Director
Bill Kauker

Creative Director
Lee Clow

Producers
Colin Hickson
Dana Balkin

Production Company
Propaganda

Advertising Agency
TBWA/Chiat/Day
Los Angeles

Agency Producers
Richard O'Neill
Dan Connelly

Sound Designers
Bob Edwards
Randy Thom

Client
XM Radio

Falling Stars

All over America, XM satellite radio's 100 channels of programming are falling to the earth. A suburban neighbourhood is bombarded by a rain of footballs, basketballs and baseballs. A 18-wheeler plows through a hailstorm of classical instruments. A nascar flattens a bus shelter. A jukebox splashes down in a lake. Vinyl records rain down on a laundromat. The XM logo appears over the stars.
 The XM satellite mysteriously sweeps past.

Direction

Director
Sean Mullens

Copywriter
John Runkle

Art Director
Shelley Weakly

Executive Creative Director
Bob Akers

Creative Director
John Brockenbrough

Producer
J J Morris

Advertising Agency
Leo Burnett (Chicago)

Executive Producer
Tom Mooney

Set Designer
Neil Wyzanowski

Production Company
Headquarters

Agency Producers
Bob Carney
Bob Davis

Puppeteer
Robert Devine

Director of Photography
Kristian Kachikis

Account Handler
Rob Morrison

Client
Nintendo

Girl Talk

In this commercial, a party girl is seen talking on the phone after a wild night out on the town. The setting is a cheap hotel room that has been completely trashed. The girl clearly likes living on the wild side, and as she recounts the previous night's escapades, one gets the impression that her male partner not only is quite a carouser but is a formidable lover as well. Throughout, we hear the sounds of her guy groaning and throwing up in the bathroom.
 As the girl talks on the phone, we see various shots of the trashed room. Finally, the bad boy in question appears at the bathroom door. In fact he is not a boy at all – he's Conker the Squirrel, protagonist of Nintendo's video game, Conker's Bad Fur Day. The obnoxious squirrel burps and breaks wind.
 A brief animation sequence featuring imagery from the game is followed by a tag at the commercial's end, in which the girl is seen pleasuring Conker by scratching his belly.

Direction

Director
Joe Pytka

Copywriter
Mark Oosthuizen

Art Director
Dave Linne

Creative Directors
Cheryl Berman
Ned Crowley
Jonathan Moore

Producer
Laure Stevens

Set Designer
Geoffrey Kirkland

Production Company
Pytka Films

Advertising Agency
Leo Burnett (Chicago)

Agency Producer
Bob Harley

Editor
Terry Kaney

Cameraperson
Joe Pytka

Lighting
Tom Kehil

**Music Producer /
Composer**
Alan Moore

Sound Designer
Moe Chamberlain

Account Handler
Jim Tracy

Marketing Executives
Michael Menden Hall
Jonathan Garson

Client
Walt Disney Studios

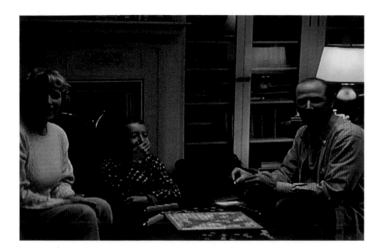

Scrabble

Much to her brother's chagrin, a young girl joins her family in a late night game of Scrabble. Her sibling, Nick, teases her remorselessly after she innocently flouts the rules by spelling 'in' backwards. However, he is soon stricken with a look of shock when his cute kid sister uses all of her letters to complete the word 'Supercalifragilisticexpialidocious.' 'Three hundred and seventy eight points,' she proudly announces. 'Want me to add that up for you, Nick?' Magic Happens. Disney.

Direction

Also accepted in
Cinematagraphy and
Use of Music

Director
Frank Budgen

Copywriters
Kash Sree
Mike Byrne

Art Directors
Andy Fackrell
Monica Taylor

Creative Directors
Hal Curtis
Dan Wieden
Jim Riswold

Producer
Alicia Bernard

Production Company
Gorgeous

Advertising Agency
Wieden + Kennedy
USA

Agency Producer
Andrew Loevenguth

Editor
Russell Icke

**Lighting
Cameraperson**
Frank Budgen

Music Composer
David Whittman

Sound Designer
Loren Silber

Account Handler
Byron Oshiro

Client
Nike

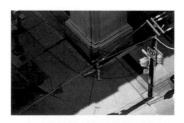
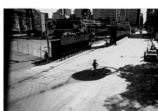
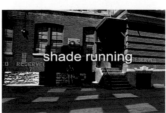

Shade Runner

Shade Runner features a young woman out for her daily run, doing everything and anything possible to avoid catching a glimpse of the sunlight. She runs down alleyways, under overpasses, through tunnels, in the shadows of buildings/landmarks and even through the moving darkness created by passing trucks, construction cranes and overhead airplanes. She's turned her own personal workout into a creative form of self expression… a form of play.

Direction

Also accepted in
Use of Music
and Editing

Director
Frank Budgen

Copywriters
Kash Sree
Mike Byrne

Art Directors
Andy Fackrell
Monica Taylor

Creative Directors
Dan Wieden
Hal Curtis
Jim Riswold

Producer
Alicia Bernard

Production Company
Gorgeous

Advertising Agency
Wieden + Kennedy
USA

Agency Producer
Andrew Loevenguth

Editor
Russell Icke

Music
Elias Music

Account Handler
Byron Oshiro

Client
Nike

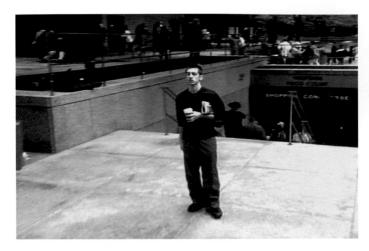

Tag

Tag follows a young man's adventure through a downtown city after he has been unexpectedly deemed 'it' by an unwelcome touch on his shoulder. He starts his morning routine at a magazine/newspaper kiosk and then realizes he has been 'tagged'. People around him suddenly scatter away from his sight line and potential touch. They scramble down subways, onto busses, into locked cars and hunch behind mailboxes and lampposts. As his frustration mounts because of his inability to tag someone else, the spot ends with him walking up to an unsuspecting target (the only one to seemingly know that he is not 'it') and chasing him off of the screen. This spot uses a city as an urban playground for this memorable childhood game.

Direction

Director
Craig Gillespie

Copywriter
Dean Buckhorn

Art Director
Eric Cosper

Creative Directors
David Lubars
Peter McHugh

Producers
Brian Latt
Lisa Rich

Production Company
MJZ

Advertising Agency
Fallon Minneapolis

Agency Producer
Rob Van de Weteringe
Buys

Editor
Eric Zumbrunnen

**Lighting
Cameraperson**
Adam Kimmel

Sound Designer
Steve Sauber

Account Handler
Maggie Shea

Marketing Executive
Brad Jakeman

Client
CitiGroup

College Tuition

This commercial takes place late at night in a suburban home. A father is repeatedly waking up his teenage son. He uses various means, ranging from loud vacuum cleaners to placing his son's hand in a bowl of warm water. In the end, we reveal the reason for Dad's strange behaviour. The son is scheduled to take his university entrance exams in the morning and the father is obviously hoping to avoid this expense by making sure the boy is exhausted. The announcer offers up CitiBank's financial advice as a better way to save for college tuition.

Direction

Director
Trevor Melvin

Copywriter
Nico Akkerman

Art Director
Bart Kooij

Creative Directors
Michael Janson
Bas Korsten

Producer
Marloes Van Den Berg

Set Designer
Marc Holmes

Production Company
Blink Productions

Advertising Agency
Result DDB

Agency Producer
Marloes Van Den Berg

Editor
Nick Diss

**Lighting
Cameraperson**
Mike Garfath

Client
Centraal Beheer

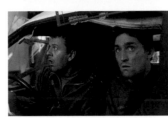
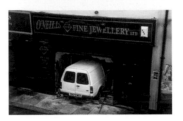

Rio
Two lads from Newcastle wake up early in the morning. They rush to get ready to go on holiday. To Rio. Rio de Janeiro to be precise. They quickly pack their stuff (clothes, tickets, passport) and speed off to the airport to catch their plane. They start to relax a bit, and start singing 'When my baby smiles at me, I go to Rio'. The driver enthusiastically joins in, but forgets to avoid a parked car. They swerve and ram a shop. But not just any old shop. A fine jewellers shop. The police sirens get closer. And you've got packed bags and two tickets to Rio for a plane that's leaving in two hours in your van. Try talking your way out of that.

Just call us. Centraal Beheer insurance.

Direction

Also accepted in
Cinematography

Director
Chris Palmer

Copywriter
Jerry Gallaher

Art Director
Clive Yaxley

Creative Directors
Bill Gallacher
Paul Hodgkinson

Copywriter
Jerry Gallaher

Producer
Susa Howat

Production Company
Gorgeous

Advertising Agency
M&C Saatchi

Agency Producer
Kayt Magrobi

Editor
Johnathon Scarlet

**Lighting
Cameraperson**
Ian Foster

Sound Designer
Johnnie Burn

Account Handler
Damian Collins

Marketing Executive
Piara Powar

Client
Kick Racism Out
Of Football

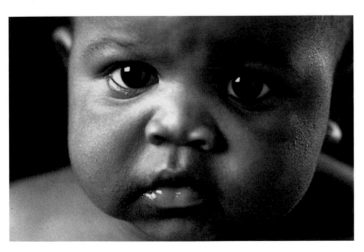

Dear White Fella
This ad is set to a poem read by Benjamin Zephaniah.

It shows a series of events seen from a black person's perspective as the poem explains that the black guy stays black throughout his life – when he's in the sun, when he's cold, ill or old.

We then see the same scenes from a white guy's perspective as the poem explains that he turns red, yellow, blue, green and grey in the same situations.

And asks how he has the cheek to call black people coloured.

Direction

Also accepted in
Cinematography
and Editing

Director
Frederic Planchon

Copywriters
Jeremy Craigen
Clive Pickering

Art Director
Neil Dawson

Creative Directors
Jeremy Craigen
Joanna Wenley

Producer
Rupert Smyth

Production Company
Academy

Advertising Agency
BMP DDB

Agency Producer
Anni Cullen

Editor
Mark Langley

**Lighting
Cameraperson**
Patrick Duroux

Music Composer
Peter Raeburn

Account Handler
Philip Heimann

Marketing Executive
Tom Morris

Client
American Airlines

Seats
In a small town, somewhere in America, we see that various seats (from a barber shop's chair to a swing) have been replaced by airline seats.
VO: We've taken out over 7,000 seats to give you more room.

Direction

Director
Brian Buckely

Copywriters
Mark Waites
Yan Elliott
Caroline Pay

Art Director
Luke Williamson
Kim Gehrig

Creative Directors
Robert Saville
Mark Waites

Producer
Kevin Byrne

Production Company
Hungry Man

Advertising Agency
Mother

Agency Producer
Sarah Case

Editor
Andrea Macarthur

**Lighting
Cameraperson**
Adam Beckman

Music Composer
Joe & Co

Sound Designer
Owen Griffiths

Account Handler
Nick Hussey

Marketing Executive
Richard Harris

Client
Coca Cola GB

Emergency
We open on a teenage boy in a supermarket. He decides to pick a Doctor Pepper out of the cooler – after all 'What's the worst that could happen?'.
The fridge door shatters sending bottles of Doctor Pepper cascading on top of him. This in turn disrupts some dippers and body lotions from the top the of the refrigerators.
Things get worse as the emergency services declare they have to 'cut him out of his pants'. He is hauled out of the supermarket and paraded up the street in front of a gathering crowd. Before long a camera crew have arrived from the local TV station and our boy is being broadcast nation wide. He is beamed into the households of thousands and recognised by class mates and will never be allowed to forget the day he was christened 'Butt Naked Boy'!
Doctor Pepper – What's the worse that could happen?

Direction

Also accepted in
Cinematography

Director
Rupert Sanders

Copywriter
Richard Foster

Art Director
John Horton

Creative Director
Peter Souter

Producer
Paul McPadden

Production Company
Outsider

Advertising Agency
Abbott Mead
Vickers.BBDO

Agency Producer
Lindsay Hughes

Editor
Neil Smith

**Lighting
Cameraperson**
Jess Hall

Sound Designer
The Brothers Ross

Account Handler
Ian Pearman

Marketing Executive
Susie Moore

Client
BT Genie

Different Planet
The commercial juxtaposes two opposite worlds. We
see a world of hustle and stress. We hear a world of
peace and tranquillity. Genie Mobile Internet gives
you more of the world you want, and less of the world
you don't want.

Direction

Director
Vaughan Arnell

Copywriters
Neame Ingram
Paul Westmoreland

Art Directors
Neame Ingram
Paul Westmoreland

Creative Directors
Mick Mahoney
Andy Amadeo

Producer
Jason Kremer

Set Designer
Louise Bedford

Production Company
Godman

Advertising Agency
cdp - travissully

Agency Producers
Anthony Falco
Ben Clarke

Editor
Gary Knight

**Lighting
Cameraperson**
Clive Tickner

Music Composer
James Sefton

Sound Designers
Dave Cooper
Adam West

Account Handler
Martin Staniforth

Marketing Executive
John Chamberlain

Client
John Grooms

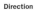

John Grooms
We open on a door being slammed in the faces of
some religious canvassers. A young disabled man,
who's decorating an upstairs room, spots them
making a beeline for his house. With the aid of
various specially adapted pieces of equipment, he
effortlessly goes downstairs and opens the door to
them. Before they even introduce themselves, he
deliberately slams the door in their faces. Our voice
over tells us how John Grooms provide purpose built
homes for thousands of people with disabilities, so
they can live their lives, just like any other member of
the community.

Direction

Director
Tom Carty

Copywriters
Kash Sree
Mike Byrne

Art Directors
Andy Fackrell
Monica Taylor

Creative Directors
Dan Wieden
Hal Curtis
Jim Riswold

Producer
Alicia Bernard

Production Company
Gorgeous

Advertising Agency
Wieden + Kennedy
USA

Agency Producer
Andrew Loevenguth

Editors
Emily Dennis
Lucas Eskin

Music
Dusty Springfield

Account Handler
Byron Oshiro

Client
Nike

Tailgating

Tailgating opens on a young kid bouncing a basketball in the aisle while riding the bus. As he exits, the boy follows closely ('tailgates') on the heels of another passenger, still dribbling. The man peers over his shoulder at the annoyance behind him, but continues on. The kid follows while avoiding all obstacles, dribbling over pedestrians, through a yellow cab, all while doing amazing dribbling skills on the heels of his selected target. Finally, the man has had enough. He heads into an alley, trying to save face he goes for the ball. The skilled youth plays with the man, egging him on even further. The man is totally stifled, but continues to try and get the ball, only embarrassing himself further as the spot ends.

Direction

Director
Frank Budgen

Copywriter
Oscar Askelöf

Art Directors
Jonas Enghage
Andreas Maum

Creative Director
Oscar Askelöf

Producer
Simon Cooper

Production Company
Gorgeous

Advertising Agency
Forsman & Bodenfors

Agency Producer
Alexandra Flink

Editor
Sam Sneade

Lighting Cameraperson
Frank Budgen

Account Handler
Jenny Everson

Marketing Executives
Peter Asberg
Karin Sjögren

Client
Coca Cola

Birth

A young couple come staggering out of the front door of their suburban house. She is in labour. Her husband clumsily tries to help her as they hurry across the lawn to the car.

In the confusion of opening the car door, the young woman throws a glance in the direction of the neighbour's house. Outside the neighbours house, a pear (human-sized) in overalls is calmly cleaning the pool. The pear looks back at the woman.

Cut to the delivery room. It's full commotion. The young woman breathes quickly, about to give birth. Her husband holds her hand and the nurses cheer her on. She has another go and this time it seems to work. And we hear the baby cry. The relieved young couple exchange loving looks before the doctor hesitantly puts the bundled-up baby in the mother's arms.

The mother looks at her newborn and… anxiously looks up at the father. The father smiles thankfully at the nurses and looks at his child. His smile is replaced by a look of complete confusion. The child isn't a child. It's… a pear! He looks at his wife. At the pear. Unable to understand. The mother looks down in shame.

Cut to the pool-attending pear, whistling a quiet tune whilst fishing up a leaf from the pool.

A text fades in: Pears. Who can resist them?
Logo: MER

Direction

Director
Gillian Wearing

Copywriter
Nigel Roberts

Art Director
Paul Belford

Creative Directors
Nigel Roberts
Paul Belford

Online Producer
Caroline Slade

Executive Producer
Kim Knowlton

Production Company
COI Communications

Advertising Agency
Ogilvy & Mather

Editor
Andrea MacArthur

**Lighting
Cameraperson**
Barry Ackroyd

Account Handler
Zoe Smith

Marketing Executive
Gill Stuart

Clients
COI/The Home Office

You Never Know
We hear a young boy's voice as he describes his love of football and collecting shiny badges. But as the camera pans down we see it is in fact a man in his mid thirties who is talking. We see his mouth move and hear the child's words coming from his mouth.

Direction

Also accepted in
Cinematography and
Use of Music

Copywriter
Walter Campbell

Art Director
Walter Campbell

Creative Director
Peter Souter

Director
Jonathan Glazer

Producer
Nick Morris

Production Company
Academy

Advertising Agency
Abbott Mead
Vickers.BBDO

Agency Producer
Natalie Bright

Executive Producer
Yvonne Chalkley

Editor
Sam Snead

**Lighting
Cameraperson**
Dan Landin

Sound Design
Johnnie Burn
Peter Raeburn

Account Handler
Caspar Thykier

Marketing Executives
David Smith
Wendy Darlington

Client
Guinness GB

Dreamer
The Dream Club, a group of people who meet regularly to dream.

Their aim is to break all dream-records, to dream dreams others only dream about.

Their drink is Guinness and after a few pints we see the club champion nod off in expert style. Tonight is a big night at the club because he's going after the biggest dream of all, the answer to the question, What is the meaning of life? He's soon deep in slumber, his dream starting with a squirrel who is asleep in a bar and who wakes with a shock to tell everyone he's just had 'the weirdest dream'. Things get strange after that as he finds himself battling with thousands of other dreamers to get to a peephole which is high up on a strange wall. Through this hole the meaning of life is revealed, the hordes of dreamers are going all out to get at it. We see him battle his way to the top. What he sees when he looks through is... never shown. But it's something hilarious, he starts to laugh in his sleep. We see the rest of the dream club and their immense fan club watching him laughing his head off. They wait patiently for their hero to wake up and reveal the secret.

Cinematography
Tom Carty

**Lighting
Cameraperson**
Alex Barber

Director
Tom Carty

Copywriter
Tom Carty

Art Director
Tom Carty

Creative Director
Peter Souter

Producer
Ciska Faulkner

Set Designer
Tom Hannam

Production Company
Gorgeous

Advertising Agency
Abbott Mead
Vickers.BBDO

Agency Producer
Yvonne Chalkley

Editor
Paul Watts

Music Composer
Welcome Duru

Sound Designers
Peter Raeburn
Tony Rapaccioli

Account Handler
Vicky Zimmerman

Marketing Executive
Jacqui Kean

Client
The Economist

Freedom of Knowledge

We hear the music of Miriam McCabe's 'Nomeva' throughout. A man stands with a restrictive conical snout on his face. Cut to see a woman in an elegant black wedding dress walking forlornly along a road. Her train is ablaze. We see an overflowing watertower. Its clockface has no hands. Cut to find a man sitting on an electric chair in a violated landscape. He's reading a newspaper with no print.

Four scorched trees sit against a savannah vista. A birdcage is hanging from one of the tree's bare branches. A beautiful bird is trapped inside.

From his prison cell, Nelson Mandela dreams. He is a young boy playing football with four outlandish characters. They torment the young Mandela by keeping the ball from him.

Cut to see a road that seemingly stretches on forever. A battered road sign reads: Freedom 27 million miles. An eerie bowler-hatted man holding a placard walks across an ominous black stormy sky. Through his placard we see a ray of light.

We now see a group of angelic children on a beach each holding bouquets of tropical flowers. A singular butterfly flits inside a prison cell. Suddenly, it multiplies forming a dense fluttering colourful explosion.

Cut back to see the children now feeding their flowers into a sculptured metallic shredding machine. A cloud of multi-coloured petals fill the air.

A traditional African tribeswoman walks through a busy city street. She's balancing a pile of Economists on her head. We close in on The Economist and title: More than just economics.

Finally, we cut back to the birdcage swaying in the wind. The door is open and the cage is now empty.

Over these images we hear the voice of Mr Mac Maharaj. My name is Mac Maharaj. During my long imprisonment with Nelson Mandela on Robben Island, all news was forbidden.

We were only allowed publications necessary for study. One day, I suggested to a comrade who was studying economics, ask for The Economist.

Mandela and friends laughed. I simply smiled, 'They'll think it's to do with economics.'

Within a month, we were receiving The Economist and reading the news we craved.

The authorities later discovered their mistake and the subscription ended.

Today, we're free to read what we choose.

Cinematography

Cinematographer
Jeff Darling

Director
Jeff Darling

Copywriter
Jill Applebaum

Art Director
Marwan Khuri

Executive Producers
Jon Kamen
Robert Fernandez
Frank Scherma

Production Company
@radical.media
(London)

Advertising Agency
Young & Rubicam

Agency Executive Producer
Ken Yagoda

Editor
Lin Polito

Music
Chris Issak

Client
Jaguar

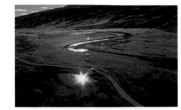

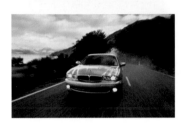

Wicked Game
Against a backdrop of a ruggedly spectacular landscape and cut to the track 'Wicked Game' by Chris Isaak, we see shots of the new Jaguar X type juxtaposed with iconic images of a couple's turbulent relationship.

Cinematography

Lighting Cameraperson
Zubin Mistry

Director
Walter Stern

Copywriter
Mike Nicholson

Art Director
Daryl Corps

Creative Directors
Peter Souter
Tony Cox

Producer
Sarah Caddy

Production Company
BBC Creative Services

Advertising Agency
Abbott Mead
Vickers.BBDO

Editor
Mark Reynolds

Sound Design
Johnnie Burn

Account Handler
Kate Sutton

Marketing Executive
Zoe Moore

Client
BBC

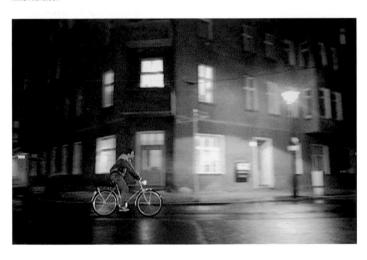

Wall
An East German man hears that the Berlin Wall is coming down. He then travels across East Berlin on his bike through the early hours. On arriving at the Wall he is confroned by a mass of confusion.
 Super: 10.59 wall
 Caught up in the emotion of the moment he takes a hammer and smashes a hole through the Wall. He then peers through anxiously and makes eye contact with the West Berliners.
 Super: 11.00 bridge
 We cut to a wide shot of everyone celebrating the fall of the Berlin Wall.
 Super: BBC News Online. Updated every minute.

Cinematography

Lighting Cameraperson
Stephen Blackman

Director
Peter Thwaites

Copywriters
Tobias Schelo
John Kelley

Art Director
Martin Nigl

Creative Director
John Kelley

Producer
Flora Fernandez-Marengo

Set Designer
Chris Oddy

Production Company
Gorgeous

Advertising Agency
Ogilvy & Mather

Agency Producer
Peter Valentine

Editor
Sam Sneade

Sound Designer
Ben Leaves

Account Handler
Clive Baker

Marketing Executive
Cathy Davies

Client
Ford Motor Company

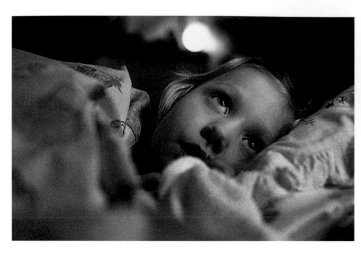

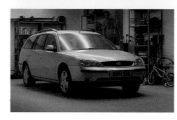

Little Girl
A little girl is woken up by the thunder and lightning of a heavy storm. Clearly frightened by it, she gets out of bed, carrying her comfort blanket. Surprisingly, she passes her parents' bedroom and wanders downstairs and through the house. The rain beats down outside and flashes of lightning illuminate the darkened rooms. The little girl heads for the door into the garage. There we see the Ford Mondeo. As the girl gets into the car, a voice over says: With its Intelligent Protection System, The Ford Mondeo is one of the safest places to be. We now see the girl sleeping peacefully in the back of the Mondeo.

Cinematography

Lighting Cameraperson
Paul Laufer

Director
Tarsem

Copywriter
Jo Moore

Art Director
Simon Robinson

Creative Directors
Leon Jaume
Nick Kidney
Kevin Stark

Producer
Tommy Turtle

Set Designer
Jed Clarke

Production Company
@radical.media
(London)

Advertising Agency
WCRS

Agency Producer
Sally Lipsius

Editor
Russell Icke

Music Composers
Graham Waugh
Raoul Brand

Account Handler
Simon Peck

Marketing Executive
Phil Horton

Client
BMW (GB)

Home
Open on a contemporary house, high on a hill. A dog is waiting patiently. From the dog's POV we see a car making its way up the winding road. It's the new BMW Compact. The dog gets up and runs through the house, excited by his master's return. We see the BMW as it handles the twisting road with ease. Cut back to the dog running in an ungainly fashion down a corridor. We see the BMW as it gracefully takes a hairpin bend. We inter-cut this with shots of the dog as it tries to take the corner in the corridor. In extreme slow motion we see it lose grip and slide into a hallway table with a vase on top of it. Everything crashes to the floor.
 The voice-over tells us that with rear wheel drive and near perfect balance nothing corners like a BMW.

Cinematography	**Art Director** Nils Andersson	**Set Designer** Chris Oddy	**Agency Producer** Peter Valentine	**Marketing Executive** Cathy Davies
Lighting Cameraperson Stephen Blackman	**Creative Director** John Kelley	**Production Company** Gorgeous	**Editor** Sam Sneade	**Client** Ford Motor Company
Director Peter Thwaites	**Producer** Flora Fernandez-Marengo	**Advertising Agency** Ogilvy & Mather	**Sound Designer** Ben Leaves	
Copywriter Roland Hasenrichter			**Account Handler** Clive Baker	

Cat
A terrified cat is caught in a thunderstorm. The rain beats down, thunder roars, lightning flashes. The cat jumps off a wall, miaowing loudly, and runs looking for cover. It encounters a ferocious dog and escapes under a fence. It runs down the street past a line of parked cars. The rain is teeming down, but instead of sheltering under one of these cars, the cat stares across the street. Something has caught its eye. Its the Ford Mondeo. The cat crosses the street and dives for cover under the car.

A voice over says: With its Intelligent Protection System, the Ford Mondeo is one of the safest places to be. The cat, safely under the Mondeo, purrs contentedly.

Cinematography

Lighting Camerapersons
Stuart Douglas
Tom Brown

Director
Stuart Douglas

Copywriter
Chris O'Shea

Art Director
Ken Hoggins

Creative Directors
Chris O'Shea
Ken Hoggins

Producers
Adam Lyne
Caspar Delaney

Production Company
@radical.media
(London)

Advertising Agency
Banks Hoggins O'Shea
FCB

Agency Producers
Georgia West
Brendan Pagne

Editor
Stuart Douglas

Music Composer
Music By Design

Sound Designers
Warren Hamilton
Johnnie Burn
James Saunders
Alex Burrett

Account Handler
Mark Wilson

Marketing Executive
Amanda Bindon

Client
Waitrose

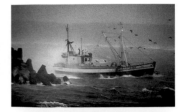

Fish
This commercial consists of colour shots of a trawler in rough seas intercut with black and white shots of fisherman at work, set to Otis Redding's 'Dock of the Bay'.

These are followed by a FVO: 'We will never ever buy fish unless it achieves at least 8 out of 10 on the Torry Institute's Scale of freshness and quality. Waitrose. Quality food, honestly priced'.

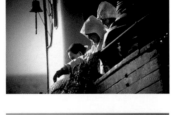

Milk
This commercial features colour shots of a farm and cows in the early morning, intercut with black and white images of the milk collection truck, to the song 'Good Morning, Good Morning'.

These are followed by a FVO: 'Only one supermarket knows every farm and farmer that supplies every pint of its fresh milk. Waitrose. Quality food, honestly priced'.

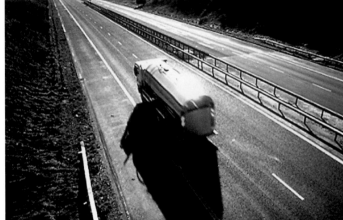

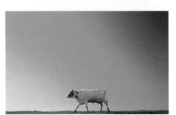

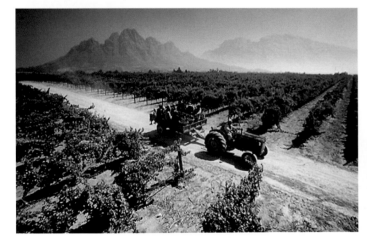

Wine
This commercial features colour and black and white shots of a South African vineyard and grape pickers set to UB40's 'Red, Red Wine'.

These are followed by a FVO: ' When the supermarket that's won more major wine awards than all the others put together says a wine is worth drinking, it's worth drinking.Waitrose. Quality food, honestly priced'.

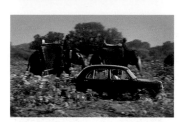

Cellars

This commercial features colour shots of the champagne cellars deep beneath the French town of Reims, intercut with images of the hustle and bustle of the of the town above, set to the music hall song 'Champagne Charlie'.

These are followed by the FVO: 'This Christmas there's a supermarket that won't only have fine French champagne on its shelves… it'll also have it in a very special Christmas Pudding. Waitrose. Quality food, honestly priced'.

India

This commercial features black and white and colour images of an unseen man travelling through India, set to Dion's 'The Wanderer'.

These are followed by a FVO: 'International Chef of the year, Sumit Malik, travels the length and breadth of India in search of authentic recipes for just one supermarket. Waitrose. Quality food, honestly priced'.

Use of Music

Director
Peter Thwaites

Copywriter
Malcolm Duffy

Art Director
Paul Briginshaw

Creative Directors
Malcolm Duffy
Paul Briginshaw

Producer
Flora Fernandez-
Marengo

Set Designer
Jeny Dyer

Production Company
Gorgeous

Advertising Agency
Miles Calcraft
Briginshaw Duffy

Agency Producer
Fiona Marks

Editor
Paul Watts

**Lighting
Cameraperson**
Karl Oskarsson

Music Composers
Paul Clarke
Adelphoi

Account Handler
Melissa Horn

Marketing Executive
Jayn Sterland

Client
Aristoc

Bum Note
We open on a stunning young woman in a gallery. Beautiful music plays. The woman sees a handsome young man. We see her shapely legs in Aristoc tights. She walks towards him. The music starts to go wrong. It sounds very discordant. The camera pulls back to reveal that we have been watching a movie and that an orchestra is putting music to the film. The men in the orchestra are all captivated by the girl's legs. They aren't paying any attention to the music in front of them. On the screen we cut away from the legs. The men return to their music and start playing beautifully again. We see the girl's legs once more as she exits the scene.
 The music goes completely wrong again.
 Title: Aristoc. For legs. For eyes.

Use of Music

Director
Sheree Folkson

Copywriters
Pete Bradly
Marc Hatfield

Art Directors
Pete Bradly
Marc Hatfield

Creative Director
Russell Ramsey

Producer
Anita Mahal

Set Designer
Marco Luppi

Production Company
Upstart Films &
Communications

Advertising Agency
Bartle Bogle Hegarty

Agency Producer
Alice Mahal

Editor
Nick Diss

**Lighting
Cameraperson**
Roger Pratt

Music Composers
Joe Campbell
Paul Hart

Sound Designer
Warren Hamilton

Account Handler
Amanda Quested

Marketing Executive
Chris Springford

Client
Unilever Bestfoods UK

Barons
This commercial spoofs the opening sequence of Dallas, showing an Italian family and playing the Dallas theme tune on a mandolin.

Use of Music

Director
Curtis Wehrfritz

Copywriter
Zak Mroueh

Art Director
Lance Martin

Creative Directors
Zak Mroueh
Paul Lavoie

Producer
Peter Davies

Production Company
Untitled

Advertising Agency
Taxi

Agency Producer
Louise Blouin

Editor
Michelle Czukar

**Lighting
Cameraperson**
Barry Parrell

Music Composer
Chris Tait

Account Handler
Joe Ottorino

Client
BMW Canada

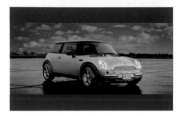

Mini Anthem
A tiny firecracker explodes on screen, thereby igniting an anthemic tribute to all things small and powerful. This culminates with the introduction of the new Mini as it too, explodes onto the screen.

Use of Music

Director
Andy Margetson

Copywriter
Andy Margetson

Producer
Steve Elliot

Production Company
MTV

Editor
Stuart Reed

**Lighting
Cameraperson**
Niels Johannsen

Choreographer
Paul Roberts

Colorist
Tareq Alkabaifi

Music Composer
Other Productions

Client
MTV Networks Europe

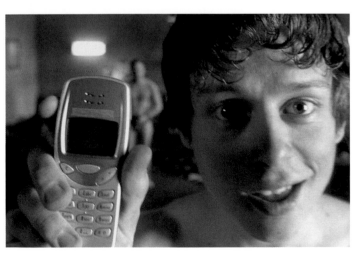

Ringtones
A young man is dancing alone to a dull ringtone, until his friend downloads a funky MTV tune featuring backing from a bevy of bikini clad beauties.

Use of Music

Director
Traktor

Copywriter
Dean Buckhorn

Art Director
Harvey Marco

Creative Director
Bob Moore

Producer
Traktor

Set Designer
Tom Hartman

Production Company
Partizan

Advertising Agency
Fallon Minneapolis

Agency Producer
Marty Wetherall

Editor
Gordon Carey

Lighting Cameraperson
Tim Maurice-Jones

Music Composer
T Bone Burnett

Account Handler
Lee Newman

Marketing Executive
Brad Barash

Client
The Lee Apparel Company

Suburbia

This commercial is part of a tongue-in-cheek campaign that encourages young people to 'Be Like Buddy Lee', the indestructible Lee Jeans spokes-doll.

As the Buddy Lee musical anthem plays, a young man strides purposefully through a suburban neighbourhood attempting to accomplish good deeds. Unfortunately, each of his attempts go painfully awry. Eventually, he comes face to face with his hero, Buddy Lee, just as Buddy risks his own life to save a man from a horrible backyard barbecue accident. There is a tremendous, fiery explosion, and of course, Buddy and his jeans remain unharmed. Our young man is clearly impressed and strides away determined to do better.

Use of Music

Director
Tom Carty

Copywriters
Bonnie Horton
Charlotte Horton

Art Directors
Bonnie Horton
Charlotte Horton

Creative Director
Mark Wnek

Producer
Ciska Faulkner

Production Company
Gorgeous

Advertising Agency
Euro RSCG Wnek Gosper

Agency Producer
Barbara Simon

Editor
Paul Watts

Lighting Cameraperson
Ivan Bird

Music Arranger
Anne Dudley

Account Handler
Merry Scott-James

Marketing Executive
David Murphy

Client
COI/DETR

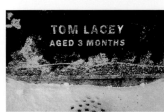

Memorial

The commercial depicts memorials to people who have died in house fires.

Their epitaphs are the feeble excuses they gave for not having a smoke alarm. The epitaphs read: 'They were too difficult to put up.' 'I didn't know where to buy them.' 'They were too expensive.' The last memorial is the gravestone of a family. The wife's excuse blames her husband. Her husband blames the landlord. Their 3-month-old child is too young to have an excuse.

Super: Excuses kill. Get a smoke alarm.

We end on a drive by shot of a burnt out house.

Animation	Animator	Visual Effects	Texture &	Directors	Creative Director	Executive Producer	Advertising Agency	Lighting	Account Handlers
Also accepted in Special Effects	Phil Dale	Supervisor Chris Knott	Lighting Artists Stuart Hall Robin Konieczny Matt Westrup	Phil Dale Chris Palmer	Chris Palmer	Andrew Ruhemann	WCRS	Cameraperson Ivan Bird	Giles Davis Darren Thomas
	Animation Producer Cara Speller	Technical Director Mark Wilson		Copywriter Andy Brittain	Designers Paul Catling John Robertson	Set Designer Marcus Rowland	Agency Producer Sally Lipsius	Music Composer Simon Boswell	Marketing Executive Emma Scammell
	CG Animators Phil Dale David Sigrist		Post Production Jon Hollis Tom Sparks	Art Director Yu Kung	Producer Suza Horvat	Production Companies Passion Pictures Gorgeous	Editor Paul Watts Off-line Editor Kevan O'Brien	Sound Designer Nigel Crowley	Client BMW (GB)

Martians

We are in London. Martians in giant tripods invade Earth and immediately set about destroying it. Realising the mortal danger the planet is in the new Mini breaks cover and challenges one of the Martians, which tries to blow it up with it's laser. The Mini, however, is too nimble and escapes.

Enraged, the Martians chase the Mini through London and out into the countryside. Using itself as bait, the Mini cleverly entices the Martian over a cattle grid whereupon one of the Martian's spindly legs slips through and trips the Martian up. As the Martian crashes to the ground the door flips open revealing a very embarrassed Martian.

The rest of the invasion fleet, realising that defeat by something as simple as a Mini makes them highly vulnerable, cancel the invasion and flee back to Mars.

The new Mini has thwarted the invasion almost as soon as it began.

Animation	Copywriter	Set Designer	Agency Producer	Account Handler
CG Animator Alastair Hearsum	Vince Squibb	Niamh Coulter	Tracey Johnston	Matt Edwards
	Art Director Vince Squibb	Production Company Paul Weiland Film Company	Editor Paul Watts	Marketing Executive Andy Groves
Animation Director Alyson Hamilton	Creative Director Charles Inge	Advertising Agency Lowe	Lighting Cameraperson Roger Pratt	Client Nestlé Rowntree
Director Vince Squibb	Producer Mary Francis			

Kiosk

Our customer is somewhat embarrassed by the promotional gift that comes free with his Aero chocolate bar.

Despite the hula-hooping mouse's desperate attempts to please, the man remains unimpressed, telling the newsagent he can keep it.

Animation

Animators
Robin Shaw
Jonas Odell
Christoph Simon

Copywriters
Jeff Bitsack
Riley Kane

Art Directors
Bryan Burlison
Dawn McCarthy

Creative Directors
Marty Orzio
Andy Hirsch
Randy Saitta

Producers
Dominic Buttimore
David Starr
Jesse Cromwell
Sam Hope

Production Companies
The Moving Picture Company
Curious Pictures
Bermuda Shorts
Jordan Caldwell

Advertising Agency
Merkley Newman
Harty

Agency Producer
Adina Sales

Music Composers
Oliver Davis
Double Six
Looper

Sound Designers
Bill Chesley
Oliver Davis

Account Handlers
Nicole Chamblin
Jennifer Getschmann

Marketing Executive
Bea Bartolotta

Client
Partnership For A Drug-Free America

Dance
The ad features an animated kid who continues to dance while drugs literally approach her. She turns her music on and begins to dance as she is approached by kids offering her drugs. As she is dancing, her arms swing to knock these kids over. Dancing is her anti-drug figuratively and literally.

Music
The ad features an animated kid who continues to listen to his music while drugs literally approach him. The young kid struts down the street, listening to his music while images of different drugs approach him. The sound waves bouncing off his headphones destry the drugs in his path.

Drawing
The ad features an animated kid who is approached by drugs and uses his drawing ability to get away. The animated kid is approached by other kids who offer him drugs. He draws himself a motorcycle and escapes the temptation.

Animation	Art Director	Chief Creative Officer	Advertising Agency	Music Composer	Client
	Adam Glickman	Bob Scarpelli	DDB Chicago	Jonathon Elias	Anheuser Busch
Animator					
Paul Griffin	**Group Creative Director**	**Producer**	**Group Executive Producer**	**SVP, Group Account Director**	
Director	Don Pogany	Marcie Malooly	Greg Popp	Steve Jackson	
Rick Schulze		Paul Hill			
	Creative Directors				
Copywriter	Adam Glickman	**Production Company**	**Editor**	**VP, Marketing**	
Craig Feigen	Craig Feigen	ILM Commercial Productions	Nick Seuser	August A Busch IV	

Come Home

A dog pushes open the screen door of a house where a late night party is taking place. He heads off to a nearby field. Suddenly, a huge tractor beam shoots down from the sky and sucks the dog into an alien space ship. The ship returns to its mother planet. The dog enters a colisseum filled with strange looking aliens. As tension fills the air, the dog unzips his skin, revealing that he's actually an alien dressed in a dog costume. The emperor looks down at the returning alien and says, 'What have you learned on earth?'. The returning alien lets loose with an enthusiastic 'WHASSUP!' The whole coliseum joins in, yelling 'WHASSUP!' The sound reverberates through the universe. On Earth, a technician monitoring a satellite dish hears the distant cacophony of 'Whassup!' echoing through his headphones. He turns to a colleague and exclaims, 'We are not alone!' Super over black: True.

Editing

Editor
Drew Thompson

Director
Bruce Hunt

Copywriter
David Guerrero

Art Director
David Guerrero

Creative Director
David Guerrero

Producer
Julianne Shelton

Set Designer
Ross NaMace

Production Company
@radical.media

Advertising Agency
BBDO/Guerrero
Ortega

Agency Producer
Bruce Davidson

Animators
Steve Oakley
Stuart White

**Lighting
Cameraperson**
Gary Philips

Music Composer
Mark Rivett

Sound Designer
Simon Kane

Account Handler
Patrick Wilkerson

Marketing Executives
Rajiv Kapoor
Andy Lambert

Client
VISA Asia Pacific

Dining Out
We open on the kitchen of a large restaurant. An intense-looking chef tastes the soup he is preparing and pronounces it to be perfect. But when it is served to a diner in the restaurant (action star Zhang Zi Yi) she tells the waiter it is 'too salty.' This sets off a confrontation between her and the chef – as well as his kitchen staff. A fight ensues, in classic martial arts style, during which most of the restaurant is smashed up. At this point, the waiter pops up and tells her there's no charge for the soup, but gives her a long bill for the 'extras.' With a flourish she fires something at the waiter which, to his relief, turns out to be her Visa card.

Special Effects

Special Effects
Jon Hollis

Director
Jon Hollis

Copywriters
Ben Priest
Peter Reid

Art Directors
Brian Campbell
Carl Broadhurst

Creative Director
Trevor Beattie

Producer
Dominic Freeman

Set Designer
Amanda McArthur

Production Company
Dominic Freeman

Advertising Agency
TBWA\London

Agency Producer
Diane Croll

Editor
Jon Hollis

**Lighting
Cameraperson**
Tony Brown

Sound Designer
Warren Hamilton

Account Handler
Gavin Thompson

Marketing Executive
David Patton

Client
Sony Computer
Entertainment Europe

Chasing Rabbits
A household dog dreams of chasing rabbits while he's asleep. His legs run faster and faster as the dream gets more intense. He's in his Third Place, why not visit yours?

Sound Design	Art Director	Production Company	Editor	Account Handlers
	Simon Langley	Academy	Marc Langley	Ben Slater
Sound Designer				Mark Petersen
Marc Langley	**Creative Directors**	**Advertising Agency**	**Lighting**	Richard Larcombe
	Tony Cox	Abbott Mead	**Cameraperson**	
Director	Peter Souter	Vickers.BBDO	Adrian Wilde	**Marketing Executive**
David Kellogg				Stephen Brown
	Producer	**Agency Producer**	**Music Composer**	
Copywriter	Mark Whittow-Williams	Ruth Hannett	James Saunders	**Client**
Richard Morcan				BT

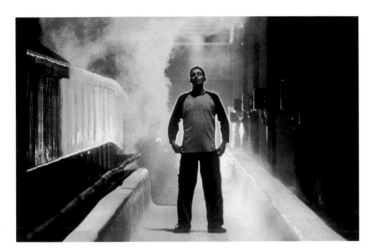

Bobsled
We are on a bobsled track high in the Alps. We follow the members of a four-man bobsled team on their incredibly fast run down the mountain. Their faces are a mask of concentration as they hold on for dear life. We then see the last guy in the back; in stark contrast to the other team members, he's completely bored with the whole affair. The voice over says 'Life seems slow after high-speed broadband.'
Super: Look Forward. BT openworld

STUDENT AWARDS

D&AD's Student Awards are a key fixture on the UK and international college calendar. They provide an essential connection between design, advertising, education and business. Real life briefs are set by leading brand names such as The Guardian, Adobe, Royal Mail and Prêt à Manger. These briefs are then judged in collaboration with practitioners from the cutting edge of advertising and design.

Winning students receive a coveted 'baby' Yellow Pencil, £1,000 and have their work showcased in the Student Awards Annual and on the D&AD Getty Images Bloodbank website. All of these rewards provide a springboard for future success, and for more than 20 years now the industry has watched D&AD Student Award winners go on to become top creatives. This year's winners are showcased over the following pages.

Student Awards Sponsors

ADOBE • ADVERTISING STANDARDS AUTHORITY • AGFA MONOTYPE • AQUENT • AVID • BT • CORUS • DESIGN COUNCIL • DIMENSION DATA • THE ECONOMIST
THE GUARDIAN • HÄAGEN-DAZS • HARPER MACKAY • JOHNSON BANKS • KIRIN BEER • KISS FM • MAIDEN OUTDOOR • THE NATIONAL MAGAZINE COMPANY
NESTA • OLYMPUS • PRÊT À MANGER • ROYAL MAIL • SAATCHI & SAATCHI • SHELL LIKE • TBWA\GGT DIRECT • TISCALI • TRANSPORT FOR LONDON • WPP

Streaming Web Media

Student of the Year

Student
Alex Hulse

Tutors
Penny Hilton
Ethan Ames

College
Ravensbourne College
of Design &
Communication

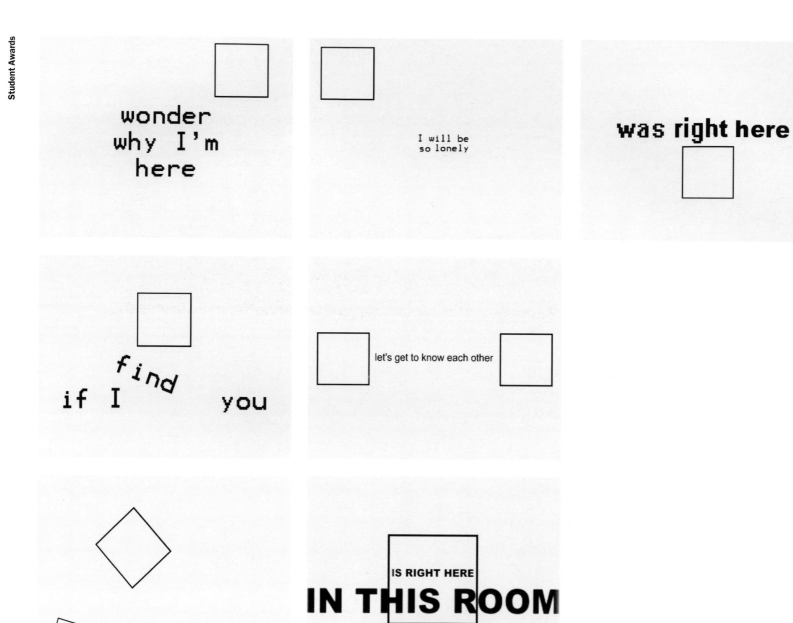

**Advertising
Silent Movie**

Second

Students
Fridtjof Alstedt
Tom Blackburn

Tutors
Lenore Gristwood
Eric Gristwood

College
Manchester
Metropolitan
University

Second

Students
Harry Dwyer
Will Flack
Aaron Wilmer

Tutors
Zelda Malan
David Morris
Lyndon Mallet

College
Buckinghamshire
Chilterns University
College

Ambient Media

First

Students
Dave Eakins
Barry Hayman

Tutors
Zelda Malan
David Morris
Lyndon Mallet

College
Buckinghamshire
Chilterns University
College

Second

Students
Mike Fallows
James North

Tutors
Linda Sinclair
Tony Tucker
Mike Moran

College
University of Central
Lancashire

Brand Identity

First

Student
Zoë Bather

Tutors
Bryn Jones
Ben Tibbs
Malcolm Kennard

College
Kingston University

First

Students
Nicola Engert
Barbara Jung
Amöne Schmidt

Tutors
Charlotte Schroner
Thomas Daum

College
Fachhochschule
Mainz, Germany

**Corus Steel
Packaging 1
Nescafé**

First

Student
Stephanie Davis

Tutor
Mike Beaumont

College
University of
Central England

Corus Steel
Packaging 2
Pedigree Masterfoods

First

Student
Verity Gibson

Tutors
John Bairstow
Glyn Hawley
Claire Lockwood

College
Sheffield Hallam
University

Second

Student
Saiko Mukai

Tutors
Bryn Jones
Ben Tibbs
Malcolm Kennard

College
Sheffield Hallam
University

Second

Student
Joy Rhodes

Tutor
Ray Gregory

College
Norwich School
of Art and Design

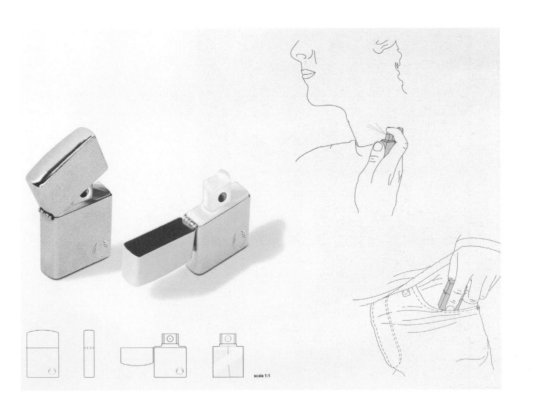

Corus Steel
Packaging 3
The Body Shop

First

Student
Nicole Aebischer

Tutors
Luc Bergeron
Remy Jacquet

College
Ecole Cantonale
D'Art de Lausanne,
Switzerland

Second

Student
Nicola Cosentino

Tutors
Luc Bergeron
Remy Jacquet

College
Ecole Cantonale
D'Art de Lausanne,
Switzerland

Direct Mail

First

College
Kingston University

Student
James Winter

Tutors
Mike Robbins
Annie Grant
Jane Chipchase

Second

College
Central Saint Martins
College of Art
and Design

Students
David Howlett
Matthew Peckham

Tutors
Clive Challis
Maggie Gallagher
Zelda Malan

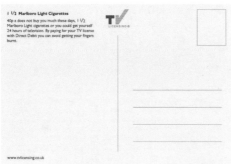

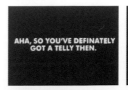 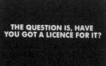 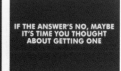
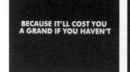 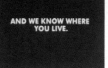

Direct Response

First

College
Buckinghamshire
Chilterns University
College

Students
Emily Portnoi
Johnny Watters

Tutors
Julie Wright
Elaine Aldington
Leah Klein

Second

College
Staffordshire
University

Students
Lisa Hastings
Jason West

Tutors
Bryn Jones
Vicki Shields
Jim Williams

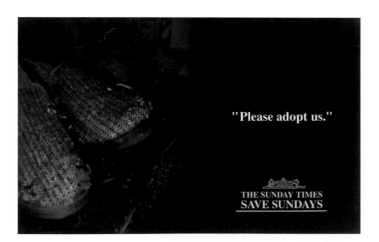

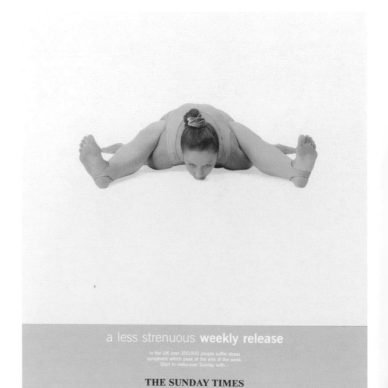

Environmental Design First

Student
Venla Kivilahti

Tutors
Kate Bonella
David Gardener

College
Southampton Institute

Second

Student
Mayumi Sakai

Tutor
Rory Hamilton

College
Royal College of Art

Graphic Design First

Student
Kristina Ruataibordee

Tutors
Amanda Lester

College
Central Saint Martins
College of Art
and Design

Second

Students
Michael Evidon
Byron Parr
Jason Skowronek

Tutor
Amanda Lester

College
Central Saint Martins
College of Art
and Design

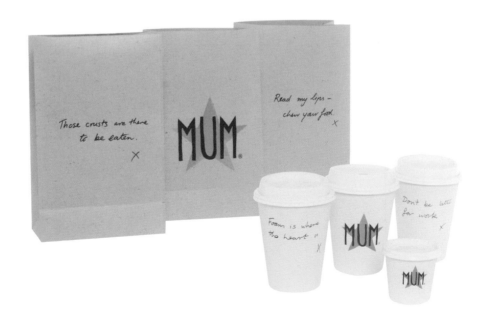

Illustration

First

Student
Nathaniel Everard

Tutors
Howard Pemberton
Brian Peacock

College
Lincoln School of
Art & Design /
University of Lincoln

Second

Student
Adam Howling

Tutor
Robert Mason

College
Norwich School
of Art & Design

Interactive Design

First

Student
Kate Green

Tutors
Paul Rodgers
Duncan Hepburn
Ian Lambert
Alex Milton

College
Napier University

Second

Student
Stephen Kane

Tutors
Gordon Robertson
David Herbert
Ock-Ryun Hur
Gary Gowans
Brian Taylor

College
Duncan of
Jordanstone College
of Art

Second

Student
Alex Shapowal

Tutors
Paul Rodgers
Duncan Hepburn
Ian Lambert
Bjorn Rodnes

College
Napier University

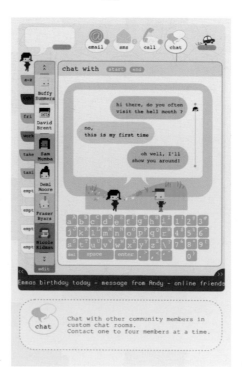

Mixed Media

Second

Student
Andy Ng

Tutors
Ned West-Sherring
Phil Jones

College
Kent Istitute of Art
& Design

Second

Students
Veerkamal Assi
Igor Bozovic

Tutors
Andrew Gossett
Lilian Lindblom

College
Middlesesx University

Multimedia

First

Students
Graeme Haig

Tutors
Gordon Robertson
David Herbert
Ock-Ryun Hur
Gary Gowans
Brian Taylor

College
Duncan of
Jordanstone College
of Art

Second

Students
Edward Walker

Tutors
Gordon Robertson
David Herbert
Ock-Ryun Hur
Gary Gowans
Brian Taylor

College
Duncan of
Jordanstone College
of Art

Photography

First

Student
Peter Corkhill

Tutor
Richard Burt

College
Herefordshire College
of Art & Design

First

Student
Joseph MacRae

Tutor
Alan McEwan

College
Stevenson College

Second

Student
Charlie Roberts

Tutors
Susan Curtis
Priscilla McIntosh

College
Northbrook College,
Sussex

Poster Advertising

First

Student
Rex Boyd

Tutor
Martin Williams

College
North Oxfordshire
School of Art & Design

Second

Student
Zaineb Latif

Tutors
Bryn Jones
Ben Tibbs
Malcolm Kennard

College
Kingston University

Press Advertising	First		College
			University of Central
	Student		Lancashire
	Sean Cullen		
	Tutors		
	Jane Souyave		
	Andy Bainbridge		
	Ron Bray		

Product Design	First	Second
	Student	**Student**
	Andrew Lang	Patrick Tonks
	Tutors	**Tutor**
	Prue Bramwell-Davis	James Dale
	John Drane	
		College
	College	Nottingham Trent
	Royal College of Art	University

Prototype bracket in opal polypropylene.

Mounting and removing the bike from the display bracket is simple - the twin hells of the front edge naturally guides the frame of the bike to its rest position.

Bicycles, when not in use are cumbersome objects to have around the home.

The aim of this product was to achieve a visually interesting and functional form that cyclists - commuter and enthusiast alike - would want to have on a wall in their home.

Originally conceived as a domestic system for cyclists to a/ store their pride and joy out of harms way this bracket could also form the basis of a modular display system for use in a retail environment.

Bicycles generally have a rearward weight bias - this system utilises the natural moment induced by the bike to lock itself onto the lobes of the bracket.

BIKE DISPLAY BRACKET - OUTLINE DETAILS

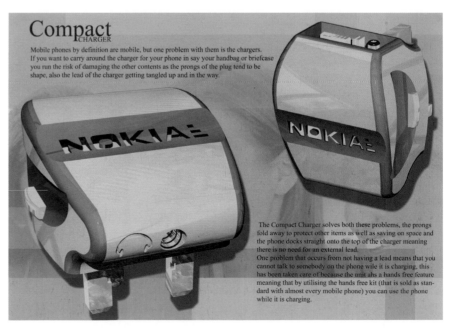

Compact CHARGER

Mobile phones by definition are mobile, but one problem with them is the chargers. If you want to carry around the charger for your phone in say your handbag or briefcase you run the risk of damaging the other contents as the prongs of the plug tend to be shape, also the lead of the charger getting tangled up and in the way.

The Compact Charger solves both these problems, the prongs fold away to protect other items as well as saving on space and the phone docks straight onto the top of the charger meaning there is no need for an external lead.

One problem that occurs from not having a lead means that you cannot talk to somebody on the phone wile it is charging, this has been taken care of because the unit ahs a hands free feature meaning that by utilising the hands free kit (that is sold as standard with almost every mobile phone) you can use the phone while it is charging.

Product Innovation **First**

Students
Anna Dabrowski
Pau-Ching Huang

Tutors
Ben Hughes
Ralph Ball

College
Central Saint Martins
College of Art
and Design

Second

Student
Adrien Rovero

Tutors
Luc Bergeron
Remy Jacquet

College
Ecole Cantonale
D'Art de Lausanne,
Switzerland

Radio Advertising **First**

Student
Nicholas Kelly

Tutors
Jackie Dickenson
Peter Sorenson

College
RMIT University,
Australia

Second

Students
Ben Lightfoot
Chris Long

Tutors
Paul White
Jane Berney

College
Auckland University
of Technology,
New Zealand

All ads would be read by the same man. A female announcer would read the tagline in a sexy voice.

1 Apparently it's illegal to marry a television in England. There must be a way around it. Maybe I'll hire a boat and marry her in international waters. I love my TV. She has no heart but plenty of beats… Sings me sweet music when I request.
KISS TV — LIVE SEXY.

2 My TV is beautiful. She can change her look whenever she wants. One minute she's retro, next minute she's a sexy diva. All I have to do is request. I turn heron in the morning. She turns me on all day.
KISS TV — LIVE SEXY.

3 My TV is pregnant. I'm not surprised, she plays just about any style of music with a beat… More than eighty tracks a week. When the little ones arrive I'll put one in each room. They can all sing me a different song when I request.
KISS TV — LIVE SEXY.

4 My TV is cheating on me… With my best friend. Found them together this morning, she was singing him house music. 'WHY?!' I screamed. Because he requested. Maybe I'll buy a radio and just put a bag over its head or something.
KISS TV — LIVE SEXY.

5 My TV says I'm not into commitment. Says if I was I'd throw the remote away and keep her channel forever. I told her I'm only in it for the music and she screamed acid house for about two hours. Fiesty little thing. Had to request a little hip hop to smooth things over.
KISS TV — LIVE SEXY.

6 My TV likes to wear the pants in our relationship. Like the other day, I requested some techno. She lost it: 'I can sing other beats you know… I'm not your object'. Well, actually you are, I reminded her.
KISS TV — LIVE SEXY.

1 Voice
SFX: Muffled house music and street ambience, the music sounds as though it is coming from inside a club.
MVO1: In ya go
FVO: Thanks Mr Robinson
MVO1: Ya right luv.
SFX:Music gets louder as door opens and fades as it shuts.
MVO1: 'Old on son. (pause) Not with those shoes mate.
MVO2: Shut up dad, let me in.
Kiss FM ident.
MVO3: Staying in is the new going out, tune into Kiss TV.

2 Voice
SFX: Loud drum n' bass music blaring, the music clearly sounds as though it is live, evoking the atmosphere of a nightclub.
MVO1: I'm going for a drink
FVO1: What?
MVO1: What do you want to drink?
FVO1: Uhm, get us a cocoa?
MVO1: One lump or two?
Kiss FM ident.
MVO2: Staying in is the new going out, Tune into Kiss TV.

3 Voice
SFX: Loud drum n' bass music blaring, the music clearly sounds as though it is live, evoking the atmosphere of a nightclub.
MVO1: Do you come here often?
FVO1: What?
MVO1: Do you come here often? (slower/loader)
FVO1: Every night. This is my house.
MVO1: Oh…
Kiss FM ident.
MVO2: Staying in is the new going out, tune into Kiss TV.

Streaming Web Media

First

Student
Alex Hulse

Tutors
Penny Hilton
Ethan Ames

College
Ravensbourne College
of Design &
Communication

Second

Student
Chris Hardman

Tutors
Bev Whitehead
Monica Biagioli

College
Surrey Institute of Art
& Design University
College at Epsom

TV Advertising

Second

Student
He Yong Bo

Tutor
Li Cao

College
Central Academie
of Fine Arts, China

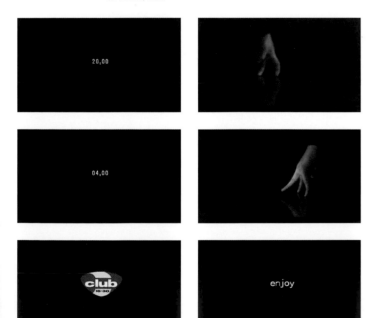

TV Titles

First

Student
Kim Crawford

Tutor
Colum Leith

College
Buckinghamshire
Chilterns
University College

Second

Students
Ghin Liew
Russell Palmer

Tutors
Phil Baines
Marc Wood

College
Central Saint Martins
College of Art
and Design

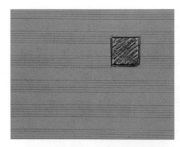

Typography

First

Student
Lydia Knights

Tutor
Martin Schooley
Sian Cook

College
Ravensbourne College
of Design &
Communication

Second

Student
Jon-Paul Daly

Tutor
Nigel Robinson

College
Buckinghamshire
Chilterns
University College

Website Design First

Student
Isaac Wong Yonshen

Tutor
Irwanta Salim

College
Temasek Polytechnic,
Singapore

Second

Students
Chloe George

Tutor
Geoffrey Thomas-Shaw

College
Chelsea College
of Art and Design

Writing First Tutor
Coz Cotzias

Students
Chris Overton
Chantal Panozzo

College
VCU Adcenter, USA

Second College
Buckinghamshire
Chilterns University
College

Student
Liz Franklin

Tutors
Lyndon Mallet
Julie Wright
Leah Klein

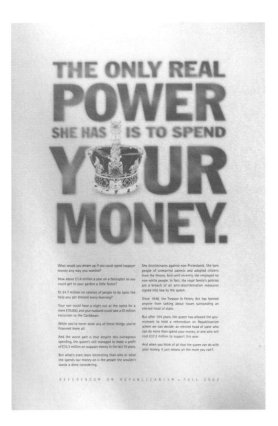

 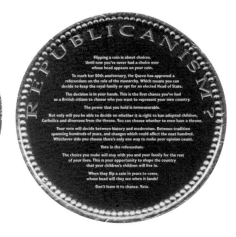

MEMBERS OF D&AD

D&AD is run for and by its members who currently include more than 2,300 design and advertising professionals, as well as students and associates.

FULL MEMBERSHIP

Open to all the creatives whose work is judged to be of a sufficiently high standard to be included in the D&AD Annual. Full Members run the association, elect the Executive and form part of D&AD's constitution. They are drawn from a range of disciplines including art directors, copywriters, designers, photographers, typographers and illustrators.

ASSOCIATE MEMBERSHIP

Open to those not working in a creative design or advertising function, but who are recognised as having encouraged and supported D&AD's aims and ideals. Most typically, Associate Members are clients, educators or those involved in the management of creative projects – for example, account handlers or marketing directors.

NEW BLOOD MEMBERSHIP

Open to students and young creatives who have been through D&AD's workshop or Student Award programmes or have had their work featured on the D&AD Getty Images Bloodbank.

BENEFITS OF MEMBERSHIP

Being a member makes you part of a creative community that includes some of the most respected names in the design and advertising industries, however, there are also many tangible advantages to joining D&AD. All members receive the following benefits:

- Free copies of Ampersand, our quarterly house magazine, and regular mailings updating you on important events and special offers
- Discounts on D&AD programmes including the President's Lectures
- Discounts on D&AD publications including The Graphics Book, The Product Book, The Copy Book and The Commercials Book
- Access to the Green Room, the member's only area of our website, where you can contact other members via email, air your views in the discussion room or ask for advice on the notice-board

In addition, all Full and Associate Members receive free copies of the D&AD Annual and DVD Showreel.

For further information please contact the Membership Department on +44 (0)20 7840 1119 or visit www.dandad.org

Gareth Abbit *Creative Services Manager*
David Abbott *Copywriter*
Matthew Abbott *Copywriter*
Alan Aboud *Creative Director*
Steve Ackhurst *Producer/Managing Director*
Elaine Adachi *Producer*
Julie Adams *Copywriter*
Marcus Adams *Film Director*
Marksteen Adamson *International Creative Director*
Nicole Aebischer *Designer*
Manu Agah *Photographer*
Akbal Ahmed *Senior Designer*
Kathleen Aiken *Design Manager*
Alan Ainsley *Design Director*
Jim Aitchison *Author*
Roger Akerman *Art Director*
Nassreen Akhtar *Facilities/Operations Manager*
Roger Akroyd *Creative Director*
David Alexander *Creative Director*
James Alexander *Designer*
Leslie Ali *Art Director*
Viqar Ali *Creative Director*
Charles Allan *Creative Director*
David Allen *Chief Executive Officer*
Jenny Allen *Senior Designer*
Matt Allen *Art Director*
Paul Allen *New Media Designer*
Nick Allsop *Art Director*
Lovisa Almgren *Art Director*
Jade Aloof *Designer*
John Altman *Composer*
Andy Amadeo *Creative Director*
Ethan Ames *Director of Studies*
Pip Amey *Art Director*
Silas Amos *Designer*
Matthew Anderson *Copywriter*
Sarah Jane Anderson *Designer*
Joan Anderson Lind *Group Account Director*
Magnus Andersson *Creative Director*
Nils Andersson *Art Director*
Jason Andrews *Senior Copywriter*
Nicholas Angell *Managing Director/Sound Engineer*
Paul Angus *Art Director*
Frank Anselmo *Art Director*
Simon Antenen *Creative Director*
Ranzie Anthony *Creative Director*
Derek Apps *Copywriter*
Neil Archer *Typographic Designer*
Robert Archer *Design Partner*
Simon Archer *Director of Photography*
Paul Arden *Director*
Richard Ardito *Art Director*
Lin Arigho *Managing Director*
Dante Ariola *Director*
Pete Armstrong *Copywriter*
Vaughan Arnell *Director*
Chris Arnold *Creative Director*
Rosie Arnold *Art Director*
Jo Arscott *Creative Director*
Vanessa Arsen *Animator*
Tim Ash *Designer*
Richard Ashby *Director*
Jon Ashwell *Art Director*
Oscar Askelöf *Copywriter*
Matt Astle *Creative*
Jayson Atienza *Art Director*
Laura Auchterlonie *Copywriter*
Ali Augur *Designer*
Will Awdry *Creative Director*
Paul Ayre *Designer*
Alex Ayuli *Senior Creative*
Alberto Baccari *Creative Director*
John Bacon *Creative Director*
Jason Badrock *Designer*
Omar Badru *El-Haj Designer*
Patrick Baglee *Creative Director*
Mark Bagshaw *Graphic Designer/Copywriter*
Julie Anne Baile *Executive Creative Director*
Darren Bailes *Copywriter*
Kevin Bailey *Graphic Designer*
Peter Bailey *Illustrator*
Stephen Bailey *Creative*
Jon Bains *Chairman/Director*
Angela Baker *Creative*
Paul Baker *Design Modelmaker*
Jan Baldwin *Photographer*
Leighton Ballett *Copywriter*
Jack Bankhead *Photographer*
Zafer Baran *Partner*
Roberto Barazzuol *Creative Director*
Adrian Barber *Creative Director*
Alex Barber *Director of Photography*

Daniel Barber *Commercials Director*
Don Barclay *Art Director*
Chris Bardsley *Creative Director*
Sally Bargman *Art Director/Creative Director*
David Barker *Copywriter*
Larry Barker *Creative Director*
Tania Barker *Creative Partner*
Justin Barnes *Copywriter*
Dirk Barnett *Design Director*
Will Barnett *Creative Director*
Jeremy Baron *Creative Director*
Kathryn Baron *Creative*
Chris Barraclough *Chairman*
David Barraclough *Design Director*
Chris Barrett *Creative*
Jacci Barrett *Executive Producer*
Lascelle Augustus Barrow *Managing Director*
Robert Barson *Creative*
Neil Barstow *Photographer*
Andy Barter *Photographer*
Hasan Barutcu *President*
Andy Barwood *Deputy Creative Director*
Pippa Baskerville *Art Director/Copywriter*
Christopher Bass *Art Director*
Pete Bastiman *Deputy Creative Director*
Shaun Bateman *Senior Copywriter*
Adam Bates *Creative Director*
John Bateson *Director*
Anthony Battaglia *Designer*
Georgious Batzakis *Creative*
Carlos Bayala *Creative Director*
Chas Bayfield *Creative*
Michael Bayfield *Creative*
John Bayley *Creative Director*
Richard Baynham *Copywriter*
John Beach *Partner*
David Beard *Designer*
Matt Beardsell *Production Director*
Luke Beauchamp *Head of Production*
Keith Beaumont *Graphic Designer*
Ian Beck *Illustrator*
Dan Beckett *Studio Creative Manager*
Roger Beckett *Copywriter*
Nick Beckhurst *Creative Director*
Victoria Beecroft *Designer*
Gareth Beeson *Designer*
Adrian Belcham *Art Director*
Paul Belford *Creative Director*
Andy Bell *Copywriter*
Christopher Bell *Creative*
David Bell *Copywriter*
Garth Bell *Graphic Designer*
Nick Bell *Copywriter*
Zoe Bell *Head of TV*
Richard Benjamin *Typographer*
Madeleine Bennett *Designer*
Marc Bennett *Art Director*
Stephen Bennett *Art Director*
Jonathan Benson *Creative*
Michael Benson *Communications Director*
Bruce Beresford *Designer*
Emilia Bergmans *Creative*
Joe Berkeley *Group Creative Director*
Cheryl Berman *Chairman/Chief Creative Officer*
Adrian Berry *Creative Director*
James Best *Group Chairman*
Jilly Best *Copywriter*
Gary Betts *Creative Director*
Chris Bevan *Creative*
James Beveridge *Design Partner*
Dave Beverley *Creative Director*
Paul Bevitt *Photographer*
Phil Bignell *Interactive Manager*
Anthony Biles *Designer*
Lloyd Billing *Managing Director*
Nicola Bingham *Creative*
Cath Birch *Interactive Designer*
Andy Bird *Head of Design*
John Blackburn *Creative Director*
Tom Blackburn *Art Director*
Bernadette Blair *Director of Undergraduate Studies*
Sid Blakeborough *Director*
Stephen Bland *Partner*
Stephen Blanks *Creative Director*
Stephen Blenheim *Design Director*
Laurence Blume *Creative Director*
Tony Blurton *Design Director*
Amma Boahene *Marketing Executive*

Martin Boase *Past President, D&AD*
Luke Boggins *Art Director*
Nigel Bogle *Joint Chief Executive*
Louis Bogue *Art Director*
Michelle Bohm *Art Buyer/Production Assistant*
Mike Boles *Deputy Creative Director*
Jane Bolton *Producer*
Jim Bolton *Creative Director/Managing Director*
Henry Bond *Photographer*
Andrew Bone *Director*
Cloudia Bonwick *Creative*
Colin Booth *Art Director*
Allen Boothroyd *Managing Director*
Brian Born *Creative Director*
Pep Bosch *Director*
Stephen Boswell *Creative Group Head*
David Botterell *Producer*
Shaun Bowen *Creative Director*
Jeremy Bowles *Director of Account Management*
Rex Boyd *Computer Artist*
Chris Bradley *Design Partner*
Dave Brady *Head of Design*
David Brady *Art Director*
Kevin Bratley *Art Director*
Emma Braund *Creative Director*
Shazia Brawley *Manager*
Jon Bray *Copywriter*
Tim Braybrooks *Copywriter*
Paul Brazier *Art Director*
Michael Brehme *Director*
Ray Brennan *Art Director*
Anita Brightley-Hodges *Creative/Managing Director*
Paul Briginshaw *Creative Director/Partner*
Tony Brignull *Copywriter*
David Brimson *General Manager – Marketing*
Andy Brittain *Copywriter*
Curtis Brittles *Copywriter*
David Brixton *Editor/Owner*
Robin Broadbent *Photographer*
Libby Brockhoff *Art Director*
Andy Brockie *Graphic Designer*
Anna Brockway *Director of US Marketing*
Gareth Bromley *Designer*
Tony Brook *Creative Director*
Mike Brooking *Copywriter*
Mike Brooks *Creative*
Sheila Broom *Lecturer*
Simon Brotherson *Art Director*
Newy Brothwell *Art Director*
Adam Brown *Director*
Bryan Brown *Managing Director*
David Brown *Director*
Desiree Brown *Creative Partner*
Graham Brown *Vice Chairman*
Kylie Brown *Planner*
Mariel Rebecca Brown *Creative*
Mel Brown *Publicity Team Leader*
Rik Brown *Art Director*
Ron Brown *Art Director*
Sam Brown *Director*
Steve Brown *Animator*
Tamara Brown *Copywriter*
Tim Brown *Chief Executive Officer*
Tim Brown *Deputy Art Director*
Warren Brown *Executive Creative Director*
Samantha Brownstien *Freelance Designer*
Paul Browton *Creative Director*
Johnny Bruce *Senior Partner*
Davor Bruketa *Design Director*
Tim Brunelle *Creative Director/Writer*
Rachel Brunning *Graphic Designer*
Cal Bruns *Executive Creative Director*
Gary Bryan *Photographer*
David Bryant *Creative Director*
Richard Bryant *Architectural Photographer*
Lisa Bryer *Managing Director*
Jane Bryson *Director*
Dave Buchanan *Copywriter*
Peter Buck *Freelance Copywriter*
Stuart Buckley *Art Director*
James Bucktin *Art Director*
Jonathan Budds *Copywriter*
Frank Budgen *Director*
Matthew Bull *Chairman/Executive Creative Director*
Sheila Bull *Copywriter*
Tina Bull *Director*

Martyn Bullock *Managing Director*
Andy Bunday *Art Director*
Paul Burke *Copywriter*
Hugh Burkitt *Chairman*
Rob Burleigh *Creative Director*
Johnnie Burn *Director/Sound Engineer*
Paul Burnett *Creative*
Ricky Burns *Art Director*
Ian Burren *Design Director*
Alex Burrett *Writer/Director*
Richard Burridge *Director*
Max Burt *Head of Planning*
Jon Busk *Account Director*
Ben Butler *Lighting Cameraman*
Chris Butler *Creative*
Liam Butler *Copywriter*
Richard Butler *Deputy Chairman*
Sarah Butler *Deputy Creative Director*
Simon Butler *Senior Art Director*
Joel Butt *Interactive Designer*
Philippa Butters *Head of Design*
Dominic Buttimore *Head of 3D Animation*
Ian Buttle *Copywriter*
Daniel Button *Writer*
Brian Byfield *Director*
Susan Byrne *Art Director*
Adrian Caddy *Creative Director*
Andrew Cade *Creative Partner*
Sam Cadman *Director*
Michael Caldwell *Photographer*
Ben Callis *Art Director*
Andy Cameron *Photographer*
Aziz Cami *Managing Partner*
Rui Camilo *Photographer*
Alister Campbell *TV Producer*
Brian Campbell *Art Director*
Joe Campbell *Company Director*
Maggie Campbell *TV Producer*
Michael Campbell *Copywriter*
Robert Campbell *Executive Producer/Managing Director*
Robert Campbell *Executive Creative Director*
Sally Campbell *Producer*
Walter Campbell *Art Director*
Finn Campbell Notman *Designer*
Alex Canning *Creative*
Jon Canning *Creative Director*
Oliver Caporn *Art Director*
Simon Carbery *Copywriter*
Mark Carman *Art Director*
Richard Carman *Copywriter*
Fiona Carpenter *Art Director*
Jeremy Carr *Copywriter*
Cameron Carruthers *Creative Director*
Debra Joanne Carter *Creative*
Kirsty Carter *Designer*
Peers Carter *Creative Independent*
Philip Carter *Creative Director*
Sam Cartmell *Copywriter*
Tom Carty *Copywriter*
Ben Casey *Creative Director*
Neil Cassie *Brand Identity Director*
Martin Casson *Art Director*
Domenic Castley *Art Director*
Ian Caulder *Interior Designer*
Mario Cavalli *Director*
Michael Cavers *Creative Director*
Celine Cawley *TV Producer*
Arianna Cefis *Senior Account Director*
Francesco Cerminara *Copywriter*
Christopher Challinor *Designer*
David Chamberlain *Senior Designer*
Christine Costello *Chief Executive Out of Home*
Trevor Chambers *Creative Director*
Karen Hoi Yam Chan *Creative*
Shu Keung Chan *Creative Director*
Theseus Chan *Creative Director*
Tom Chancellor *Creative*
Christopher Chapman *Senior Designer*
Nicola Chapman *Interaction Designer*
Tom Chapman *Managing Director*
Andrew Chappin *Art Director*
Kellie Chapple *Account Director*
Charity Charity *Global Creative Director*
Tim Charlesworth *Copywriter*
Vincent Chasteauneuf *Art Director*
Andy Cheetham *Creative Director*
Fiona Chen *Art Director*
Reno Cheng *Vice President*
Steve Chetham *Art Director*
Man-Wai Cheung *Senior Designer*
Stanley Cheung *Creative*

Joanne Chevlin *Head of Typography*
Ian Chilvers *Director*
Susie Ching *Head Hunter*
Chris Chiu *Creative Director*
Peter Chodel *Creative Director*
Sandy Choi *Design Director*
Eunice Chong *Creative Director*
Dion Christie *Creative*
Chris Church *Designer*
Thomas Chutalla *Copywriter*
Paul Cilia La Corte *Designer*
Alan Cinnamond *Creative*
Sandy Cinnamond *Creative*
John Claridge *Photographer*
Bryan Clark *Director*
Edmund Clark *Photographer*
Lee Clark *Creative*
Lucy Clark *Creative*
Nick Clark *Creative Director*
Andrew Clarke *Creative Director*
Eoghain Clarke *Art Director*
Gabby Clarke *Senior Designer*
John Clarke *Director*
Matthew Clarke *Creative*
Melanie Clarke *PA*
Tanya Clarke *Web Designer*
Annette Clayton *Brand Manager*
Kirsten Clayton *Business Director*
Phil Cleaver *Creative Director*
Max Clemens *Art Director*
Nick Clement *Creative*
Nicholas Clements *Chief Executive*
Bart Cleveland *Creative Director*
Tony Clewett *Art Director*
Anthony Cliff *Art Director*
Tom Climpson *Art Director/Designer*
Carly Damon *Creative*
Kate Clough *Creative*
Stephen Coates *Art Director/Designer*
Barney Cockerell *Creative Director*
Phil Cockrell *Creative Director*
Jonathan Coles *Head of Design*
Sam Collett *Lead Designer*
Matt Collier *Art Director*
Peter Collingwood *Copywriter*
Damon Collins *Art Director*
Nigel Collins *Creative*
Patrick Collister *Executive Creative Director*
Jamie Colonna *Art Director*
Alan Colville *Designer*
Caroline Colwell *Board Account Director*
John Commander *Past President, D&AD*
Jayne Connell *Design Director*
Katie Connor *Creative*
Richard Connor *Art Director*
Graeme Cook *Copywriter*
Matthew James Cook *Art Director*
Courtney Cooke *Public Affairs Assistant*
Gary Cooke *Creative Director*
Gene Cooke *Designer*
Mark Cooke *Creative Services Director*
Kirsty Cooper *Creative*
Roger Cooper *Designer*
Steve Cope *Designer/Director*
Alison Copus *Marketing Director*
Peter Corkhill *Photographer*
David Cornell *Commercials Director*
John Cornell *Retoucher*
Lieve Cornil *Lettering Artist*
Daryl Corps *Art Director*
Christine Costello *Chief Executive Out of Home*
Rosalind Coughlin *Designer*
Carol Coulter *Head of Art*
Michael Coulter *Creative Director*
Tim Count *Director*
Michael Courthold *Art Director*
Keith Courtney *Creative Director*
Mandy Courtney *Board Account Director*
Geoff Cousins *Creative Director*
Jon Cousins *Director*
Jason Coward *Account Director*
Richard Coward *Graphic Designer*
Andy Cox *Creative Partner*
Barry Cox *Director*
Martin Cox *Director*
Patrick Cox *Senior Design Director*
Tony Cox *Creative Director*
Mike Cozens *Creative Director*
Andrew Cracknell *Executive Creative Director*
Jeremy Craigen *Creative Director*
Scot Crane *Editor*

Craig Crawford *Copywriter*
Kim Crawford *Graphic Designer*
Mark Cridge *Managing Director*
Iain Crockart *Director*
Martin Crockatt *Typographer*
Steve Cronan *Managing Director*
Stuart Cronin *Creative Develpment Manager*
John Cross *Director*
John Crossland *Designer*
Bruce Crouch *Creative Director*
Michael Crowe *Copywriter*
Simon Cryer *Creative Director*
Sara Cubitt *Communications Manager*
Michael Cudlipp *Chief Executive/Company Secretary*
Peter Cudlipp *Director*
Sean Cullen *Creative*
Karen Cunningham *Joint Managing Partner*
Fiona Curran *Graphic Designer*
Doug Currie *Photographer*
Alan Curson *Copywriter*
Hal Curtis *Creative Director*
Gavin Cutler *Editor/Owner*
Paul Cutter *DOP/Director*
Matthew D'Arcy-Hunt *Art Director*
Sonal Dabral *Managing Director/Executive Creative Director*
Anna Dabrowski *Industrial Designer*
Leslie Dacey *Office Manager*
Graham Daldry *Copywriter*
Philip Dalc *Director*
Pip Dale *Deputy Creative Director*
André Dammers *Copywriter*
Carly Damon *Creative*
Pru Daniels *Account Handler*
Senje Darbar *Art Director*
Peter Darrell *Film Director*
Ashted Dastor *Creative Director*
Andy Davey *Senior Partner/Founder*
Hannah David *Art Director*
Ian David *Art Director*
Andrew Davidson *Illustrator*
Glynn Scott Davidson *Art Director*
Tony Davidson *Creative Director*
Gill Davies *Design Director*
Hugh Davies *Copywriter*
Michael Davies *Creative*
Steve Davies *Design Director*
Tanya Davies *Designer*
Tivy Davies *Head of Typography*
Alan Davis *Art Director*
Oliver Davis *Composer*
Paul Davis *Creative Director*
Peter Davis *Creative Director*
Stephanie Davis *Graphic Designer*
Bill Davison *Programme Leader Graphic Communications*
Janice Davison *Design Director*
Anthony Dawson *Film Director*
Gary Dawson *Copywriter*
Neil Dawson *Art Director*
Nigel Dawson *Typographer*
Nigel Dawson *Creative Director*
James Dawton *Associate Director*
Derek Day *Head of International Creativity*
Michel de Boer *Designer/Partner*
Will De L'Ecluse *Designer*
Justin de Lavison *Illustrator/Image Manipulator*
Rea de Matas *Graphic Designer*
Johanna De Mornay Davies *Creative*
Kim De Paolis *European Marketing Manager*
Arnhel de Serra *Photographer*
Trevor De Silva *Copywriter*
Gerard de Thame *Director*
Ian Dean *Graphic Designer*
Robert Decleyn *Copywriter*
Kerry Deffley *Creative*
Leslie Dektor *Director*
Jonathan Del Gatto *Editor*
Elizabeta Delana *Vice President/Design Director*
Caspar Delaney *Producer/Joint Managing Director*
Gregory Delaney *Creative Director*
Paul Delaney *Creative Director*
Simon Delaney *Director*
Theo Delaney *Film Director*
Tim Delaney *Creative Director*
Alan Delgado *Senior Designer*
Stephen Dell *Director*
Alan Dempsey *Copywriter*
Mike Dempsey *Art Director*
David Denneen *Director*

Richard Denney *Art Director*
Emily Dennis *Editor*
Richard Dennison *Art Director*
Michael Denny *Director*
Jonathan Dent *Designer*
Mark Denton *Director*
Stephen Denton *Copywriter*
Gus Desbarats *Chairman*
Simon Devine *Senior Producer*
Martin Devlin *Partner*
Harriet Devoy *Creative Director*
Shaun Dew *Director*
Mark Dibsdall *Account Director*
Dan Dickenson *Producer*
Simon Dicketts *Creative Director*
Charles Dickins *Photographer*
Melissa Dickinson *Designer*
Kurt George Dieckert *Executive Creative Director*
Leslee Dillon *Copywriter/Owner*
Julian Diment *Managing Director*
Blackett Ditchburn *Chief Executive*
Paul Diver *Creative Director*
Peter Dixelius *Copywriter*
Gavin Dobbs *Writer*
Keith Dodds *Designer*
Patricia Doherty *Creative Director*
Vanessa Doherty *Vice President Consumer Marketing*
John Donnelly *Creative Director*
Christine Donnier-Valentin *Photographer*
Marty Donohue *Creative Director/Senior Vice President*
Sheila Donovan *Graphic Designer/Lecturer*
Elke Dossler *Graphic Designer/Art Director*
Lesley Dougal *Copywriter*
Blaise Douglas *Art Director*
Julian Douglas *Account Director*
Stuart Douglas *Senior Designer*
John Dowling *Senior Designer*
Terry Dowling *Postgraduate Studies*
Nick Downes *Art Director*
Jim Downie *Senior Art Director*
Sean Doyle *Senior Copywriter*
David Droga *Executive Creative Director*
James Drury *Creative*
Stephen Drysdale *Creative Group Head*
Ian Ducker *Creative Director*
Bruce Duckworth *Designer*
Sarah Dudley *Art Director*
Malcolm Duffy *Copywriter*
Mandy Duffy *Copywriter*
Belinda Duggan *Design Director*
Gert Dumbar *Designer*
Rob Duncan *Graphic Designer*
Dick Dunford *Creative Director*
Sara Dunlop *Director*
Laurence Dunmore *Director*
Edwina Dunn *Chief Executive Officer*
Iain Dunn *Director of Strategy*
Steve Dunn *Art Director*
Alexandra Dunstan *Art Director*
Marie-Catherine Dupuy *President in Charge of Creation*
Michael Durban *Art Director*
Pat Durkin *Copywriter*
Alan Dye *Graphic Designer*
Dave Dye *Art Director*
Antony Easton *Art Director*
Bryan Edmondson *Director*
Gerard Edmondson *Copywriter/Group Head*
Bronwen Edwards *Graphics Operations Director*
Ed Edwards *Copywriter*
Gareth Edwards *Sales Manager*
Garnet Edwards *Art Director*
Matt Edwards *Board Account Director*
Rhys Edwards *Art Director*
Steve Edwards *Art Director*
Lindsay Egmore-Frost *Group Account Director*
Steve Eichenbaum *Creative Director*
Kay Eichner *Creative Director*
Brian Eley *Executive Creative Director*
Jonathan Ellery *Creative Director*
Roberta Elliott *Senior Designer*
Simon Elliott *Creative Director*
Stephen Elliott *Creative Director*
Yan Elliott *Copywriter*
Adam Ellis *Designer*
Simon Elms *Composer*

John Elsom *Copywriter*
Kate Elson *Managing Director*
Philip C Ely *Creative Director*
Garry Emery *Design Director*
Gabby Emms *Senior Packaging Designer*
Nicola Engert *Graphic Designer*
Marion English *Design Director*
Michael English *Artist*
Nina Eriksen *Photographer*
Joseph Ernst *Creative*
Karl Escritt *Graphic Designer*
Simon Esterson *Designer*
Carolyn Evans *Creative*
Richard Evans *Art Director*
David Eveleigh Evans *Art Director*
Nathaniel Everard *Freelance Illustrator*
Kirsten Everett *Creative*
Michael Everett *Copywriter*
Tom Ewart *Art Director*
Uche Ezugwu *Copywriter*
Liz Faber *Creative Director*
Andy Fackrell *Art Director*
Mark Fairbanks *Creative*
Loraine Fajutag *Graphic Designer*
James Farnell *Associate Director*
Will Farquhar *Copywriter*
Gerry Farrell *Creative Director*
Jennifer Farrington *Art Director*
Mark Farrow *Designer*
Nick Farrow *Graphic Designer*
Jeff Faulkner *Creative Director*
Gary Fawcett *Art Director*
Neil Fazakerley *Copywriter*
Graham Featherstone *Art Director*
Paul Fella *Director*
Chris Felstead *Art Director*
Matthew Felstead *Editor*
Tim Fendley *Consultant Creative Director*
Verity Fenner *Art Director/Copywriter*
Paul Fenton *Head of TV*
Gavin Ferguson *Associate Director*
Shaun Fernandes *Creative Director*
Michelle Fever *Copywriter*
Mark Fiddes *Creative Partner*
Alan Field *Partner*
Sandy Field *Graphic Designer*
Isabel Fielden-Smith *Creative*
Paul Fielding *Managing Director*
Paul Filby *Interactive Art Director*
Joylon Finch *Art Director*
Kathryn Findlay *Director*
Graham Fink *Creative Partner*
Gail Finlayson *Graphic Design*
Nick Finney *Director*
Robert Fippard *Graphic Designer*
Kate Fishenden *Director of Brand Expression*
Andrew Fisher *Copywriter*
Paul Fishlock *Creative Director*
Rodney Fitch CBE *Chairman/Chief Executive*
Richard Fitton *Art Director*
Will Flack *Creative*
Julian Flanagan *Copywriter*
Fergus Fleming *Senior Art Director*
Alan Fletcher *Designer*
David Fletcher *Designer*
Howard Fletcher *Writer*
Rob Fletcher *Creative Director*
Victoria Fletcher *Graphic Designer*
Alex Flint *Senior Copywriter*
Richard Flintham *Art Director*
Sarah Flower *Brand Manager*
Adrian Flowers *Photographer*
Nicholas Flugge *Art Director/Copywriter*
Michael Foden *Copywriter*
Matt Follows *Copywriter*
Mark Fong *Creative Director*
Brett Foraker *Creative Director*
Dean Ford *Director*
Jonathan Ford *Creative Partner*
Lee Ford *Art Director*
Nicole Forster *Designer*
Max Forsythe *Photographer*
John Foster *Art Director*
Laura Foster *Creative*
Nigel Foster *Producer*
Rebecca Foster *Graphic Designer*
Richard Foster *Copywriter*
Nancy Fouts *Director*
Jon Fox *Copywriter*
John Fragomeni *Editor/Post Supervisor*
Joseph Fraine *Copywriter*
Alan Frame *Creative Director*
Cliff Francis *Executive Creative Director*

Katie Francis *Video Commissioner*
Dorothee Frank *Designer*
Simon Frank *Creative Director*
Elizabeth Franklin *Copywriter*
Stephen Franks *Director*
Dominic Frary *Senior Designer*
Andrew Fraser *Copywriter*
Paul Fraser *Copywriter*
Eddy French *Film Editor*
John French *Partner*
Piero Frescobaldi *Director/Producer*
Jason Fretwell *Senior Creative*
Heiko Freyland *Copywriter*
Jane Frost *Controller Corporate Marketing*
Vince Frost *Creative Director*
James Fryer *Copywriter*
David Fudger *Tutor*
Naoto Fukasawa *Designer*
Jane Fuller *Managing Director/Executive Producer*
Sarah Fullerton *Designer*
Res Furling *Designer*
Javier Furones Ambit *Art Director*
Bill Gallacher *Creative Director*
Charles Gallichan *Head of Advertising*
Juan Gallo *Managing Director*
Matthew Galvin *Illustrator*
Steve Gandolfi *Editor*
Mark Gandy *Client Services Director*
Annie Gardener *Managing Partner*
David Gardiner *Photographers Agent*
David Gardiner *Creative Director*
Antonio Gardoni *Director*
Surrey Garland *Head of Copy*
Jeremy Garner *Creative Director*
Malcolm Garrett *Chairman*
Paul Garrett *Creative Director*
Tim Garth *Copywriter*
Robin Garton *Copywriter*
Stephen Gash *Managing Director*
Malcolm Gaskin *Creative Director*
Peter Gatley *Art Director*
Charlie Gatsky *TV Producer*
Xavier Gauderlot *Consumer Marketing Manager*
Stephen Gaull *Design Manager*
Peter Gausis *Art Director*
Matt Gee *Executive Producer*
Kim Gehrig *Art Director*
Nick Gentry *Director*
David George *Creative Director*
Harry Georgiades *Art Director*
Dan Germain *Copywriter*
Dominic Gettins *Deputy Creative Director*
Aftab Gharda *Head of School/Undergraduate Studies*
Kate Gibb *Screenprinter*
Peter Gibb *Creative Director*
Steve Gibbons *Design Director*
Grant Gibson *Designer/Art Director*
Luke Gifford *Graphic Designer*
Ed Gill *Director*
Slade Bourbon Gill *Copywriter*
Stuart Gill *Executive Creative Director*
Craig Gillespie *Commercials Director*
Barry Gillibrand *Creative Director*
Dexter Ginn *Art Director*
Marco Giusti *Producer*
Joe Glasman *Composer*
Felix Glauner *Executive Creative Director*
Gill Glendinning *Copywriter*
Sunita Gloster *Business Development Director*
Ian Glover *Designer*
Nigel Glynn-Davies *Sound Designer*
David Godfree *Art Director*
Lexi Godfrey *Executive Producer*
Neil Godfrey *Art Director*
Jo Godman *Managing Director*
Bonnie Goldfarb *Executive Producer*
Tony Golding *Managing Director*
Jonathan Goldstein *Composer*
Adrian Goldthorpe *Account Director*
Rennie Gomes *Managing Director*
Michael Gonclaves *Creative*
Grace Goni *Creative Director*
Bill Goodenough *Group Executive Deputy Chairman*
Colin Goodhew *Graphic Designer*
Mark Goodwin *Copywriter*

Anna Goodyear *Creative*
Stuart Gordon *Animation/Director*
Michael Gore *Creative Director*
Paul Gore *Director*
Natalie Gorf *Creative*
Andrew Gorman *Creative Director*
Matthew Gough *Soundwriter*
Carl Gover *Executive Producer*
Elizabeth Gower *Managing Director*
Gerry Graf *Executive Vice President/Executive Creative Director*
Regan Grafton *Art Director*
Gordon Graham *Senior Copywriter*
James Graham *Account Director*
Karen Graham *Creative*
Mark Graham *Graphic Designer*
Alan Grainger *Photographer*
Nigel Grasham *Marketing Director*
Helen Gray *Illustrator*
Nigel Gray *Creative Director*
Paul Gray *Designer*
Sarah Gray *Head of Marketing*
Susie Gray *Account Director*
Cathy Green *Joint Managing Director*
Jerry Green *Deputy Chairman*
Malcolm Green *Creative Director*
Matthew Green *Creative*
Robin Green *Art Director*
Ross Green *Concept Designer*
Simon Green *Commercial Director*
Stephen Greenberg *Creative Director*
Howard Greenhalgh *Director*
Jon Greenhalgh *Director*
Michael Greenlees *President*
Paul Greeno *Freelance Designer*
Eddy Greenwood *Art Director*
Faye Greenwood *Production Assistant*
Mark Greenwood *Art Director*
Laura Gregory *Executive Producer*
Caroline Greville-Morris *Production Designer*
Adam Griffin *Copywriter*
Michael Griffin *Producer*
Mick Griffin *Partner/Editor*
Simon Griffin *Copywriter*
Chris Griffiths *Creative*
Joanne Griffiths *Creative*
Oscar Grillo *Animation/Director*
Martin Grimer *Creative Director*
Lol Grinter *Creative Director*
Chris Groom *Art Director*
Stephen Grounds *Executive Creative Director*
Paul Grubb *Creative Director*
Peter Grundy *Partner*
Roger Gual *Art Director/Film Director*
Angel Guerrero *Business Unit Director*
David Guerrero *Chairman & Executive Creative Director*
Mauricio Guimaraes *Director*
Andy Gulliman *TV Producer*
Nick Gutfreund *Group Managing Director*
Fernando Gutiérrez *Partner*
Zlatko Haban *Architect/Designer*
Dennis Hackett *Editor*
John Hackney *Managing Director/Producer*
Helen Hadfield *Producer*
David Hadley *Creative*
Roland Hafenrichter *Creative Director*
Karen Hagemann *Art Director*
Graeme Haig *Creative*
Bruce Haines *Chief Executive Officer*
Jeremy Haines *Creative Partner*
Alistair Hall *Graphic Designer*
Jess Hall *Director of Photography*
Jonathan Hall *Art Director*
Melissa Hall *Creative Services Assistant*
Robin Hall *Designer*
Sarah Hallatt *Agency Producer*
Siggi Halling *Copywriter*
Clem Halpin *Design Director*
Geoff Halpin *Creative Director*
Stuart Hamilton *Photographer*
Vivienne Hamilton *Wordsmith*
Warren Hamilton *Director/Sound Engineer*
Garrick Hamm *Creative Director*
Andrea Hammond *Account Director*
Edward Hammond *Draughtsman*
Simon Handford *Senior Copywriter*

Andrew Hands *Creative*
Martin Handyside *Partner*
Mike Hannett *Art Director*
Maria Hanson *Designer*
Nicholas Hanson *Director*
Nick Hanson *Creative Director*
Bryan Harber *Sales Director*
George Hardie *Designer/Illustrator*
Ian Harding *Creative Director*
Chips Hardy *Copywriter*
Peter Hardy *Copywriter*
Paul Hargreaves *Art Director*
Liz Harold *Career Consultant*
Shaw Harper *Creative Director*
Justin Harpham *Senior Designer*
Wim Harrington *Joint Creative Partner*
Anson Harris *Copywriter*
David Harris *Creative Partner*
John Harris *Creative Partner*
Matthew Harris *Designer*
Mike Harris *Art Director*
Richard Harris *Creative*
Tony Harris *Creative Director*
Adrian Piers Harrison *Managing Director*
Barbara Harrison *Principal*
David Harrison *Creative Consultant*
Glenn Harrison *Creative Director*
Iain Harrison *Copywriter*
Jerry Harrison *Partner/Creative Director*
Ina Harsch *Graphic Designer*
Simon Harsent *Photographer*
Antony Hart *Graphic Designer*
Richard Hart *Creative Director*
Kim Hartley *Design Director*
Kiki Hartmann *Creative Director*
Chris Hartwill *Director*
Mark Harwood *Photographer*
Laurence Haskell *Photographer*
Derrick Hass *Art Director*
Dean Hastie *Design Director*
Lisa Hastings *Creative*
Nick Hastings *Executive Creative Director*
Lionel Hatch *Creative Director*
John Hatfield *Technical Director*
Anna Hawley *Director*
James Haworth *Director*
Ian Hay *Designer*
Richard Haydon *Art Director*
Adam Hayes *Creative*
Martyn Hayes *Design Director*
Thomas Hayo *Group Creative Director*
Antonia Hayward *Design Director*
Richard Haywood *Designer*
Tim Hazeal *Photographer*
Anthony Head *Designer*
Jamie Heap *Creative*
John Heaps *Chairman*
Ted Heath *Copywriter*
Alex Heathcote *Producer*
Sam Hecht *Industrial Designer*
Tony Hector *Art Director*
Antje Hedde *Art Director/Designer*
Neil Hedger *Designer*
John Hegarty *Creative Director*
Alan Heighton *Illustrator*
Knut Helgeland *Creative Manager*
David Helps *Board Creative Director*
David Henderson *Copywriter*
Ian Henderson *Creative Director*
Sue Hendrikz *Account Manager*
Cathy Heng *Art Director*
Yik See Heng *Graphic Designer*
Kim Henley *Copywriter*
David Hensley *Director of Consulting*
Camilla Herberstein *Art Director*
Kevin Herman *Senior Designer*
Robert Herman *Head of Production*
Christian Hermansen *Art Director*
Bob Heron *Copywriter*
Steven Hess *Partner*
Margie Hetherington *Designer*
Richard Hewis *Graphic Designer*
Annabel Hewitt *Senior Account Director*
Jerry Hibbert *Animation Director*
Clare Hieatt *Senior Copywriter*
Sue Higgs *Copywriter*
Jane Hilder *Designer*
Kevin Hill *Designer*
Peter John Hill *Creative*
Robert Hillier *Senior Lecturer*
Aaron Hinchion *Typographer*

Nik Hindson *Film Editor*
Nick Hine *Art Director*
Andrew Hirniak *Director*
Clifford Hiscock *Creative Director*
Paul Hiscock *Designer*
David Hobbs *Art Director*
Peter Hobden *Creative Director*
Jamie Hobson *Lecturer*
Nicholas Hockley *Designer*
Derek Hodgetts *Copywriter*
Maggie Hodgetts *Head of Graphic Design*
Paul Hodgkinson *Creative Group Head*
Ovind Hoel *Designer*
Justin Hogbin *Account Director*
Jocelyn Hogg *Photographer*
Ken Hoggins *Joint Executive Creative Director*
Andrew Holden *Creative Group Head*
John Holden *Photographer*
Paul Holden *Creative Director*
Ruth Holden *Designer*
Roger Holdsworth *Copywriter*
Mike Holland *Product Designer*
Jerry Hollens *Deputy Creative Director*
Jon Hollis *Flame Artist/Director*
Johan Holm *Creative*
Adrian Holmes *Creative Director*
David Holmes *Designer/Art Director*
Kevin Holmes *Corporate Design Manager*
Tim Holmes *Design Director*
Andrew Holt *Account Manager*
Gary Holt *Executive Creative Director*
Adam Holtrop *Copywriter*
Anna-Marie Holub *Creative*
Sookyung Hong *Graphic Designer/Illustrator*
Steve Hooper *Copywriter*
Sam Hope *Producer*
Duncan Horn *Flame Artist*
Melissa Horn *Account Director*
Andrew Horner *Director of Photography*
John Horner *Managing Director*
Michael Horseman *Director*
Bonnie Horton *Creative*
Charlotte Horton *Creative*
Greg Horton *Creative Director*
John Horton *Art Director*
Lauren Horton *Art Director*
Suza Horvat *Producer*
Jim Hosking *Director*
Keren House *Creative Director*
Mark Howard *Art Director*
Stewart Howard *Creative Director*
Gareth Howat *Partner*
Alun Howell *Copywriter*
Gareth Thomas Howells *Art Director*
David Howlett *Designer*
Adam Howling *Illustrator*
Adam Hoyle *Interactive Designer*
Joe Hoza *Typographer*
Kay-Lu Hsiung *Executive Producer*
Ean-Hwa Huang *Executive Creative Director*
Dean Hudson *Creative*
Tom Hudson *Senior Copywriter*
Sabrina Huffman *Editor*
David Hughes *Illustrator/Author*
Graham Hughes *Photographer*
Gerry Human *Creative Director*
Colin Hume *Managing Director*
Barrie Hunt *Creative Director*
Simon Hunt *Group Creative Director*
Andrew Lorimer Hunter *Creative Director*
Jimmy Hunter *Creative Director*
Mark Hunter *Copywriter*
Mike Hurst *Director of Creative Services*
Dingus Hussey *Graphic Designer*
Nick Hussey-McKnight *Project Director*
Iain M Hutchinson *Designer*
Craig Hutton *Design Director*
Mark Hutton *Senior Graphic Designer*
Matthew Iles *Creative*
Sarah Ilsley *Studio Manager*
Shinichi Imanaka *Illustrator*
Christopher Impey *Photographer*
Charles Inge *Creative Director*

Neame Ingram *Creative*
Mark Iremonger *Producer*
Baz Irvine *Lighting Cameraman*
Richard Irvine *Managing Director*
Richard Irvine *Managing Director*
Richard Irving *Head of Art/Creative Partner*
Bob Isherwood *Creative Director*
Izmee Ismail *Managing Director*
Jonathan Ive *Vice President Industrial Design*
Rob Jack *Copywriter*
Craig Jackson *Senior Copywriter*
Frances Jackson *Partner*
Paula Jackson *Copywriter*
Joji Jacob *Copywriter*
Agathe Jacquillat *Graphic Designer*
David James *Photographer*
Ross Jameson *Copywriter*
Michele Jannuzzi *Director*
Rob Janowski *Copywriter*
Ann Jaques *Art Director*
Leon Jaume *Executive Creative Director*
Kenneth Jaworski *Director*
Victoria Jebens *Managing Director*
David Jeffers *Managing Director*
Adrian Jeffery *Creative Partner*
Adam Jenkins *Editor*
Nina Catherine Jenkins *Creative Director*
Tom Jenkins *Creative Director*
Dave Jenner *Typographer*
David Martin Jennings *Copywriter*
Andy Jex *Art Director*
Armin Jochum *Creative Director*
Jonathan John *Copywriter*
Simon John *Design Director*
Andy Johns *Art Director*
Chris Johnson *Creative*
Hugh Johnson *Proprietor*
Michael Johnson *Creative Director*
Richard Johnson *Associate Creative Director*
Stephen Johnson *Creative Director*
Derek Johnston *Creative Director*
Matthew Joiner *Creative*
Barrie Joll *Commercials Director*
Alex Jones *Designer*
Bryn Jones *Designer/Lecturer*
Cindy Jones *Director*
Colin Jones *Art Director*
David Jones *Director*
David Jones *Creative Director*
Edward Jones *Copywriter*
Marc Jones *Graphic Designer*
Penny Jones *Designer*
Phil Jones *Vice Chairman*
Steve Jones *Senior Creative*
Yannakis Jones *Art Director/Copywriter*
Ewan Jones-Morris *Photographer*
Simon Jordan *Director*
Michael Joseph *Photographer*
James Joyce *Graphic Designer*
Jane Joyce *TV Producer*
James Judge *Artworker*
Jerry Judge *Managing Director*
Alexandra Jugovic *Creative Director*
Barbara Jung *Illustrator*
Maria Kallis *Designer*
Satoshi Kambayashi *Illustrator*
Charles Kane *Copywriter*
Stephen Kane *Graphic Designer*
Esther Kaposi *Communication Consultant*
Angela Katsapas *Art Director*
Asuka Kawabata *Designer*
Darren Kay *Creative Director*
Gareth Kay *Planner*
Shauna Kealy *Graphic Designer*
Adam Kean *Creative Director*
Jacqui Kean *Brand Marketing Manager*
Nik Keane *Global Account Director*
Rebecca Keast *Creative*
Jamie Keenan *Designer*
Gavin Kellett *Copywriter*
John Kelley *Executive Creative Director*
Sabina Kelly *Graphic Designer*
Steve Kelsey *Designer*
Steve Kelynack *Head of Creative*
Paul Kemp *Copywriter*
Paul Kemp-Robertson *Director of Corporate Communications*
Matthew Kemsley *Head of Design*
Canna Kendall *Headhunter*
Ingvar Kenne *Photographer*
Iain Kennedy *Global Brand Director*

Mark Kennedy *System Operator*
Richard Kennedy *Typographer*
Roger Kennedy *Director of Typography & Design*
Roger Kennedy *Head of Typography*
Simon Kershaw *Creative Director*
Robert Kerwin *Brand Director*
Barry Kettlewell *Design Director*
Jeffrey Keyton *Vice President Design/Off Air Creative*
Tham Khai Meng *Regional Creative Director*
Sanjay Khare *Creative Director*
Phoa Kia Boon *Designer*
Rick Kieswetter *Copywriter*
Paul Kilvington *Brand Architect*
Jung Wong Kim *Designer*
Paul King *Chairman/Design Director*
Tom Kinsella *Head of Advertising*
Barry Kinsman *Director*
Rodney Kinsman *Art Director*
Joanne Kirby *Art Director*
Margaret Kirby *Managing Director*
Janice Kirkpatrick *Director*
Ken Kirkwood *Photographer*
Nathan Kirkwood *Designer*
Robert Kitchen *Creative Director*
Matthew Kitchin *Producer*
Philip James Kitching *Art Director*
Alan Kitching RDI, *AGI Typographic Artist*
Daniel Kleinman *Director*
Nick Klinkert *Art Director*
Kevin Kneale *Copywriter*
Jonathan Kneebone *Co-Creative Director*
Kieran Knight *Copywriter*
Lydia Knights *Designer*
Jonathan Knowles *Photographer*
Claus Koch *Managing Director*
Anne Kohlerman *Graphic Designer*
Franka Kojundzic *Illustrator*
Piers Komlosy *Copywriter/Art Director*
Sasha Kosevic *Art Director*
Joanna Kotas *Multimedia Designer*
Dennis Koutoulogenis *Copywriter*
Denis Kovac
Richard Krabbendam *Copy Director*
Delle Krause *Executive Creative Director*
Jason Kremer *Producer*
Henrik Kubel *New Media Designer*
Beate Kubitz *Head of Training & Communications*
Anna Kulikowski *Senior Graphic Designer*
Yu Kung *Art Director*
Bon Kwan *Design Consultant*
Ray Kyte *Design Director*
Yvette Lacy *Creative Director*
Shawn Lacy-Tessaro *Executive Producer*
Mei Kit Lai *Senior Account Executive*
Alyn Lambert *Designer*
Becky Lambert *Publishing Manager*
Benjamin Lambert *Industrial Designer*
David Lambert *Photographers Agent*
Martin Lambie-Nairn *Designer*
Victoria Lamburn *Marketing Executive*
Alex Lampe *Designer*
Neil Lancaster *Copywriter*
Andrew Lang *Product Designer*
Sue Lang *TV Producer*
Joss Langford *Consultant*
Kristina Brigitte Langhein *Designer*
Suzanne Langley *Senior Designer*
Allen Langlois *Managing Director*
Sue Lashbrooke *Account Director*
Barry Lategan *Photographer*
Liza Lau *Graphic Design*
Nathan Usmar Lauder *Creative Director*
Lucilla Lavender *Designer*
Paul Lavoie *President/Creative Director*
Beverly Law *Copywriter*
David Law *Senior Designer*
Shem Law *Design Director*
Jason Lawes *Senior Art Director*
Bruce Lawley *Copywriter*
Peter Lawlor *Composer*

Amanda Lawrence *Designer*
Andy Lawson *Head of Art*
Ryan Lawson *Copywriter*
Carl Le Blond *Creative Director*
Tanya Le Sieur *Producer*
Aaron Lear *Designer/Art Director*
Richard Learoyd *Film Editor*
Mark Leary *Photographer*
Diane Leaver *Copywriter*
Geoff Leavold *Copywriter*
Bill Ledger *Illustrator*
Boyoung Lee *Art Director*
Harvey Lee *Art Director*
Lester Po Fun Lee *Photographer*
Richard Lee *Designer*
Szu Hung Lee *Creative Director*
Stephen Legate *Typographer*
Adrianne LeMan
Managing Director
Richard Lemon *Art Director*
Nils Leonard
Typographer/Ad Designer
Edwin Leong *Creative Director*
Jeremy Leslie *Creative Director*
Timothy Leslie-Smith
Graphic Designer
James Lewis *Director*
Mary Lewis *Creative Director*
Viviane Li *Designer*
Shih How Liew *Art Director*
Heidi Lightfoot *Director*
David Lightman
Agency Account Handler
Sami Lill *Creative*
Jon Lilley *Copywriter*
Adrian Lim *Copywriter*
Renee Lim
Associate Creative Director
Ron Lim *Art Director*
Graham Lincoln *Creative Partner*
Andrew Lindsay *Creative Director*
Gavin Lindsay *Model Maker*
Tim Lindsay *Managing Director*
Dave Linne *Creative Director*
Domenic Lippa *Director*
Rami Lippa *Creative Director*
James Lipscomb *Designer*
Tony Liston *Creative Director*
Peter Little *Copywriter*
Steve Little *Copywriter*
John Lloyd *Creative Director*
Jim Lobley *Art Director*
David Lock *Managing Director*
Linda Loe *Designer*
Nick Lofting *Film Editor*
Edward Loh *Managing Director*
Julia Lohmann *Designer*
Mike London *Art Director*
Steven Loong *Copywriter*
Martin Loraine *Copywriter*
Martin Lore *Designer*
Peter Lorimer *Writer*
Deborah Loth *Creative Director*
Clint Lovell *Graphic Designer*
Patrick Low
Executive Creative Director
David Lowe *Music Composer*
Matthew Lowe *Creative Director*
Chris Lower *Creative Director*
James Lowther
Creative Director/Chairman
James Loxley *Writer*
Stuart John Lugg *Photographer*
Bo Lundberg *Illustrator*
Stein Lundberg *Art Director*
Markéta Luskacová *Photographer*
Sophie Lutman *Designer*
David Lyle *Chief Executive*
Andrea MacArthur
Managing Director/Editor
Rob MacDonald *Creative Director*
Paula MacFarlane *Design Director*
Shona Maciver *Director*
Ken Mackay *Director*
Holly Mackenzie *Assistant
Broadcast Director*
David Mackersey *Art Director*
Clare Mackie *Freelance Illustrator*
Camilla Mackintosh
Recruitment Consultant
Chris MacLean *Sound Engineer*
Kevin MacMillan *Art Director*
Farrokh Madon *Senior Writer*
Pier Madonia *Art Director*
David Magee *Creative Director*
Tim Maguire *TV Producer*
Vicki Maguire *Copywriter*
Mick Mahoney *Creative Director*
Simon Maidment
Design Consultant
Oliver Maisey *Creative Director*
Ivica Maksimovic *Creative Director*
Kate Male *Head of Television*

Lyndon Mallet *Director/Copywriter*
Andreas Malm *Art Director*
Simon Manchipp
Design Director/Founder
Tim Mann *Graphic Designer*
Todd Mannes
Senior Graphic Designer
Cara Mannion *Graphic Designer*
Thomas Manss
Art Director/Proprietor
Paul Marangos
Senior Henry Editor (2D)
Alex Maranzano *Designer*
Alfredo Marcantonio *Copywriter*
Pearce Marchbank *Designer*
Andy Margetson *Director*
Pedro Marin-Guzman
Creative Director
Javier Mariscal *Designer*
Fiona Marks *TV Producer*
John Marles *Director*
Colin Marr *Creative Director*
Andrew Marsden
Marketing Director
Laura Marsden *Creative*
Alan Marsh *Photographer*
Giles Marsh *Creative*
Ann Marshall *Designer*
Guy Marshall *Graphic Designer*
Jamie Marshall *Creative*
Jill Marshall *Managing Director –
Branding & Packaging*
Jason Martell *Product Designer*
Amanda Martin *Managing Director*
Greg Martin *Creative Director*
Paul Martin *Designer*
Richard Martin *Sound Engineer*
Natalia Martin Esteve *Copywriter*
George Martino
Managing Director
David Mason *Director*
Perry Mason *Creative*
Stephanie Mason *Creative*
Paul Massey *Photographer*
Dave Masterman *Art Director*
Rhian Mathias *Graphic Designer*
Charles Mawer *Creative Director*
Billy Mawhinney *Creative Director*
Stephen Mawhinney *Art Director*
Andrew Maxwell *Art Director*
Peter Maxwell *Project Architect*
David May *Art Director*
Sigi Mayer *Creative Director*
Melonie Maynard *Design Director*
David Mayo
Regional Management Supervisor
Douglas McArthur OBE
Chief Executive
Ian McAteer *Managing Director*
Brian McCabe *Art Director*
Graham McCallum
Creative Director
Enda McCarthy *Account Director*
Patrick McClelland *Copywriter*
Nicola McClements
Graphic Designer
Mark McConnachie *Designer*
Vicki McConnel *Creative*
John McConnell *Director*
Dan McCormack
Art Director/Copywriter
James McCormick
Junior Art Director
Alex McCuaig *Creative Director*
Eilidh McDonald *Creative*
Gavin McDonald *Art Director*
Louise McDonnell *Director*
Vincent McEvoy *Head of Art*
Sarah McGibbon
Freelance Photographer
Richard James McGillan *Director*
Brian McGregor *Art Director*
Andrew McGuinness
Creative Director/Copywriter
Shaughn McGurk *Senior Designer*
Shaun McIlrath
Executive Creative Director
Ian McIlroy *Design Director*
Lynne McIntosh *Graphic
Designer/Typographer*
Adrian McKay *Design Director*
Andy McKay *Head of Art*
Bruce McKelvie *Head of Television*
Bruce McKenna *Editor*
Mike McKenna *Senior Copywriter*
Paul McKenzie *Creative*
Kris McKnight *Graphic Designer*
Andy McLeod *Creative Director*
Paul McLoughlin *Senior Designer*
John McManus *Film Editor*
Brigid McMullen *Partner/Designer*
Kirsten McNally *Account Director*
Danielle McNeill *Creative*

Stuart McReath *Illustrator*
Tony McTear *Art Director*
Philip McVicar *Art Director*
Jonny Meakin *Illustrator*
Tim Mellors
Chairman/Creative Director
Jack Melville *Creative Director*
Bruce Menzie *Copywriter*
Jeff Merrells
Director of Typography
David Merrifield
Graphic Design Consultant
John Merriman
Executive Creative Director
Jason Merry *Graphic Designer*
Robert Messeter *Art Director*
John Messum *Art Director*
Janos Meszaros *Consultant*
Philip Metson *Design Director*
Costas Michalia *Creative Director*
Mike Middleton *Art Director*
Michael Mieke
Director of Photography
Allison Miguel *Creative Consultant*
Marcia Mihotich *Graphic Designer*
Ruan Milborrow *Creative Director*
Greg Milbourne *Art Director*
David Miles *Treasurer*
Jeremy Miles *Chairman*
Brian Michael Millar
Creative Director
Bertie Miller *Managing Director*
Chris Miller *Copywriter*
Kathy Miller *Designer*
Polly Miller *Art Director*
Quenton Miller *Art Director*
Rodney Miller *Partner*
Graham Mills *Creative Director*
Greg Mills *Producer*
Colin Millward *Creative Director*
James Milne *Product Designer*
Howard Milton *Designer*
Marcello M Minale Jnr
Creative Director
Manisha Mistry *Graphic Designer*
Zubin Mistry
Director Of Photography
Alex Mitchell *Illustrator*
Chris Mitchell *Illustrator*
Greg Mitchell *Art Director*
Peter Mitchell *Managing Director*
Richard Mitzman *Designer*
Takeshi Mizukawa
Interactive Director
Samir Modi *Vice Chairman*
Nick Moffatt *Art Director*
Gerry Moira
Executive Creative Director
Tim Molloy *Head of Design*
Stuart Money *Designer*
Dave Monk *Art
Director/Copywriter*
Neil Monk *Director*
Seshan Moodley *Group Head*
Ben Mooge *Creative*
Janette Mooney *Creative Director*
Simon Mooney *Photographer*
Tom Mooney
Partner/Executive Producer
Wendy Moorcroft *Copywriter*
Jo Moore *Copywriter*
Joe Moore
Senior Graphic Designer
Nick Moore *Creative Director*
Phil Moore *Creative Director*
Timothy Moore *Designer*
Andy Morahan *Director*
Ciprian Morar *Designer*
William Morden *Executive Vice
President/Chief Creative Officer*
Karen Morgan *Designer*
Henry Morland *Creative Director*
David Morley *Partner*
Matt Morley Brown
Joint Creative Director
Alan Morrice *Creative Director*
Claire Morris *Interactive Designer*
David Morris *Designer*
Debbie Morris *Creative Director*
Ed Morris *Partner*
James Morris *Photographer*
Kevin Morris *Copywriter*
Nick Morris *Joint Managing
Director/Owner*
Robert Morris *Art Director*
Simon Morris *Head of Art*
Brian Morrow *Director*
Alice Morton *Creative*
Rocky Morton *Director*
Andy Mosley *Graphic Designer*
Stephen Moss *Copywriter*
Dan Moth *Copywriter*
Zak Mroueh *Copywriter*

Todd Mueller *Creative Director*
Chris Muir *Copywriter*
Willem Mulder *Creative Director*
Damian Mullan *Design Director*
Ken Mullen *Copywriter*
Tom Mulvee *Photographer*
Isla Munro *Product Designer*
Tony Muranka
Advertising Creative Independent
Andrew Murdoch *Copywriter*
John Murphy *Composer*
Patricia Murphy *Film Director*
Richard Murray *Director*
Robin Murtough *Copywriter*
Alexander Musson
Design Director
Pam Myers *Director*
Richard Myers *Vice Chairman*
Bob Mytton *Director*
Subha Shiva Naidu *Art Director*
Minaz Nanji *Designer*
Ovais Naqvi *Group Director*
Stephanie Nash *Designer*
Betsy Nathane
Associate Creative Director
Janet Neil *Design Director*
Thomas Neish *Designer*
Dan Nelson *Film Editor*
Joseph Nelson *Designer*
Arun Nemali *Copywriter*
Marty Neumeier *President*
Quentin Newark *Designer*
Betsy Ng *Senior Copywriter*
Joanne Ng *Copywriter*
Robin Nicholas *Head Typography*
Steve Nicholls *Copywriter*
Lisa Nichols *Writer*
Amy Nicholson *Creative Director*
Mike Nicholson *Copywriter*
Dorte Nielsen *Art Director*
Kate Nielsen *Creative Director*
Rob Nielsen *Art Director*
Mark Nightingale *Art Director*
Catherine Nilsson *Typographer*
Colin Nimik *Copywriter*
Catherine Nishan *Photographer*
Chuck Nobles *Principal*
Barbara Nokes *Creative
Advertising Consultant*
Roger Nokes *Creative Director*
Eoghan Nolan *Creative Director*
Margaret Nolan *Creative Director*
Matt Noonan
Producer/Managing Director
Stina Nordquist *Designer*
Susanne Norman
Production Co-ordinator
Alex Normanton *Graphic Designer*
Mehdi Norowzian *Director*
Emma Norrie *Creative*
Daniel Norris *Creative*
James North *Copywriter*
Simon North
Client Services Director
Tilly Northedge *Designer*
Jim Northover *Vice Chairman*
Graeme Norways *Art Director*
Tom Notman *Art Director*
Adrian Nunn *Creative Director*
Daniela Nunzi *Designer*
Timothy O'Brien *Creative Director*
Vikki O'Connor *Account Director*
Daniel O'Donoghue *Worldwide
Director of Strategic Planning*
Gerard O'Dwyer *Creative Director*
Ciaran CC O'Hagan *Researcher*
John O'Keefe *Creative Director*
Steve O'Leary *Designer*
Kate O'Mulloy *Head of Television*
John Anthony O'Reilly *Writer*
Chris O'Shea
Executive Creative Director
John O'Sullivan *Creative Director*
Michael O'Sullivan
Creative Director
Patrick O'Sullivan
Managing Director
Ramiro Oblitas *Designer*
Chris Oddy *Art Director*
Barbro Ohlson
Head of Graphic Design
Lena Ohlsson *Creative*
Catherine Ojakovoh *Consultant*
Rebecca Oliver *Director*
Robert Oliver *Art Director*
Sam Oliver *Creative*
Phil Olsen *Creative*
James Oneill *Designer*
Fabio Ongarato *Creative Director*
Jeff Orr *Executive
Creative Director*
Richardnew Orrick *Film Editor*
Mark Osborn

Creative Services Director
Deborah Osborne
Graphic Designer
Mark Osborne *Art Director*
Tom Osbourne *Art
Director/Copywriter*
Kate Owen *Film Editor*
Garry Owens *Photographer*
Jaqueline Owers *Senior Designer*
Michael Oxberry
Senior Art Director
Ines Pach *Designer*
Ronald Packman *Director*
Gurjeet Padam *Art Director*
Mark Padfield *Art Director*
Alan Page *Creative Director*
John Pallant
Executive Creative Director
Chris Palmer *Creative Director*
Russel Palmer *Creative*
Chantal Panozzo *Copywriter*
Stuart Pantoll *Creative*
Simon Panton *Creative Partner*
Kim Papworth *Creative Director*
Ronnie Paris *Music Composer*
Malcolm Park *Designer*
Alan Parker *Director*
Brad Parker *Animation Supervisor*
Grant Parker *Art Director*
John Parker *Photographer*
Philip Parker *Publishing Manager*
Kim Parrett *Senior TV Producer*
Mike Parsons *Photographer*
Nick Parton *Art Director*
John Pasche *Creative Director*
Stephen Paskin *Creative Director*
Daniel Patching *Designer*
Peakash Patel *Graphic
Designer/Animator*
Shishir Patel *Creative*
Ewan Paterson *Copywriter*
Neil Patterson *Creative Partner*
Nicholas Pauley
Managing/Creative
Kate Paull *Creative*
Derek Payne *Copywriter*
Geoff Payne *Film Editor*
Arnold Pearce *Executive Producer*
David Pearce *Managing Director*
Harry Pearce *Director*
Jack Pearce *Creative Director*
Mark Pearce *Creative Director*
Alex Pearl *Copywriter*
John Pearson-Taylor
Creative Director
Tim Peckett *Creative Director*
Matthew Peckham *Writer*
Reggie Pedro *Painter/Illustrator*
Shaheed Peera *Art Director*
Nicholas Peers *TV Producer*
Simon Pemberton
Creative Partner
Simon Pemberton *Illustrator*
Robert Pendar-Hughes
Director of Photography
Wayne Peng *Film Director*
Tommy Penton *Illustrator*
Joanna Perry *Copywriter*
Oliver Perry *Copywriter*
Scott Perry *Copywriter*
Lina Persson *Photographer*
Lorens Persson *Sound
Designer/Engineer*
Suthon Petchsuwan *Director*
Nick Peters *General Manager*
Michael Peters OBE *Chairman*
Alex Peterson
Website/Graphic Designer
Tor Pettersen *Designer*
Bob Pettis *Partner*
James Phelan *Director*
Steve Philpott *Marketing Director*
Mark Phippen *Graphic Designer*
Barnaby Pickard *Creative*
Clive Pickering *Copywriter*
John Pickering
Designer/Photographer
Theo Pike *Writer*
Steve Pini *Film Editor*
Michéle Katherine Pithey
Copywriter
Christopher Pitt *Corporate Writer*
Donna Pittman *Designer/Director*
Robert Plant *Creative*
Nicholas Platt *Creative Director*
Mandy Plumb *Marketing Manager*
David Pocknell *Principal*
Spiros Politis *Photographer*
Jane Pollard *Design Manager*
Jason Pollard
Director of Retail Strategy
Jeanna Polley *Producer*
Nicholas Pollitt *Director*

Jake Polonsky
Director of Photography
Aziyade Poltier-Mutal *Special
Events Manager*
Jay Pond-Jones *Creative Director*
Russell Porcas *Photographer*
Simon Porteous *Designer*
Nick Portet
Group Creative Director
Emily Portnoi *Writer*
Carol Potter
Global Business Director
Michael Potter *Managing Director*
Rob Potts *Copywriter*
Clare Poupard *Designer*
Andrew Powell *Creative*
Carol Powell *TV Producer*
Chris Powell *Chairman*
Dick Powell *Director*
Eliot Powell *Copywriter/
Group Head*
Mark Powell *Director*
Matthew Powell-Perry *Creative*
Bradley Power *Engineer/
Sound Designer*
Michelle Power *Designer*
John Powner *Graphic Designer*
Malcolm Poynton *Executive
Creative Director*
Richard Prentice *Art Director*
George Prest *Copywriter*
David Preutz *Photographer*
Dave Price *Art Director*
Richard Price *Producer*
Ed Prichard *Creative Director*
David Prideaux *Copywriter*
Ben Priest *Designer*
Keith Priest *Partner*
Paul Priestman *Director*
Hamish Pringle *Director General*
Graham Pugh *Copywriter*
Justin Pumfrey *Photographer*
James Purssell *Photographer*
Tim Purvis *Creative Director*
Jamie Putnam *Head of Copy*
Nick Pye *Creative*
Justin Quillinan *Director*
Stephen Quinn *Publishing Director*
Greg Quinton *Creative Director*
Dom Raban *Designer*
Stuart Radford *Partner*
David Rainbird *Creative Director*
Jon Raine *Creative Director*
MT Rainey *Joint Chief Executive*
Kjell Ramsdal *Creative Director*
Claire Ramsden *Photographer*
Russell Ramsey *Art Director*
Michael Rand *Art Director*
Zoe Randall *Graphic Designer*
Ester Ranes *Creative*
Harry Rankin
Director/Photographer
Rupert Rawlinson *Designer*
Andrew Ray *Creative Director*
Mark Reddy *Creative Director*
Marie Redmond
Managing Director
Samantha Redwood *Creative*
Crispin Reed *Managing Director*
Julia Reed *Managing Director*
Nigel Reed *Creative Director*
Sharon Reed *Chief Executive*
Simone Rees *Art Director*
Andrew Regan *Creative Director*
David Reid *Creative Partner*
Geoff Reid *Copywriter*
Marion Reilly *Graphic
Designer/Advertiser*
Michael Reissinger
Design/Creative Director
Adrian Reith *Managing Director*
Andreas Rell *Creative Director*
Lynda Relph-Knight *Editor*
Erika Rennel Björkman
Graphic Designer
Amanda Renshaw *Publisher*
Roger Rex *Copywriter*
Fraser Reynolds
Industrial Designer
Joy Rhodes *Graphic Designer*
Juan Manuel Ricciarelli
Creative Director
Simon Rice *Art Director*
David Richards *Designer*
Jill Richards *Headhunter*
Paul Richards *Managing Partner*
Sarah Richards *Creative*
Tom Richards *Art Director*
Darren Richardson
Creative Director
Robert Riche *Design
Director/Designer*
David Richmond *Creative Director*

Robin Richmond *Designer*
Martin Riddiford *Director*
Juergen Riehm *Pricipal*
Torsten Rieken *Creative Director*
Tony Riggs *Art Director*
Martha Riley *Art Director*
Simon Riley
Deputy Creative Direction
Tim Riley *Copywriter*
Carl Erik Rinsch *Director*
Ian Rippington *Illustrator*
Jim Riswold
Associate Creative Director
Ian Ritchie *Creative Director*
John Ritchie *Deputy Chairman*
Nigel Ritchie *Creative Director*
Jan Ritter *Creative Director*
Mike Rix *Typographer*
Paul Rizzello *Copywriter*
Mark Roalfe
Executive Creative Director
Jephson Robb *Product
Designer/Managing Director*
Michael Robert *Creative Director*
Charlie Roberts *Creative*
Judy Roberts *Flame Artist*
Nigel Roberts *Copywriter*
Sarah Roberts *Designer*
Sarah Roberts *Senior Designer*
Andrew Robertson *Designer*
Lindsay Robertson *Creative*
Barry Robinson *Design Director*
Colin Robinson *Designer*
David Robinson *Designer*
Frederick Robinson *Producer*
Ginger Robinson *Copywriter*
Michael Robinson *Graphic
Designer/Illustrator*
Nik Robinson *Senior Designer*
Simon Robinson *Art Director*
Susan Robinson *Creative Director*
Wayne Robinson *Copywriter*
Paul Rodger *Director*
Adam Rogers *Creative*
Danny Rogers *Director*
Jon Rogers *Director*
Justin Rogers *Copywriter*
Victoria Rogers *Design &
Communications Manager*
Jeneal Rohrback *Creative Director*
Joe Roman *Director/Designer*
Jeremy Roots *Designer*
Kerry Roper *Typographer*
Graham Rose *Director*
Nigel Rose *Creative*
Director/Vice Chairman
Peter Rose *Creative Director*
Jeremy Rosenberg
Account Director
Meg Rosoff *Copywriter*
Andrew Ross *Designer*
John Ross *Photographer*
David Rossiter *Copywriter*
Paul Rothwell *Managing
Director/Producer/Partner*
Teresa Roviras *Graphic Designer*
Samantha Rowe *Creative*
Sebastian Royce *Copywriter*
Stephen Royle *Designer*
Kristina Ruataibordee
Graphic Designer
Karen Rubins *Creative*
John Rushton *Director*
Jonathan Russell *Proprietor*
Michael Russell *Photographer*
Peter Russell *Copywriter*
Richard Russell *Copywriter*
Rick Russell *Editor*
Nick Ryan *Director*
Phil Rylance *Art Director*
Tom Sacchi *Director*
Anthony Sadler *Creative Director*
Gaynor Sadler *Creative Director*
Helen Sadler *Art Director*
Christopher Rousseau
Sainsbury Art Director
Gerard Saint *Creative Director*
Maurizio Sala
Chief Creative Director
John Salmon *Creative Director*
Ceri Dene Sampson
Senior Designer
Sam Sampson *Chairman*
Derek Samuel *Creative Director*
Ron Samuel
Writer/Creative Director
Madeleine Sanderson
Managing Director
Colin Sands *Designer*
Mike Sands *Art Director*
Ted Sann *Chairman/
Chief Creative Officer*
Luke Sargent *Creative*

INDEX

AWARDS SPONSORS

How did we get so much work in the book? Well, for a start, we manipulated the jury.

Adobe® Illustrator® 10

What happens when a masterpiece comes to life?

Find out when you try the new industry-standard vector graphics software, Adobe Illustrator 10. Adobe Illustrator 10 defines the future of vector graphics by providing indispensable tools to cross media design professionals, Web designers and Web developers for efficiently publishing artwork. Explore with groundbreaking creative options and powerful tools for publishing artwork on the Web, in print and everywhere. Produce superb Web graphics using symbols and innovative slicing options. Develop creative ideas with live distortion tools. And publish in record time with dynamic data-driven graphics and other new productivity features.

For further details on how Adobe Illustrator 10 can help turn your work into a collection of masterpieces visit www.adobe.co.uk/illustrator or call 0131 458 6842.

We make the connection, they make the difference.

Great Ormond Street Hospital (GOSH)
Registered Charity No. 235825

Great Ormond Street Hospital (GOSH) was Founded in February 1852. ¶ It was the first children's hospital in the English speaking world, and it has grown to an internationally famous centre of excellence in child healthcare. ¶ Much has changed in medicine over that time but GOSH is committed to delivering the best and most up to date treatment now and in the future. ¶ The hospital treats 100,000 patients a year, both at its central London site and through clinics scattered across the country. ¶ It offers the largest range of children's medical specialists under one roof, so children with some of the rarest and most complex problems can be treated. ¶ In addition to its medical care, GOSH researches childhood illness, and plays a major role in training children's doctors and nurses. ¶ While the NHS pays for the day-to-day running of the hospital, it's charity, Great Ormond Street Hospital Children's Charity aims to raise an extra £12 million each year to provide family support services, buy the best in new equipment and help us do even more research.

CRACK DEALERS

SOCIAL
GAUGES

What do you know about
COCAINE?

Rescue me

FLICK
MY SWITCH

PLACE GLASS HERE

(...it's just the beer talking.)

You should
be here!
love
Bx

CREAM by Matt Soffe
STARE by Florin Bobu
ER TALKING by Julia Rocha Miranda

Don't you wish policy makers listened to designers?

Get ready to talk, because Brussels is all ears.

The EU wants to know how design thinking can help with planning for tomorrow. That means you have the chance to be part of a conference and exhibition showing leading European policy makers exactly that. It will focus on design projects and the tools and techniques they use to envision the future. One of them could be yours.

This *Future Perfect* event, in Brussels on 10 & 11 December, is part of *Design for Future Needs,* a project exploring how design thinking can help improve tomorrow's quality of life. It's being run by a group of European design organisations led by the Design Council. You can also get involved by completing a questionnaire on design methods that will contribute to a research study in advance of the conference.

So, why not put yourself in the big picture?

For more information about the *Future Perfect* conference, email: office@beda.org

To find out more about the conference exhibition, and receive the *Design for Future Needs* questionnaire, email Clive Grinyer at the Design Council: cliveg@designcouncil.org.uk

UK creatives

Matthew Abbott
Tony Cox
Ron Brown
David Dye
Peter Souter
Stuart Baker
Cameron Blackley
Walter Campbell
Martin Casson
Damon Collins
Daryl Corps
Mike Durban
Tom Ewart
Peter Gausis
John Gorse
Mike Harris
John Horton
Steve Hudson
Dave May
Rob Oliver
Paul Pateman
Simon Rice
David Sullivan
Paul Young
Paul Brazier
Barney Ashton
Chris Bardsley
Jeremy Carr
Tom Carty
Antonia Clayton
Sean Doyle
Victoria Fallon
Richard Foster
Tom Jenkins
Ben Kay
Diane Leaver
Simon McQueen
Cameron Mitchell
Mike Nicholson
Tony Strong
Gideon Todes
Mary Wear
Nick Worthington
Jon Burkhart
Liz Waldron
Steve Long
Dave Shelton
Nick Westall
Steve Stretton
Andy Tribble
Chas Ardley
Peter White
Matt Morley-Brown
Lisa Nicholson
Mike Williams
Craig Rodderick
Peter Harold
Marc Simpson
Glenn Smith
David Palmer
Ken Hoggins
Chris O'Shea
David Alexander
Pete Cayless
Rob Fletcher
Jon Grainger
Lee Healey
Matthew Lee
Andrew Lennard
Simon Parkin
Mark Robinson
Chris Walker
Bryn Attewell
Jason Cascarina
John Cook
Richard Glendenning
Amanda Kirke
Graham Pugh
BrianRiley
David Wolff
Nick Gill
John O'Keeffe
Will Awdry
Rosie Arnold
Roger Beckett
Stephen Butler
Russell Ramsey
John Hegarty
Tom Hudson
Louis Bogue
Andrew Smart
Paul Best
Adam Chiappe
Pete Bradly
Rik Brown
David Cloke
Verity Fenner

Johnny Leathers
Tony McTear
Dave Monk
Steve Robertson
Richard Robinson
Adrian Rossi
Adam Scholes
Alasdair Welsh
Yang Yeow
Pete Cain
Howard Collinge
Jon Fox
Paul Fraser
Alex Grieve
Marc Hatfield
Mark Hunter
Graham Lakeland
Justin Moore
Nick O'Bryan Tear
George Prest
Shawn Preston
Matthew Saunby
Claudia Southgate
Hugh Todd
Dougie Wood
Matt Waller
Hugh Todd
Dick Dunford
Robin Revell
Andrew Cracknell
Dominick Lynch-Robinson
Jerry Gallaher
Chips Hardy
Matt Head
Clive Yaxley
Joel Clarke
Andy McGinness
Paul Alderman
Giles Horton
Rachel Warzencraft
Ray Barrett
Stephen Benjamin
Christian Cochrane
Martin Siddle
Andy lie
Steve Sanderson
Mark Reddy
John Webster
Larry Barker
Paul Angus
Leslie Ali
Nick Allsop
Neil Dawson
Alex Bamford
Stuart Buckley
Brian Fraser
Mike Hannett
Rob Jack
Annie Jaques
Michael Kaplan
Mary Lam
Alan MacCuish
Ed Morris
Grant Parker
Justin Tindall
Joanna Wenley
Tony Whetton
Darren Bailes
Dave Buchanan
Paul Burke
Tim Charlesworth
Tim Cordell
Jeremy Craigen
Dave Denton
Andrew Fraser
Ted Heath
Simon Learman
Patrick McClelland
Ewan Paterson
Clive Pickering
Mick Sands
James Sinclair
Adam Tucker
Simon Veksner
Justine Walker
Dean Webb
Caryl Harris
Phillip Hansen
Jane Owens
Rob Kitchen
Loz Simpson
Tim Brookes
Lynda Kennedy
Paul Sharp
Frank Tyson
Paul Westmoreland

Tone Abdool
Danie Bryant
Phil Forster
Neame Ingram
John Parker
Graham Tindall
Chris Torbay
Paul Turner
David Prideaux
Paul Anderson
Tim Ashton
Martin Beard
Peter Worral
Tim Batten
Simon Cheshire
Jonathan Madden
Malcolm Chambers
Glen Colgate
Richard Germain
Steve Webb
Jeremy Payne
Rob Scott
Jolyon Grose
Jon Brain
Richard Dorey
Bina Tarulli
Chris Felstead
Mike Ferguson
Gary Fraser
Simon Haslehurst
Cathryn Jayne
Rod Marsh
David Morgan
Archie Powel
Eric Ronshaugen
Suzanne Botha
Mark Dawson
Warren Detsiny
Ashling Geh
Natalie Herbert
Adele Lang
Mark McCall
Christina Mitsis
Roger Noakes
James Rose
Tony Skinner
Nico Tatarowicz
Simon Wood
Simon Frank
John Trainor
Alan Price
Jeremy Watson
Hugh Williams
Ian Cawley
Gary Walker
Steve Chetham
Richard Donavan
Jon Canning
Phil Howells
Ian Hunter
Marie Goodwin
Simon Kershaw
Pamela Craik
John Leney
Philip Keevill
Mark Buckingham
Steve Coelho
Chris Jones
Leigh Roberts
Rebecca Rae
John Spinks
Nick Hastings
Neil Bishop
Ray Brennan
David Burn
Susan Byrne
Stephen Campbell
Dave Chidlow
Phil Chitty
Jon Daniel
Steve Drysdale
Neil Durber
David Godfree
Richard Holmes
Paul Jordan
Steve McDermott
Paul Reading
Olly Robinson
Roger Sealey
Mim Sorrentino
Steve Wakelam
Steve Boswell
Don Bowen
Mark Gilmore
Ben Hartman
Alex Hinge
Roger Holdsworth

Simon Impey
Richard Hughes
Tim Langford
Angus Macadam
Steve Meredith
Maddy Morris
Jonny Pittard
Andy Powell
Michelle Power
Roger Rex
Mark Waldron
Trevor Webb
Matt Wheeler
Steve Whiteley
Nick da Costa
Rod Love
Mark Fiddes
David Little
Alan Herring
Richard Tennant
Joanna Turner
Malcolm Green
Gary Betts
Greg Delaney
Tom Drew
Richard Warren
Ronnie Brown
Richard Prentice
Andy Kellcher
Tim Peckett
Ken Sara
John Sutcliffe
Peter Kew
Jon Elsom
Josh Haines
Mike Pantelides
Pat Thomas
Paul Cardwell
Ivan Davies
John Long
Rachel Carroll
Chris Kirk
Miles Gillman
David Shute
Simon Peek
Tim Brown
Paul Grubb
Dave Waters
Mike Honey
Paul Hancock
Peter Hayes
Eugie Pacelli
Claudio Pasqualetti
Matt Lee
Simon Riley
Brendan Wilkins
Steve Grounds
Rob Morris
John Anastasio
Glen Farnhaich
Willmott
Rebecca Wright
Mike Guegan
Gary Walton
Jon Iredale
Alan Spicer
Leslie Welch
Mike Johnson
Mark Wnek
Olly Caporn
Dominic Gettins
Chris Herring
Andy McKay
Dexter Ginn
Bonnie Horton
Charlotte Horton
Nick Klinkert
Gavin Lester
Steve Rutterford
David Chalu
Antony Goldstein
Pete Hardy
David Jennings
Nigel Rose
Michelle Allsop
Chris Barton
Alexei Berwitz
David Bradbury
Paul Copeland
Steve Eltringham
Simon Haynes
Lee Smith
Nick Bird
Martin Duckworth
Tim Garth
Karl Lobley

Angus Wardlaw
Richard Flintham
Andy McLeod
Andy Jex
Dave Masterman
Sean Thomson
James Townsend
Ed Edwards
Rob Potts
Ros Sinclair
Giles Keeble
David Legon
Geoff Weedon
Julian Andrews
Duncan McClean
Gary Willis
Martin Gent
Martin Hodges
Tim Williamson
TimMellors
John Bacon
Andy Blackford
Dan Brooks
Mark Collis
Stuart Wilson
Jimmy Blom
David Bonitto
Mick deVito
Kevin Ferry
Roger Manton
Brendan Parker
Paul Pickersgill
Nick Rowland
Chris Sainsbury
Nick Taylor
Gary Woodward
Jamie Bell
Harry Burke
Jocelyn Fiske
Kate Humphries
Ivor Jones
Scott King
Kevin Morris
Dave Rimell
Harry Shaw
Chris Street
Chris Waite
Nick Morgan
Kent Shively
Phil Webb
Newy Brothwell
Tony Curran
Clark Edwards
Chris Owens
Lex Quinn
Matthew Lloyd
Paul Marshall
Bruce Menzie
Ravi Beeharry
Tracy Murray
Nigel Pollard
Wayne Robinson
Huw Rolands
Meg Rosof
David Rossiter
Richard Saunders
Angela Savidan
Andrew Singleton
Sacha Ward
Mark Wilkins
James Parker
Ronnie Wishart
Tim Delaney
Dave Beverley
Mike Kirkwood
Rob Burleigh
Ian Ducker
Will Farquhar
Steve Paskin
Paul Walter
Glenn Gibbins
Chris Hutton
Micky Larosse
Emer Stamp
Michelle Taylor
Julie Oakley
Shay Reading
Simon Roseblade
Ben Tollett
John Messum
Paul Silburn
Alex Flint
Nick Bell
Mark Tutssel
Jonathan Budds
Anita Davis
Robert Gill
John Jessup
Steve Jones

Chris Badgerlan
Mitchell
Nigel Vigus
Richard Johnson
Matt King
Jaspar Shelbourne
Blaise Douglas
Alistair Wood
John Ashwell
Simon Brotherson
Annie Carlton
Peter Celiz
Max Clemens
Matt Collier
Jim Garden
Sam Holbrook
Jon Iles
Christine Jones
Lewis Lloyd
David Mackersey
Steve Martin
Joanna Mawtus
Crawford Mollison
Mike Murphy
Brett O'Connor
Wayne Pashley
Serge Pennings
Dick Poole
Veryan Prigg
Emma Reddish
Adaolfe
Alastair Scully
Andy Smith
Geoff Turner
Royden Turner
Jono Wardle
Paul White
Dave Woodall
Nick Wooton
Richard Barrick
Jason Berry
Jenny Bond
Charity Charity
Steve Clarke
Geoff Cousins
Trevor DeSilva
John Donnelly
Peter Dunkley
Mike Foden
Siggi Halling
Jonathan John
Ravi Karawdra
Kieran Knight
Ryan Lawson
Andrew Mancuso
Tim Johnson
Steve Henry
Pete Kirby
Axel Chaldecott
Alan Young
Jim Bolton
John Parkin
Catriona Campbell
Christian Cantrell
Stuart Farquhar
Tom Geens
Dan Norris
Zane Radcliffe
Andy Taylor
Jonathan Thake
Warren Jo Webb
Ian Williamson
Chas Bayfield
Jonathan Burley
Robert Clayman
Justin Hooper
Rick Kiesewetter
Andy Lloyd Jones
Jayne Marar
JonathanMitchell
Mike Oughton
Roderick Sensky
Lee Tan
Georg Thesman
Jo Wallace
Dean Wei
Simon Welsh
Martin Galton
Steve Hooper
Graham Mills
Jack Nolan
Paul Walton
Simon Armstrong

Martin Loraine
Annabelle
Manwaring
Richard Connor
Richard Evans
John James
Paul Miles
Rob Neilson
Mark Norcutt
Rob Spicer
Adam Staples
Julie Adams
Simon Brooks
Adam Griffin
Laurie Ingram
Laurence Quinn
Jack Stephens
David White
Gary Sharpen
Dave Brady
Kim LeLiboux
David Christensen
Charles Inge
Simon Morris
Vince Squibb
Matt Allen
Andy Amadeo
Don Barclay
Simon Butler
Jeff Curtis
AlanDavis
Frank Ginger
Wayne Hanson
Jason Lawes
Sami Lill
Richard Littler
Darryl McDonald
Gavin McDonald
Tom Notman
Alastair Ross
Rodger Stanier
Gordon Graham
Sam Heath
Kevin Kneale
Adrian Lim
Mick Mahoney
Sarah Naughton
Mark Ronquillo
Laurence Seftel
Nick Shackleton
Geoff Smith
Gethin Stout
Ken Taylor
Micky Tudor
Jeremy Willy
Tony Malcolm
Guy Moore
Andrew Singleton
Lucy Collier
Neil Craddock
Darren Wright
Graham Kerr
Jason Hyde
Martin Pierson
Roland
Hafenrichter
John Kelley
Tony Hill
Carl LeBlond
Pete Sudgen
Steve Taylor
Marcus Vinton
Ruth Bellotti
Paul Burch
Roger Akerman
Dan Anderson
Niel Anderson
Sally Bargman
Dave Brown
Rob Brown
Marcel Ceuppens
Ian Edwards
Simon Hepton
Barney Hobson
Mark Hurst
Huw Jenkins
Ashley Jouhar
Adam King
Jason King
Simon Mannion
Andy McAdie
Zeina Oakes
Ian Heartfield
Sue Higgs
Vicki Maguire

Bill Thompson
Rick Chant
Matt Crabtree
Alan Docherty
Jonathan Eley
Stuart Fermor
Damon Flynn
Neil Bradley
Mandana Foroughi
Jason Gill
Stuart Gill
Dave Green
Jerry Green
Mike Lawrence
Steve McCallum
Chris McDonald
Simon O'Neil
Don Polson
Paul Scott
Martyn Smith
Magnus Thorne
James Vigar
Paul Watson
Steve Webb
Paul Briginshaw
Malcolm Duffy
Steve Grime
Neil Patterson
Fabrice Ward
Neale Horrigan
Tim Snape
Daniel Fagg
Keith Holyoake
George Marsden
Stephen Pipe
Malcolm Caldwell
Michael Campbell
Michael Sequeira
Jackie Steers
Chris Aldhous
Paul Domenet
Julian Dyer
Andrew Fisher
Dave Fowle
Steve Williams
Michael Burke
Kes Gray
Steve Heath
Kim Henley
Jason MacBeth
Paul Quarry
Noel Sharman
Antony Woodward
Ross Ludwig
Rebecca Clarke
Louise Murray
Robert Campbell
Mark Roalfe
Richard Dennison
Andy Clough
Richard Denney
Gregg Harper
Stuart Elkin
Jo Wills
Jerry Hollens
Kevin Baldwin
Rosie Elston
Kirsten Everett
Simon Hipwell
Mark Prime
Steve Dunn
Gregg Mitchell
Peter Gatley
Mike Boles
Tony Miller
Rick Brim
Phil Cockrell
Graeme Cook
Brian Cooper
Phil Dearman
Geoff Dodd
Richard Hartley
Dave Henderson
Richard McGrann
Dominic Paver
Oliver Pugh
Ben Steiner
Rob Porteous
Derek Payne
Karl Sanderson
Christian Sewell
Dom Sweeney
Roger Pearce
Dean Turney
Simon Stephenson
Phillip Gooch
Danny Lloyd
Guy Gumm
Andy Wyton
Kate Ward
Russell Wales

Andy McAnaney
John McLaughlin
Sam Oliver
Sebastian Royce
Jes Shaw
David Williams
Seth Crew
Selwyn Learner
Sarah Sowerby
Carmel Thompson
Gary Monaghan
David Stansfield
Matt Anderson
Stuart Anderson
Dave Fleetwood
Darren Giles
Steve Nicholls
Jo Tanner
Phil Wilce
Gary Craig
John Prior
Kevin Blackman
Jonathan Yadin
Andy Wakefield
Jamie Colonna
Henrick Delehag
Mike Earl
Stephen Glenn
Terry Harris
Peter Hodgson
Keith Holyoake
George Marsden
Michael Campbell
Michael Sequeira
Jackie Steers
Chris Aldhous
Paul Domenet
Tago Byers
Yan Elliot
Paul Campion
Mark Fretten
Ross Jameson
Rob Janowski
Ira Joseph
Hugo Kondratiuk
Jason MacBeth
Paul Quarry
Antony Woodward
Rebecca Clarke
Robert Campbell
Mark Roalfe
Andy Clough
Richard Denney
Mike Sutherland
Liz VanPut
Jo Wills
Jerry Hollens
Giles Hepworth
Chris Hodgkiss
Will Bates
Martha Riley
Majella Lewis
Gregg Mitchell
Peter Gatley
Mike Boles
Rick Brim
Tom Spicer
Graeme Cook
Duncan Timms
Barry Jennings
Steve Williams
Kurt Trew
Bruce Crouch
Johnny Eugster
Ben Clapp
Oliver Pugh
Ben Steiner
Russell Schaller
Elliot Harris
Tony Hector
Stein Lundberg
Thomas Chadulla
Phillip Gooch
Alexander Jaggy
Mark Howard
Guy Gumm
Simon Friedberg
James Gillam
Suzanne Hails
Neil Chappell
Colin Lamberton
Steve McKenzie

Kayode Allen-Taylor
Dave Askwith
Nik Studzinski
Guy Bradbury
Ben Callis
Chris Bleakley
Andy Clarke
Eoghain Clarke
Samantha Carroll
Phil Clarke
Brian Connolly
Len Coward
Beverley Fortnum
Ian Gabaldoni
Dave Hillyard
David Hobbs
Colin Jones
Kevin Jones
Duncan Marshall
Greg Martin
Stuart Mills
Antony Nelson
Brett Salmon
Kai Sawatzki
Tony Barry
Tim Fitzgerald
Matt Gooden
David Graham-Dao
Pete Harle
Kerry Hawkins
George Hepburn
Nick Hine
Nick Hutton
Frazer Jelleyman
Phil Martin
Gavin McGrath
Adam Poller
Jim Seath
Damon Troth
Rob Turner
Steve Williams
Michael Burke
Pat Burns
Tara Ford
Alasdair Graham
Carol Haig
Simon Hardy
Stuart Harkness
Andy Howarth
Paula Jackson
Alan Moseley
Joanna Perry
Ben Priest
Peter Reid
Nigel Roberts
Tony St Ledger
Sam Taylor
Ben Walker
Dave Woods
Jonathan Barber
Ali Bates
Mike Ansher
John Berridge
Roger Cayless
Jessica Beresford
Duncan Dearle
Dawn Generous
Steve Gillespie
Ali Hancock
Neil Harvey
Martin Illing
Danielle McCauley
Neil McDonald
Anita Neil
Ricky Norsden
Steve Paton
Rob Taylor
Dan Wilkins
Gwenda Brophy
Giles Ecott
Ryan Edwards
John Flynn
Simon Jaunay
Denise Martyn
Simon Phipps
Craig Robinson
Louise Rooney
Emily Stokes
Simon Wilson
Ruan Milborrow
Mike Belton
Paul Roberts
Jan Heron
Luke Kelly
Andy Smart
Neil Crocker
Cathy Hutton
Simon Micheli

Emilie Moore
Rob Decleyn
Sean Larkin
Graham Shurlock
Marcus Woodcock
Steve Smith
Roland Haynes
Scott Bain
Jane Briers
Tony Bradmore
Andy Dibb
Tom Burnay
Vince Chasteauneuf
Tony Hardcastle
Remco Graham
Yu Kung
Dave Kelly
Sigi Phyland Tiobertson
Simon Robinson
Henry Rossiter
Kevin Stark
Steve Wioland
Simon Aldridge
Will Barnett
Murray Blackett
Andy Brittain
Dave Cornmell
Dominic Corp
Gary Dawson
Mick French
Martin Gillan
Caroline Hampstead
Tim Harris
Jude Healy
Stefan Jones
Paul Kemp
Nick Kidney
Steve Little
Jo Moore
Matt Woolner
Kim Papworth
Chris Groom
Matt Follows
Juliet Carter
Peter Blake
Greg Cole
Lynne Casey
Jude Chandler
Martyn Fern
Theo David
Mick Eglinton
Yuk Man
Jerry Gomez
Ed Gosney
Andy Mawson
Marc Muggeridge
Neil Redding
Dave Scott
Gordon Scott
Jo Smith
Jan Treadgold
Giles Winser
Alex Atkinson
Jo Beale
Barry Evans
Tim Ferguson
Simon Fraser
Jeremy Golding
Anne Hackett
Cathy Halstead
Paula Jarvis
Peter Kenny
Richard Mitchell
Sheila Moore
Matt Mostyn
Patrick Norrie
Craig O'Brien
Justin Rogers
Lisette Teasdale
Hannah Wallis
Diane Williams

In the meantime call 020 7287 2211 for our reel. Or read pages 408 & 411; 1997, 423; 1998...

info@eardrum.com

EARDRUM

gettyimages

passion

gettyimages.com

'She lives for the camera.' Photographer Tim Flach on casting.
Advertising, design, sport, news, entertainment, editorial. The world's leading images.

**Sponsors of the D&AD award
for writing in advertising**

sit

in

stand

out

The Mill, New York.

OAA
OUTDOOR ADVERTISING
ASSOCIATION
congratulates
Abbott Mead Vickers. BBDO
on winning the silver poster award with
'Missing Piece'
for
The Economist

PEARL & DEAN
CINEMA CATEGORY SPONSOR

PROMOTING CREATIVITY IN BUSINESS AND
SETTING STANDARDS FOR 40 YEARS

HAPPY BIRTHDAY D&AD FROM
PEARL & DEAN - CINEMA CATEGORY SPONSOR

Award winning design from Phaidon

...ewind: Forty Years of Design ...d Advertising

...blished on the occasion of ...AD's 40th anniversary.

...ited and written by Jeremy ...erson and Graham Vickers, ...th introductory texts by Jeremy ...llmore, Alan Fletcher, Richard ...ymour, John Webster and ...ter York

...0 x 250 mm, 11⅜ x 9⅞ inches, ...2 pp, *c.*1000 colour, ...0 b&w illustrations

...rdback: 0 7148 4271 0

... 45.00 UK

... 75.00 EUR

... 75.00 US

...comprehensive and international ...rvey of the history of design ...d advertising.

...atures a range of high-profile ...signs and advertising campaigns, ...cluding British Airways, Nike, ...ne Out, Levi Strauss, Habitat, ...eenpeace and Volvo.

...esents the work of leading ...actitioners and design agencies, ...cluding the Conran Design Group, ...P, Saatchi's, Cliff Freeman & ...rtners, Pentagram, Wolff Olins, ...b Gill, Ridley Scott and Alan ...rker.

Spoon 100 designers, 10 curators, 10 design classics

210 x 300 mm, 8¼ x 11⅞ inches, 448 pp, *c.*1000 colour illustrations

Specially bound with a formed steel cover: 0 7148 4251 6

£ 45.00 UK

€ 75.00 EUR

$ 75.00 US

A global up-to-the-minute overview of contemporary product design

100 of the most interesting product designers who have emerged internationally in the last five years, chosen by 10 influential curators.

400 pages of designers' projects, extensively illustrated with photographs, sketches and drawings.

A design object in its own right, Spoon's steel cover is formed in the shape of a wave.

Specially developed with the assistance of Corus, Europe's leading supplier of packaging metals, Spoon is bound in Promica® Pristine, a lightweight, polymer-coated steel that is smooth, versatile and extremely resistant.

Alexey Brodovitch Kerry William Purcell

290 x 250 mm, 11⅜ x 9⅞ inches, 272 pp, *c.*275 colour, 75 b&w illustrations

Hardback: 0 7148 4163 3

£ 45.00 UK

€ 75.00 EUR

$ 75.00 US

A comprehensive monograph on a legendary 20th-century graphic designer.

Rare, previously unpublished material from archives and private collections around the world.

Reproduces in full 3 photography books designed by Brodovitch, including the extremely rare Ballet, and 3 issues of Portfolio magazine, a much-heralded journal that is now a cult collectable.

Depicts Brodovitch's work with such eminent collaborators as Man Ray, Richard Avedon, André Kertész and Herbert Matter.

Merz to Emigré and Beyond: Progressive Magazine Design of the Twentieth Century Steven Heller

290 x 250 mm, 11⅜ x 9⅞ inches, 240 pp, *c.*250 colour, 100 b&w illustrations

Hardback: 0 7148 3927 2

£ 45.00 UK

€ 75.00 EUR

$ 75.00 US

A visual and narrative history of the avant-garde magazine.

Features an extensive selection of magazines from all over the globe linked to key artistic movements and epochs, including Dada, Futurism, Surrealism, Modernism and Punk .

Illustrated with over 300 newly photographed original magazine covers and inside spreads.

Problem Solved: A Primer for Design & Communications Michael Johnson

245 x 210 mm, 9⅝ x 4¼ inches, 288 pp *c.*500 colour, 150 b&w illustrations

Hardback: 0 7148 4174 9

£ 29.95 UK

€ 49.95 EUR

$ 49.95 US

The first book to analyse the design issues and problems involved in contemporary advertising and graphic design.

Illustrated with hundreds of colour examples of all types of design and communication work from corporate identity to posters to magazine layouts.

Contains case studies on the work of international designers and creative consultancies.

Written to appeal to students of design, marketing and communication as well as professionals.

To place orders, for further information or to obtain a full colour catalogue contact **Customer Services** on
UK **T** 020 7843 1234 **F** 020 7843 1111 USA **T 1 877 PHAIDON** (toll free) **F 1 877 742 4370** (toll free)

Alternately, to place orders, to learn more about Phaidon, to keep up to date with our publications, to sign up to receive our newsletter, and to benefit from special promotions, visit us at **www.phaidon.com**

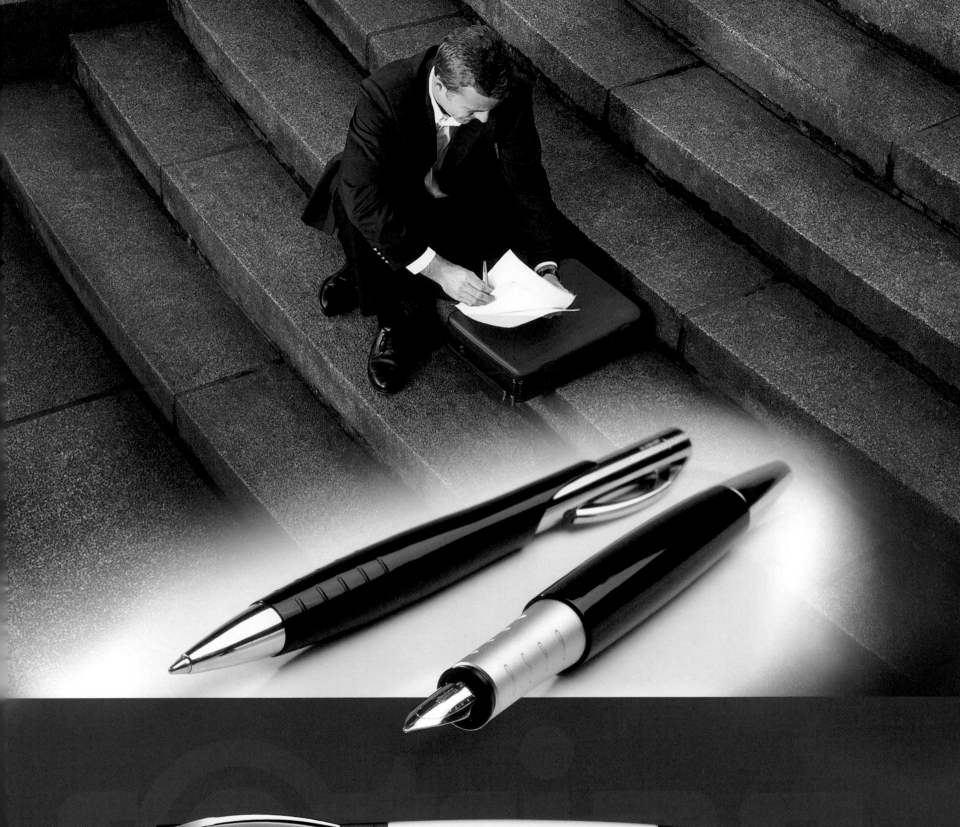

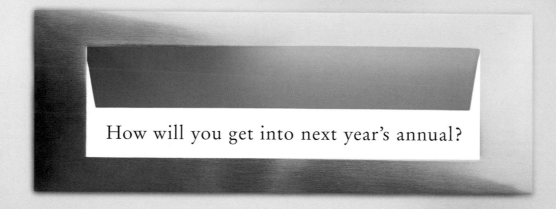

How will you get into next year's annual?

Proud supporters of D&AD.

Royal Mail

The Real Network

The only British radio nomination at D&AD this year was awarded to "Hello David" for Toyota Avensis, produced by Shell Like.
To contact Shell Like, e-mail shelllike@shelllike.com or call 020 7255 5224 and say

Congratulations to all the winner:

SVC
Film House
142 Wardour Street
London W1F 8ZU
+44 (0)20 7734 1600
post@svc.co.uk
www.svc.co.uk

Telecine, Inferno, Flame, Infinity, Avid, Computer Animation, Mac Design and Motion Cont

VENTURA

Taking Print Further

www.venturalitho.com
T + 44 (0) 1689 887700

weboptimiser

Why do the best web sites get a better class of visitor?

The more qualified your web traffic, the faster your path to profitability. The more revenue per visitor, the better your return on investment.

These are the two realities of Internet business today. And these are the reasons why so many successful web sites are optimised by WebOptimiser:

> A higher quantity **and** quality of visitor

> Faster, more interactive and intuitive sites

> Higher site revenues, lower running costs

> Systems to track, profile and communicate with visitors

With 60 major brands as customers, a growing network of expert partners and a unique portfolio of services, we can help you.

Free Optimisation Assessment

Find out what we think of your site, with a free Optimisation Assessment:

> Call us on 0800 614 421

> Email david@weboptimiser.com or

> Visit www.weboptimiser.com

Visibility • Functionality • Loyalty • Economy

Used by over 60 leading brands, WebOptimiser provides a unique portfolio of services – from search engine optimisation and competitive analysis to email marketing strategies, on-site polls and visitor tracking.

WebOptimiser
T: 0800 614 421
www.weboptimiser.com

Dulverton & Asquith-Drake

TRUST YOUR SENSIBILITIES HAVE NOT BEEN OFFENDED